Memorials to Shattered Myths

D0826766

Memorials to Shattered Myths

VIETNAM TO 9/11

Harriet F. Senie

OXFORD
UNIVERSITY PRESS

OXFORD

UNIVERSITY PRESS

Oxford University Press is a department of the University of Oxford. It furthers the University's
objective of excellence in research, scholarship, and education by publishing worldwide. Oxford is
a registered trade mark of Oxford University Press in the UK and in certain other countries

Published in the United States of America by Oxford University Press
198 Madison Avenue, New York, NY 10016, United States of America

© Oxford University Press 2016

All rights reserved. No part of this publication may be reproduced, stored in a retrieval system,
or transmitted, in any form or by any means, without the prior permission in writing of Oxford
University Press, or as expressly permitted by law, by license, or under terms agreed with
the appropriate reproduction rights organization. Inquiries concerning reproduction outside
the scope of the above should be sent to the Rights Department, Oxford University Press,
at the address above.

You must not circulate this work in any other form
and you must impose this same condition on any acquirer

Library of Congress Cataloging-in-Publication Data
Senie, Harriet.
Memorials to shattered myths : Vietnam to 9/11 / Harriet F. Senie.
p. cm.
Includes bibliographical references and index.
ISBN 978–0–19–024839–0 (cloth) — ISBN 978–0–19–024840–6 (pbk.) —
ISBN 978–0–19–024841–3 (updf) — ISBN 978–0–19–024842–0 (epub) 1. Memorials—Social
aspects—United States. 2. Memorialization—Social aspects—United States. 3. Victims—United
States. 4. Nationalism and collective memory—United States. I. Title.
NA9347.S46 2015
725'.940973—dc23
2015013447

1 3 5 7 9 8 6 4 2

Printed in the United States of America on acid-free paper

For my late husband, Burt Roberts,
who made this book and so many things possible.

And for my daughter, Laura Kim Senie,
who truly taught me the meaning of the word "yet."

The Latin *monumentum* derives from the verb *moneo*, (to warn),
and thus signifies something that serves to warn, or remind with
regard to conduct of future events.

JULIAN BONDER, *"MEMORY-WORKS: THE WORKING MEMORIALS"*
IN A COMPANION TO PUBLIC ART, *ED. CHER KRAUSE KNIGHT*
AND HARRIET F. SENIE (WILEY-BLACKWELL, FORTHCOMING)

{ CONTENTS }

Acknowledgments ix

Introduction 1

1. The Vietnam Veterans Memorial: A Symbolic Cemetery
on the National Mall 11

2. Immediate Memorials: Mourning in Protest 40

3. Oklahoma City: Reframing Tragedy as Triumph 59

4. Columbine: The Power of Denial 94

5. Commemorating 9/11: From the *Tribute in Light*
to *Reflecting Absence* 122

Conclusion 169

Notes 175
Bibliography 237
Index 247

{ ACKNOWLEDGMENTS }

My late parents, Ernest and Gerda Freitag, escaped from Nazi Germany just in time although not all of my mother's family did. They never identified as victims in any way even though they, like so many, left comfortable lives behind and began again. Their way of being in the world prompted me to think about many of the larger issues discussed here.

This book was inspired and widely informed by the writings of many scholars, most notably Erika Doss, Kenneth E. Foote, Patrick Hagopian, Edward Linenthal, Katherine S. Newman, Jack Santino, Kirk Savage, David Simpson, Marita Sturkin, Justin Watson, and Paul Williams. Even when our interpretations diverge, I am indebted to their foundational works. My field research has been facilitated by many more than I can name here. I am indebted to Vietnam War veteran Duery Felton Jr., curator of the of the objects left at the *Vietnam Veterans Memorial* when they were stored at the Museum and Archaeological Regional Storage Facility, for an invaluable tour of the warehouse in Lanham, Maryland. Thanks to Kari Watkins, Director of the Oklahoma City National Memorial and Museum, who took time during her intensely busy schedule on the tenth anniversary of the bombing to answer questions and secure space for me to attend several special receptions and programs. Thanks also to various museum staff members who over the years answered queries from my research assistants (named below). Lorena Donohue, Deputy Director/Curator of Collections of the Littleton Museum in Colorado, discussed the Columbine shooting and provided an immeasurably helpful tour of the exhibition she curated on the occasion of the tenth anniversary. Thanks too to Rhonda Erdman for her perspective on the Columbine shootings and for showing me some important related local sites.

I benefited greatly from the opportunity to present papers pertaining to aspects of this book and from the comments and questions from audience members at various academic conferences, most notably: XXIX International Congress of the History of Art, Amsterdam, Sept. 1996; Akademie der Kunste, Berlin, Nov. 1998; Columbia University Seminar in American Civilization, Oct.1999; XXX International Congress of the History of Art, London, Sept. 2000; Carnegie Mellon University, Nov. 2000; "Art and Influence," Stockholm, Sept. 2001; New York University, March 2002; Scottsdale Museum of Contemporary Art, Sept. 2002; Lower East Side Tenement Museum, Oct. 2003; XXXI International Congress of the History of Art, Montreal, Aug. 2004; College Art Association, Atlanta, Feb. 2005; Women's Caucus for Art,

Boston, Feb. 2006; Pulitzer Foundation for the Arts, St. Louis, June 2007; Columbia University, Department of Architecture and Planning, Nov. 2011; "Curating Trauma: Displaying the Unspeakable from Memorials to Global Representation of Victims," New York University, May 2012.

My research assistants Annie Dell'Aria, Sheila Gerami, Naraelle Hohensee, and Cara Jordan did exceptional work, above all Jennifer Favorite, who also aided in editing and in all aspects of preparing the manuscript for publication. I cannot thank her enough. Cher Knight, Elke Solomon, and Sally Webster read various portions of the book and discussed them with me at length. I am much indebted to their ideas and suggestions, as I am to the anonymous reviewers of this manuscript. A very special thanks to my daughter, Laura Kim Senie, a superb editor and proofreader who not only reviewed and corrected the final version of the manuscript but also made the process fun. My late husband, Burt Roberts, was a constant and invaluable sounding board as well as my first reader. His ideas inform much of this book.

My thanks to Brendan O'Neill and his assistant Stephen Bradley at Oxford University Press for guiding the manuscript through the reviewing and publishing process. My first book, *Contemporary Public Sculpture: Tradition, Transformation and Controversy*, was published by Oxford, and I am happy to return to their fold.

Introduction

It is conventional to dignify the dead, to disguise any sense that death
may be without meaning or purpose.

DAVID SIMPSON, *9/11: THE CULTURE OF COMMEMORATION*

National memorials typically celebrate political rulers, military leaders, and
victories in war, concretizing a collective identity that constitutes a form of
civic religion. From the start this genre was problematic in the United States,
a new nation with no precedents for commemoration. Who should be hon-
ored by the new democracy, and what should their monuments look like?
European models celebrating monarchs or popes were not deemed appropri-
ate; presidents, it was felt, required something different. There were, however,
no trained U.S. artists capable of envisioning or realizing new paradigms. It
took years to finalize the form of a national memorial even for such an obvi-
ous subject as George Washington. There were many design iterations for the
Washington Monument before it was finally built on the National Mall in 1885
as a result of the efforts of Lieutenant Colonel Thomas Casey of the Army
Corps of Engineers.[1] That now-famous obelisk (an ancient Egyptian form),
interestingly, offers no clue as to the identity of its subject.[2]

Memorials to famous wars were no less problematic. To date the American
Revolution lacks an official national memorial, while the Civil War's most
famous commemorative complex is a cemetery. The *Bunker Hill Monument*
in Charlestown, Massachusetts, was built to commemorate the first major
battle of the American Revolution, which actually took place on nearby
Breed's Hill on June 17, 1775, but was not realized for another five decades. Al-
though the Americans did not actually win this battle, the relatively unpre-
pared soldiers managed to repel two major assaults and the encounter was
seen as "a symbol of American military perseverance and heroism."[3] Like the
Washington Monument, it took the form of an obelisk, although there was

much debate over whether a column would be more appropriate. The winning design was by Horatio Greenough (1805–1852); the Marquis de Lafayette laid the cornerstone in 1825, the fiftieth anniversary of the battle. Well-known statesmen, including Daniel Webster, spoke at significant anniversaries. Eventually the monument became part of the Boston National Historical Park and the end point of the city's Freedom Trail. As the surrounding area became economically depressed and plagued by crime, contemporary perspectives challenged the local meaning of the memorial. In 1998 the artist Krzysztof Wodiczko (b. 1943) created a temporary public artwork using the memorial as a backdrop for a video projection. Images of faces and hands of local residents appeared on the *Bunker Hill Monument*, accompanied by individual voices, playing over a loudspeaker, which reminisced about murdered children or siblings.[4] The once-heroic national monument now valorized local victims.

While the American Revolution created the United States, the Civil War almost ended the Union. It took decades to realize the *Lincoln Memorial* on the National Mall, finally built to commemorate the one-hundredth anniversary of the birth of the sixteenth President (February 12, 1909). The work of sculptor Daniel Chester French (1850–1931) and architect Henry Bacon (1866–1924), erected opposite the *Washington Monument*, emphasized Lincoln's role as the savior of the nation rather than the emancipator of the slaves. The inscription above the statue of Lincoln reads: "In This Temple as in the Hearts of the People for Whom He Saved the Union the Memory of Abraham Lincoln Is Enshrined Forever." Over time as the site was variously used to commemorate significant moments in the civil rights movement, the emphasis of the memorial shifted. The concert by contralto Marian Anderson in 1939 was followed by the famous "I Have a Dream" speech delivered on the steps of the site in 1963 by Martin Luther King Jr.[5] More recently, Barack Obama visited the memorial a few days prior to his inauguration in 2009 as the first African American President of the United States. The meaning of memorials is never fixed.

Initially both the *Washington Monument* and *Lincoln Memorial*, linchpins of national identity, might be said to embody strategies of diversion. The *Washington Monument* avoided a heroic depiction of the first President, who was dubbed the American Cincinnatus in reference to the Roman patriot known for his reluctance to lead except in critical times. The *Lincoln Memorial*, by deliberately eschewing any reference to the contentious issue of slavery and the racial problems that continued to beset the country even after its abolition, demonstrated that memorials are at least as much about trying to forget as they are about remembering. Drew Gilpin Faust in *This Republic of Suffering* (2008) defined the burial of the Civil War dead as the central legacy of that nationally defining war.[6] Gettysburg, one of several soldier cemeteries dedicated in 1863 after the turning point of the war, contained the bodies of

more than 3,500 Union soldiers. Arlington National Cemetery, dedicated a year later, eventually included those who died in subsequent wars, with distinct sections demarcated for confederate soldiers, former slaves, and nurses. These cemeteries constitute a significant memorial legacy. Although post–Civil War history was anything but conflict-free, many U.S. citizens prospered in this period of new industrialization and the development of railroads.

According to historian Susan-Mary Grant, by the middle of the twentieth century (also known as the "American Century") the country emerged from World War II with "economic and, arguably, cultural global dominance."[7] This status was seriously shaken during the 1950s by the House on Un-American Activities Committee's so-called McCarthy Hearings, which turned Americans against each other by mandating that they report on alleged Communist activities of their friends and acquaintances. When the Cold War (which dated from roughly after World War II through 1990) ended, it resulted in the loss of the unifying effects of a common enemy (the Soviet Union) to an already divided nation. It was the Vietnam War, however, that split the country more sharply than anything since the Civil War. The quagmire of this undeclared war, which ended in 1975, continues to influence U.S. presidents and key elements of their foreign policy to the present day.[8]

How could the United States commemorate this contentious conflict? Obviously the *Vietnam Veterans Memorial* (*VVM*) on the National Mall, commissioned by the veterans who fought in the war, could not be triumphal in any traditional sense. The memorial competition eliminated any political statement about the war, insisting only on the listing of the names of the war dead. Accordingly, Maya Lin's reflective wall reads like a symbolic cemetery—and people respond to it as such.[9] Although her memorial prompted controversy when it was installed in 1982, eventually it became a focal point where all could gather to mourn, regardless of their view of the war. The political rift prompted by opposing views on the conflict, however, did not heal. Many could not reconcile their faith in this country, which they considered the most powerful on earth, with the fact that the United States lost an undeclared war against a small nation in Southeast Asia.[10]

More recently, similar memorial subjects of a non-military nature also called into question assumptions about national identity: terrorist attacks on the federal building in Oklahoma City, the World Trade Center in New York, and the Pentagon in Arlington County, Virginia, as well as the rampage at Columbine High School in Littleton, Colorado. The Oklahoma City bombing of a federal building in 1995, a little more than a decade after the *VVM* was dedicated, rocked another myth of national identity in a country that had not yet reunited after the Vietnam War.[11] Suddenly the American heartland no longer seemed safe, attacked by an American-trained, decorated U.S. soldier. The built memorial in Oklahoma City, too, refrained from referring directly

to the cause of death of the victims; rather it simply noted the times before and after the explosion on its framing gates. A complex of many elements, it included a symbolic cemetery defined by 168 chairs, one for each person who died.[12]

A scant four years later, the Columbine High School shootings in a well-to-do suburb of Denver, Colorado, challenged the widely mediated myth of the American high school experience as an idyllic part of growing up. The shooting of children by children within the confines of their school challenged the accepted idealized cultural fantasies about adolescence. Although a local event, it took on national significance through widespread media coverage, the presence of President Bill Clinton at key anniversaries, and the subsequent cultural codification of Columbine as a symbol of a specific and especially toxic kind of homegrown violence. The built memorial in Littleton also created a kind of symbolic cemetery, a partially enclosed space with a waist-high structure at its center, engraved with the names of each of the deceased, with each name accompanied by a quote submitted by a family member. Enclosed by a semi-circular wall punctuated with comments by those immediately affected by the tragedy as well as a quote by President Clinton, it omitted the names of the young shooters and the nature of their crime.

The bombing of the World Trade Center in September 2001 (soon after referred to as 9/11) sent shock waves through the entire world, suddenly revealing the United States to be vulnerable to outside attack at its center of economic power. It occurred following a time of deep political divisiveness that was prompted by the decision of the U.S. Supreme Court to allow the hotly debated 2000 presidential election results in the state of Florida to stand, thereby awarding the presidency to George W. Bush rather than to Vice President Al Gore.[13] The national memorial to 9/11, strongly influenced by Maya Lin's *VVM*, also included a symbolic cemetery. Designed by Michael Arad, two sunken voids within the footprints of the destroyed Twin Towers are each surrounded by a ledge inscribed with the names of the dead at which visitors leave tributes, much as they do at the symbolic cemeteries of all the memorials discussed here.

Each of these events challenged long-held cultural myths of an already frayed sense of national identity, and each corresponding memorial solution conflated the concept of a public memorial with that of a private cemetery. Although this conjunction was not new, its formal expression in permanent, national memorial structures was. Previously the *London Cenotaph* (1920), literally an empty tomb, was a place where "commemoration and mourning were inextricably entwined," as Jay Winter demonstrated.[14] Initially meant to be a temporary structure, it served as the centerpiece for a Victory March in London, thereby keeping the focus on both the war dead and the war that was won at great cost. The dates of the First World War are inscribed above the sculpted wreaths at each end and the words "The Glorious Dead" beneath

them symbolically cloak the war's victims (neither named nor buried here) in a mantle of triumph. Designed by Sir Edwin Lutyens, the *Cenotaph* is a single structure adapted to commemoration and mourning practices by a population that needed both. Lutyens's *Thiepval Memorial to the Missing of the Somme* (1928–1932) is dedicated to the 72,191 missing British and South African men who died in these battles (1915–1918) and have no known grave. A major influence on Maya Lin, it takes the form of a monumental complex arch with the names of the missing inscribed on its interior walls, organized by the division in which they fought. The memorial also includes sixteen stone laurel wreaths inscribed with the names of the battles, thus closely linking the names with the war in which they died. A symbolic cemetery of white crosses located behind the imposing arch that defines the memorial is a distinct and separate element.

By contrast, the multi-part structures discussed here integrate dominant spaces for mourning into their conceptual essence and the actual centers of their primary memorial spaces, while barely referencing the cause of the commemorated deaths. Adjacent education centers and museums focus prominently on the victims in a context of reinterpretation (Vietnam) or survival, courage, and recovery (Oklahoma City and 9/11). Their formal elements, together with the spaces they create, distinguish these later memorials from the World War I examples that Winter discusses. While the later memorials display what he calls "an extraordinary statement in abstract language about mass death and the impossibility of triumphalism," the American structures focus on individuals lost and the triumph of hope. They also create communities of mourners, individuals who are suddenly linked by grievous loss, as happened after the Civil War as well.[15]

The design of the *VVM* evokes a giant tombstone, thus conflating the function of cemeteries with the purpose of memorials, focusing on the private losses of individuals while excluding any reference to the larger national significance of this traumatic war. Memorials to the subsequent events valorized victims and granted a dominant role to their families in the commissioning process. As a result, strategies of diversion and denial prevailed, not an unusual approach when it comes to memorials. What was new was this emerging paradigm of the memorial/cemetery hybrid.

In the twentieth century there was no greater challenge of building memorials to victims than the Holocaust. The location of the United States National Holocaust Memorial Museum (USNHMM), a block from the National Mall in Washington, D.C., implicitly framed the Holocaust as somehow *critical* to American national identity and/or national memory. How this Americanized version of the Holocaust came to be institutionalized is a complicated story.[16] Initially, Americans were introduced to the Holocaust through the *Diary of Anne Frank* (first published in the United States in 1952) with the goal of using the young victim as a symbol of hope.[17] Themes of optimism and courage,

central to her story and popularized by filmmakers, are also embedded in the mission statements of the memorials and museums discussed in this book. Notably, these themes appear nowhere in the USNHMM.

Announced some two-and-a-half decades later on the nation's first Day of [Holocaust] Remembrance, commemorated in the U.S. Capitol Rotunda on April 4, 1979, and chartered by an Act of Congress in 1980, the USNHMM was proposed by President Jimmy Carter, allegedly to bolster the waning support of the Jewish community upset by his sale of fighter planes to Saudi Arabia.[18] The primary mission of the USNHMM is "to advance and disseminate knowledge about this unprecedented tragedy; to preserve the memory of those who suffered; and to encourage its visitors to reflect upon the moral and spiritual questions raised by the events of the Holocaust as well as their own responsibilities as citizens of a democracy."[19] This museum, defined as being primarily about knowledge, was not charged (as are the memorial institutions discussed here) to "offer comfort, strength, peace, hope and serenity."[20] Rather, the USNHMM was intended to provide "a powerful lesson in the fragility of freedom, the myth of progress, the need for vigilance in preserving democratic values."[21] It confronted difficult national issues: "a shameful policy of [American] do-nothingness and, worse, of restrictive immigration laws that blocked the escape of great numbers of European Jews."[22] Furthermore, it acknowledged the critical failure of the United States to bomb the railroad lines that led to the death camps. These aspects complicate the celebratory theme of the U.S. military's liberation of the Jews and other prisoners at the camps. The USNHMM stands in sharp contrast to the memorial museums or education centers dedicated to Vietnam, Oklahoma City, and 9/11 that focus overwhelmingly on hope, if not triumph.

The Holocaust, nevertheless, is directly or indirectly associated with the memorials discussed here. The USNHMM is linked to the *VVM* by its national site and date of official approval; both were chartered in 1980. One scholar, Edward Linenthal, wrote books on both the history of the Holocaust Museum and the *Oklahoma City National Memorial*, one immediately after the other.[23] Thus he was ideally positioned to convey ideas about the former project to those in charge of the latter; indeed Linenthal stated that the Oklahoma City Museum was "consciously modeled after the Holocaust Museum."[24] The Columbine shootings were apparently planned to take place on the 110th birthday of Adolf Hitler. The director of the *National September 11 Memorial & Museum*, Alice M. Greenwald, previously held the position of director of the USNHMM. Several writers have cited the Holocaust museum model as an obvious but inappropriate source for the September 11 Memorial Museum. As Adam Gopnik commented, "Every photograph of a Jewish child is a memory recovered from oblivion," while 9/11 was "already as well documented as any incident in history."[25] The Holocaust continues to exert a powerful, if often diffused influence.

To date, memorials have failed to acknowledge that there are distinctions among groups of victims. Notably there are those who fight in wars (whether by choice or draft), who are by definition at risk and also may be victims of misguided policy; those who die as *targeted* victims of genocide, such as victims of the Holocaust; and those who are killed in terrorist attacks while they are going about their daily lives. All have been valorized—but it is this last category that is the most problematic. As Kirk Savage observed, "[T]he question of which category of victim deserves a monument is fundamentally political, and the answer depends on the meanings that society assigns to their trauma. The severity of the trauma is not the crucial factor, but rather its collective significance."[26] Mass civilian deaths at Oklahoma City, Columbine, and the World Trade Center occurred in a safe environment rendered suddenly lethal by a rampage or terrorist attack. They were all in a sense collateral damage, valorized as heroes while their families were granted a related special status in determining their built memorials. This conflation of heroes and victims forms the assumptive basis of the memorials discussed here. So, too, does the diversionary narrative of hope that emphasizes the triumphal communal spirit prompted by the respective heinous crimes, which projected war-like destruction into our civic midst.

The recent literature on memorials and memory is vast; the following indicates those texts that were most influential to the development of this book. Kenneth E. Foote's *Shadowed Ground: America's Landscapes of Violence and Tragedy* provided an essential categorization of ways in which sites of past savagery are sanctified, designated, rectified, or obliterated.[27] Erika Doss's *Memorial Mania: Public Feeling in America*, which frames memorials in terms of the emotional or affective conditions that motivated their commission, was also critical. Kirk Savage's *Monument Wars: Washington, D.C., The National Mall, and the Transformation of the Memorial Landscape* provided not only an exemplary analysis of commemorative monuments in the nation's capital, but a paradigmatic definition of the *VVM* as the nation's first therapeutic memorial.

In the present work, chapter 1, "The Vietnam Veterans Memorial: A Symbolic Cemetery on the National Mall," analyzes the various sources and implications of what Savage termed "the capital's first true victim monument."[28] The site of the *VVM*, between the *Lincoln Memorial* and *Washington Monument* on the National Mall, defines the Vietnam War as central to U.S. unity and identity even though the conflict it commemorates prompted a divisive political crisis, pitting those who wanted to fight to a decisive and victorious end (hawks) against those who wanted the country to withdraw because they felt it had no business interfering in what they considered another country's national issue (doves). Jan C. Scruggs, the veteran who initiated the commission, wanted to honor the sacrifice of those who fought by listing their names, thereby deliberately separating the soldiers from the war. Visitors responded

immediately to Maya Lin's funereal design as if it were a giant tombstone, un-expectedly leaving tributes at the base of the so-called Wall much as they might at a local burial ground, thus conflating mourning practices typical at a cemetery with the functions of a memorial. The *VVM* became and still is a prototype, particularly in the listing of the names of the dead and the creation of a memorial complex offering multiple perspectives rather than a single structure with more limited meaning. These elements, framed by a focus on the deceased, are evident in all the memorials discussed here.

The cemetery rituals that are commonplace at the *VVM* are also a familiar, widespread response to sudden death, whether the result of an automobile accident, a drive-by shooting, or an act of terrorism. Chapter 2, "Immediate Memorials: Mourning in Protest," defines immediacy as the most salient and essential characteristic of this ritual. Currently these clusters are referred to as altars or memorials that are described as spontaneous or makeshift, re-flecting their unsettled meaning. Evident at roadside memorials and widely publicized outpourings in response to the sudden deaths of celebrities, imme-diate memorials can be contextualized within the history of American cem-eteries. They briefly transform public spaces into sites of mourning and are often implicit protests against a range of perceived social ills. Their constitu-tive elements are typically stored in national and local archives, thus trans-forming each item into a kind of sanctified relic and thereby amplifying the valorization of victims that is the focus of the permanent built memorials.

The Oklahoma City bombing on April 19, 1995, was considered a national event because the Alfred P. Murrah building was a federal entity. The bomber, Timothy McVeigh, chose this target precisely because it represented the gov-ernment; his attack on the second anniversary of the FBI-led siege on the Branch Davidian compound outside Waco, Texas, was both an act of revenge and protest. Chapter 3, "Oklahoma City: Reframing Tragedy as Triumph," links the memorial's central element, 168 sculptures of empty chairs, to ear-lier Holocaust memorials in Berlin that would have been familiar to the proj-ect architects, Hans and Torrey Butzer, who lived there at the time of the competition. The public responded to the chairs as grave markers, leaving gifts on and around them on important personal occasions as well as on an-niversaries of the attack, similar to the rituals that take place at the *VVM*. Exhibitions in the adjacent museum, in particular a room that plays an audio recording of routine government transactions interrupted by sudden dark-ness and sounds of the explosion, comprise various forms of reenactment em-bedded in a narrative that culminates in hope. The evolution of the bombing from the initial devastation to spiritual and economic renewal is *celebrated* in significant anniversary rituals.

The Columbine High School shooting on April 20, 1999, occurred just four years after the Oklahoma City bombing. The official memorial by DHM Design is a strictly local enterprise built without federal funds, a modest

structure located near the school but invisible from it. Chapter 4, "Columbine: The Power of Denial," considers the almost immediate demolition of the library, where most of the deaths occurred, and the refusal to acknowledge or even to name the two shooters who also killed themselves, anywhere in the memorial or in anniversary ceremonies. Arguably, the local faith-based cemeteries, with their commemorative markers for the victims, are equally if not more important memorials than the official complex. In this highly religious community that includes a strong evangelical Christian base, spiritual interpretations dominated the narratives that emerged after the shootings. Two films by award-winning directors, Michael Moore (*Bowling for Columbine*) and Gus Van Sant (*Elephant*), suggested alternative interpretations, raising issues that might have been explored in a memorial museum.

Chapter 5, "Commemorating 9/11: From the *Tribute in Light* to *Reflecting Absence*," discusses how the immediate and intermediate memorials for 9/11—ranging from relics of the destroyed buildings to the *Tribute in Light* (the temporary twin shafts of light first projected into the night sky on the six-month anniversary of 9/11 and annually thereafter)—assumed paramount importance in the public grieving process. Although interpretations of the light projection were framed almost exclusively in terms of hope and transcendence, visually it evoked the aftermath of the devastation—the transformation of buildings and bodies into dust. Similarly, the built memorial by Michael Arad and Peter Walker, with its focus on two voids sited in the footprints of the World Trade Center towers and defined by massive waterfalls, recalls the televised loop of the falling buildings that was replayed endlessly in the days following the attack and on anniversaries. Accompanied by the sound of rushing, continuously draining water, these features recreate the experience of both sudden and ongoing loss.

The adjacent museum, built on a site that undoubtedly contains unidentified remains, is literally a cemetery of some 9/11 victims. The museum (an integral part of the conception of the memorial, as it was in Oklahoma City) honors the victims with a wall of faces similar to the way images of the dead are presented in the other memorial museums and education centers discussed here. This form of commemoration succeeds in creating a kind of bland uniformity, similar to a high school yearbook or the "Portraits of Grief" featured in the *New York Times* after 9/11 and later analyzed by David Simpson.[29] Family members of those who perished in these civic tragedies have become a class of privileged participants in the memorial process. Relatives of victims of other tragedies are rarely honored in this way, nor do they play such a prominent role in the creation of public memorials—evidence that the focus on individual loss takes precedence over the longer view of the national significance of the commemorated events. The needs of victims' families could be addressed much more effectively by having them determine what kind of intermediate memorials they and their communities need in the time

between the awful rupture of the event and the completed permanent memorial. Permanent memorials are meant to last, to provide symbols and structures that may be reinterpreted by succeeding generations. They define a place first for public mourning and then for remembering. Formally and through usage over time, they may convey or distort actual events. By focusing on the absent bodies and invoking their presence, the memorials discussed here obscure history. They incorporate strategies of diversion that direct our attention away from actual events (a form of denial) and reframe tragedy as either secular or religious triumph, or both.

While it is debatable that those who fought in Vietnam were victims, the casualties of Oklahoma City, Columbine, and 9/11 cannot be framed in any other terms. By focusing primarily on the victims, memorials to these events succeed in separating them from the event that caused their death. That was always the intent of the *VVM*, a critical strategy at the time because the war was so highly controversial. Subsequently, however, the attempt to individualize the deceased has merged the function of cemeteries, where death and mourning are personal, with remembering and grieving in public, where actual and symbolic losses are communal. The present work traces the evolution and consequences of this new hybrid paradigm and its accompanying diversionary triumphal narratives.

The Vietnam Veterans Memorial: A Symbolic Cemetery on the National Mall

For death is in the end a personal and private matter, and the area contained within this memorial is a quiet place, meant for personal reflection and private reckoning.

MAYA LIN, *GROUNDS FOR REMEMBERING*

The Vietnam War was the first televised war, eliding the sense of personal separation that characterized the experience of previous reportage. It remains a wound from which the nation has not recovered. As John Hellmann stated: "Vietnam is an experience that has severely called into question American myth. . . . On the deepest level, the legacy of Vietnam is the disruption of the story, of our explanation of the past and a vision of the future."[1] Walter Capps explained the title of his book, *The Unfinished War: Vietnam and the American Conscience*, in terms of the nation's ongoing inability to reach an acceptable resolution of the war, a way of integrating it into a satisfactory historical narrative.[2] Patrick Hagopian observed: "In the middle of the 1990s, 72% of a sample of the American public still agreed that the Vietnam War was 'one of the worst moments in American history.'"[3] More recently Marvin Kalb and Deborah Kalb in *Haunting Legacy: Vietnam and The American Presidency from Ford to Obama* discussed the various ways in which this undeclared war has continued to influence international policy at the presidential level.[4] The widespread refusal to accept the American loss in Southeast Asia is reflected in the ongoing argument that the war could have been won. In many conscious and unconscious ways, this particular past is still with us.

Before Vietnam we expected national war memorials to honor the cause and those who died for it as one.[5] But the *Vietnam Veterans Memorial* (*VVM*), the most visited and copied memorial in American history, was intended from the start to separate the dead from the undeclared war in which they disappeared or perished.[6] This concept was embedded in the commission guidelines. It was implicit in Maya Lin's thinking about the design and its realization. Additions

to the Wall, as Lin's sculpture is often called, only emphasized this element. And from the start people behaved as if the bodies of the dead were buried there; they made rubbings of the names and left tributes at its base, both well-established cemetery rituals. The memorial's site on the National Mall in Washington, D.C., chosen even before its design, defined this symbolic cemetery as a place of national mourning. The *VVM* remains a model because it continues to serve the need for a symbolic cemetery for the casualties (which arguably include the nation itself) of an undeclared and unresolved war.

The Commission

The national struggle to commemorate U.S. involvement in Vietnam began with a gesture that failed to refer explicitly to the undeclared critically divisive war.[7] In 1978, three years after the last American had left Saigon, the Army determined that they lacked a sufficiently intact unidentifiable body to add to those already in the Tomb of the Unknowns at Arlington Cemetery.[8] Instead they suggested that some medals and a plaque be placed behind the tomb. The plaque read: "Let all know that the United States of America pays tribute to the members of the Armed Forces who answered their country's call." It required a subsequent Congressional act prompted by the Veterans Affairs subcommittee to modify this vague inscription with the words "who served honorably in Southeast Asia during the Vietnam era." This modest recognition was not publicized.

Two years earlier, during the nation's Bicentennial, Jan C. Scruggs (b. 1950), a twice-wounded Vietnam veteran, spoke to Congress about the need for readjustment counseling for those who had served. This emphasis on the veterans' undeniably great needs, however, prompted criticism because it cast them in a decidedly non-heroic light. Returning from the war to study psychology, Scruggs was drawn to the issue of survivor guilt and Jung's emphasis on the importance of collective cultural symbols.[9] In 1979 the former corporal in the U.S. Army 199th Light Infantry Brigade saw Michael Cimino's powerful film, *The Deer Hunter*, which tracks the story of three young men from their home in rural Pennsylvania to their military service in Vietnam and back, ending with a funeral breakfast.[10] As friends mourn the death of their veteran comrade, his fiancée begins, haltingly, to sing *God Bless America*. Gradually all join in and then together they toast "To Nick," thereby linking this personal death to a fractured national identity. Within months of viewing the film, Scruggs proposed a memorial at a planning meeting for Vietnam Veterans Week (scheduled by Congress for May 1979).[11] Although his idea was rejected, shortly thereafter Scruggs formed the Vietnam Veterans Memorial Fund (VVMF).[12]

The Fund's initial concern was to secure the site of the memorial; their first choice was Constitution Gardens on the Washington Mall.[13] Located between the *Washington Monument* and the *Lincoln Memorial*, two iconic structures honoring the presidents responsible for defining the country's origin and its

continuity, this location was directly linked to national identity. On April 30, 1980, after a year of campaigning, Scruggs obtained Congressional approval to build the memorial here.[14]

The Evolution of a New Paradigm

The open competition to design the *VVM* held in 1981 was the largest in American history to date, with 1,421 anonymous entries.[15] A professional jury consisting of two architects, two landscape architects, three sculptors, and a critic deliberated for four days before reaching a unanimous choice.[16] The winner, Maya Ying Lin (b. 1959), then an architecture student at Yale University, closely followed competition guidelines specifying that the memorial list all the names of the war dead and missing, be "reflective and contemplative in character, harmonious with its site," and above all, "conciliatory, transcending the tragedy of war."[17] These guidelines led to what art historian Kirk Savage has called "the nation's first 'therapeutic' memorial . . . a memorial made expressly to heal a collective psychological injury."[18]

In an undated press release the VVMF stated that, of all submitted proposals, Lin's design "most clearly meets the spirit and formal requirements of the program. It is contemplative and reflective. It is superbly harmonious with the site, and yet frees the visitors from the noise and traffic of the surrounding city. Its nature will encourage access on all occasions, at all hours, without barriers. . . . It is uniquely horizontal, entering the earth rather than piercing the sky."[19] From the outset, this last characteristic suggested a kind of burial. Built into a rise in the land, the Wall apparently merges into the earth (Figure 1.1).

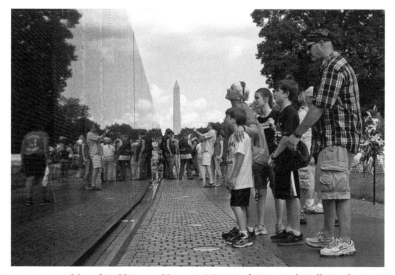

FIGURE 1.1 *Maya Lin.* Vietnam Veterans Memorial, *National Mall, Washington, D.C. U.S. Department of Defense photo by Linda Hosek.*

The components of Lin's memorial are simple: two 246-foot-long tapering segments, beginning at eight inches above ground level and reaching a height of ten feet at the center, where they meet at an angle of 125 degrees.[20] The highly polished, mirror-like black granite surface reflects visitors, the surrounding landscape, and the sky in a constantly changing array. Each wall segment is made up of seventy panels; each panel is inscribed with the names of the dead and missing arranged chronologically by date of death or disappearance, starting at the top of the right-center panel and ending on the bottom of the left-center panel. Thus the names of the first and last casualties meet at the juncture of the two long sections, suggesting a closed loop or closure (Figure 1.2). This sequence incorporated a factor of time—historical (the

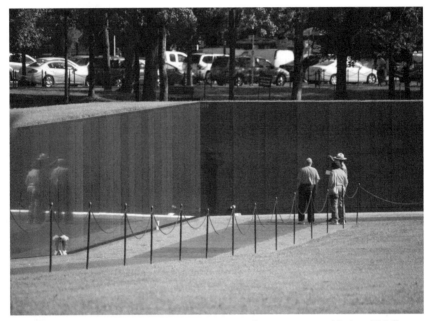

FIGURE 1.2 *Maya Lin.* Vietnam Veterans Memorial, *center section, National Mall, Washington, D.C. Photograph by Tim Evanson.*

chronology of war casualties) and actual (the time it takes to look up a name in one of the site's printed directories and find it on the discreetly numbered wall panels). Since the names of individuals killed in the same battle would be grouped together, Lin thought that this would "return the veterans to the time-frame of the war."[21]

Lin imagined that visitors would be able to walk right up to the Wall, approaching it perpendicularly from across a grassy field, and thus would be able to grasp its implicit chronology.[22] The huge number of visitors,

however, together with drainage problems at the site, required the addition of a paved path set a small distance in front of the Wall to allow for a runoff gutter. This changed the experience at the memorial from one of direct access (and retreat) to a processional. The dominant experience of the memorial, now defined by the path visitors take to traverse it, runs counter to the listing of the names that began and ended in the center. Patrick Hagopian analyzed this dramatic alteration as a powerful example of the way meaning at memorials changes over time in response to public participation.[23] People now walked into the implicit domain of the dead until they were engulfed by the height of the central panels and then exited once more into the landscape of the living as the Wall decreased in size. The memorial has been discussed so consistently in terms of this ritual experience that it has become part of its perceived content. Indeed it is difficult today to imagine the *VVM* otherwise.

Developed in a class on funerary architecture at Yale, Lin's concept was clearly influenced by World War I memorials, specifically Sir Edwin Lutyens's *Thiepval Memorial to the Missing of the Somme* (1927–1932) at Thiepval in northern France.[24] Dedicated to those who died in the six-month battle of 1916, Lutyens's work consists of a complex cluster of arches merged into a single form that reaches a height of 145 feet (Figure 1.3). Located in an

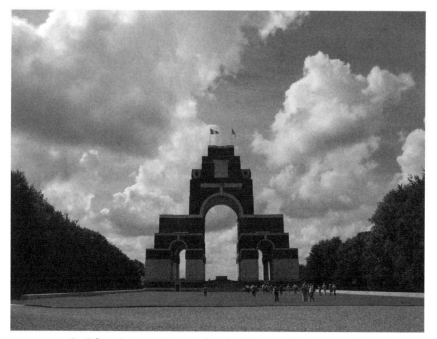

FIGURE 1.3 *Sir Edwin Lutyens.* Memorial to the Missing of the Somme, *Thiepval, France. Photograph by Wikimedia Commons user "Carcharoth."*

expansive landscape setting, it is approached across a wide, flat lawn and entered by climbing a low flight of stairs. Atop the stairs at the center of the giant arch is a large stone slab; Lutyens had been asked to design such a structure to be placed in every British war cemetery in the world. Suggesting

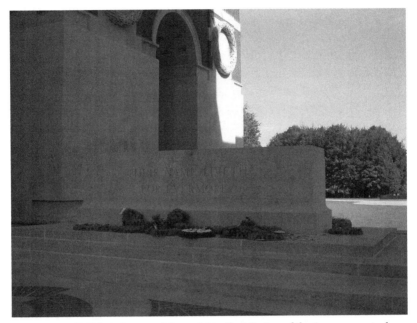

FIGURE 1.4 *Sir Edwin Lutyens.* Memorial to the Missing of the Somme, *central stone, Thiepval, France. Photograph by Amanda Slater.*

both an altar and a sarcophagus, it is inscribed: "Their Name Liveth For Evermore" (Figure 1.4). In 2000, when I visited the site, people were still leaving things there—mostly notes and red paper poppies—attached to one of the 73,357 names of the dead listed alphabetically by regiment on the walls of the interior arches.[25]

Passing through the central arch and walking down the rear steps, visitors descend into a Franco-British cemetery of six hundred white markers denoting the graves of mostly unknown soldiers (Figure 1.5). A book where visitors may leave messages is attached to the base of the back wall of the arch. Directed to the deceased, most inscriptions simply state "RIP" (Rest in Peace). Thus Lutyens's memorial provides a landscape setting and a rite of passage—across the field, up the stairs, into the arch, past the names, and down the stairs into the cemetery. People usually exit by retracing their steps. Lin described Lutyens's memorial as "a journey to an awareness of immeasurable loss."[26] In a sense, she conflated the essential elements of his memorial (the extended grassy approach, the listing of the names, and the

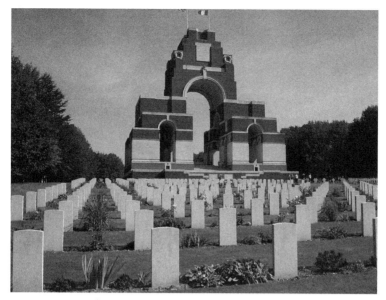

FIGURE 1.5 *Sir Edwin Lutyens.* Memorial to the Missing of the Somme, *cemetery, Thiepval, France. Photograph by Amanda Slater.*

actual cemetery) and reconfigured them in her design for the *VVM*. Instead of a literal cemetery, Lin embedded her memorial into the earth and created an aggregate tombstone. She saw the *VVM* as an impermeable membrane separating the living from the dead, "as if the black-brown earth were polished and made into an interface between the sunny world and the quiet, dark world beyond that we can't enter."[27]

In an art historical context the placement of the *VVM* may be related to earthworks, which also have a funerary link. These large-scale sculptures created directly in (rather than on) the land were most often built in remote sites. The first contemporary earthwork, according to art historian Suzanne Boettger, was Claes Oldenburg's *Placid Civic Monument*, an excavation dug and promptly filled, in Central Park on October 1, 1967, as part of the *Sculpture in Environment* exhibition of contemporary outdoor art in New York.[28] By then Oldenburg (b. 1929) had already designed a number of imaginary monuments for New York City (and other cities), including *Colossal Block of Concrete Inscribed with Names of War Heroes* (1965).[29] He referred to the Central Park work as "the hole"; American Studies professor Erika Doss has called it an "ephemeral civic grave."[30] Dug by professional cemetery workers, *Placid Civic Monument*'s dimensions suggested a grave-sized opening in the earth, albeit one without a body. Although Oldenburg's piece was not a typical earthwork, it signaled a new approach to sculpture that emerged at the time of the Vietnam War. As depicted nightly on television, the jungle landscape of Vietnam was a palpable factor in the war; often it seemed to be the enemy itself. So

perhaps it was not a coincidence that themes of conquering and reshaping the landscape appeared in contemporary art at the same time.[31] Indeed, Oldenburg remarked in his notebook, "Grave is the perfect (anti) war monument."[32]

While the placement of the *VVM* into the land was closely linked to the precedent of earthworks, its form was directly influenced by the work of Richard Serra (b. 1939), who was teaching at Yale while Lin was a student there. Serra, too, was strongly influenced by earthworks.[33] His first large-scale landscape sculpture, *Pulitzer Piece: Stepped Elevation* (1970–1971), installed in St. Louis, Missouri, consists of three triangular two-inch thick Cor-Ten steel plates of varying lengths, tapered to a point at one end and five feet high at the other (Figure 1.6). Serra intended the piece to incorporate elements of time: "All of the landscape pieces involved anticipation and reflection and walking and experiencing the time of the landscape. The pieces acted as barometers or viewing edges within the landscape."[34] Lin, who has often acknowledged Serra's influence, incorporated this way of organizing space formally and experientially in the *VVM*.[35]

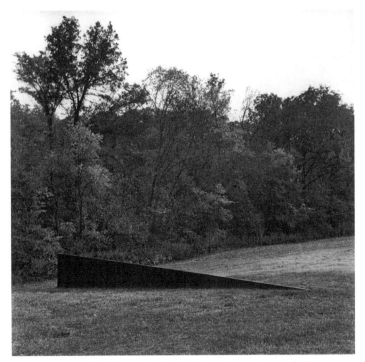

FIGURE 1.6 *Richard Serra*. Untitled, Pulitzer Piece: Stepped Elevation. *1970–1971. Three Cor-Ten steel plate fins. Fin 1: 60 x 2 x 483 in.; Fin 2: 60 x 2 x 551 in.; Fin 3: 60 x 2 607 in. Collection of Emily and Joseph Pulitzer Jr. Photograph by Skunk-Kender, New York. Copyright Richard Serra/Artists Rights Society (ARS), New York.*

The *VVM*, then, is a synthesis of diverse influences. Lin's design is elegant and evocative, apparently ideally suited to its site and subject, and all but obliterating

the possibility of imagining any other monument that would work as well in its place. Yet ultimately a memorial is rarely judged on artistic merit alone, if at all. Rather its relevance is determined by audience response. In this, perhaps more than any other memorial in American history, the success of the *VVM* has been overwhelming. And it is in the criticisms it prompted, as well as the behavior of people at its site, that the meaning of the *VVM* can be best understood.

The Controversy

Even before it was built, the design of the *VVM* prompted intense controversy, much of it orchestrated by H. Ross Perot, who had financed the memorial competition. At various times the Texas millionaire compared Lin's memorial to "a mass grave" and "a tombstone."[36] Arguments pro and con reflected ongoing contentious attitudes toward the Vietnam War, consistently conflating art and non-art issues.[37]

Both the VVMF and Maya Lin felt that a listing of the names of the dead and missing was all that was needed to honor them. Initially, Lin envisioned a single wall but technical issues made that impossible.[38] This would have made the memorial even more evocative of a cemetery, appearing like a giant gravestone (a marker where causes or circumstances of death are typically not noted). To satisfy the demand that the living who served also be acknowledged at the site, the VVMF agreed to add a prologue and epilogue to the memorial. The former, inserted at the top of the Wall before the first name, reads: "In honor of the men and women of the armed forces of the United States who served in the Vietnam War. The names of those who gave their lives and those who remain missing are inscribed in the order that they were taken from us." The latter, inserted near the ground after the last name, reads: "Our nation honors the courage, sacrifice and devotion to duty and country of its Vietnam veterans. This memorial was built with private contributions from the American people. November 11, 1982." Taken together, the inscriptions grant war status to the Vietnam conflict, insist on honor for all those who served, and define the *VVM* as an official monument of the people, not the government.[39]

The most easily countered objections to the design of the *VVM* were those disputing the sequence of the names. The argument against listing them in alphabetical order was apparent: the memorial would look like a huge telephone book, with groupings of common names like Smith and Jones lessening the impact of individual identity. This is evident in the on-site directories in which the names, out of necessity, are printed in alphabetical order. Listing names according to date of death approximates the way bodies are added to a cemetery where family units are often grouped; on the Wall military units may be linked by the time(s) of their sustained losses.

The form of the memorial prompted diverse and sometimes mutually exclusive interpretations. In its shape some saw the V-sign for peace made by

protesters of the war, while others perceived an open book.[40] Critic Elisabeth Hess had a feminist reading, suggesting that the sculpture was "placing at the base of Washington's giant phallus a wide V-shape surrounded by a grassy mound."[41] Actually the span of the *VVM* is far too wide to form a literal "V," while its vertically tapering edges negate the book comparison that the text of names implies.

The issue of the *VVM*'s color was more complex. The black granite was seen by many as symbolic of shame and dishonor, especially in contrast to the many white marble memorials in Washington, D.C. Lin found black "a lot more peaceful and gentle than white" and more importantly, better able to reflect its surroundings when polished.[42] Racial politics also entered into the discussion. A disproportionately large number of those who fought in Vietnam were black, prompting the common criticism that the war had become a form of ethnic genocide. According to Scruggs, these associations were finally squelched by General George Price, a black officer who liked the memorial. At a particularly crucial meeting he stated: "I remind all of you of Martin Luther King, who fought for justice for all Americans. Black is not a color of shame. I am tired of hearing it called such by you. Color meant nothing on the battlefields of Korea and Vietnam. Color should mean nothing now."[43] Of course, black is also the traditional color of mourning, and that is precisely what happens at the Wall.

In the minds of many, the black color of the memorial made it difficult to separate honoring the veterans from damning the war, and the pervasive criticism of the memorial as unheroic was deemed very serious. Before a televised meeting of the Fine Arts Commission on October 13, 1981, twice-wounded veteran Tom Carhart, previously a volunteer at the VVMF, referred to the Memorial as "a black gash of shame."[44] A few months later, in January 1982, some thirty-two Congressmen sent a letter to President Ronald Reagan that called the design "a political statement of shame and dishonor . . . intent on perpetuating national humiliation."[45] Essentially, the emphasis on avoiding commentary on the war in the context of healing is a strategy of denial, as Patrick Hagopian has demonstrated.[46] It is impossible to build a neutral memorial: the site, shape, inscription, and so on all convey a message. Put another way, in abstract art the form is the content, albeit open to interpretation in distinct ways at different times by varying individuals. In the end, I would argue, building what is essentially a symbolic cemetery on the National Mall and focusing on the war's casualties was (as the memorial's harshest critics intuited) an implicit criticism of the war. At one point Scruggs even commented that he saw the memorial project as a form of revenge.[47]

Punctuating and sometimes overriding the barrage of criticism leveled at the memorial design was the clash of politics and personalities. Scruggs and Secretary of the Interior James G. Watt, whose approval was necessary to obtain a construction permit, were often at odds. Ross Perot, as sponsor of the memorial competition, also played a critical role.[48] Disappointed with Lin's winning entry, he tried to organize an opposition and, allegedly through

behind-the-scenes negotiations, succeeded in making the approval of her design contingent on the inclusion of a representational sculpture. But the VVMF also had powerful supporters in the nation's capitol, including individuals at the White House, who intervened at critical moments on behalf of the memorial (albeit for their own political reasons).[49]

Additions to the Memorial

> In a funny sense the compromise brings the memorial closer
> to the truth. What is also memorialized is that people still cannot
> resolve that war, nor can they separate the issues, the politics, from it.
> MAYA LIN

Many veterans complained that there was nothing of the lived experience of the war in Lin's design, nothing of the heroic soldier typified not only in previous memorials but in the movies of World War II that many of them had seen as youths.[50] The Wall was about sacrifice and loss; many felt the need for something more positive.[51] At one point in the design process, the VVMF considered requiring a figurative component in the memorial design but decided against it because they felt the American people had already seen the war on television. The VVMF concluded not only that no more realistic images were necessary, but also that no single one could adequately represent the diverse population that had served in the Vietnam War.[52] Motivated by a desire to keep the *VVM* on schedule and a belief that the opposition had the power to block it completely, in 1982 the VVMF agreed to a compromise proposed by General Mike Davison, leader of the 1971 Cambodian invasion: they would include a flagpole and a representational sculpture at the site.[53] Although the compromise initially called for the placement of these two additions at the center of the *VVM*, eventually an agreement was reached to place them across the grassy field adjacent to Lin's Wall and nearer to the *Lincoln Memorial*.[54]

The Flagpole

Although it is rarely mentioned in any discussion of the *VVM* complex, the flagpole appeared as important to the protestors as the figurative statue; the two elements were joined together from the start.[55] The inscription at the base of the flagpole reads: "This flag represents the service rendered to our country by the veterans of the Vietnam War. The flag affirms the principles of freedom for which they fought and their pride in having served under difficult circumstances." Symbolic of the nation, the flagpole explicitly defines the veterans as patriotic and implicitly frames Vietnam as a worthy American cause fought for the key principles of democracy and freedom. It asserts a sense of national identity that was critically shaken by the war.

The Three Servicemen

There was no national competition for the first figural addition to the *VVM*. Instead the VVMF appointed an ad hoc panel consisting of four Vietnam veterans, none of whom had professional experience in the arts.[56] They chose sculptor Frederick Hart (1943–1999), previously part of the design team that placed third in the original *VVM* competition. Their proposal featured a semicircular wall listing all the names with three figures atop: a kneeling soldier next to a fallen comrade at one end of the wall and a third infantryman running toward them at the other.

In 1981, while Hart was working as a stone carver at Washington National Cathedral, he won the competition to create the reliefs and statuary for its west facade, arguably "the biggest and most prestigious commission for religious sculpture in America in the 20th century."[57] During his time in the Cathedral, Hart undoubtedly saw the statue dedicated to Norman Prince in St. John's Chapel, in the oldest part of the church (Figure 1.7).[58]

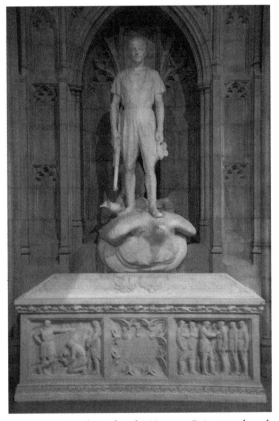

FIGURE 1.7 *Paul Landowski. Norman Prince tomb and sculpture, Washington National Cathedral, Washington, D.C. 1937. Marble. Photograph by Wikimedia Commons user "Remember."*

The young man who died in World War I was depicted by Paul Landowski (1875–1961) standing on top of his sarcophagus wearing army garb, carrying a weapon in one hand and combat gear in the other.[59] His features are generically idealized and he stands in a variation of a classical contrapposto pose, one foot slightly ahead of the other. Hart's *Three Servicemen* present a frontal view similar to Landowski's depiction of Prince (Figure 1.8).

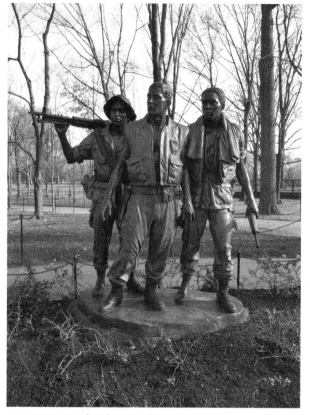

FIGURE 1.8 *Frederick Hart.* The Three Servicemen, *National Mall, Washington, D.C. Photograph by Jennifer K. Favorite.*

The servicemen are also dressed realistically in fighting gear and stare into the distance in ways that clearly mimic the statue in St. John's Chapel. This source for *The Three Servicemen* has remained unrecognized over the years, in part because Hart never acknowledged it.[60] Then, too, it is not included in public tours or illustrated in books of the Cathedral because, as one docent observed in December 2005, they are not too comfortable with the image of an armed man in a church.[61] Prince's parents, however, had donated the entire chapel, a gift contingent on their son's burial in the Cathedral together with the statue, which was installed in 1936.

The Fine Arts Commission approved Hart's model for *The Three Service-men* on October 13, 1982, after a compromise location was finalized. Installed near the entrance to the site closest to the *Lincoln Memorial*, the soldiers appear to gaze across an empty field at the memorial wall. J. Carter Brown, at that time Chairman of the Commission and Director of the National Gallery of Art, observed: "The three soldiers act as a kind of Greek chorus, facing the monument, commenting on its meaning. We were lucky with the statue; it could have been kitschy, but it isn't."[62] Brown's obvious relief reflects the gap between his art world and the one in which Hart worked. The former never really developed a language to discuss the latter as anything but "not art." Hart's interpretation, however, was not so different from Brown's. He saw "the wall as a kind of ocean, a sea of sacrifice that is overwhelming and nearly in-comprehensible in its sweep." His statues, he felt, were placed "upon the shore of that sea, gazing upon it, standing vigil before it, reflecting the human face of it, the human heart."[63] The relationship of Hart's sculpture to the Wall has often been interpreted in terms of the three figures gazing at their ultimate fate. Hagopian suggested the experience was "as if a visitor stumbled into a graveyard and imagined that he might find his own grave."[64]

As Scruggs and the VVMF had predicted, *The Three Servicemen* revealed the limitations of figurative art: once one group was portrayed, others would feel a need to be represented as well. It was upon seeing Hart's statue, not after experiencing Lin's Wall, that Diane Carlson Evans was moved to build a me-morial dedicated to the service of women in the Vietnam War.

Vietnam Women's Memorial

Diane Carlson Evans, a housewife and mother from Falls River, Wisconsin, had spent a year (1968–1969) in Vietnam as head nurse at a forward Army base near the frontline at the Cambodian border.[65] She attended the dedication of the *VVM* in 1982, where she encountered names of men who had died while under her care and experienced an onslaught of intense memories. But it was the unveiling of Hart's sculpture that concretized her mission: to make sure that the women who took part in the Vietnam War were not excluded from the narrative of war remembrance. Only eight names on the Wall belonged to women but 11,500 served in Vietnam. For Evans: "The Wall was complete be-cause the men and women who died in Vietnam were together on the Wall. . . .[But] If we are now going to see men in the flesh and blood, portrayed visible as men, then that [perpetuates] the cultural stereotype that only men go off to war."[66] Evans's story echoed Jan Scruggs's: an intense emotional expe-rience (one triggered by a film, the other by a sculpture) inspired a mission to build a memorial to honor a previously ignored segment of the population.

When Evans formed the Vietnam Women's Memorial Project in 1984, she used a thirty-three-inch bronze model of a military nurse by Rodger M. Brodin (1940–1995) as the focus of a five-year fundraising campaign (Figure 1.9).[67]

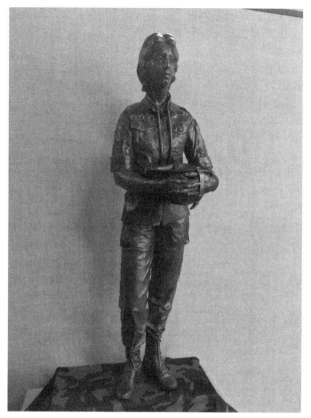

FIGURE 1.9 *Rodger M. Brodin.* The Nurse. *1984. Bronze. Photograph by Neil K. Brodin. Copyright 1984, Brodin Studios, Inc. All rights reserved.*

By the fall of 1985 there were four replicas of *The Nurse* circulating around the country and garnering local approval. Some people in Washington, however, had problems with another addition to the National Mall in general and with *The Nurse* in particular. The Fine Arts Commission rejected the proposal 4 to 1.[68] Subsequently, the project directors gained the support of five major veterans' organizations, with some six million members altogether.[69] In a fourteen-minute segment aired on *60 Minutes* in February 1989, Morley Safer championed the women's cause by featuring the contributions of five military nurses who had served during the war. Evans saw this as a turning point.

During 1988 a bill to build what was now called the *Vietnam Women's Memorial (VWM)* circulated in the U.S. House and Senate. By the year's end Congress had passed, and President Reagan had signed, a law authorizing a memorial, but not at the coveted Constitution Gardens site. On November 28, 1989, after another more vigorous public relations campaign focused on lawmakers in Washington, President George H. W. Bush signed legislation for

the desired location on the Mall. Following Fine Arts Commission instructions, this time the Vietnam Women's Memorial Project (VWMP) held a competition with both art professionals and veterans on the selection panel. There was a contentious split between the two groups, the former favoring an abstract design, the latter preferring a figural bronze statue. Ultimately the board selected sculptor Glenna Goodacre (b. 1939), whose entry was originally an honorable mention.[70] By March 1993 her design had been approved by all regulatory agencies.[71]

While Hart's *Three Servicemen* stare at the Wall, the *VWM* is self-contained, a four-figure bronze sculpture in the round with an implicit narrative (Figure 1.10). The focus of the group is a woman seated on a pile of

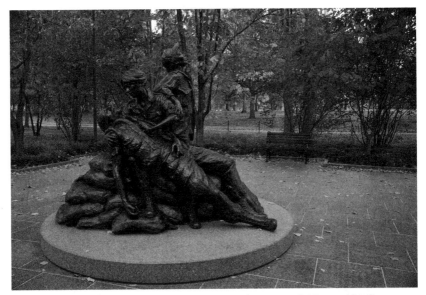

FIGURE 1.10 *Glenna Goodacre.* Vietnam Women's Memorial, *National Mall, Washington, D.C. Photograph by Flickr user pcouture.*

sandbags, looking down into the bandaged face of a wounded soldier cradled in her lap; this is the recognizable pose of the *Pietà*, well known from centuries of Christian images depicting the Virgin Mary cradling the body of the dead Christ. However, Goodacre intended to convey that the soldier would live.[72] Moving in a counter-clockwise path from the central feature, the next figure is a standing woman with African-American features, looking skyward, her body apparently arrested in a moment of recognition. The sculptor imagined her searching for "a medevac helicopter or, perhaps . . . help from God." The third woman (not visible in the illustration) kneels with her eyes downcast, evoking a traditional figure of mourning. For the artist "her posture reflects her despair, frustrations, and all the horrors of war." These

figures, like Hart's, are generic, but Goodacre's have symbolic titles: the *Pietà* group is called "Caring," the standing figure "Hope," and the kneeling figure "Despair." Traditionally, sculptures depicting Christian virtues or vices often took the form of women wearing classical attire. Such images, long-familiar features found in public spaces and adorning church architecture of earlier centuries, have been the focus of feminist critiques that address the paucity of celebratory images of actual rather than symbolic women in the public realm.[73]

The *VWM* appears to form a closed circle, its figures posed in a series of exaggerated gestures, creating a visually jarring note when contrasted to other parts of the *VVM*. The implicit message of this composition is that the women's experience is still separate, unrelated in formal and substantive ways to the rest of the memorial complex. It attracts far fewer visitors than Hart's statue, even on national holidays. This does not mean that the *VWM* does not resonate with its intended primary audience, the women who served. For example, Jill Johnson, a service club director for Army Special Services in Vietnam at the same time as Evans, saw Goodacre's figures as her sisters.[74]

The *VWM* was unveiled on Veterans Day in 1993 and dedicated by Vice President Al Gore at a ceremony entitled "A Celebration of Patriotism and Courage." "Let's all resolve," he implored, "that this memorial serve as a vehicle for healing our nation's wounds. Let's never again take so long in honoring a debt."[75] But a memorial alone cannot heal. Its impact is determined by the responses of its visitors, and people behave very differently at the symbolic cemetery that is the Wall than they do at the two figurative sculptures across the lawn. There is no self-imposed silence at either statue: people use them both as personal "photo ops." Those who photograph the Wall usually do so from a respectful distance.

In 2004 a plaque was set into the ground adjacent to Hart's statue. It reads: "In memory of the men and women who served in the Vietnam War and later died as a result of their service." This was a veiled reference to the fatal after-effects of the war, which included illnesses due to Agent Orange, physical and psychological injuries, and suicides. On Veterans Day 2005 a number of wreaths were placed around Hart's figures, but not nearly as many as could be found lining the Wall. *The Three Servicemen* attracted a respectful crowd but not an awed or silenced one. The newly installed plaque was largely ignored; indeed, it is barely visible. At the *VWM* (a much more remote site surrounded by benches) there was far less activity and more imposed narrative. Speakers at a podium tried to explain and contextualize the nature of a woman's experience in the war. One young man wearing fatigues and smoking a cigarette was photographed by a small video crew while draped over the figures: respect was not evident. The sculpture, composed of so much posturing, seemed to prompt some more in its visitors. Children saw it, as they do much public art, as something to climb.

The two figurative statues foster a decidedly gendered reading of war experience. When school groups visit the *VVM* the boys frequently cluster around Hart's soldiers, while the girls are photographed next to Goodacre's sculpture. And although the Wall, *The Three Servicemen*, and the *VWM* together with the flagpole are intended as a memorial complex, I overheard one young boy standing at the Hart statue point toward the Wall and say excitedly to his mother, "Look, there's the *Vietnam Veterans Memorial*." In the end the additions to Lin's Wall remain separate, prompting distinct, less reverential responses.

The *VVM* as Symbolic Cemetery

It almost seems remarkable that no one is actually buried at the Wall.
A casual visitor who did not know better could certainly assume that
there are veterans buried there.
JAN SCRUGGS, *WRITINGS ON THE WALL: REFLECTIONS
ON THE VIETNAM VETERANS MEMORIAL*

As discussed above, each of the figural additions to the *VVM* had formal associations to sculptures that depict death. *The Three Servicemen* was apparently based on a tomb sculpture in Washington National Cathedral, while the *Vietnam Women's Memorial* was modeled after a traditional *Pietà* group. But it was Maya Lin's Wall that prompted visitors to behave as if they were at a cemetery. As historian John Bodnar observed: "In many ways [the *VVM*] resembled the cemeteries that were erected in the south immediately after the Civil War where people could honor those they had lost and express their grief."[76] The Civil War, called the "most devastating conflict in American history," led to the creation of Arlington National Cemetery as "a burial place for Union and Confederate soldiers."[77] Arlington, with two major memorials to symbolize lives lost (one for each side) was, like the *VVM*, intended to heal a nation. Over time its role expanded, evolving into the nation's most revered burial ground, appropriately aligned with the Mall on the axis that was to mark the *Washington Monument*, the *Lincoln Memorial*, and the *VVM*. Presidents John F. Kennedy and William Howard Taft are buried there, as well as distinguished military heroes and prominent figures of U.S. history. The *Tomb of the Unknown Soldier* now includes bodies to represent World War I, World War II, the Korean War, and an empty sarcophagus with the inscription: "Honoring and Keeping Faith with America's Missing Servicemen, 1958–1975." This was added after the remains of the soldier representing losses in Vietnam were identified and removed. At the entrance to the cemetery is a sign that reads: "WELCOME TO ARLINGTON NATIONAL CEMETERY / OUR NATION'S MOST SACRED SHRINE /

Please Remember These Are Hallowed Grounds." Throughout the cemetery there are black circular reminders that a sacred site demands a certain kind of behavior: "Arlington National Cemetery / Silence and Respect."

Silence and respect characterize behavior at the *VVM*. In a sense, silence was implicit in the guidelines for the competition, which insisted that the memorial make no political statement about the war. It might be argued that refusing to discuss the war was tantamount to a negative statement about it and that silence itself could be considered a distinct form of rhetoric.[78] Although responsibility for the creation of meaning at a memorial (or any work of art) ultimately rests with the viewer, the rhetorical effect of silence is heightened at the *VVM* by its reflective surface. As one confronts the names, essentially staring both separation and mortality in the face, interpretation inevitably becomes personal and—given the nature of this war—political. That people do create their own frame of reference or narrative is evident in the array of objects, which have been left in tribute at the base of the memorial.

Visitors behave reverentially, as if they were at a cemetery, largely because the presence of bodies is implied by the list of names on the Wall. The insistence on the identity of the dead and missing emerged as an issue during the Civil War. The listing of the names became a major focus of war memorials to World War I when so many of the dead were unidentifiable.[79] Even though most of the Vietnam dead are buried in local cemeteries across the country, interment is implied by the way the memorial is placed into the ground.[80] Indeed, the *VVM* has been linked to a romanticist tradition of American cemeteries that emerged during the mid-nineteenth century.[81] This tradition, with its roots in picturesque Mount Auburn Cemetery in Cambridge, Massachusetts, insisted on a memorial "that evokes the most sublime emotions, that affects healing through emotional response, that promotes contemplation by joining the best of art and nature." Historian Robert Morris referred to it as "a new gravescape."[82]

Objects Left, Individuals Remembered

> The irresistible need many visitors feel to touch a chiseled name, kiss it, talk to it, offer it flowers or gifts, leave it notes or letters, is evidence enough of the dead's privative presence in the stone—a presence at once given and denied.
>
> ROBERT POGUE HARRISON, *THE DOMINION OF THE DEAD*

Even before the *VVM* was built, individuals began leaving things at the site. As the concrete was being poured a U.S. Navy officer dropped his dead brother's Purple Heart into the foundation trench.[83] And there were many

veterans who, upon seeing a preview news clip of the memorial, immediately took themselves and often their families to Washington.[84] Yet no one expected the massive leaving of objects on Veterans Day in 1982, when the memorial was officially dedicated. This practice, although much diminished in volume, continues to the present day.

From the start, any non-perishable object left at the Wall was saved by National Park Service employees and trained volunteers who monitored the memorial daily. After two years, in 1984 the Vietnam Veterans Memorial Collection (VVMC) was formed to organize and care for the growing number of items that were then stored in the 25,000-square-foot Museum and Archaeological Regional Storage Facility (known by its acronym MARS) in nearby Maryland. The first curator of the collection, Duery Felton Jr., was a Vietnam veteran who had been awarded a Purple Heart for his service in the war. Among other things, Felton played a major role in selecting the objects that were subsequently featured in Thomas B. Allen's book, *Offerings at the Wall: Artifacts from the Vietnam Veterans Memorial Collection* (1995) and that remain the focus of the collection. Felton was succeeded in 1997 by Tyra Walker, a trained art historian with museum experience: she made it her mission to locate and catalogue the published objects.[85] In 2000–2001 the collection was moved to its current location in Landover, Maryland, at the National Park Service Museum Resource Center (MRCE).

To date the VVMC contains over 100,000 objects. This is, as far as I know, the first documented collection of such an ongoing offering.[86] American Culture professor Kristin Hass has interpreted it as evidence of "a tremendous effort to reconstitute the nation and the citizen's faith in it."[87] Allen considered the objects "tangible bonds between those who fell in Vietnam and those who remembered, like a mystic communion with the dead."[88] I see them primarily as reflecting strategies of personal mourning, but with a national overlay. These items tell us much about the way individuals construct memory, how they remember people or events in tangible form—the way they "make memory real."[89] As many have noted, visitors feel the presence of the dead more at the *VVM* than at their actual gravesites. At a national memorial this ritual leaving of objects, beyond linking the living to the dead, defines the way individual experience and public events are conflated in memory. Here various official, shared, and personal memories merge. The objects are material evidence of collected (not collective) memory. They reflect not only different personal strategies for mourning but also divergent opinions about the Vietnam War.[90]

For veterans the Wall became a meeting place; the official site for remembering, mourning, and in many cases, personal healing. Some committed suicide at the memorial; others scattered ashes of the dead at its base.[91] As time passed, personal connections to the names on the Wall became ever more distant. Nevertheless, the names of so many dead resonate, and the war

remains a haunting specter in American history. As subsequent wars continue to be compared to Vietnam, the *VVM* becomes again and again a national public forum. At the official program for Veterans Day 2005, many speakers standing at a podium in front of the *VVM* affirmed the need to support U.S. troops in Iraq regardless of personal opinions of that war.[92] Implicit then as it was in the *VVM* guidelines was that the cause (the war) was divisive and possibly wrong. Also implicit was that mourning (honoring the dead) was the primary focus.

While she was designing the *VVM*, Maya Lin made a conscious decision not to immerse herself in the details of the war. Instead she chose to think about death, about how and where people cope with the death of a loved one. In her proposal she wrote, "[I]t is up to each individual to resolve or come to terms with this loss. For death is in the end a personal and private matter and the area containing this within the memorial is a quiet place, meant for personal reflection and private reckoning."[93] She might well have been describing a cemetery.

Burial customs vary, and the materials left at the Wall undoubtedly reflect a variety of mourning practices.[94] At cemeteries and at the *VVM*, many people concretize their memories in an array of objects.[95] The articles originally left at the memorial appear to fall into four main categories: (1) relics pertaining to the deceased; (2) gifts for the dead; (3) objects of shared experience; and (4) documentation and commentary. Understandably, these categories overlap, but usually their primary intention seems clear. The first three suggest a personal relationship with the deceased.

(1) Relics in the form of clothing, medals, or other items particularize individuals beyond their names on the Wall. Tim O'Brien, in a moving story entitled "The Things They Carried," itemized the whimsical as well as essential items "humped" by "legs" or "grunts," objects that defined their experience with vivid immediacy.[96] The personal relics left at the Wall stand for the individual, as do the relics of saints in a Christian context. Many have a wartime context. At MARS there was a locker of clothing, uniforms hung on hangers and caps, as well as a selection of boots and sandals commonly worn in Vietnam. There were also a number of wood "short timer" or "marker" sticks used by soldiers to keep count of their remaining days of service. There were countless dog tags and an empty mess kit. Some relics were composite objects: one framed collage contained military unit patches, a toothbrush, and a package of gum. Like the initial Purple Heart dropped into the concrete foundation of the memorial, the leaving of these relics might be considered a symbolic burial.

(2) Gifts for the dead, especially evident on national holidays or individual birthdays, commonly take the form of objects intended to please or soothe. Perishable flowers, probably the largest category of objects left at the *VVM*, obviously cannot be saved but many bring them as they do at cemeteries. Others leave stuffed animals, some covered in army camouflage; one teddy bear was embroidered with names of individuals and regiments. There was also a lollipop tree and some "boo-boo bunnies" (washcloths folded into the shape of rabbits, at one time popular in the Midwest); I suspect that these items were left by mothers or caretakers. Other gifts specifically define the identity of the giver. Letters with personal messages or remembrances are common.[97] Many are from children who never knew or barely remember their fathers. Children also leave tassels from commencement hats and even diplomas. Cards and gifts are routinely left on holidays and birthdays. Amidst the candy and decorated eggs in one beribboned Easter basket is one plain white egg, signed, "Uncle Billy."

(3) Rather than emphasize the role of the giver, some objects serve to evoke a shared experience that the living once enjoyed with dead. Games and sports are remembered through marbles, playing cards, a basketball, or an autographed baseball and glove. There are marijuana joints and drug paraphernalia (confiscated as contraband) and many bottles of liquor and beer (Jack Daniels and Budweiser appear to be the most popular brands). By transferring the remembered experience to the memorial site, symbolically extending it into the present and implicitly into perpetuity, these objects transform a place of public mourning into a site of private experience, a site of life. Some, like money, suggest the payment of old debts, but most are an attempt to mark a place where the living and dead may continue to be together. In this sense they are like the gifts but are unlike the relics, as the latter more likely signal a kind of closure.

(4) Documentation and commentary take many forms: objects, letters, journals, photo albums, as well as works of art that refer to larger issues, to the Vietnam War, and to our society in general. Framed photographs and entire albums document individuals and wartime activities; almost all are inscribed with identifications and narratives. There are countless American flags asserting patriotism. There is also a South Vietnamese flag (presumably a war souvenir) covered with signatures of veterans. Some political messages are more specific. A black triangle containing an inverted pink triangle is dedicated: "In memory of the gay soldiers in

Vietnam: Made heroes for fighting other men, shamed for loving men," and dated Gay and Lesbian Pride Day, June 14, 1987. A straw bonnet decorated with flowers has a red, white, and blue patch stating: "The Civil Rights Act/Simple Justice"; it also sports purple ribbons printed with the letters NOW, standing for the National Organization for Women.

There are both realistic and abstract paintings in the collection, as well as a large number of collages or mixed media objects that might be considered composite memorials. An abstract painting of broad diagonal strips of brown, red, white, and blue is dedicated to all the veterans affected by Agent Orange and other herbicides used in the war. A small, brightly colored carousel decorated with Christmas lights, American flags, tinsel, and balloons includes an inscription assuring the POWs and MIAs that they are not forgotten. A construction entitled "After the Holocaust" composed of a wounded dummy and an assortment of upended broken appliances affixed to a cart was left after a protest demonstration against nuclear weapons.

It is the objects of commentary that change the *VVM* most profoundly. They convert a place of national mourning into a site of public assembly, albeit a silent one. These objects go beyond the personal tributes commonly left at individual graves in private burial grounds. They reclaim for this symbolic cemetery a role generally fulfilled by cemeteries in the United States during the nineteenth century, that of "a forum to publicize grievances and to right wrongs."[98] With them the entire memorial site serves to reflect—literally—the various responses to the Vietnam War and its evolving place in national memory.

The Traveling Walls

The intense response prompted by the *VVM* was not restricted to its site. Like the outpouring of tributes left at the Wall, the reaction was immediate, unexpected, widespread, and ongoing.[99] The Wall inspired the creation of several half-size models (portable walls) that traveled around the country on flatbed trucks (Figure 1.11). Even before construction on the *VVM* was completed, a local government agency asked the VVMF for the right to build a small replica at a highway road stop near the Delaware Memorial Bridge to honor veterans from Delaware and New Jersey; that petition was denied.[100] Nevertheless, at one time there were six half-size replicas of the Wall, none with a fixed location.[101]

As part of the activities commemorating the fifteenth anniversary of the dedication of the *VVM*, the VVMF formally unveiled a museum to accompany its traveling wall, a harbinger of the Vietnam Veterans Memorial

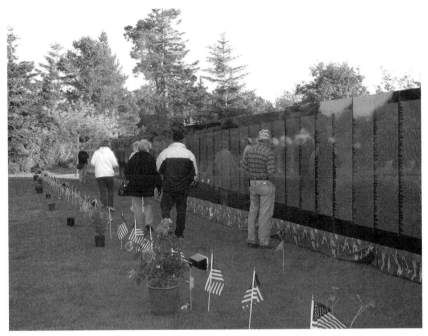

FIGURE 1.11 *Vietnam Traveling Memorial Wall in Florence, Oregon, May 2007. U.S. Navy photo by Mass Communication Specialist 1st Class Barbara L. Bailey.*

Education Center that will be built on the National Mall adjacent to the Wall once the necessary funds are raised. According to Scruggs, the purpose of the traveling museum was to "provide exhibits to help the public better understand the historical perspective of this long and costly war."[102] Panels built into a thirty-six-foot state-of-the-art trailer include memorabilia left by visitors either at the *VVM* or its half-size traveling version, objects pertaining to peace demonstrations during the war, a map and chronology of the Vietnam conflict from its historical inception, and a CD-ROM of "educational vignettes." The most significant display features success stories of Vietnam veterans. It includes testimony from several U.S. Senators at the time—among them Charles Hagel (R-NE), Bob Kerrey (D-NE), John Kerry (D-MA), John McCain (R-AZ), and Charles Robb (D-VA)—along with the founder and chairman emeritus of America Online (Jim Kimsey), the founder and CEO of Federal Express (Fred Smith), and a former star football player (Rocky Bleier of the Pittsburgh Steelers). These reminders of the many civilian contributions made by Vietnam veterans were intended to counter images of the severely damaged and angry veterans frequently featured in the news and Hollywood films. By contrast, the planned education center will focus on images of all those who died in the war.

National sponsors for the VVMF's touring wall and museum include the Veterans of Foreign Wars (VFW) and Turner Network Television (TNT). In small towns the traveling walls act as catalysts for communal mourning; for some the resistance to painful memories seems easier to overcome in familiar surroundings.[103] According to the VVMF, local ceremonies vary, depending on what the community wants to do. Some locations stage parades, flyovers, readings of the names, candlelight ceremonies, or some combination of these rituals.[104] The mementos left by people are typically stored in the local historical society.

The VVMF's traveling wall came to midtown Manhattan on Veterans Day 1998, courtesy of the Bell Atlantic Arts and Humanities Foundation, which is known to have a strong commitment to veterans' issues. An advance notice arrived on my telephone bill. The traveling wall was erected in Bryant Park, a space equal to two city blocks, adjacent to the west side of the New York Public Library's central branch on Fifth Avenue (between 40th and 42nd Streets). The small gathering of attendees consisted of apparently homeless veterans clothed in red jackets and hats, representatives of the Salvation Army, and Cub and Boy Scouts who handed out flags to all those present. The main speaker at the event was Toby Webb, executive vice president of Bell Atlantic and a Navy veteran. "The true power of the Wall," he said, "was that it launched our nation's healing . . . helping America to finally begin to put behind us the divisions of the Vietnam years." After a communal singing of the National Anthem, Webb introduced two spiritual leaders: James O'Loughlin (Medicine Chief of the Native American Cherokee Confederacy) and Rabbi Jacob Z. Goldstein (Staff Chaplain of the New York Army National Guard in upstate Latham). Neither was local or represented a mainstream group.[105]

The actual experience of visiting the traveling wall is nothing like visiting the original.[106] Half-size panels rest on visible supports raised several inches off the ground. Not built into the earth, not overpowering in size, with names that appear to be written rather than engraved, it lacks both actual depth and formal authority. Nevertheless, people are moved. Some of those who gathered at the opening ceremony in New York in the pouring rain brought personal mementos and left them at the base of the structure, echoing the behavior of visitors to Lin's Wall in Washington, D.C.

The *VVM* as Prototype

Lin's Wall became an immediate prototype that persists to the present day: its most repeated features are an emphasis on the names of the dead, the use of reflective surfaces, and a participatory experience.[107] The *Korean War Veterans Memorial* (1995), sparked by the success of the *VVM* and located not far

from it, is highly indebted to the earlier monument's design. It includes a re-flective wall that incorporates an array of images that are apparently emerg-ing from its depth, as well as a figurative component.[108] The tableau of thirty-eight over-life-size soldiers on patrol defines this as a site of life, albeit a potential killing field rather than a symbolic cemetery (Figure 1.12).

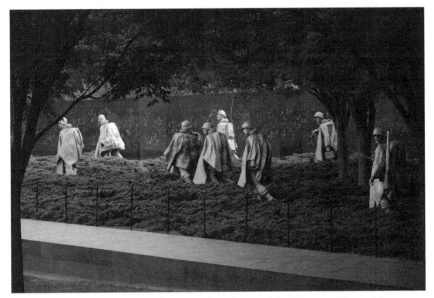

FIGURE 1.12 *Frank Gaylord and Louis Nelson.* Korean War Veterans Memorial, *National Mall, Washington, D.C. Photograph by Tim Brown.*

The *VVM* has been linked to another famous memorial of its time, the NAMES Project AIDS Memorial Quilt.[109] Like Scruggs, AIDS Quilt founder Cleve Jones was motivated by the "threat of oblivion to another generation, a population America also seemed eager to forget."[110] In 1985, Jones asked par-ticipants in the annual march in honor of Harvey Milk (the elected member of the San Francisco Board of Supervisors, assassinated in 1978) to make placards featuring the name of someone they knew who had died of AIDS. When these were hung on the facade of the federal building in San Francisco, the effect was described by Yale Divinity School professor Peter S. Hawkins as "stunning: a wall of memory that, simply by naming names, exposed both private loss and public indifference." Although this suggested a quilt to Jones, Hawkins and others found the link to the *VVM* wall equally compelling.[111] In 1998, Jones referred to both the Wall and the Quilt as "mediums for reaching the dead."[112] Individual quilt panels measure three by six feet—the size of a human grave. By 1987 the Quilt had become such an important national memorial that it was displayed on the Washington Mall (Figure 1.13). Like the traveling *VVM*

replicas, sections of the quilt exhibited in various locations make possible a wider "performance of mourning."[113] In each instance it seems that the "aura" of the work—the sense that the dead are present—creates, for a time, a symbolic cemetery.

FIGURE 1.13 *The NAMES Project. AIDS Memorial Quilt, as displayed on the National Mall, Washington, D.C., during the 2012 International AIDS Conference. Photograph by Wikimedia Commons user "Bluerasberry."*

The Vietnam Veterans Education Center

Writing about the *VVM* in 1991, Robert Harbison mused that perhaps at some point "this anti-monument will seem so enigmatic it needs explaining."[114] At the time of this writing the underground Vietnam Veterans Memorial Education Center (VVMEC), designed by Ennead Architects (formerly known as Polshek Partnership), with an exhibition developed by Ralph Appelbaum Associates (designers of the installations at the U.S. Holocaust Memorial Museum), is in the fundraising stage: eventually it will be built on the Mall across the road from the *VVM* itself. Commissioned by Jan Scruggs and the VVMF, the VVMEC will feature a timeline that normalizes the Vietnam War, contextualizing it in a historical trajectory that begins with the American Revolution.

The VVMF has been engaged in educational activities since the late 1990s.[115] In October 1999 they developed a high school curriculum, *Echoes From The Wall: History, Learning and Leadership through the Lens of the*

Vietnam War Era, and distributed it free of charge to the nation's 27,000 public and private high schools.[116] The following year Scruggs, standing on the steps of the *Lincoln Memorial* with Vietnam veterans Senator Chuck Hagel (R) of Nebraska and Representative John P. Murtha (D) of Pennsylvania, announced his plan to introduce legislation for the construction of the VVMEC. After some national resistance, support for the project was granted by the NPS at the direction of President George W. Bush a few months after September 11, 2001. Among the justifications Scruggs cited for building the VVMEC was the alarming statistic that only 30% of American students could identify on which continent Vietnam is located.[117]

The mission of the Education Center is framed in terms of keeping alive the memory of the individuals who lost their lives during the war: "As those who served pass away, as family memories are forgotten, The Center will tell the stories of their lives, stories of courage, hope, love, family, and unshakable faith in our country."[118] A large "wall of faces" of those whose names are listed on the Wall will follow a yearbook type of installation similar to those at the memorial museums dedicated to the Oklahoma City bombing and 9/11 attacks. Specific individuals will be featured on their birthday, their image accompanied by information about their hometown and military rank, as well as date and place of death. Birthdays of the deceased are, of course, private celebrations, typically prompting visits to cemeteries by family members and friends. In addition to a display of faces of those who died in Vietnam, the Center will also include a selection of the objects that have been left at the memorial.

Special exhibitions under headings of "Loyalty," "Respect," "Service," "Honor," and "Courage" will heroicize the dead. The "Legacy of Service" section will contain videos of soldiers who have served in other national wars, thus contextualizing the Vietnam military conflict in terms of a much less controversial history. While there is an implicit element of denial in never actually calling the *VVM* a symbolic cemetery, it pales beside this deliberate attempt to do what Scruggs once fiercely resisted: "to make Vietnam what it had never been in reality: a good, clean, glorious war seen as necessary and supported by a united country."[119] Although no single structure like the Wall could possibly incorporate the problematic and fractious history of a war that included the My Lai massacre, massive student uprisings, and social protests, a war that ultimately led to preventing the reelection of a seated President to a second term, this kind of content could surely be addressed in an education center.

Conclusion

Maya Lin's sculpture signaled a rebirth of memorial art and a paradigm change of major proportions, singularly appropriate to the war that tore this country apart as nothing had since the Civil War.[120] Thus it is fitting that the

roots of its commemorative strategies are so closely linked to Arlington National Cemetery, where so many of those who died in that earlier conflict are buried.[121] The Wall signaled a shift of emphasis from honoring the war dead by valorizing and validating the war in which they lost their lives to paying tribute only to their service. Indeed, the symbolic cemetery implicit at the *VVM* could be read as an attempt to bury both the undeclared war (there is no mention of war even in the title of the memorial) and its challenge to a concept of national identity that defines the United States as a winner of righteous wars. This focus on the dead, together with the form of the Wall itself, conflated memorials and cemeteries—thereby diverting national memory from the war itself to its immediate victims.[122]

From the start, visitors left objects at the Wall as if they were at an actual burial ground, popularizing a ritual that has since become a familiar part of contemporary life. Specifically, this practice is echoed in the immediate memorials that quickly gather at the site of sudden death. Like the *VVM*, this widespread occurrence reveals the unifying power of mourning, often suggesting an underlying element of protest. The subjects of these temporary memorials are always victims, and rarely those who have lost their lives in sacrifice. Historically, to be honored by a memorial of any kind suggested a heroic status. At the *VVM*, however, the distinction between heroes and victims has been eradicated. This conflation has become typical of our time. In a cemetery, of course, this distinction is moot: in a memorial it is highly problematic.

{ 2 }

Immediate Memorials: Mourning in Protest

Rituals begin as spontaneous responses to a given situation, fulfilling
needs which people may not even be able to verbalize. . . . When
effective responses to crises become ritualized their very familiarity
brings about a feeling of comfort and empowerment.

C. ALLEN HANEY, CHRISTINA LEIMER, JULIAN LOWERY[1]

Sudden public deaths rend the social fabric in shocking, tragic ways.[2] They
shatter the illusion of safety, destroying expectations of continuity and
prompting a pervasive impulse to "do something."[3] People brought an array
of objects to the *Vietnam Veterans Memorial* (*VVM*) in Washington, D.C.,
and to the sites of the Oklahoma City bombing, the Columbine High School
shootings, and the attacks of September 11, 2001 (9/11). Similarly, people today
routinely leave aggregates of flowers, candles, crosses, stuffed animals, photo-
graphs of the deceased, personal notes, and cards at the sites of celebrity
deaths, fatal traffic accidents, and violence that have taken place on streets, at
work, and in schools. Widespread and regularly reported, these outpourings
are variously described as spontaneous or makeshift memorials or shrines.
Referring to the array of objects that people leave to mark the place of death
as "makeshift" belittles the poignancy of individual contributions as well as
the visual and emotional power of the whole.[4] Calling these composite con-
structions shrines suggests a predominantly religious intention. Even though
they briefly sacralize a public space and may resemble culturally specific reli-
gious structures, these memorials are initially more about personal mourn-
ing than worship or veneration.[5] They segregate the scene of death, creating a
place to begin the painful process of transforming the recently alive into ever-
evolving memories. Ultimately they are about honoring victims and implic-
itly protesting the cause of their death.

Since this practice is by now predictable, it should no longer be characterized as spontaneous.[6] Rather, its salient characteristic is immediacy. Creating immediate memorials has become a contemporary mourning ritual.[7] It has been described as a kind of public performance because anyone can participate and express his or her feelings in any form or manner.[8] As close to the site of sudden death as possible, people share grief, feel the comfort of community, and try to make sense of what happened. This populist practice, evident in all the memorials discussed here, has its roots in cemetery customs.[9] The ritual of leaving an array of objects and messages at a grave is most prominent at celebrity death sites but is also common at personal ones, including those for pets.[10] Among the many objects typically found at gravesites and immediate memorials are images or photographs of the dead. This practice has been linked to Roman death masks and was widespread during the Victorian era and the nineteenth century in the United States; it continues today.[11] Latin American customs are still seen in celebrations of the Day of the Dead (Dia de Los Muertos), which take place in cemeteries and include leaving a variety of objects as well as reaffirming the link of the living with the departed. In recent years this tradition has become more public in the United States.[12]

Quite a few scholars have observed that the practice of leaving things at gravesites in cemeteries has diminished with the increase in regulations of permissible behaviors, while immediate memorials in public space have become more common.[13] Cemeteries reflect the values of the living, primarily their cultural attitude towards death.[14] New models come into being in response to economic, social, and ideological shifts.[15] Immediate memorials created in response to the events discussed in this book incorporated both cemetery customs and a valorization of victims.

The Evolution of American Cemeteries

For centuries the dead were interred in no special order, either in graveyards near the town commons or in church interiors and backyards. Churchyards often buried the dead en masse, which kept congregations together in perpetuity. With these burial practices, the living resided more or less comfortably with the dead in their midst. As J. B. Jackson observed, "Located in the center of the village, concealed by no planting, plainly visible to all, it was a group monument, a constant reminder to emulate the virtues of the dead and to follow the precepts of the faith."[16] From the start, however, graveyards reflected economic class distinctions. Paupers were buried in unmarked potter's fields with their names noted only on their coffins, while the wealthy were buried in churches as close to the altar as possible.[17] Throughout the

postcolonial period, as towns and cities grew and health issues developed, graveyards were, for the most part, routinely moved from place to place, ever further from the living and from prime real estate.[18]

Eventually more formal cemeteries replaced graveyards, at first following the garden model exemplified by Mount Auburn, which opened in 1831 in Cambridge, Massachusetts. This development was contemporaneous with the public parks movement and the emergence of landscape architecture as a profession.[19] Mount Auburn was not only one of the country's first large-scale open spaces, but also a model for New York City's Central Park.[20] Character-ized by curving roadways, gently sloping hills, and tall trees, the garden cem-etery provided areas of symmetrical family plots easily reached by a system of paths. Above all, Mount Auburn created an aesthetically pleasing environ-ment, a public amenity that attracted many visitors who were there simply to enjoy the green outdoors. With this cemetery, New Englanders hoped to create a cultural institution that would instill the proper values in a growing working-class populace.[21] By the 1850s the rural cemetery had become the preferred model, replacing the city graveyard.[22]

Funeral directors organized professionally in 1882, and cemetery superin-tendents five years later.[23] This development was part of the City Beautiful movement, which emphasized civic improvement and urban design, and led to a new type of cemetery. By 1900 a lawn model had replaced the wooded park. Forest Lawn Memorial Park in Glendale, California, opened in 1917 and became the quintessential lawn cemetery (Figure 2.1).[24] Graves were marked

FIGURE 2.1 *Forest Lawn Memorial-Park, Glendale, California. Photograph by Maia Weinstock.*

by plaques flush with the ground and containers for flowers just below ground level. This standardization simplified maintenance and supervision. With the business of burial increasingly in the hands of professionals and public hospitals, replacing the home as the place where most Americans died, death became a marginalized part of life. By the mid-twentieth century it was such an unpopular subject that Geoffrey Gorer observed: "[D]eath had replaced sex as the taboo topic of modern culture."[25] Less than a decade after Gorer's conclusion, Jessica Mitford, in *The American Way of Death* (1963), challenged the widespread profiteering of the funeral industry.[26] Despite their designation as *parlors* or *homes*, these modern environments were remarkably uniform and impersonal.[27]

By the end of the twentieth century, cemeteries (once as culturally significant as churches), had disappeared from the daily landscape and community consciousness.[28] As a result their ritual practices slipped relatively unnoticed into our midst. But it may be precisely because cemeteries and the function they once served have receded from civic awareness that the practice of immediate memorials has flourished. Grieving in a public space expresses the need to share private loss and to have it acknowledged. Although, or perhaps because, public experience in our culture has increasingly been rendered physically private by television and the Internet, there is still an overwhelming need to make the mediated "there" *here*. Standing on the actual ground where something significant happened triggers a visceral experience; it links people to history and to one another. Sudden fatalities in public catapult death once again—shockingly—into the midst of life. Just as cemeteries "announce a special realm dedicated to the departed," immediate memorials create a temporary sacralized space.[29] And people respond to these memorials as they would in a cemetery, gathering at the place of death or the nearest available public space. They bring objects similar to those left at graves and leave messages individualizing and praising the deceased. Although the bodies of those they honor are buried elsewhere, immediate memorials revive the role American cemeteries historically played in public life.

Like earlier cemeteries, immediate memorials serve a communal function as well as a personal one, blurring distinctions between the private and public spheres.[30] Typically including a range of symbolic objects not usually found in public, they conflate spiritual and secular categories.[31] Unlike earlier cemeteries intending to influence the behavior of the working classes, however, immediate memorials are a message to those in control from the populace they rule. They are inherently expressions of protest, calling attention to the cause of the random death(s) being commemorated. In this context the dead may become political symbols and may signal a need for change. Implicit in roadside memorials, where the practice of immediate memorials may have begun, it is also true of immediate memorials for

celebrities, random victims of urban violence, killing sprees in work places and schools, and terrorist attacks.

Roadside Memorials

Among the iconic photographs in Robert Frank's *The Americans* (1958) is an image of three roadside crosses. Frank didn't just capture a trinity of the familiar marker, but found one bathed in an apparently otherworldly light, imbuing it with a remarkably spiritual aura. As Jack Kerouac observed: Frank "had sucked a sad poem right out of America onto film," and cars, the road, and death loomed large within it.[32] It would be hard to overestimate the significance of the road in American culture. "The longest engineered structure ever built" is at the core of national identity, as expressed in ideas about the frontier and freedom.[33] The ever-present possibility to move on implies the potential to reinvent oneself and start anew.[34] French critic Jean Baudrillard insisted that to understand America, "you have to take to the road."[35] But the road is also frequently the site of sudden death. In 2012 there were 33,561 traffic deaths nationwide, a small increase from the previous year's total of 32,479.[36] Crosses or other markers make these deaths visible; they are disturbing evidence of the dark side of the road. Like other immediate memorials, they function as reminders of death in the midst not only of life, but also of a way of life. Although it is rarely acknowledged, driving remains the most potentially hazardous activity in which most Americans engage.[37] Because the victims are singular, their cumulative toll is not always apparent.

Roadside deaths, of course, existed well before any kind of vehicular traffic. In the United States, deaths along the road were noted from the years of Spanish exploration in the late seventeenth century, and were best documented in the American Southwest.[38] Although generally associated with Latino customs in Catholic countries, roadside memorials also incorporate aspects of diverse Native American beliefs. And while they may predate Christianity, their most familiar and sometimes only element is a cross. Usually between two and three feet high and made of wood, they are often painted white and typically include the name of the victim.[39] However, there are many variations. In some places the cross is adorned with objects of a distinctly secular nature (notes, cards, toys, photographs, seasonal decorations, and birthday gifts, similar to the things left at the *VVM*); in a few instances relics from the crash vehicle are attached.[40] The cross has been adopted by many who are not of the Catholic faith.[41] Mothers Against Drunk Driving (MADD) chose a cross as the centerpiece for their official roadside marker.[42] The cross, nevertheless, is an undeniable sign of Christianity, and in certain states roadside crosses have elicited protests from those who are not Christians.[43] Regardless

of how one interprets their spiritual content, roadside crosses are a widespread secular phenomenon.[44] They have even prompted several articles by "Miss Manners" on appropriate form and social behavior.[45]

Images of roadside crosses as well as other immediate memorials are a common feature in daily newspapers and nightly television news. One of the most famous car crashes of all time occurred on August 31, 1997, resulting in the death of Princess Diana of Wales and prompting vast and far-reaching examples of the immediate memorial phenomenon (Figure 2.2).[46] Some writers have attributed the widespread dissemination of this custom to media coverage in general,[47] but media attention alone is not enough to explain the proliferation of this or any other ritual. These practices survive only if they

FIGURE 2.2 *Immediate memorial to Princess Diana and Dodi Fayed, Place de l'Alma, Paris, France. Photograph by Brian Leon.*

satisfy some basic need(s). Family members and friends of the deceased and sometimes witnesses to a fatality repeatedly confirm the value of visiting the site of death and marking it in some way. Even if the victims died far from home, some people journey to the death site.[48] Others who neither were witnesses nor had any relationship to the victim(s) sometimes participate in these commemorations if a traffic fatality is part of their personal history. The openness of this practice and its flexibility in form, content, and duration help explain its ongoing popularity.

Like other immediate memorials, roadside crosses provide a public place to mourn and, according to some faiths, define a critical space for the liminal position of the soul before burial.[49] Even after the body has been interred, the roadside memorial often continues to take precedence over the cemetery as a place for repeated visits. If the body has been cremated and the ashes scattered, the roadside memorial may become the only extant mourning site.[50] Unlike many immediate memorials, roadside crosses may have an extended life, especially if there is ongoing evidence of use.[51] In addition to insisting on the right to make their own memorials, people use crosses and other commemorative objects along the road to express rage at personal loss or to protest absent traffic signals or signage at dangerous spots, generally hazardous road conditions, drunk driving, the anonymity of most traffic accidents, often unpunished perpetrators, or any combination of the above. In Louisiana, journalists used roadside crosses as evidence to bolster cases for repairing roads and installing new traffic signals and a railroad crossing caution light.[52] One writer describes the practice as "resistant performance, [both] protest and warning."[53] There is some evidence that this strategy works: drivers acknowledge taking notice, slowing down, and occasionally appointing a designated driver.[54] MADD considers roadside memorials a significant part of their campaign.[55]

By focusing on positive change and by trying to correct the factors that led to the deaths of their loved ones, participants in roadside mourning channel their anger as well as their grief. One man acknowledged that the cross he erected to commemorate the death of his dog was both "an expression of rage and an accusation against the red car" that killed him.[56] By mourning in protest, individuals manifest the hope that the deaths of their loved ones may prevent similar accidents in the future. By revealing the dangers of automobile travel, contemporary roadside memorials raise awareness of a cumulative death toll that is reported one by one. By calling attention to road conditions, they implicitly find fault with elected officials who have not maintained or corrected them. And like other immediate memorials, they commemorate anonymous lives cut tragically short, individuals acknowledged publicly only in death. By contrast, when the victims are celebrities, the practice of immediate memorials frequently becomes an international media phenomenon.

Celebrity Displays

Americans now consume celebrities like potato chips.
RUSSELL BAKER

Celebrities are a fact of contemporary life.[57] Whether stars of the entertainment industry, noted politicians, or athletes, celebrities embody individual fantasies and cultural myths. People relate important personal dates to publicized events in the lives (and deaths) of their secular idols. Created by the media that sustains them, celebrities incorporate contemporary cultural values.[58] Thus, feelings about them are a complex mix; their worth may be suspect but the responses they prompt feel (and may be) authentic.[59] Although celebrities are easily open to disparagement as yet another example of rampant consumerism without redeeming value, they may also serve as powerful social connecters.[60] People bond when trying to catch a glimpse of the celebrity or visiting their home.[61] When a celebrity dies, especially if that death is sudden and unexpected, communal grieving only strengthens that connection. If that death is linked to larger societal issues, as it was with Princess Diana, John F. Kennedy Jr. (JFK Jr.), or the popular Latina performer Selena, the mourning ritual takes on elements of national critique.[62]

Like Princess Diana, JFK Jr. died prematurely and was admired for appearing to be a regular guy, a normal person in spite of his fame, wealth, and movie–star good looks.[63] As with royalty, the celebrity status of the son of the thirty-fifth President of the United States began at birth. As his uncle, Senator Edward M. Kennedy, stated in his eulogy, "From the first day of his life, John seemed to belong not only to our family, but to the American family. The whole world knew his name before he did."[64] While rescue missions searched for the missing plane he was piloting en route to the Kennedy compound in Hyannis Port, Massachusetts, television screens and newspaper articles reproduced his image as a three-year-old playing under his father's desk in the oval office, and the iconic moment when, a short time later, he saluted the coffin of the assassinated President. After JFK Jr.'s death was confirmed on July 19, 1999, an editorial in the *New York Times* stated that "father and son seem joined now as symbols of a kind of familial and national loss."[65]

The Kennedy family (often dubbed "America's royals") has suffered many tragic deaths but none as symbolic as these. What seemed to end with the elder Kennedy was a renewal of the presidency, a different kind of American politics—one that might recapture the optimism that seemed to die with the postwar economy. The sudden death of JFK Jr. ended a nascent hope that the son might carry on his father's short-lived career. Even though there was no indication that JFK Jr. planned to go into politics, the national implications of his death were widely expressed. As Michael Wolff observed in *New York*

Magazine, "In dying, quite apart from anything in life, he is, right now, being transformed into our future and our hope—our lost future and lost hope."[66]

Following the announcement of JFK Jr.'s death, immediate memorials were created at the graves of his father and his uncle in Arlington National Cemetery, at the house in Boston where his father was born (now a national historic site), and most extensively in front of his residence at 10 North Moore Street in Manhattan.[67] There were also public tributes on the beach at Martha's Vineyard where the plane was last sighted and, at the time of the private memorial mass, around the church of St. Thomas More on the Upper East Side of Manhattan, but these were relatively small and short-lived. [68]The primary and longest-standing immediate memorial to JFK Jr. clustered along the sidewalk adjacent to the Tribeca building where he and his wife, Carolyn Bessette-Kennedy, lived (Figure 2.3). A neighbor observed:

> Flowers, so many flowers, mostly single red roses, but also bunches from the deli and fancy, amazing bouquets. Tickets to sports events, a cup of coffee signed with love, a moldy mango from the first day, bagels, stuffed animals and notes. One read: "When my mother was my age, she wept for the President she had, now we weep together for the President we will never have." Some letters asked for intercession with others in heaven. Many were in Spanish.[69]

FIGURE 2.3 *A metal sculpture of a three-year-old John F. Kennedy Jr., saluting, sits among flowers left at the entrance to the residence of Kennedy and his wife Carolyn Bessette Kennedy in New York Tuesday, July 20, 1999. AP Photo/Mark Lennihan. Copyright 2015, The Associated Press.*

Gifts from children included "a favored quartz rock in a plastic bag," as well as "many toy airplanes." This array also contained: "An original front page of The New York Post from JFK's assassination, bottles of Champagne, a signed football and a slew of paintings, collages and sculptures."[70] Another writer noted the different belief systems evident in the various messages and their geographic spread, which included "Laguna Beach, CA, Kansas City, Puerto Rico, and Japan."[71] Overall, the cluster resembled the objects left at the *VVM* in their multiple and varied references to the nation, religion, the life of the deceased, and heartfelt loss. As one editorial writer observed in the *New York Times*, JFK Jr. was "a link to deep scars on the American political psyche.[72] And the immediate memorial to his death may be read as a protest of the absence in politics of what his family, especially his father, once represented. But the circumstances of his actual death, like Princess Diana's, were more mundane. He died in an airplane crash, apparently caused by poor judgment about flying conditions and the failure to take sensible precautions.[73]

For the general public a celebrity death signals the end of a fantasy. With Princess Diana it was the hope that the princess with real problems would serve as a model for a different kind of monarchy. With JFK Jr. it was the dream of the return of Camelot, a utopian ideal used to describe JFK's brief presidency. Unlike these celebrity deaths that reverberated internationally, the death of Selena Quintanilla Perez, the popular singer known professionally as Selena, focused attention on the marginalized position of the Latino population in the United States. The decade of the 1990s had already seen a range of legislation aimed at restricting undocumented immigrants' access to health care and schooling for their families. On the one hand constraints were imposed from above; on the other there was conflict among various Latino groups. Selena's success in Tejano music, a genre originating around the Texas-Mexico border, crossed various competing Latino expressions of political and cultural identity.

Selena was murdered at the age of twenty-three on March 31, 1995, by the former president of her fan club.[74] Almost at once, enormous crowds gathered at the Day's Inn Motel in Corpus Christi, Texas, where she had been shot, and created an immediate memorial at the site as well as on the chain link fence surrounding her home (Figure 2.4).[75] Selena's popularity, like Diana's, expanded exponentially following her death. As the market for Selena products increased, so did corporate recognition of a U.S. Latino market.[76] The April 1995 issue of *People Weekly* featuring Selena sold out overnight, prompting a special seventy-six-page tribute later in the month and plans to launch a Spanish version of the publication.[77] According to theater and performance historian Deborah Parédez, by mourning Selena, people began to envision "a future for Latina/os that moves past her murder and toward a space of cultural and political reclamation." [78] Implicit in that imagining was a critique of their present situation.

FIGURE 2.4 *A trio of young mourners kneel and pray outside the home of slain Tejano singer Selena Quintanilla Perez the day after her death on April 1, 1995. Selena was shot to death March 31, 1995, at a Corpus Christi motel room by former fan club president, Yolanda Saldivar, who was convicted of the crime October 23, 1995, in Houston, and later sentenced to life in prison. AP Photo/David J. Phillip. Copyright 2015, The Associated Press.*

Tributes to Sudden Death in the Street, Workplace, and School

Immediate memorials taken as an aggregate reflect socioeconomic inequities that persist in our culture. Frequently commemorating victims of random bullets, police brutality, or hate crimes, they serve both as expressions of protest and outlets for communal grief and rage. Honoring the

deceased as martyrs or heroes, they often reflect the prevalent belief systems of the local population, as well as widespread problems. In areas where gangs and drug trafficking are prominent, random shootings are alarmingly common.

On August 22, 2003, a four-year-old girl and a twenty-one-year-old man were fatally shot on a residential street in East Orange, New Jersey. Surrounding the assortment of teddy bears, candles, and messages for the dead were several signs in bold upper case: ENOUGH IS ENOUGH. The press speculated that gang rivalry was involved; there was no indication that the little girl was an intentional target.[79] On November 5, 1992, when Malice Green, an unemployed African American former steel worker, was beaten to death by two white Detroit police officers, apparently for refusing to open his fist, an immediate memorial was created at the site of his death. It consisted of the typical messages, flowers, and candles, but also contained shells, shoes, bibles, and other objects associated with veneration in African and Christian traditions.[80] African cemeteries reflect the belief that the spirit of the deceased must be placated to keep it from haunting the living.[81] This includes leaving items at the memorial that the newly dead used in life and therefore might continue to want. Seashells indicate a dividing line between the living and the dead because they are associated with water, considered in African belief to be the realm of the dead.

A mural was painted on a nearby wall some five days after Malice Green's death.[82] Memorial walls, like immediate memorials, are familiar phenomena in African American and Latino communities. They appear shortly after the time of death, provide a focus for mourning and remembering, and often attract similar objects at their base. Since they are commissioned works, typically by a single artist or group, they are more formalized. Because they require a wall surface, they cannot always mark the precise place of death. Shortly after the mural to Malice Green appeared, a mirror was placed at the site in such a way that visitors saw themselves and Green at once (or as one). In the context of African burial practices, mirrors, with their smooth, reflective surfaces, are considered symbols of water or the presumed "watery transition between life and death."[83] Green's immediate memorial, surrounded by crosses, was filled with messages addressing his perceived martyrdom. As it became a destination for both motorists and local residents, two orange traffic cones were added to create a secondary viewing space to the now sacralized site of Green's death. The drive-by memorial to Malice Green seemed to provide solace to a community, a focus for public rallies during the time of the trial of the accused officers and after. Without escalating to violence, these gatherings were implicit and explicit protests against police brutality.

When Margaret L. Mitchell, an African-American woman in Los Angeles, was killed by Hispanic police officers, the immediate memorial that

marked the site of her death became a focus for publicizing the problems of the mentally ill homeless.[84] Occasionally, the element of protest is more oblique. When a homeless man was beaten to death in Paterson, New Jersey, the immediate memorial insisted on his identity—that is, the fact that he had a name: Hector Robles.[85] This focus on the identity of the suddenly dead, often previously anonymous except to their personal circle, characterizes both immediate and permanent memorials to the events discussed in this book.

Violent Crimes in the Workplace

Violent crimes that take the lives of multiple victims often occur in workplaces, particularly fast food restaurants and post offices. It has been suggested that these environments may become substitutes for the family arena, a place for acting out unresolved issues.[86] On July 18, 1984, James Huberty, an unemployed security guard, shot and killed twenty-one people and wounded nineteen others in a McDonald's restaurant in San Ysidro, California, and was eventually killed by a San Diego Police sharp shooter.[87] At the time it was the worst single-day, single-gunman rampage in U.S. history. The victims, ranging in age from under one year to seventy-four years old, were predominantly of Mexican descent. Allegedly Huberty, who had been fired the week before, had complained that Mexicans were taking all the jobs.[88] The fast food restaurant was torn down in September, two months after the shootings, and a new one opened a few blocks away the following year.[89] The McDonald's Corporation deeded the land to the city of San Diego, which in turn sold it to Southwestern College in 1988, where it became the site of their Education Center and a memorial consisting of twenty-one hexagonal granite pillars ranging from one to six feet, one for each of the dead. All are routinely covered with flowers, and objects are often placed at their base, similar to those at other immediate memorials and cemeteries.[90]

Kenneth Foote identified four approaches to dealing with sites of tragedy: sanctification, designation, rectification, and obliteration.[91] Sanctification creates a sacred space of commemoration with some kind of permanent marker. Designation also involves marking a site, but without attending rituals of consecration. Rectification restores a site to its former use by, say, removing the immediate memorial from the scene of sudden death. Obliteration goes a step further by removing all traces of the tragedy, including the building or site where it occurred. This is often what happens to schools where children have been killed. The most helpless victims, children also are the most symbolic. They represent the future, and their sudden death suggests its foreclosure. (School shootings will be discussed further in chapter 4, which focuses on the Columbine killings.)

Immediate Memorials and Art

Understood as expressions of mourning in protest, immediate memorials are clear signals of a range of societal ills. This potent expression has caught the attention of a range of artists who have appropriated its visual vocabulary, some as a tribute to its power and poignancy, others as a protest to official memorials. Although immediate memorials have been denigrated in the press as "makeshift" and are often confined to discussions of folk or vernacular art, their aesthetic has appealed to photographers, installation artists, and painters, who respond to their authenticity. Indeed, they reflect many characteristics that are consistent with contemporary art concerns. They are fragmented, non-hierarchical, collaborative efforts and as such constitute a genuinely democratic form of (public) art.

Photography

Photographer David B. Nance photographs roadside memorials because they "are almost always hand-made, and they vary a great deal in form and style. They communicate an imagery and an iconography which is (at least as yet) not driven by, or even much affected by, commercial or media influences."[92] He intended, he said, "to photograph every highway roadside memorial I saw on my travels, and to attempt to make an interesting and aesthetically justifiable photograph of each one, capturing some of its individuality but also placing each one in the context of the landscape in which it is found." Focusing on examples in Colorado, Illinois, Iowa, New Mexico, and Kansas, he realized: "There is no 'right' way to mourn. These memorials are reflections of genuine emotions experienced by real people, and they are surely entitled to be respected as such . . . they confront us with the reality of death as an actual event that arrives for a particular person, at a particular place, at a particular time." Although Nance was initially concerned about the private nature of these memorials, he concluded that their public placement justified his enterprise. His images are accompanied by a description of the scene, a personal and professional appreciation of roadside memorials, their place in local history, and their artistic resonance (Figure 2.5).[93]

While photographic images of immediate memorials like Nance's may be appreciated in books or online, exhibiting photographs of them is problematic. An art venue inherently transforms the images, potentially defusing the original impulse that prompted the tributes and thus potentially muting their impact. The reviewers of Chris Taylor's 2003 exhibition *Roadside Memorials, Shrines and Other Markers* at Garfield Artworks in Pittsburgh found the still images less compelling than the accompanying video by Jay Golden, *Journey to Remembrance*.[94] It is likely, as David Nance observed, that immediate roadside memorials must be experienced singly in a space that encourages private reverie.

(a) (b)

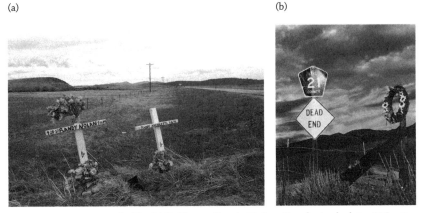

FIGURES 2.5a AND 2.5b *David B. Nance.* Randy Nolan, Randy Archuleta, U.S. 285,
South of Fairplay, in South Park, Park County, Colorado *(May 17, 2000), and* Dead
End, U.S. Hwy 24, in Tennessee Park, north of Leadville, Colorado *(July 22, 1999),
from the* Descansos *series. Copyright David B. Nance, provided courtesy of the artist.*

Photographer Alexandra Broches's interest in immediate memorials is
part of her larger interest in cemeteries and monuments in the landscape
(Figure 2.6). She relates roadside memorials to practices at the *VVM* and to
responses to the death of Princess Diana.[95] Other photographers, for example
Martha Cooper and Dario Oleaga, focused specifically on the immediate me-
morials created in New York City after the attacks of 9/11. Their work will be
discussed in chapter 5.

(a) (b)

FIGURES 2.6a AND 2.6b *Alexandra Broches.* Tohono O'odham Reservation, Arizona
(1999) and South Kingstown, Rhode Island *(2003), from* Sites of Memory and Honor.
2014. Copyright Alexandra Broches, provided courtesy of the artist.

Artists' Altars

As noted, immediate memorials reflect the mourning customs of different cultures. Latino, African, and Caribbean cultural heritages have inspired artists to create works that incorporate similar forms and images. In the 1988 exhibition catalogue accompanying *Ceremony of Memory: New Expressions in Spirituality among Contemporary Hispanic Artists*, Tomas Ybarra-Frausto identified four such forms that artists have incorporated in their work: domestic altars, *ofrendas* (offerings typically left at domestic altars on El Dia de Los Muertos [the Day of the Dead]), *nichos* (niches), *capillas* (small chapels) characteristic of yard shrines, and *cajas* (boxes) used in the manner of Christian reliquaries to house sanctified objects.[96] Artists typically appropriate any number of cultural sources and combine them with personal expressions to create a new amalgam.

Amalia Mesa-Bains was among the first artists to consistently incorporate elements of her Chicano heritage in her work. Her personal altars to Frida Kahlo and Dolores del Rio (Figure 2.7), as well as to her grandmother, reflect

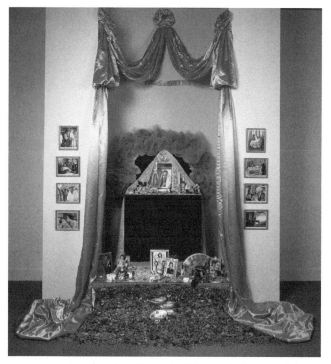

FIGURE 2.7 *Amalia Mesa-Bains.* An Ofrenda for Dolores del Rio. *1991. Mixed media. Smithsonian American Art Museum, museum purchase through the Smithsonian Institution Collections Acquisition Program. Copyright 1991, Amalia Mesa-Bains.*

diverse inspirations, including references not typically or overtly addressed in a single work. As the artist acknowledged: "In my work, I follow traditional Mexican altar-making practices: I do my own papercuts, screen my own altar cloths, and make my own paper flowers as well as create my own *nichos* and *retablo* boxes (with the help of a carpenter). In addition, I am preparing to do my own bread and candy making."[97] Mesa-Bains considers these works "ceremonial centers" that enable her "to reach a spiritual sensibility through aesthetic form." She does not view her altars as "directly religious" but uses them "to pay homage to ancestors as well as other historical figures I find important."[98]

In the 1989 catalogue accompanying *Contemporary Hispanic Shrines*, David Rubin defined the artist's mission as "universalizing the altar by transforming it from church related structure into generic vessel for spiritual expression" and thus able to engage an audience regardless of an individual's specific religious beliefs.[99] This is precisely how culturally specific expressions of mourning are experienced at immediate memorials. Creating an altar is both empowering and healing. As Mesa-Bains observed: "When you remember people in the act of making an altar, they're absolutely alive for you again, and you're given back all that they embodied."[100] Elsewhere she observed: "The altars are a recognition of your unbroken relationship to the dead."[101] She also described the objects placed at immediate memorials as *ofrendas*, used by people for devotional purposes and thereby marking a social space.[102] Mesa-Bains and others working in a similar vein refer to the same cultural traditions that are reflected in many immediate memorials.

Appropriation

Appropriating the work of established canonical artists became an established art style in the 1970s, made famous by artists such as Sherrie Levine and Richard Prince. More than any other contemporary artist, Thomas Hirschhorn has appropriated the visual language of immediate memorials to make a statement about art. According to Hirschhorn, the form of his altars to artists like Piet Mondrian (Figure 2.8) and Otto Freundlich and writers like Ingeborg Backmann and Raymond Carver

> comes from the spontaneous altars that one can see here or there, made by people who wish to give a precarious homage to someone deceased on the spot, by accident, suicide, murder, or heart attack (Gianni Versace, J. F. Kennedy Jr., Olaf Palme). The forms of these homages are alike, whether made for celebrities or made for the unknown.... With this wild mixture of forms, the messages of love and attachment to the deceased person are expressed without any aesthetic preoccupation; it is this personal commitment that interests me. It comes from the heart. It is pure energy.[103]

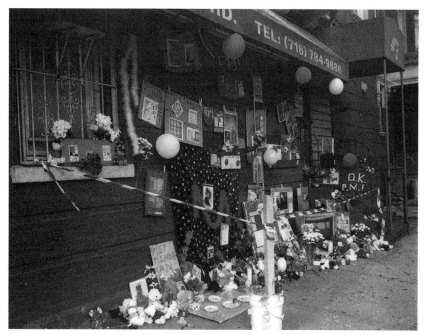

FIGURE 2.8 *Thomas Hirschhorn.* Mondrian Altar. *1997. Installation view: "September 11," MoMA PS1, New York, 2011. Copyright Thomas Hirschhorn. Courtesy of the artist and Gladstone Gallery, New York and Brussels.*

Composed of candles, flowers, stuffed toys, photographs, and notes, Hirschhorn's unmarked temporary installations (lasting for about two weeks each) could easily be mistaken for immediate memorials. Indeed, the public is free to add items or take things away. Hirschhorn's altars dedicated to his personal heroes are exhibited both in art venues and urban spaces. For the latter he prefers non-strategic sites, "just any place, for people may die anywhere." A piece dedicated to Freundlich, a sculptor whose work was illustrated on the cover of the infamous Nazi Degenerate Art exhibition (1937) and who died at Majdanek concentration camp in Poland, was exhibited in Basel and Berlin (1998) as part of the first Berlin Biennale.[104] Hirschhorn admired the American writer Raymond Caver for his writings "about the shattered American dream" and initially sited his altar in Fribourg (1998).[105] Two years later, in Philadelphia, he reinstalled Carver's memorial on the street adjacent to the galleries at Moore College of Art and also in Glasgow as part of a group show.[106] For the artist: "These altars are questioning the status of a monument today by their form, by their location and their duration."[107] The same could be said of immediate memorials.

A critique of traditional monuments also informs Hirschhorn's "direct sculptures" (*sculptures directes*). Inspired by the immediate memorial to Princess Diana at the Place de l'Alma in Paris, he created temporary

monuments to Benedict de Spinoza, Gilles Deleuze, Antonio Gramsci, and
Georges Bataille at emphatically non-art sites. The *Spinoza Monument* was
built in 1999 in the Red Light District in Amsterdam; the monument to De-
leuze in a lower-class neighborhood in Avignon as part of the art festival "La
Beaute" in 2000; the monument to Bataille in a housing project for Turkish
workers in Kassel, Germany, in conjunction with Documenta 11 in 2002.[108]

What attracted the artist to the immediate memorial in the Place D'Alma
was the transformation of a previously unused and unnoticed monument
that marks the plaza, the *Flame of Liberty* (1987): "What counts for me is that
this sculpture is appropriated by its environment, signed, marked, changed,
and no longer imposed by a force from above, but integrated, welcomed or
not welcomed, confronted, by the heart from below."[109] Part ad hoc reading
room, part billboard, Hirschhorn's monuments cannot be mistaken for im-
mediate memorials. The artist defines them as "community commitments in
contrast to the altars, which are personal commitments."[110]

Hirschhorn's condemnation of official monuments is all-embracing:

> My critique of the "monument" comes from the fact that the idea of the
> monument is imposed from above. A monument is determined, produced,
> and situated by decisions from above, by the power. And its forms corre-
> spond to the will to lead people to admire the monument and along with it
> the dominant ideology—whether it is the monument to Abraham Lincoln
> or Christopher Columbus, the monument to the memory of the first step
> on the Moon or the memorial wall in Washington D.C. of those who lost
> their lives in Vietnam. Something demagogic always remains in a monu-
> ment. I want to fight against hierarchy, demagogy, this source of power.[111]

But it is possible that Hirschhorn's intended local (non-art) audience also per-
ceives his monuments as impositions from above, in this case the art world.[112]
He uses the visual language of immediate memorials to critique officially
built commemorations, calling attention to the exclusion of a popular com-
ponent in their creation, but his educated references stem from a tradition
about which a local population may not be informed.

Immediate memorials reflect a populist insistence to determine where and
how to grieve publicly. The prevalence of this practice, originating in ceme-
tery customs, has been a major factor in all the memorials discussed here. The
objects people left at each site have been collected, stored, and displayed.
These personal relics, creating tangible links to the suddenly dead, form an
essential element in the focus on victims of events that shattered myths of
national identity.

Oklahoma City: Reframing Tragedy as Triumph

Oklahoma City made us all Americans again.

PRESIDENT WILLIAM J. CLINTON, OKLAHOMA CITY
AT THE TENTH ANNIVERSARY OF THE BOMBING

The Oklahoma City bombing was situated within starkly contrasting
convictions about the essence of American identity.

EDWARD LINENTHAL, *THE UNFINISHED BOMBING*

The bombing of the Alfred P. Murrah Federal Building in Oklahoma City on
April 19, 1995, prompted headlines proclaiming terrorism in the nation's
heartland—shocking in and of itself but especially so in a region presumed
quintessentially safe.[1] The casualties were random victims who died at the
hand of a young American, a Gulf War veteran disillusioned with his country
and its values. The 168 victims were killed going about their daily lives, as
were the victims of the Columbine shootings and the 9/11 attacks.

The Oklahoma City bombing was the latest and most dramatic evidence
that belied the myth that the American Midwest was a safe haven, home to
a contented populace. In 1986 there had been a post office shooting in
nearby Edmond, Oklahoma; there too the target was a workplace.[2] Be-
cause this was a federal building, the Federal Bureau of Investigation (FBI)
was immediately involved, and subsequently national funding was made
available to construct a memorial. Initial speculations pointed to an out-
sider as the likely perpetrator of the attack (Muslims were often men-
tioned), a reaction typically voiced after school and post office shootings.[3]
Essentially this response was, as Richard Goldstein observed in *The Vil-
lage Voice*: "We have met the enemy—and he is anyone but us."[4] But Timo-
thy McVeigh was born and bred in the United States, which raised questions

about fissures in the social fabric of Middle America that neither the built memorial nor its museum address.[5]

McVeigh was born in 1968, a pivotal year in U.S. history that was marked by extreme violence: the assassinations of civil rights leader Martin Luther King Jr. and presidential candidate Robert F. Kennedy, as well as widespread protests against the undeclared war in Vietnam. It was a year when issues of national identity often were fiercely contested. April 19, the day of the Oklahoma City bombing, marked the start of the Revolutionary War two hundred years earlier at the Battles of Lexington and Concord. The date also coincided with the two-year anniversary of the deaths near Waco, Texas (variously referred to as the Waco Siege, Waco Massacre, or just Waco). The fifty-one-day standoff led by the FBI began with an attempt by the U.S. Bureau of Alcohol, Tobacco, and Firearms (ATF) to execute a search warrant of the Branch Davidian Seventh Day Adventists' compound headed by David Koresh. It ended in a fire that killed seventy-six cult members, including twenty-five children.[6] For McVeigh, the Waco incident was the tipping point. He had gone to the site to protest the attack and considered his bombing of the federal building in Oklahoma City a just revenge; others who shared his views saw it as a declaration of war against the government.[7]

By the time McVeigh visited Waco, he had been honorably discharged from the Army, a sergeant awarded the Bronze Star for his service in the Gulf War. His longstanding passionate interest in guns and survivalism was far from unusual in his home town of Pendleton, New York, a rural area in the northwestern part of the state, near Buffalo. A high school graduate who won a Regents' Scholarship, he decided against college and enlisted in the army after failing to find a more remunerative way to earn a living. The Buffalo area was then experiencing the worst economic downturn since the Great Depression, and jobs were scarce. After his stint in the army, McVeigh applied to join the Army Special Forces but failed to meet the requirements.[8] He became increasingly disenchanted with what he perceived as the government's infringement on individual rights, particularly the right to bear arms. He was not alone in his beliefs. By the mid-1990s special militia groups (on the rise since the Vietnam War era) constituted a significant and increasingly disenfranchised segment of the American population, the latest incarnation of what historian Catherine McNicol Stock identified as a long American tradition of "rural radicals."[9]

At the time of the bombing the Murrah Building housed seventeen federal agencies, three non-federal agencies and a day care center. McVeigh's specific targets were the ATF and the Drug Enforcement Agencies (DEA), both on the top floor of the nine-story office building. The greatest casualties, however, were in the Social Security Administration, the Federal Employees Credit Union, and the day care center on the second floor. The 168 dead included 19 children. Later McVeigh claimed that if he had known about

the day care center, he would have chosen a different target.[10] Oddly, considering McVeigh's views, there was no FBI office in the building. Once it was determined that McVeigh and Terry Nichols (an Army buddy and fellow Gulf War veteran eventually found guilty of aiding him in the bombing) were Americans with a grudge against their government, they were routinely identified as loners or outsiders. But McVeigh, trained by the Army, saw himself as a rugged individualist in the tradition of John Wayne, whose moral independence and actions were not only praiseworthy but essential elements of the American masculine ideal.[11] Historian Edward T. Linenthal observed that the bombing "revealed a toxic American landscape, teeming with alienated and embittered anti-governmental groups who understood themselves as remnant patriots guarding American freedoms."[12]

Although the bombing offered ample evidence of a dissident core in the nation's heartland, no aspect of the three-part built memorial—a multi-part sculptural environment, a museum, and an institute devoted to anti-terrorism—acknowledges fissures in the body politic. By focusing almost exclusively on the victims and the good citizens who came to one another's aid, attention was consistently diverted from the root causes of the bombing and its implications. Starting with the memorial process, often defined as a therapeutic activity for victims' families and survivors, and continued in successive anniversary rituals that tracked the mood and evolution of the city from devastated disaster site to tourist destination with a revitalized downtown, a triumphal narrative of hope and renewal prevailed.

Immediate and Intermediate Memorials

While people gathered as close as they could get to the Murrah Building to create an immediate memorial, rescue workers assembled their own at the site.[13] As soon as people began leaving tributes, national guardsmen erected a simple wood frame enclosure covered with plastic. From the start, there was a concerted effort to preserve these talismanic objects that defined the relationships between the living and the suddenly dead. These and other items were eventually transferred to the chain-link fence that marked the boundaries of the off-limits area (Figure 3.1).

Initially covering twenty square blocks, the site became smaller as the rubble clearing progressed and finally, after the damaged structure was imploded, included only the block that defined the building's footprint. As the perimeter changed, so did the nature of the space, evolving from "a crime scene, then to a hazardous site, and then to a space that became, for some, 'sacred ground.'"[14] The fence functioned as an ersatz wall, protecting onlookers from the view of the destruction while keeping their focus on the victims. A portion of the fence was eventually included in the permanent memorial,

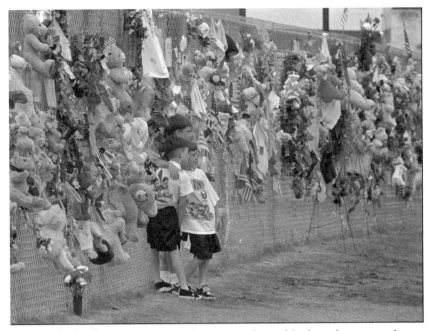

FIGURE 3.1 *Three young tourists pose for photos in front of the fence that surrounds the remains of the Oklahoma City Murrah Federal Building, Tuesday, June 25, 1996. The bomb site is a popular tourist stop for people on summer vacation. Tourists often leave gifts and notes on the fence. AP Photo/J. Pat Carter. Copyright 2015, The Associated Press.*

just outside the gate that marks the time the bombing ended. Typically imme-diate memorials like the fence are temporary, inextricably linked to their sites by the death(s) that occurred there. Exposed to the elements, they require care and maintenance. Their importance seems evident, what to do with them is less so. At Oklahoma City the objects were initially archived and then stored in the memorial museum adjacent to the sculpture complex; eventu-ally some were selected for exhibition.

On May 7, within two weeks after rescue workers ended the search for victims, some three thousand people visited the site of the bombing and were offered yellow buckets with small chunks of the debris. Oklahoma Governor Frank Keating also gave everyone a state flag and a blank diary so that they might record their reactions to the bombing, an interesting confla-tion of national emblems with the personal. Two months later, in July, the National Endowment for the Art's Design Program sponsored a workshop to consider ideas about how to rebuild. Recommendations included that the Murrah site be considered "a national memorial; be specific as well as inter-pretive; include surrounding buildings as well as the Murrah block; and be the result of an international competition reviewed by a combined local/national panel."[15]

From the first moments after the bombing until the official memorial was built, a single image served both as the iconic focus for the Oklahoma City tragedy and as a kind of interim memorial. Reproduced on television and magazine covers around the world, the representation of fireman Chris Fields carrying the lifeless body of one-year-old Baylee Almon from the wreckage encapsulated the tragedy in terms of the death of a baby and the role of rescuers, particularly firemen (Figure 3.2).[16]

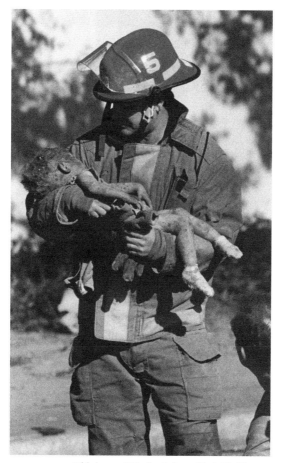

FIGURE 3.2 *Oklahoma City firefighter Chris Fields, 30, holds one-year-old Angel Baylee Almon, who was thrown from the Stars and Stripes Daycare Center on the first floor of the Alfred P. Murrah Federal Building in downtown Oklahoma City when the explosion occurred. April 19, 1995, Oklahoma City, Oklahoma. The image won Charles Porter IV the 1996 Pulitzer Prize for Spots News Photography, exclusively represented by ZUMA Press. Copyright Charles Portero IV/ZUMApress.com.*

The image proliferated as a statue and was emblazoned on T-shirts, a coin, greeting cards, and even a phone card.[17] This widespread commercial use and the sense of impropriety it prompted led the memorial committee to exclude figurative representations from its competition guidelines. (This prohibition, similar to the initial decisions about the *VVM*, is discussed further below.) The theme, however, had larger implications. Marita Sturken discusses its various iterations as "reenactments" that were "attempts to create an image of redemption and comfort from an image of trauma."[18] The innocence of children could be linked to the presumed innocence of the country before the bombing, while those who stepped in to help (whether it was their job or not) became de facto civic heroes, honored as if their service were of a military nature. There were religious implications as well: as Ruby C. Tapia suggested, it was a variation of the theme of the *Pietà*, with a male figure in "the place held traditionally, iconically for the grieving mother."[19]

Defining the Built Memorial

As Kenneth Foote noted: "Not so long ago, a memorial of this sort would have been considered improper, almost an affront to a community's self-image. Now such a memorial is viewed as reflecting respect for the victims and their families and paying tribute to the community's ability to constructively respond to adversity."[20] In July 1995, a scant two months after the bombing, a memorial task force was appointed by Oklahoma City Mayor Ronald Norick and chaired by local attorney Robert (Bob) Johnson. The focus of the 350-member group would be "to create a memorial that is appropriate, enduring, non-exclusionary, and sensitive to the needs and feelings of those who were most directly affected by the bombing."[21] The Oklahoma City memorial was intentionally therapeutic in the sense that Kirk Savage defined, not only in its intention but also in its process.[22] Although there was insistence all along that the bombing was a national event and would be remembered by a national memorial, the process was emphatically local. A special subcommittee of survivors and family members of the dead met monthly. Rather than focus on the form the memorial might take, they considered: "What should people feel when they visit the memorial? What should they learn? What kind of experience should it provide?"[23] According to the clinical psychologist who facilitated the meetings, the group insisted that there be no mention of the perpetrators, lest they get any recognition and become famous.[24] On March 26, 1996, after an intense and fractious process, a mission statement was published based on input from survivors and family members, surveys distributed via the internet prompting over ten thousand responses, and countless unsolicited suggestions from the general public as well as professionals (artists, architects, and landscape architects).[25] It defined the site of the memorial

complex as the place where the Murrah Building once stood and specified the inclusion of an information center, the Survivor Tree, and the names of the dead as well as survivors (but not in the same place). The chosen themes were: "remembrance, peace, spirituality and hope, cherished children, comfort, recognition, and learning."[26]

Remembrance specified "a beautiful universal symbol . . . focusing on victims and survivors of the April 19 blast . . . as individuals with many roles—family members, friends, co-workers and neighbors;. . . [their] cultures, races and ages . . . should be evident." The intention was to convey that the victims could have been the viewer or someone they knew. *Peace* was defined as a "setting where visitors have the opportunity for reflection," perhaps best accomplished through the use of natural elements described in a way that echoes the model of the garden cemetery (discussed in chapter 2). *Spirituality and Hope* expressed the wish that the memorial "be powerful, awe-inspiring and convey the sense of deep loss caused by the bombing" but also "evoke feelings of compassion and hope, and inspire visitors to live their lives more meaningfully. It should speak of the spirituality of the community and nation that was so evident in the wake of the attack." Since this was a designated national memorial, there could be no mention of the specifically religious activity that characterized the recovery and memorial effort from the start. Initially, crosses appeared in the immediate memorials, while churches served as centers for the recovery efforts. The primacy of the religious frame was still evident by the tenth anniversary.[27]

The theme of *Cherished Children* required that the complex "include a special place for children . . . a component designed to reach kids on 'their level,' both physically and cognitively" and "offer them assurance that the world holds far more good than bad." *Comfort* specified that the same uplifting message be provided for adults. The memorial "should ultimately offer an uplifting experience—elevating the memory of the dead and survivors and, in some way too, the spirit of those who visit." Considering the members of the committee who crafted this statement, the emphasis on comfort is not surprising. It is precisely what they needed so soon after their traumatic experiences and grievous losses. This overriding concern, however, manifests one of the problems of the therapeutic memorial: it obscures the event and its larger significance.

Recognition required "a tribute to those who helped," including rescue, recovery, and medical professionals, and volunteers who aided in many different capacities, providing both practical as well as "emotional and spiritual support." This recognition was intended to convey "the sense of pride such responses created," and provide "an inspiring contrast between the brutality of the evil and the tenderness of the response." A widespread outpouring of support typically greets all kinds of civilian disasters and destruction, whether natural or man-made; however, such communal spirit rarely lasts.[28]

Nevertheless, new heroes emerge—those who exhibit civic behavior, helping others in need.

Learning was to take place in an information center that would include facts about and reactions to the bombing. Because visitors should "never forget the event or the people it touched," elements would include "personal stories about those who died and those who survived." Ultimately it "should instill an understanding of the senselessness of violence, especially as a means of effecting government change. It should convey the imperative to reject violence." No connection was made between personal experiences of assault and the history of national violence in a country where war has often been viewed as a solution, starting with the American Revolution and most recently seen in Iraq and Afghanistan. The mission statement, like the competition guidelines for the *VVM*, with its stated focus and critical omissions, determined both what could and could not be built.

The Memorial Competition

The selection process moved ahead with unusual speed, spurred in part by a concern that the city needed to capitalize on the nation's attention in order to finance its plans.[29] The competition guidelines and a site plan were available by November 15, 1996; less than two months later (January 7, 1997) competitors were invited to a special exhibition located in the ruins of the Murrah parking garage. Intended to convey the horror of the bombing experience, it included partially destroyed relics of office life and samples of debris, newscasts of the blast, and photographs of the wreckage as well as its victims; a looped recording of Bette Midler singing "Wind Beneath My Wings" played in the background.[30] Submissions were due the following month (February 10). Semi-finalists were announced on the second anniversary of the bombing and finalists selected on July 3, 1997.

The competition was a two-tiered process. A Stage I evaluation panel selected the finalists and honorable mentions, and a Stage II selection committee chose the winner. The first major controversy centered on the composition of the jury. Paul Spreiregen, author of a book on competitions, had been hired as an advisor based on his experience as director of the competition for the *VVM*; he insisted on a professional jury with local residents serving in an advisory capacity.[31] As he saw it: "The entries have to be evaluated by a group of designers who are eminently respected or you are not going to draw from the field you want."[32] When the chair, Bob Johnson, insisted that the nine-member group include three bombing survivors or family members, Spreiregen resigned together with the co-chairman of the memorial subcommittee who had recruited him, Oklahoma oil executive William Cleary. For Cleary: "[T]he charge to our committee was a technical one: to find the best person to run

a competition and get all the input from the mission statement, but not have all the people involved in the emotion get involved."[33] He was concerned that "emotions were dominating the process."[34] Johnson then hired Donald J. Stastny, FAIA, of Portland, Oregon as the professional advisor, and Helene Fried, a public art consultant based in the San Francisco Bay Area.[35]

The Stage I evaluation panel, a combination of six professional members and three individuals who served on the family and survivor committee, emphasized "simplicity and a non-stressful experience" over "complexity and disorientation," even though the latter precisely described the nature of the event and its aftermath.[36] They also noted that "Figurative sculpture, while powerful, may not appropriately address the Mission Statement" and specifically requested entrants "not to depict physical representation of any known person, living or dead" in their submission. This became known as the Baylee Almon clause, intended to preclude any use of the already famous and widely popular image of the firefighter and the dead baby (discussed above).[37] The wish for "a variety of experiences to bring the visitor back more than once" reflected a concern with attendance numbers; indeed, by the tenth anniversary local visits had declined sharply. The last requirement insisted that "the memorial should be uniquely 'Oklahoma City'" and hoped that it might "become the symbol of the city, both figuratively and spiritually." Thus the local committee called for a memorial that would serve as a city symbol, defining Oklahoma City as a place of recovery and its residents as good citizen survivors, thereby envisioning a future civic identity forever linked to the bombing.

All 624 Stage I design entries were first shown to family members and survivors, then to the general public, and finally to the evaluation panel, which met on March 25 and 26, 1997.[38] Their unanimous selection of five finalists and nine honorable mentions was announced on April 19: "The common thread throughout is that each . . . creates a 'place' of remembrance that is timeless, not just an icon whose meaning and importance diminishes as memories fade." Winning design teams were asked to create both an architectural and animated model, "to continue evolving the concepts appropriately interpreting the Mission Statement: 'We come here to remember those who were killed, those who survived and those changed forever. May all who leave here know the impact of violence. May this memorial offer comfort, strength, peace, hope and serenity.'"[39]

Although Johnson originally stated that the fifteen-member Stage II jury be entirely community-based (eight survivors or family members and seven from the community at large), it eventually included four professionals, nine survivors, and two family members.[40] None of the five finalists, announced on July 3, 1997, were well known but then neither was Maya Lin when she won the competition to design the *VVM*. The winning proposal was by Locus Bold Design, a Berlin firm of young architects founded by Hans and Torrey Butzer

with Sven Berg.[41] According to Stanley Collyer, editor of the magazine *Competitions*, their design "showed an understanding of separation of the public and semi-private, contemplative realms, and was the design which fulfilled the criteria to the highest degree as defined in the program."[42]

The Memorial

The memorial covers a three-acre site and consists of nine distinct elements: the Gates of Time; the Reflecting Pool; the Field of Empty Chairs; the Survivor Tree; the Rescuers' Orchard; the Survivors' Wall; Architectural Remains; the Children's Area; and the Memory Fence (Figure 3.3). Although these elements were specified in the guidelines, their form and placement were not.

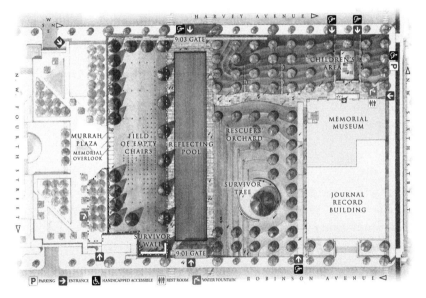

FIGURE 3.3 *Locus Bold Design. Oklahoma City National Memorial and Museum. Site overview. Oklahoma City, Oklahoma. Photograph courtesy of Oklahoma City National Memorial Museum.*

The Gates of Time

Bronze-covered concrete gates bracket the memorial, marking the before and after of the blast: 9:01 and 9:03. Thus, time is a factor as it is on the *VVM*, where the war dead are listed in the order they died. Here the gates bracket the two minutes that came to define both the lives of local residents and subsequently the civic identity of Oklahoma City. The gates exist on a

larger scale than the rest of the memorial. When seen in sunlight, they appear to shine like gold. Jim Yardley, writing in the *New York Times*, likened them to "an entrance to a tomb" and Erika Doss called them "tomblike monoliths."[43] Thus, the entire complex could be read as a symbolic cemetery. The Butzers conceived the "gates as a narthex and the space within as spiritual. The inscription of the times overhead can be read as chapter and verse, in the biblical sense."[44] Each gate is also inscribed with the memorial mission: the hope that visitors will experience "comfort, strength, peace, hope and serenity." One has to walk through a gate and down a short flight of steps to enter the actual space of the memorial where the dead are specifically invoked (Figure 3.4).

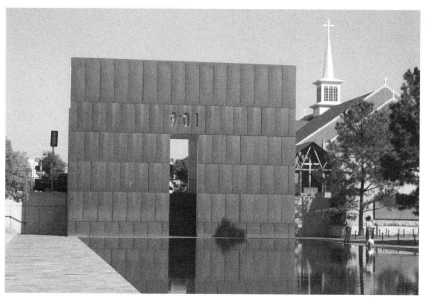

FIGURE 3.4 *Locus Bold Design. 9:01 Gate of Time, Oklahoma City National Memorial, Oklahoma City, Oklahoma. Photograph by Wikimedia Commons user "Dual Freq."*

The Reflecting Pool

A 318- by 53-foot shallow rectangular pool separates the symbolic resting place of the dead from the active space of the living; it runs along what had been Fifth Street, the route McVeigh followed to detonate his bomb. Flush to the ground, it evokes the pool on the National Mall at the base of the *Lincoln Memorial* that reflects both that structure and the *Washington Monument*. Lined with black granite, the dark reflective surface of the Oklahoma City pool recalls the granite walls of the *VVM* where visitors look past the names of the dead to see themselves and their surroundings. Here the pool reflects the sky; at least one person saw this as heaven.[45] The Butzers saw the pool as symbolizing the absence of loved ones but it is the memorial's empty chairs that accomplish this most vividly.[46]

The Field of Chairs

Each of the 168 empty chairs defined by narrow rectangular bronze backs atop glass bases is inscribed with the name of one of the victims; of these, 19 smaller chairs represent the bombing's youngest victims (Figure 3.5). The chairs, whose shape echoes that of the Gates of Time, are illuminated at night. Arranged in nine rows, one for each of the Murrah Building's floors, their placement is intended to indicate where individuals died. Erika Doss likened their layout to "a well-ordered necropolis."[47] According to Helene Fried, the chairs were supposed to fill the void left by the building and provide human scale.[48] The chairs are a kind of hybrid sculpture, suggesting a variant of artist Scott Burton's sculpture/furniture, but one with a strong symbolic resonance. For some like Diane Leonard, whose husband died in the blast, they were *too* evocative. She dreaded seeing them, because "We look at empty chairs in our homes every day."[49]

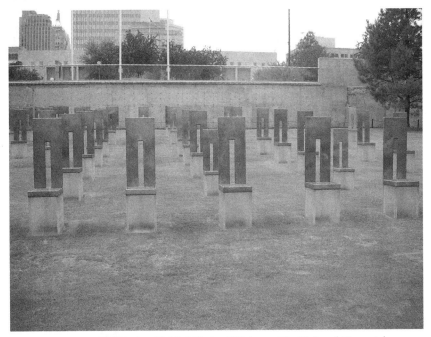

FIGURE 3.5 *Locus Bold Design. Field of Chairs, Oklahoma City National Memorial, Oklahoma City, Oklahoma. Photograph by Beatrice Murch, beatricemurchphotography.com.*

Although the empty chair is a widely used symbol of absence or death, there is likely a specific model for its use here.[50] The Butzers, who worked in Berlin at the time of the bombing and memorial competition, would have known Karl Biederman's recently unveiled Holocaust memorial, *The Abandoned*

Room (Der Verlassene Raum, 1988–1996) (Figure 3.6). Consisting of a bronze table and two empty chairs, one overturned, it is situated in the middle of the Koppenplatz, a quarter where Eastern European immigrants once lived and Jewish institutions co-existed with their Christian counterparts.[51] Part of the first large East German Holocaust memorial project, this piece— commissioned in 1988 to both commemorate the fiftieth anniversary of Kristallnacht and recall the Jewish citizens of Berlin—was realized only in 1996. At the time of the commission it represented a new type of memorial for East Germany (one without a base) and therefore was much discussed.[52] Here the mundane, the unremarkable, becomes strange, even alarming, evoking a recent and sudden absence. *The Abandoned Room* signals that all may not be as it appears in the newly comfortable present, may not be taken for granted, and may not hold.

FIGURE 3.6 *Karl Biederman.* Der Verlassene Raum, *Berlin, Germany. 1988–1996. Bronze. Photograph by Jennifer K. Favorite.*

The rows of chairs in Oklahoma City prompted one landscape architect to think of Arlington National Cemetery "where the identical nature of the markers unites the individuals."[53] Similarly, a woman whose mother died in the bombing objected to the chairs because "They look like headstones in a cemetery."[54] Marita Sturken observed that the "chairs provide a space where the dead are perceived to reside, even though no one is actually buried there."[55] Paul Goldberger likened their appearance at night to "a glowing field of votive candles," but concluded that "they still resemble tombstones."[56] From the start the Butzers imagined that the chairs would provide "a place for friends and family to leave behind tokens of their love."[57] Hans observed that in this

use the chairs "start to become places as well as sculptures."[58] They function as grave markers, especially on bombing anniversaries and holidays when family members gather and leave things on or around them. Although visitors rarely sit on them, one individual who was in the second grade when his mother was killed said he might have liked to sit on her chair and imagine that she was holding him.[59]

The nighttime illumination of the chairs may have been inspired by another Berlin Holocaust Memorial, Israeli sculptor Micha Ullman's *Library* (1994–1995), which commemorates the infamous Nazi book burning of May 1933 (Figure 3.7).[60] Situated underground on the Bebelplatz, surrounded by cultural and educational institutions along the famous Unter den Linden Boulevard, it consists of a glass-covered subterranean room painted a stark, eerie white and lined with empty floor-to-ceiling bookshelves. During the day the glass is often fogged, rendering the empty library all but invisible, but at night it is lit up, drawing people to the light emanating from below. And so the very ground of Berlin, like the unconscious mind, seems to suppress trauma during the day only to release it, hauntingly transformed, into the night. The light emitted by the bases of the chairs at Oklahoma City is much more reassuring; it is a golden glow rather than a white glare. But although it is above ground, it seems to come from another (or nether)

FIGURE 3.7 *Micha Ullman. Library, Berlin, Germany. 1994–1995. Mixed media. Photograph by Jennifer K. Favorite.*

world. Thus the Oklahoma City Memorial has at its center a symbolic cemetery, one that evokes the bodies of the dead as if they were buried there, prompting behavior among visitors that is similar to that at actual cemeteries and at the *VVM*.

The Survivor Tree

From the start the tree that survived the bombing (Figure 3.8) played a

FIGURE 3.8 *Survivor Tree, Oklahoma City National Memorial, Oklahoma City, Oklahoma. Photograph by Dustin M. Ramsey.*

major symbolic role. Before the bombing, the American Elm in the downtown parking lot was valued primarily as the only source of shade in the lot.[61] After the blast, the tree took on new meaning; evidence was recovered from its trunk and branches and great care was taken to ensure its ongoing health. As it began to flourish, cuttings from the tree were made available for public purchase; on each anniversary of the bombing they were distributed all over the country. Defined on the memorial's website as "a symbol of human resilience," the Survivor Tree serves as the logo for the museum, appearing on stationery and other souvenirs sold in the gift shop (Figure 3.9). Surrounded by a plaza, it functions as a gathering point and as a backdrop for a speaking area on public occasions, framing events with an implicit narrative of recovery.

(a) (b)

(d)

(c)

FIGURE 3.9 *Survivor Tree logo on Oklahoma City National Memorial Museum gift shop items. Photograph courtesy of Oklahoma City National Memorial Museum.*

Rescuers' Orchard

A combination of nut-bearing and flowering trees indigenous to Oklahoma encloses and protects the Survivor Tree. An inscription on the low wall that surrounds the Tree states: "To the courageous and caring who responded from near and far, we offer our eternal gratitude, as a thank you to the thousands of rescuers and volunteers who helped." The Rescuers Orchard thus acknowledges the new heroes of memorials to disaster—those who provided aid.

Children's Area

Adjacent to the Rescuers' Orchard, the Children's Area commemorates the responses from children at the time of the bombing. It features a wall containing a selection of tiles they designed. Children also sent cards, letters, and teddy bears, ultimately saved in the museum. The area provides a place for today's children to

respond to the bombing on numerous chalkboards on which they may leave what the website describes as "their own messages of hope and comfort."

Survivors' Wall

Located on the east side of the Memorial are two granite panels salvaged from the only remaining wall of the Murrah Building, later etched with the names of more than eight hundred survivors. After much deliberating, the memorial task force defined a survivor as someone "who was within the perimeter . . . or suffered serious bodily injury resulting in admittance to a hospital."[62] Their names were listed in alphabetical order under the agency that employed them; the agencies, too, were arranged alphabetically.

Architectural Remains

Chunks of damaged walls from the Murrah Building, some with protruding rebar, are sited at the eastern edge of the memorial at a distance from the field of chairs. These architectural relics serve both as evidence of the destruction and counterpoints to the living survivor tree. Berlin, too, has a significant architectural ruin used for memorial purposes. Located in the center of the city, the partially destroyed tower of the Kaiser Wilhelm Memorial Church (the remains of a bombing raid during World War II) was left to serve as a reminder of the futility of war. Widely visible, it would have been familiar to anyone visiting or living in Berlin.

The Memory Fence

A portion of the chain-link fence that was part of the immediate memorial was installed just outside the Gate of Time that marked the temporal end of the bombing. On the occasion of the tenth anniversary, Jane Thomas, collections manager of the Memorial Museum, observed: "We never dreamed the fence would live with us forever, but family members and survivors were not willing to let the fence go away."[63] Over time, this section of fence became a kind of generic immediate memorial (Figure 3.10). At some point between the second and third anniversaries of the bombing, people began leaving things in memory of other losses, such as victims of car crashes or drive-by shootings that took place far from Oklahoma City. After the sudden death of Princess Diana in 1997 (just two years after the bombing), people left messages as well as objects for her. They also gathered at the fence on 9/11.[64] On the tenth anniversary one reporter referred to it as "a remnant of the original 'people's memorial.'"[65] The fence itself was memorialized in an exhibition of photographs, *As We See It: The Murrah Memorial Fence* at the East Gallery of the Oklahoma State Capitol from April 13 to May 29, 1999.[66] Wall text stated that it "honors the victims and survivors of the bombing . . . [and] affirms the persistence of the human spirit and capacity for compassion."[67] Immediate memorials were thus valorized as a form of public mourning and a subject worthy of display in a government venue.

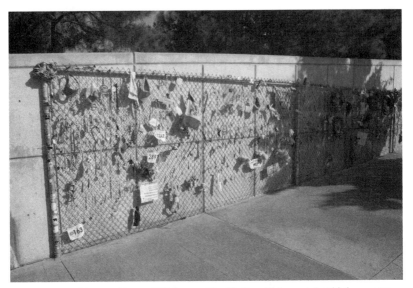

FIGURE 3.10 *Memory Fence, Oklahoma City National Memorial, Oklahoma City, Oklahoma. Photograph by Wikimedia Commons user "Dual Freq."*

Overall, the Oklahoma City memorial has the appearance of an ad hoc add-on design. Its aesthetic reflects a postmodern preference for a composite memorial as opposed to a unified whole. The individual features not only look radically different from one another but also provide different kinds of experiences, and each puts you literally in a different place. Thus one walks through the gates, gathers around the chairs, admires the survivor tree, reads the names on the periphery, or engages with the items on the memory fence. It's almost as if the totality commemorates different events. A more experienced architect or a team combining architects, landscape designers, and artists might have realized a more unified composition to convey the mandate of the mission statement more forcefully. It is possible that if the mission statement had been created with more input from outside professionals, it might not have mandated so many disparate elements. As is, there is no overriding narrative; that was provided by the Oklahoma City Memorial Center.

The National Memorial Center

This memorial center is a testament to faith, the precious nature of the freedom from fear, and a reflection that Americans always unite in the face of a common enemy. Without it, future generations will not learn of the horror of that moment and the innocence that we lost.

BOB JOHNSON, CHAIRMAN, OKLAHOMA CITY NATIONAL MEMORIAL

TRUST, AT THE OPENING OF THE MUSEUM

The Oklahoma City National Memorial Center (NMC, also referred to as the museum), the last of the tripartite memorial to be completed, was dedicated some months before the sixth anniversary of the bombing. It is housed in a building that was formerly home to *The Journal Record* (a local business publication) and other offices; many of its employees had been severely injured in the 1995 bombing. Subsequently, an important building relic, a dented fire escape door, was displayed in the museum and the remaining damaged staircase was left on the façade of the NMC building. The museum was intended to provide an experiential narrative, a counterpoint to the profound sense of absence conveyed by the sculpture complex. A ten-chapter installation begins with the morning of the bombing and ends with themes of hope, if not triumph. Although it was inspired by the United States National Holocaust Memorial Museum (USNHMM) that opened a scant two years before the bombing, it tells a much simpler story without considering root causes or problematic aspects, reflecting what Lawrence Graver described as American "democratic optimism and a susceptibility to easy consolation."[68]

It should be said that linking the Holocaust and the bombing of Oklahoma City verges on both the absurd and the obscene, not just in the difference in numbers killed (although that is of staggering significance) but also in the fact that systematic nationalized genocide cannot be compared to a single bombing apparently engineered by one disenfranchised young man with a single accomplice. The Holocaust and the Oklahoma City bombing are not equal as defining moments; Jewish scholars and others continue to express concern that the Jewish people are repeatedly defined by genocide rather than their long history of contributions to society. Oklahoma City, now surely defined by its bombing, had no comparable history. The bombing was an act of terrorism with complex underpinnings that remain to be explored. In no way was it a crime or tragedy comparable to genocide. That said, the two events are related by the fact that the USNHMM served as an inspiration for the NMN. They are also connected by the work of Edward T. Linenthal, author of both *Preserving Memory: The Struggle to Create America's Holocaust Museum* (1995) and *The Unfinished Bombing: Oklahoma City in American Memory* (2001).[69] The Holocaust Museum presents a nuanced narrative, questioning the role of the United States, among other critical issues. Complicated analysis of any sort is notably absent in the displays at the NMC. Oklahoma City, in patterning their museum on the USHMM, laid claim to a kind of righteous victimhood that had been a defining element of identity politics since the 1970s and for which the Holocaust is thought to have served as model.[70]

The opening of the NMC on February 19, 2001, like that of the sculpture complex, was marked by a strong federal presence. In 1995 George W. Bush was governor of Texas and attended the memorial service that his wife,

Laura, helped organize; it was her idea to invite the Reverend Billy Graham.[71] In 2001, Bush, by then President of the United States, delivered opening remarks for the NMC that included a strong message of faith. As one reporter remarked: Bush was "using the language of a preacher to describe the bombing and its aftermath as a struggle between good and evil."[72] The president quoted St. Paul and observed: "On this earth, tragedy may come even on a warm spring day. But tragedy can never touch eternity . . . beyond the gates of time lie a life eternal and a love everlasting. You in Oklahoma City are victims of tragedy and witnesses to hope. You have overcome evil, and you have suffered with courage. And for that, your nation is grateful."[73] Oklahoma Governor Frank Keating sounded a similar message in a more secular vein: "The legacy of this place is heroism and goodness."[74]

The goals of the NMC were clear. As executive director Kari Watkins explained: "We try to tell the story simply, in a way that can be understood by folks from 6 to 106. . . . At the same time, we want the experience to be a challenge, to inspire people to draw some hope for creating change in their own lives without the futility of violence."[75] Each installation or "chapter" could be seen as an enactment of the tragedy but ending with an uplifting message.[76] Chapter 1, "Background on Terrorism," provides databases and personal accounts relating to "the perception of the reality of terrorism in the United States in the decade leading to the bombing."[77] However, the context of the patriot movement, including the pervasiveness of militias, is not addressed. Chapter 2, "History of the Site" is a summary of "before." Chapters 3A and 3B are deliberately experiential. "The Hearing" places viewers in a closed room where they listen to an audio recording of the last words of a routine meeting of the Oklahoma Water Resources Board that was suddenly interrupted by the blast; then everything goes black. Placing visitors in an environment evoking the experience of the bombing sets the tone of re-enactment early in the museum. There is no way to bypass this room; one exits directly into "Confusion," which documents the first minutes following the explosion. Chapter 4A, "Chaos," displays damaged relics from the site accompanied by sounds of police and emergency radios (Figure 3.11). "Survivor Experiences" (Chapter 4B) are presented in videos and interactive computer stations. The first section of the museum presents an intense and immersive experience. The emphasis then shifts to the mediated story and the reactions of local residents.

"Investigation Story: The First Hours" contains photos, graphics and narrative text that document the beginning of the investigation (Figure 3.12). Chapter 5A, "World Reaction," displays media reports from around the world on April 19 (Figure 3.13). "Rescue and Recovery" (Chapter 5B) presents the story through artifacts and videos from the perspective of the rescuers (Figure 3.14).

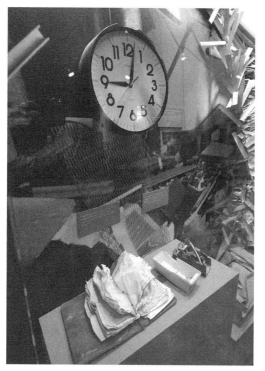

FIGURE 3.11 *"Chaos," Oklahoma City National Memorial Museum. Photograph courtesy of Oklahoma City National Memorial Museum.*

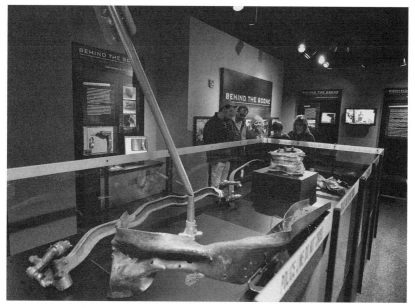

FIGURE 3.12 *"Investigation Story: The First Hours," Oklahoma City National Memorial Museum. Photograph courtesy of Oklahoma City National Memorial Museum.*

FIGURE 3.13 *"World Reaction," Oklahoma City National Memorial Museum. Photograph courtesy of Oklahoma City National Memorial Museum.*

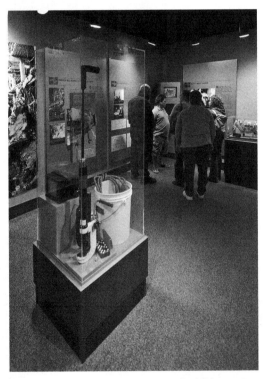

FIGURE 3.14 *"Rescue and Recovery," Oklahoma City National Memorial Museum. Photograph courtesy of Oklahoma City National Memorial Museum.*

These sections are followed by "Investigation Story: The First Days," focused on the continuing gathering of evidence. Chapter 6, "Watching and Waiting" presents the first weeks in terms of the working rescuers and the waiting families. Chapter 7, "Gallery of Honor" contains photographs of each of the 168 dead displayed together with an object chosen by a family member (Figure 3.15). A photographic, yearbook-like presentation of the

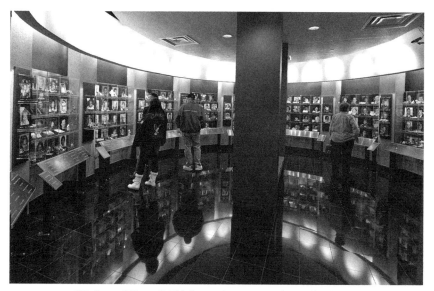

FIGURE 3.15 *"Gallery of Honor," Oklahoma City National Memorial Museum. Photograph courtesy of Oklahoma City National Memorial Museum.*

victims is also used at the National September 11 Memorial Museum and will be included at the Vietnam Veterans Memorial Education Center. Chapter 7B, "Funerals and Mourning" (emphasizing the "faith tradition and comfort from friends and strangers"), includes excerpts from memorial services and funerals.

Chapter 8, "Impact," features "Videos [that] highlight the determination and resourcefulness of survivors and families in affecting change in government." This section also presents examples of "healing in progress." Chapter 9, "Behind the Scene: The Oklahoma Bomb Investigation," follows and documents the collection of evidence that led to the arrests. McVeigh is mentioned only in a small section devoted to his trial and conviction. According to curator Heidi Vaughn, "We didn't want to make a big deal out of him. But he is part of the story."[78] Arguably, he is the key to understanding the story. How did his history in and with the military influence his subsequent behavior? What role did his rejection by the Special Unit Forces after his honorary discharge from the military play? There are many pertinent questions.

Around the time of McVeigh's impending execution the Southern Poverty Law Center's *Intelligence Report* was devoted to the current status of the patriot movement.[79] It is a good example of what might have been included in the museum to prompt a more thoughtful discussion.

Finally, Chapter 10, "Hope," shows how "the community has rebuilt since that fateful day. . . . Origami Cranes show the hope that was displayed after the bombing, and the positive thoughts of people around the world that better tomorrows emerge from the experience and resilience of this community." The entire museum narrative presents a closed loop: "This is what happened (to us). This is what we saw and felt. And this is how we triumphed." Nothing is contextualized. The exhortation to avoid violence is not linked to the fact that the United States often resorts to violence as a national strategy of intervention. Nowhere does the NMC reference the powerful presence of the NRA and the commitment of many, including McVeigh, to interpret the Second Amendment to the U.S. Constitution in terms of an individual's rights to bear arms. (See chapter 4 for a further discussion of gun control issues.)

On September 16, 2014, the museum opened a second floor with "enhancements": a forty-foot glass overlook and a new installation detailing the capture and prosecution of Timothy McVeigh. The overlook enables visitors to view the memorial from the museum. According to Kari Watkins, it "is meant to break out of the old and 'overlook' this memorial that's meant to be, not a cemetery, but a place of celebrating life."[80] However, since the chairs—the central element of the memorial—both evoke and occasionally function as headstones it is difficult to interpret the complex as anything other than a symbolic cemetery (as discussed in detail above).

The new wings are "dedicated to telling the story of the investigation and justice."[81] Intended to appeal to younger viewers, it incorporates technology with touchscreens and interactive applications. There are also actual objects that once belonged to McVeigh—his car as well as his gun, knife, and driver's license, which were not available to the museum for display earlier. Documents delineate the process that led to his arrest and what followed, highlighting the various roles of the individuals involved and thereby echoing the narrative of triumph expressed in the exhibition. The victims of the bombing continue to be honored as people who gave their lives for their country. What is enhanced are the framing of McVeigh as the criminal and local residents as heroes, or, as the museum website proclaims, the addition "contrasts the brutality of the event with the tenderness of the response."[82] Although twenty years have passed, there are no reflections about McVeigh's motives or the broader implications of his act and the beliefs that prompted it.

Linenthal, in the introduction to the second printing of his book on the Holocaust museum, cautioned: "Memorials bearing witness to mass murder struggle to transform the event . . . into a redemptive, consolatory narrative. The dead still teach and inspire us. *Consequently, their deaths mean something*

(my emphasis). There is always the danger that the allure of redemptive narratives will inappropriately soften the story of mass murder or transform it into an act of heroic sacrifice."[83] Indeed, the NMC's photographic presentation of the victims together with personal tokens evokes a lively group portrait embedded in an overriding narrative of heroics and hope. To even contemplate their deaths as meaningless seems impossible, just too painful, especially when family members play a determining role in the commissioning process.

Anniversaries

Anniversaries are markers of evolving emotions and memories. They provide a useful chronicle of the aftereffects of the Oklahoma City bombing and the emerging narratives that defined it. As family members and survivors determined the memorial they wanted, anniversary events increasingly reflected Oklahoma City's place in national memory as an exemplar of the American Spirit (or Oklahoma Standard) and the triumph of renewal in the wake of disaster. Common elements at these events included religious remarks by national politicians and comparisons of the victims of the bombings to military deaths in war.

The First Anniversary: April 19, 1996

Downtown Oklahoma City, still devastated one year after the bombing, was the focus of an extensive urban renewal plan with a giant void at its center awaiting a memorial.[84] But the city finally had a new civic identity, a positive image to counteract the Okie portrait presented in John Steinbeck's *Grapes of Wrath*.[85] As Mayor Ron Norick observed: "Everywhere I go now, people immediately know where Oklahoma City is and what went on here. I don't think the visibility has been negative. The nation got a good look at this city and what its people are all about."[86] With that new image came the opportunity to realize a long-planned revitalization of the downtown area.[87]

The Oklahoma Gazette's one-year anniversary issue ended with a feature on the April 5 visit of President Clinton and First Lady Hillary Clinton, including coverage of their meeting with victims' families.[88] Clinton spoke in deeply religious terms, asserting that

> The miracles of Jesus and the miracles of the human spirit in Oklahoma City only reflect the larger miracle of human nature that there is something eternal within each of us, that we all have to die, and that no bomb can blow away even from the littlest child that eternity which is within each of us. This is, after all, Good Friday. It is a day for those of us who are Christians that marks the progress from hope and despair to hope and redemption.[89]

Clinton remained involved with Oklahoma City throughout his presidency and thereafter, returning to speak at the tenth anniversary. (He was featured in the response to Columbine as well.)

The first anniversary of the bombing was marked by a private ceremony for victims and family members at the north end of the building site where the blast was centered. The 168 seconds of silence ended with a flyover of four fighter jets and the tolling of a bell in a nearby bomb-damaged church. Mourners left flowers and mementos at the barren site, which now included a temporary memorial with photographs of the former federal building along with the words from the newly approved mission statement: "We come to remember those who were killed, those who survived, and those who were changed forever. May all who leave here know the impact of violence. May this memorial offer comfort, strength, peace, hope and serenity." Later that morning Vice President Al Gore and Governor Frank Keating took part in the Remembrance Day ceremony at the Myriad Convention Center located several blocks from the Murrah site. Both spoke of the impossibility of measuring the time needed to grieve and the importance of faith. Images of the 168 victims were projected on a giant screen as many in the audience wept, especially at the appearance of the 19 children. Family members and survivors held teddy bears and waved pens with lights that looked like candles. By the time President Clinton's videotaped message was aired more than half the seats were empty. But then only two thirds of the ten-thousand-seat auditorium had been filled at the start of the ceremonies.[90] For many the first anniversary public rituals were too overwhelming to attend. Counseling requests at Project Heartland, set up a few steps away from the bombing site, went up fivefold in the week before April 19.[91] A number of federal employees took the day off.

It took nearly a year before the extent of the obvious injuries could be tallied. In addition to the 19 dead children, 30 were orphaned and 219 lost at least one parent. In addition, 850 people were injured, 7,000 lost their workplace, and 462 lost their homes. Approximately 387,000, one third of the local population, knew someone killed or injured in the bombing. Some 190,000 had attended at least one funeral, often having to choose between two or more scheduled at the same time.[92] The general consensus that the city and its residents were still hurting was hardly surprising.[93] People suffered from flashbacks and panic attacks. They reported failed relationships and problems on the job. There were still numerous unanswered questions in the case against McVeigh and Nichols; many in Oklahoma City said they would find no peace until the two were executed.[94] After a year the sense of community that followed the bombing had disintegrated.[95] Hostile factions developed between those who lost children and those who lost adult family members, prompted by the perception that the former were getting all the attention, and Baylee Almon's mother most of all. And there were arguments over the distribution of funds designated for the victims and their families.

The Second Anniversary (1997)

The second anniversary service also featured 168 seconds of silence and a reading of the names of the dead at ten-second intervals as survivors and family members walked onto the site with flowers. This year they received the first generated seedlings from the Survivor Tree. The five finalists for the built memorial were introduced in a public program called "The Future of the Site."[96] A letter from President Clinton affirmed the spirit of community that followed the attack: "With the destruction of the Murrah Federal Building, we learned once again that America is a family, and such a brutal attack on any American is an attack on us all."[97] Governor Keating encouraged visitors to continue leaving items on the memory fence: "That fence has become our shrine and it is fitting that on this second anniversary we adorn it with tributes and memories."[98]

There was also a service at a church in Denver where McVeigh was standing trial.[99] The date also marked the fourth anniversary at the Branch Davidian compound near Waco. At a ceremony in Waco, former United States Attorney General Ramsey Clark stated: "Here on this site is the symbol of the struggle for religious freedom and the right to love in our society. If two million Muslims can come to Mecca, then Americans can come here."[100] A handful of demonstrators outside the White House called for a special prosecutor to investigate the raid that prompted McVeigh's bombing.[101]

When McVeigh's guilty verdict was announced on June 3, 1997, many came to Oklahoma City's memory fence. That evening during a vigil at the Survivor Tree, those who survived the bombing and family members of the victims prayed and held hands. Then they poured water on the ground from plastic bottles, a symbolic gesture of letting go of some of their grief.[102]

The Third Anniversary (1998)

By the third anniversary the most critical issue seemed to be what to do with the unidentified human remains from the bombing. Victims' families met to consider where such "fragmented tissue" should be buried. Although most seemed to favor the actual building site, it was eventually decided to bury them near the State Capitol.[103]

The Fourth Anniversary (1999)

The fourth anniversary was the first after the official groundbreaking for the built memorial, which had occurred the previous October 26; Vice President Al Gore lifted the first shovelful of earth in front of a crowd of thousands. Referring to the victims, he stated: "as much as any solider who ever fought in any war, they paid the price of our freedom."[104] The conflation of the military

(potential heroes) and those who were clearly victims continued. Family members and survivors took home handfuls of dirt from the bombing site and that evening the memory fence was moved to make room for the official memorial. By the time of the fourth anniversary some forty thousand items had been left there.[105]

Only some five hundred people attended the quiet official ceremony. As usual, the names of the dead were read; this year people dropped flowers over a glass wall onto the site of the former Murrah Building. Rev. Paul Dunn exhorted the crowd: "We may never forget, but we must forgive."[106] By the next anniversary the symbolic center of the Oklahoma City tri-part memorial would be complete.

The Fifth Anniversary (2000)

The fifth anniversary of Oklahoma City preceded the first anniversary of the Columbine shootings by one day.[107] It also coincided with the opening of a new Branch Davidian Church near Waco and a memorial to those killed at Waco.[108] Most significantly, it marked the official dedication of the Oklahoma City National Memorial. Ceremonies included the usual solemn reading of the names of the dead but this year, after a special service, survivors, rescuers, and family members were escorted to the specific chair dedicated to their loved one.[109] Now they were able to leave flowers and other gifts at this personalized place.

Once again there was a strong federal presence at the official ceremony held later that evening.[110] Both President Clinton and Attorney General Janet Reno spoke, as did Oklahoma City Mayor Kirk Humphreys, Governor Keating, and Oklahoma senior Senator Don Nickles. Clinton, the last speaker, reminded the audience that this was also "the 225th anniversary of the beginning of the American Revolution."[111] He continued: "There are places in our national landscape so scarred by freedom's sacrifice that they shape forever the soul of America—Valley Forge, Gettysburg, and Selma. This place is such sacred ground."[112] Writing about that day, Linenthal took strong exception to this "transformation of mass murder into patriotic sacrifice" and suggested that Oklahoma City should be linked instead to other "sites of terrorism and mass murder: the Sixteenth Street Baptist church in Birmingham, Alabama, the McDonald's in San Diego, and Columbine High School."[113] For the most part, however, the Clinton narrative prevailed and the conflation of the killing fields of war and the sites of civilian destruction continued.

In conjunction with the fifth anniversary, the RAND Corporation sponsored a conference titled "Terrorism and Beyond: the 21st Century" that focused on national preparedness and potential counter-terrorism tactics. Speakers included representatives from Israel, France, the United States, and other countries. The chair was Don Ferrill, whose daughter had been killed in the

bombing. A former small-town newspaper publisher, he was now chair of the National Memorial Institute for the Prevention of Terrorism (NMIPT), which comprised the third part of the national memorial.[114] The Institute, described as "a public policy research center," was housed in the same building as the Memorial Museum but its entrance was on the other side of the memorial.[115]

The fifth anniversary also marked the launching of the annual 26.2-mile Memorial Marathon. A pasta party held the night before the race on the General Services Administration Plaza overlooking the Memorial grounds provided a social opportunity for runners to meet family members, survivors, and rescue workers. And, arguably, it signaled the civic renewal that would eventually become the dominant anniversary theme.

The Sixth Anniversary (2001)

According to Kari Watkins, then spokeswoman (later director) of the memorial museum, a year after the unveiling of the symbolic memorial and some months after the dedication of the museum, "families and survivors just wanted to have a low-key, simple ceremony."[116] Earlier that year, on February 19, President George W. Bush had dedicated the Museum. On May 16, Timothy McVeigh was to be executed at the federal prison in Terre Haute, Indiana.[117] The precise location was announced on the anniversary of the bombing and reports of the execution, the memorial, and victims' responses were invariably linked.[118] Due to a last-minute discovery that the FBI had withheld nearly 4,500 documents from the defense team, the execution was postponed to June 11.[119] Many came to the memorial both on the eve and day of the execution.[120] The 2001 anniversary was the last one before 9/11.

The Seventh Anniversary (2002)

Paul Goldberger, then architecture critic for the *New York Times*, visited Oklahoma City in the fall of 2001 "when fires were still smoldering at Ground Zero." He referred to the bombing as "the only event in recent American history that comes remotely close to the terrorist attack on the World Trade Center in lower Manhattan."[121] To further cement this connection, a New York City contingent attended the seventh anniversary ceremonies in Oklahoma City. Bob Bender, CEO of the American Red Cross of Greater New York stated categorically: "The only difference between what happened in New York and here is the scale. The events and how they affect people are alike . . . exactly alike."[122] Oklahoma City Mayor Kirk Humphreys, on a previous visit to the World Trade Center site, defined both 9/11 and Oklahoma City as "an attack on America."[123]

After 9/11, Oklahomans sent thousands of teddy bears to New York and a group of volunteers composed of family members and survivors traveled to

Ground Zero. Mayor Humphreys observed: "This year has not only brought us tragedy, it's brought us triumph. We here have been able to help our friends across the country, returning the favor that they gave us seven years ago. This open communication has enabled us to overcome barriers, and has helped in the recovery process here in Oklahoma City."[124] Although these crimes were intrinsically different (homegrown versus international terrorism) with consequentially different results (168 versus nearly 3,000 victims) in radically different cities, emphasis on the shared mourning experience expanded the importance of Oklahoma City, contextualizing the bombing of the federal building in a larger national and international narrative.

The Eighth Anniversary (2003)

Attended by hundreds, not thousands, this quiet anniversary included the ritual reading of the names. All three parts of the built memorial were operative and the new federal building was under construction.

The Ninth Anniversary (2004)

By the ninth anniversary the new Oklahoma City Federal Building designed by Ross Barney + Jankowsky Architects of Chicago was complete. Not all agencies had moved in; some never would. Groundbreaking ceremonies on December 5, 2001, were described by one reporter as "a patriotic event crafted to project both healing and defiance in a community still reeling from the deadly bombing."[125] Attendance at the memorial services in 2004 was low and feelings were apparently conflicted as former workers at the Murrah Building struggled to come to terms with working in a new building directly across the street from the site where many of their co-workers died.[126] The new federal building was described as "a monument of a different sort . . . a fortress-like structure of stone walls and blast-resistant glass patrolled by Federal Protective Service officers . . . ranked by an architectural magazine as 'the fourth-safest building in the world.'"[127]

The ceremony for the ninth anniversary of the bombing was held in the First United Methodist Church sanctuary. Following the traditional 168 seconds of silence, children of the victims read the names of the dead. Thirteen family members of victims of the 9/11 attacks were in attendance.[128] The Memorial Museum featured a new exhibition, *Portraits of Survival—The Original Art of the Murrah Building*, consisting of works originally installed under the General Services Administration's percent-for-art program. Joan Mondale, wife of former Vice President Walter Mondale, who had dedicated the art in 1978, was invited to open the exhibition.[129] On the Saturday preceding the anniversary (April 17), the Museum began a new public program, "First Person—Stories of Hope." Each Saturday afternoon through Labor Day

weekend a family member, survivor, or rescue worker told their story of "how horror has been transformed to hope since 1995."[130] This public program was held in the "Chapter 10: Hope" section of the museum, underscoring the official triumphal narrative.

The Tenth Anniversary (2005)

During the tenth anniversary's weeklong celebration, designated the National Week of Hope, the prevailing narrative had all but erased actual history.[131] Mayor Mick Cornett commented: "At this point, we almost have to remind citizens that we have to be respectful of what happened here with the bombing. It does seem like a long time ago and in a different place."[132] Museum Director Kari Watkins announced: "We designed this week to send a signal to the world that there is hope."[133] Lois Romano, who had covered the story for the *Washington Post* from its inception, began her article: "There was something very different about this anniversary, something less raw and painful, and something perhaps even uplifting. And that's the way it was intended."[134] Events were covered live by CNN and Brian Williams anchored the NBC Nightly News from the memorial site. Altogether some six hundred journalists and technicians from eighty-seven news outlets were present, more than at McVeigh's execution on June 11, 2001.[135]

In the weeks that preceded the anniversary, the Spreading Our Branches program planted seedlings from the Survivor Tree at a school in each of the twenty cities where a bombing victim had lived.[136] The week officially began on Sunday, April 17, with A Day of Faith, described as "a tribute to the sustaining power of faith during the decade" since the bombing.[137] In the afternoon there was a Holocaust remembrance program at the built memorial; it was the official Holocaust Remembrance Day (Yom Ha Shoah). The Jewish Federation of Greater Oklahoma sponsored a solemn service that clearly linked Holocaust survivors with those who survived the bombing, enlarging an ever-greater pool of honored American victims and perhaps attempting to integrate the city's Jewish population (an obvious minority) more securely within the city's new identity.

The far larger crowd at the evening candlelight ceremony was animated and cheerful, more like one awaiting a popular concert; indeed the program did contain music. Christian songs followed by *The Star-Spangled Banner* affirmed Christianity as the national religion. Frank Hill, chairman of the Oklahoma City Memorial Foundation, observed that the event was intended "to recognize how faith has played a part in our healing and to honor the more than 200 Clergy and Chaplains who assisted in the bombing."[138] All seats were taken and many stood. The evening was beautiful, mild, and clear. The adjacent pool reflected hundreds of flickering candles, and the celebratory mood was palpable.

The second day, A Day of Understanding, featured a press luncheon and symposium at the private Petroleum Club on the thirty-sixth floor of the Chase Tower in Oklahoma City's central business district. The moderator of the panel, composed primarily of local journalists, reminded the professional audience that this was the anniversary of the 1906 San Francisco earthquake.[139] The speakers emphasized that after the bombing they were Okies first, journalists second, doing their jobs to contribute to the recovery efforts. Sue Hale recalled her decision to run profiles of the lives of the victims in *The Oklahoman*. The featured speaker was the late Anthony Shadid, an Oklahoma native who had won the 2004 Pulitzer for his reporting on the Middle East for the *Washington Post*. He had lived in Jerusalem and Baghdad and spoke of having been shot by an Israeli soldier on Easter Sunday in 2002. He considered "meaning an illusive ideal" in the philosophical sense, and while he insisted that there was no comparison between events in the Middle East and Oklahoma City his very presence implicitly linked them. That evening NBC anchor and managing editor Brian Williams gave the keynote speech at a packed reception in the Bank One Lobby. He had been in the Oval Office on the day of the bombing and had accompanied President Clinton to Oklahoma City.

The actual anniversary, A Day of Remembrance, began with a service in the United Methodist Church, which had been damaged by the blast and served as a morgue after the bombing.[140] There were several video monitors located around the church interior so people who were not able to find seats in the nave could watch the program; the crowd was composed mostly of family members, survivors, and rescue workers. There was an audio feed for those outside. Frank Hill announced that there were over forty survivors of 9/11 in the audience. Vice President Dick Cheney, chair of the Oklahoma-based company Halliburton and a private citizen at the time of the bombing, had joined survivor Polly Nichols to raise large amounts of money. He asserted: "Our created universe has a moral design and the forces of evil will not prevail." He reminded listeners of Billy Graham's visit after the bombing and his words from Psalm 46:5: "God is in the midst of the city; It shall not be moved." Former President Clinton, who embodied the federal presence at Oklahoma City from the start, stated that the city "gave us our heart back as a country." Republican Congressman Ernest James Istook, Jr., who had been influential in passing critical funding legislation in 2004, officially dedicated the anniversary activities as "a national week of hope."

After the formal ceremony, bagpipes sounded as people proceeded to the field of chairs for what was described by John Kifner in the *New York Times* as "a mixture of wake and family reunion."[141] All the chairs had flowers; many had personal notes, photographs, and pennies (symbolic of money raised by school children). Quite a few people wore T-shirts with images of the

deceased. Some groups gathered around individual chairs and sang hymns; others prayed in Spanish. Throughout the days surrounding the anniversary, and especially on April 19, people continued to leave things on the memory fence located on what Memorial Museum archivist Jane Thomas described as the "healing" side of the built memorial.[142] According to Thomas, the anniversary always prompted an outpouring of items.

An evening dinner at the Oklahoma City Civic Center inaugurated the annual Reflections of Hope Award, intended for "a living person or group whose extraordinary work had significantly affected a community, state or nation."[143] The ceremony began with the appearance of four members of the Kiowa Black Leggins Warrior Society in full Native American dress. The recipients of the award were Jamila Mujahid and Najiba Maram, founders of the Voice of Afghan Women Radio.[144] The station broadcast up to eleven hours a day to a wide audience of listeners, 95% of whom "cannot read, do not have access to electricity or telephone."[145] In accepting the $10,000 award, Mujahid linked Kabul and Oklahoma City as terrorist sites, but the comparison fell flat. As one reporter observed, the Afghan journalists "from one of the world's most bombed cities . . . offered condolences to Oklahomans who endured a single bombing a decade ago."[146]

This event was clearly intended to situate Oklahoma City in an international context. Arguably the nation's first victims, Native Americans were more closely linked with current victims across the globe in Afghanistan. In the audience a table sponsored by the Jewish community (that had previously held Holocaust remembrance services at the built memorial) had some empty seats. Oklahoma City's new status, evidenced by the media attention and the dignitaries present, was a direct result of the bombing; the city was now an acknowledged player in the worldwide community of terrorist victims, linked not only to Columbine and 9/11 but well beyond. The latest exhibition at the Memorial Museum, *Changed Forever—Forever Changing* (April 19–December 31, 2005) emphasized the connection between Oklahoma City and those cities directly affected by 9/11: New York City, Washington, D.C., and Shanksville, Pennsylvania. Shared themes were defined as Terror, Courage, Response, Experiences, and Lessons.

The weeklong Festival for the Arts (complete with music, art, and crafts) also opened on the tenth anniversary at a site just six blocks south of the memorial.[147] People shopped and snacked on local fair food, including Indian flatbread and funnel cakes. Wandering through the various displays it was difficult to remember the event that prompted it. The fifth annual memorial marathon attracted some twelve thousand runners.[148] Hotel rooms were hard to come by and there was evidence of urban renewal all around.

The revival of the city was the dominant theme in press coverage of the events. *The Wall Street Journal* announced:

> Oklahoma City's downtown is thriving. The Bricktown district is buzzing with night life, people are moving downtown, there is a gleaming new federal building blocks from where the Murrah building once stood and property prices are booming. Add to that two successful stadiums, a $52 million performing arts center, a $22 million central library, a "Riverwalk" type canal, a trolley, clubs and restaurants, and the downtown of the once-sleepy city of 500,000 is bustling.[149]

Although the passage of a sales tax increase for redevelopment purposes two years before the bombing laid the foundation for renewal, it was the bombing that provided the impetus for major growth. The financial impact of the memorial had been huge. According to a fundraising brochure, since February 2001, "the total economic effect . . . is 10,505 jobs supported and $173,980,000 in income based on paid visitation to the Museum."[150] The Memorial was considered the linchpin in downtown revival.

On the day before the tenth anniversary Oklahoma Governor Brad Henry signed legislation allocating five million dollars to match a federal appropriation for an endowment that would insure the future of the memorial.[151] The funds, secured through State of Oklahoma House Bill 1001 and authored by state Senator Bernest Cain (D-Oklahoma City) and Rep. Susan Winchester (R-Chickasha), was signed into law at the Survivor Tree. Governor Henry proclaimed: "This is a holy place—a place for people across the state and across this nation and frankly all across this world to come and reflect and hopefully find a renewed fervor for peace in the world."[152]

Conclusion

Bob Johnson, the head of the memorial committee, defined his accomplishment this way: "For the first time in the history of the country, we democratized a memorial process. We wanted those most directly affected by the tragedy to be involved in every aspect of it."[153] This premise—that giving those mostly directly affected by the tragedy a decisive role democratizes the process—is highly questionable.[154] How can individuals overwhelmed by recent grief take on a responsibility that must have a future-oriented perspective? Elsewhere Johnson asserted that this process had transcended other models by "intentionally becom[ing] part of the healing process."[155] But commissioning a permanent memorial as a kind of therapy perverts the nature of the process, which ideally is driven by thoughtful deliberation informed by historical context, not intense mourning. Johnson implied that opting not to

use design professionals as part of the process is the essence of a democratic process. The foundation of democracy, however, rests on the premise of an informed citizenry, not an emotionally wounded one.

A more appropriate process of commissioning memorials should follow the common practice of representative democracy, with input from family members included along with artists, architects, landscape architects, (art) historians, and other professionals who have experience with memorials and the necessary fundraising and public relations skills to realize them. Architectural practice also serves as a model where primary users serve in advisory capacities, providing information about their needs and concerns. The competition should be organized and led by an experienced professional.

There was a time in national history when memorial commissions were routinely awarded to those considered the best artists of their day, and those artists often worked with architects. Today architects rather than artists predominate in most memorial competitions in the United States.[156] In any case, building a memorial is a professional enterprise and the commissioning process should reflect that, including the means to involve local citizens. As the jury for the *VVM* demonstrated, professionals are not opposed to taking a chance on an unknown designer. Even though the Butzers' memorial in Oklahoma City fulfills the mission statement, it lacks the profound simplicity and subtlety of Maya Lin's evocative sculpture in Washington, D.C.

The Oklahoma City memorial process was rife with questionable assumptions and dubious results. Presidents Clinton and George W. Bush, present at significant ceremonies, spoke in terms of faith and hope and conferred heroic status on the local victims, valorizing them as if they had served in the military. The memorial sculpture with its 168 empty chairs evokes a cemetery. The adjacent museum institutionalizes a triumphal narrative punctuated by dramatic experiences of re-enactment, while failing to address the motives of the bomber. This omission works against their own stated goal of preventing future terrorism. The National Memorial Institute for the Prevention of Terrorism intended to frame the bombing in a global context. By drawing facile comparisons to Afghanistan, however, it fails to consider the unique, salient geopolitical factors of distinct locations, which does not really create a global context. The bombing and its aftermath, including an influx of federal dollars to help fund the memorial complex, prompted an economic and cultural revival of the city that took a scant ten years, an actual civic triumph that increasingly re-contextualized the significance of the bombing. The strategies of diversion and denial manifested in Oklahoma City set the tone for future American responses to terrorism, no matter the scale.

Columbine: The Power of Denial

What happened in Littleton pierced the soul of America.

PRESIDENT BILL CLINTON, ON THE FIRST ANNIVERSARY
OF COLUMBINE, APRIL 20, 2000

There are a host of personal, professional, political, and ideological agendas at work, explicitly and implicitly, in all things Columbine.

JUSTIN WATSON, *THE MARTYRS OF COLUMBINE*

If you were to come upon the discreetly located memorial to the Columbine shootings, you would be hard pressed to determine what precisely was being commemorated besides the deaths of thirteen individuals.[1] Nestled in a public park a short distance from the now famous high school, it might easily be taken for an outdoor chapel but for the absence of crosses. A closed inner circle, focused solely on the victims, is surrounded by an outer wall with comments from some of those directly affected by the tragedy, signalling an overwhelmingly local perspective. The rampage that resulted in these deaths has been effectively erased here, replaced by themes of mourning and hope, evocative of the imagined "before" state of the community and spiritual afterlife of the victims. Consistently framed in an evangelical Christian context, this Columbine memorial along with others dedicated to the tragedy manifest what in secular terms could be considered the power of denial.

Before the high school shootings, Littleton, Colorado, a community of approximately forty thousand residents, was just another upper-middle-class suburb, an embodiment of the American dream in a post-Levittown world.[2] Located just outside of Denver, it was known for the quality of its schools; they were a key reason people moved there.[3] Then, on April 20, 1999, Columbine high school seniors Eric Harris and Dylan Klebold killed thirteen and wounded twenty-three before committing suicide. The subject of one of the

most closely followed news stories of the decade became, as reporter Jeff Kass observed, "a one-word banner for American dysfunctionalism."[4] Or as writer Dave Cullen summed up: "Columbine came to embody everything noxious about adolescence in America."[5]

The Columbine High School killings occurred a scant few months before the premature death of John F. Kennedy Jr. While the latter marked the end of the dream of a Kennedy presidency, the former, arguably, stood for something even larger. High school has long figured prominently in American literature, films, and television. It marks a quintessential beginning, at least in our cultural imaginings. Celebrated as a time of first cars and first sex, it promises freedom without adult responsibilities. As religious studies professor Justin Watson observed: "High schools are not social universes unto themselves, but can be understood as particularly intensive microcosms of contemporary America."[6] Eric Harris and Dylan Klebold, who planned their attack at Columbine for at least a year, described it "as a means to a greater end, to terrorize the entire nation by attacking a symbol of American life."[7]

Although not the first nor the last school shooting in U.S. history (it was actually the tenth), Columbine prompted the greatest shock waves and media response.[8] School shootings had become news three years earlier (in 1996) in rural towns such as Moses Lake, Washington; West Paducah, Kentucky; Pearl, Mississippi; and Jonesboro, Arkansas.[9] The Jonesboro shooting spree attracted national attention because the killers were so young, only eleven and thirteen years old. It was also unusual in that the youths shot their victims from afar and did not kill themselves.[10] Columbine, however, remains the archetype to which all others are linked and against which they are compared, at least in terms of the death toll. It has become a marker of time; references to before or after Columbine are common.[11] In 1999 it was treated as nothing short of a national disaster, and in some ways it was, signaling a significant fissure in part of the social fabric. It garnered so much attention at least in part because of its suburban setting and the composition of its student body. In her definitive study of school shootings, sociologist Katherine S. Newman determined that these crimes, committed almost exclusively by white boys, occurred mostly in rural or suburban towns. Thus they "contradict our most firmly held beliefs about childhood, home, and community."[12]

On April 20, 1999, eighteen-year-old Eric Harris and seventeen-year-old Dylan Klebold, armed with guns and bombs, entered Columbine High School with the intention of committing the largest mass murder in U.S. history. The date was the 110th birthday of Adolph Hitler, and it followed by one day the one-year anniversary of the Oklahoma City bombing.[13] Like other seemingly sudden killing sprees, it was well planned in advance; some 81% of school shooters publicize their intentions.[14] As was often the case,

however, prior warnings were difficult to act upon because the evidence of isolated incidents was scattered. Although Eric and Dylan had not been identified as having noteworthy discipline problems at school, they had been involved in a Halloween prank, shooting BB guns at children trick-or-treating. More seriously, Eric, angry at his friend Brooks Brown for not giving him a ride to school, heaved ice at Brown's car, causing the wind-shield to crack; subsequently he posted death threats on Brown's website.[15] These included: "I'm coming for EVERYONE soon and I WILL be armed to the fucking teeth and I WILL shoot to kill." Since Brown was specifically listed as a target, his parents went to the police but their complaint did not prompt significant action.[16] Although Brown's parents continued to alert the police to Eric's alarming behavior, his pro forma apology to Brown seemed to satisfy local law enforcement. After Eric and Dylan were caught breaking into a van to steal electronic equipment, they were enrolled in a twelve-month juvenile diversion program that included writing a letter of apology to the owners of the van, taking anger management classes, and doing community service. Both boys completed the program with excellent reviews just ten weeks before the shootings.[17] They managed to fool the pro-fessionals in a manner Jeff Kass described as "expertly deceitful," prompt-ing him to conclude that the program "probably prodded them towards Columbine as they chafed against the strict guidelines and boiled inside against being caught."[18] Clearly, the system failed to detect serious psycho-logical problems or deflect ongoing violence.

Eric and Dylan had signaled their intentions in various school assign-ments. In December 1997, in response to recent school shootings, Eric wrote: "[I]t is just as easy to bring a loaded handgun to school as it is to bring a cal-culator. . . . Students bring guns to school for many reasons. Some for protec-tion, some for attacking, and even some to show off."[19] In February 1999, Dylan wrote an especially violent story featuring a lone killer dressed in a long black trench coat and carrying a knife and guns in a duffle bag, walking along a dark street and proceeding to kill a group of "college preps."[20] The boys documented their plans, including their desire to kill themselves and as many others as possible, on videotapes made in the basement of Eric's home over the course of a year before the rampage. These recordings became known as the Basement Tapes.[21] At one point they called their impending rampage a "suicide plan."[22] In the end their ambitions were foiled by their lack of exper-tise in bomb construction.[23] Had they been successful and escaped, they wanted to "hijack a plane and crash it into New York City."[24] The boys hoped their plans would one day be shown around the world. An FBI agent observed: "They wanted to be martyrs and to document everything they were doing."[25] Harris eagerly anticipated getting "the respect we're going to deserve."[26] They dreamed of living forever "in memory and nightmares." Their goal was an alarmingly accurate version of celebrity fame; they envisioned movies of their

exploits, arguing whether Steven Spielberg or Quentin Tarantino would be the better director.[27] Instead, eventually both Michael Moore and Gus Van Sant made films based on Columbine.[28]

The Immediate Memorial

As news of the shootings spread, people created "a shrine the size of a football field" across the street from the high school, as close as they could get to the site of death (Figure 4.1).[29]

FIGURE 4.1 *Unidentified onlookers stop to view the growing display of flowers, cards, and balloons left at a makeshift memorial in Clement Park near Columbine High School in Littleton, Colorado, Wednesday, April 28, 1999. Twelve students and one teacher were killed by two gun-toting students during a shooting rampage at the school last week. AP Photo/Eric Gay. Copyright 2015, The Associated Press.*

They hung messages for the victims from paper chains strung between trees. One memorial for student Rachel Scott clustered around her car, which remained in the parking lot. The religious nature of the community was evident in the objects left by mourners and in the spiritual nature of the gathering, which according to Erika Doss had "the appearance of an outdoor revival meeting."[30] Altogether an estimated two hundred thousand items were left at the scene, including flowers that were constantly replaced and stuffed animals that were eventually donated to local hospitals. Although many items (some 40–50%) were damaged by rain and snow, approximately eight thousand objects had been catalogued by the following year and stored at the Littleton Historical Society.[31] These appeared to fall into categories similar to objects left at the *VVM*: relics pertaining to the deceased, gifts for the dead, objects of shared experience, and commentary.[32] Many former students of murdered teacher and coach Dave Sanders left their old athletic shoes, baseballs, and basketballs, most of which were left with notes recalling pranks, winning games, advice given, and so on. Commentary included letters, poems, works of art, and religious symbols. Some addressed violence in society, especially in schools. There were drawings by elementary school children; one five-year-old sent a box of Band-Aids.[33] Classes and entire schools as well as businesses sent large posters or banners of support.

An immediate controversy erupted over whether the deaths of Eric and Dylan should be acknowledged in some way. Greg Zanis, a carpenter from Naperville, Illinois, made fifteen crosses intended for the immediate memorial—thirteen for the victims and two for the shooters.[34] Although Zanis had no personal connection to Columbine, one week after the shootings (allegedly at the request of some Columbine students) he brought the six-foot-tall, unpainted wooden crosses to Clement Park atop Rebel Hill, adjacent to the site where the permanent memorial would eventually be built (Figure 4.2).[35] In order to differentiate the crosses for the killers, he used a different style of lettering for their names. He felt: "They had a mom and a dad. They had friends. I think everyone has lost here."[36] According to evangelical Christian belief, however, while the slain were believed to be martyrs, the killers were seen as essentially evil and beyond salvation. Soon their crosses were covered with obscenities. Some believed that writing on the crosses was a sacrilege, while others considered dedicating crosses to the killers was blasphemy. Anthropologist Sylvia Grider observed: "The Zanis crosses became the locus for the community to act out its conflicted responses to the murders."[37] On April 30, Brian Rohrbough, whose son Daniel was one of the victims, destroyed the crosses for Eric and Dylan. He explained: "We don't build a monument to Adolf Hitler and put it in a Holocaust museum—and it's not going to happen here."[38]

FIGURE 4.2 *Mourners visit a memorial of crosses on a hill overlooking Columbine High School in Littleton, Colo., on Saturday, May 1, 1999. Only thirteen crosses stood at the site Saturday morning after Brian Rohrbough, the father of shooting victim Daniel Rohrbough, removed the crosses of suspects Eric Harris and Dylan Klebold and destroyed them. AP Photo/Ed Andrieski. Copyright 2015, The Associated Press.*

Zanis retrieved the remaining crosses but subsequently was asked to reinstall them in the park. Religious symbols could not remain on public property, however, and the crosses were moved to a cemetery in Littleton. After a time they were taken to a federal warehouse in Denver to be stored with other Columbine relics. Zanis continued to bring thirteen crosses to Columbine for anniversary rituals. He also toured them around the country at his own expense for various memorial and prayer services, a practice reminiscent of the *VVM* traveling walls.[39]

Eradicating the Scene of Death

The determination to omit any reference to Eric and Dylan was echoed in the rush to eliminate the scene of the crime as quickly as possible. Some families of the Columbine victims formed a group called HOPE (Healing of People Everywhere) and raised $3.1 million to replace the library (where ten out of twelve students had been killed) with a two-story glass atrium, and to rebuild it on the opposite side of the school.[40] A plaque listing the thirteen victims is located just outside the rebuilt library. Every area where a child died was

rebuilt, a strategy for dealing with sites of violence that has been defined by Kenneth E. Foote as "obliteration [in which] the site is not just cleansed but scoured [and] . . . not returned to use."[41] HOPE members felt that "Demolishing the site of so much death will help students avoid painful memories."[42]

The atrium featured a mural by Virginia Wright-Frierson, a North Carolina author and artist whose cousin Ellin Hayes was a social studies teacher at Columbine who had taught seven of the slain students.[43] Hung from the ceiling and lit from the supporting beams below, the multi-paneled landscape was intended to create "the illusion of the ceiling floating . . . like looking up in nature, with the effect of light emanating from above." (Figure 4.3)[44] Many expressed a sense that the mural appeared to lift a great weight; the mother of one victim said, "We've set our children's spirits free."[45]

FIGURE 4.3 *Virginia Wright-Frierson. Columbine High School Mural, detail. 2000. Photograph by Eric Molinsky for Studio 360 from PRI and WNYC.*

The Memorial Process

A twenty-eight-member memorial committee was formed in June 1999, charged with selecting a design consultant, holding a series of public meetings, and compiling information gathered from over 3,500 survey responses. Chaired by Bob Easton, director of the Foothills Park and Recreation District in Lakewood, it included Columbine faculty and students, administrative staff from Jefferson County (in which Columbine High School is located), as well as school district and community members.[46] There was a defined hierarchy of levels of participation within the committee: (1) the families of those killed at Columbine, identified as those most affected by the shootings; (2) the injured and their families; (3) past and present high school students, staff, and faculty who participated in design workshops and contributed data; (4) community members who were surveyed and invited to an open house.[47] Thus, similar to the process at Oklahoma City, those most immediately touched by the violence played the most prominent role, emphasizing both their special status and implicitly the therapeutic value of the memorial process.

The committee's mission was "to develop a consensus recommendation to create a physical, permanent memorial for our community and others to honor and respect those touched by the Columbine High School tragedy."[48] Their goal was:

> [T]o create a respectful place where family members, members of the community and visitors could go *to gain an understanding of the innocent victims of Columbine* [emphasis mine]; to create a memorial with content and purpose 100% derived from members of the Columbine community, and keeping with the scale, materials and natural forms found in the Columbine area; to recognize and honor the deceased, the injured, the survivors and community members; to incorporate the Columbine "Never Forgotten" Ribbon in the concept design for the memorial.[49]

Thus, the victims were defined as paramount and the memorial as decidedly local. Nowhere is the nature of the tragedy defined, the crime mentioned, or the killers named; nor were they in the built memorial.

At the six-month anniversary of the shootings (October 20, 1999) Littleton was still reeling, both from the shootings and the aftershock. The mother of one of the injured students had committed suicide and anonymous bomb threats were a regular occurrence. Findings of the ongoing investigation, riddled with contradictions, emerged gradually. There were increased numbers of visits to mental health facilities as well traffic accidents and DUI arrests. At the start of 2000, a young boy had been found dead in a dumpster near the high school; on Valentine's Day two students were shot in a Subway sandwich shop two blocks away from the school; a

star of the basketball team committed suicide. Kids were calling it the "Columbine Curse."[50]

By the first anniversary the library was walled off. Signs outside the school defined it as "a camera-, audio- and video-equipment-free zone."[51] There was a full schedule of memorial services and events at churches, secular sites, the high school, and Clement Park.[52] The day began early with a community prayer breakfast in Our Father Lutheran Church; later there were services at other churches. A special remembrance was held at Columbine Garden at Olinger Chapel Hill Memorial Church and cemetery, where several of the Columbine dead were buried. Greg Zanis installed his thirteen wooden crosses there; the site was already functioning as a de facto memorial for Columbine.

As part of the day's ceremonies, Denver Mayor Wellington Webb and his wife placed a memorial wreath on the front steps of the City and County Building, and Colorado Governor Bill Owens led a remembrance on the Capitol steps, observing: "Today is about the angels who are watching over us— helping us to heal and helping us to remember." He stated: "Columbine will be with us forever just as the Oklahoma City bombing."[53] At 11:21 a.m. there was an official statewide moment of silence to honor the victims. The high school held a private gathering of students and staff in the gym, followed by a community remembrance service at the Clement Park Amphitheater hosted by the parents of Rachel Scott, one of the victims. Some estimated three thousand people attended, far fewer than the one hundred thousand who were present at the first anniversary of Oklahoma City.

Many local students skipped classes that day.[54] Bomb threats closed several nearby schools and were reported in at least six other states. The majority of local residents seemed to believe that irresponsible parents were to blame for the rampage, together with a lack of individual responsibility and a decline in moral values.[55] Reporters observed: "If there was a theme to the day, it was this: Take responsibility for who you are and how you treat people."[56] Relatives of the victims asked news organizations not to mention the names of the killers.[57] President Clinton continued to provide a national voice, praising the outpouring of support for Littleton and quoting the Bible: "Blessed are they that mourn, for they shall be comforted."[58] A freshman at a nearby university doubted that the tolerance being touted was prevalent. Rather, she said: "Everyone wants to stuff grief and not deal with it."[59] Many, noting the closeness of the Oklahoma City and Columbine anniversaries, commented that this seemed like National Disaster Week.[60]

At the end of the 1999–2000 school year the Columbine Yearbook was dedicated to the victims and there was an attempt to represent students who excelled in other areas besides sports.[61] In May 2000 the second class of Columbine survivors graduated; two of the nine were in wheelchairs. Patrick Ireland, one of the wounded, who was advised by doctors that he

would never walk again, was now able to limp to the stage to claim his diploma. In his valedictory address he observed: "The shooting made the country aware of the unexpected level of hate and rage that had been hidden in high schools."[62] For him and many others, Columbine High had become emblematic of a national problem. A short time after graduation the Memorial Committee announced the selection of a site in Clement Park, in proximity to but not visible from the school.[63] Although they favored a distant site further removed from the place where the shootings occurred, students had objected. That July the Denver firm DHM Design, working with artist Tad Savinar from Portland, Oregon, presented three designs to the parents of the shooting victims but, according to official records, some felt it was too soon to decide.[64] Others reported a general disappointment with the proposals.

Although money for the library project had been raised in four months, fundraising for the official memorial had stalled. Groundbreaking, originally intended to coincide with the fifth anniversary, was delayed indefinitely because only one quarter of the money had been secured.[65] The memorial committee hired a consulting firm, which planned to use the fifth anniversary to spike contributions.[66] Bill Clinton returned for the 2004 anniversary to give the project a boost with a $300,000 contribution.[67] By then all the students who were enrolled at the high school at the time of the shootings had graduated, although siblings of the wounded were still in attendance. Former students and now college graduates Steve and John Cohen sang their song, "Columbine Friend of Mine," which had become something of an anthem for the tragedy and was often sung at memorial services.[68] Emphasizing the religious frame that surrounded the shootings, the lyrics include: "In God's son hope will come, his red stain will take our pain" and "Christ of grace attend this place we look to you. Honor you."[69] At the sunset vigil in Clement Park, survivors, friends, and family members once again shared memories of the victims. Four F-16 fighter jets flew over the amphitheater and the names of the dead were read aloud. Doves and white balloons were released amidst flickering candles, first thirteen and then two hundred others to stand for the larger community.[70] Anne Marie Hochhalter, who was paralyzed from the waist down as a result of the shooting, and whose mother had committed suicide six months afterwards, uttered what had become the dominant narrative. Focusing on the positive, that since the rampage she and other survivors had gone on to college and careers, she ended her speech with the mantra: "We can show we are strong. And we can get through anything with the help of God, family and friends."[71]

Olinger Chapel Hill Mortuary and Cemetery continued to serve as a de facto memorial site. Thirteen black granite crosses were emblematic of the spiritual narrative that explained Columbine. As one frequent visitor

observed: "I think the people who were moved by this, they're not coming from a worldly position. All good that has come out of this; all the blessing, there are so many people who now lead a more godly life."[72] Groundbreaking for the official memorial finally took place in June 2006, just after the seventh anniversary. Clinton was there again because, he said, "millions of Americans were changed by Columbine." He quoted one of his favorite lines by Hemingway: "The world breaks everyone and afterward many are strong at the broken place," and he compared survivors to severely wounded Vietnam veterans, (like many others) conflating the civilian victims of a crime with war casualties.[73] In the press the Columbine shootings were now linked to both Oklahoma City and September 11, 2001.[74]

Two months later in August 2006 construction began on a reduced memorial design. A ten-foot-high water wall had become a small fountain, the intended polished granite walls were to be built of Colorado sandstone, and staircases leading to the hilltop overlooking the memorial were replaced with pathways.[75] Reporters observed the creation of many interim memorials; the football field had been renamed for Matthew Kechter, one of the victims, and there were various plaques dedicated to the others. A music teacher kept a picture of Dave Sanders on his classroom wall.[76] And, most importantly, by this anniversary the library had been rebuilt.

A few weeks before the eighth anniversary, there was a controversy about a memorial for a local Navy SEAL killed in Afghanistan and awarded the Navy Cross (the services' second highest award for valor after the Medal of Honor). The privately funded over-life-size bronze statue by Robert Henderson depicted Petty Officer 2nd Class Danny Diets, Jr. kneeling with his rifle held across his chest and pointed toward the ground. The intended site, Berry Park, was close to his home but also near several schools. A significant vocal number felt that a statue with a gun was problematic and contradicted the "clear message of nonviolence that we teach in Littleton schools."[77] This anti-gun argument so enraged others that some surmised that it might actually have helped the family raise money for the project. In any event, the dedication took place on July 4 as planned, with federal endorsement signaled by the presence of Secretary of the Navy Donald C. Winter; Rear Admiral Joseph D. Kernan, commissioner of Naval Special Warfare Command; and Republican U.S. Representative Tom Tancredo of Colorado.[78]

The Columbine Memorial

The official Columbine memorial was dedicated on September 21, 2007, some eight-and-a-half years after the shootings, to an audience estimated to be in the hundreds (Figure 4.4).

FIGURE 4.4 *DHM Design. Columbine Memorial, Clement Park, Littleton, Colorado. Photograph by Flickr user "RLEVANS."*

Previous failures to raise the necessary funds were linked to the "economic downturn, 2001 terrorist attacks, a southeast Asian tsunami, Hurricane Katrina, and other disasters that diverted potential donors' attention."[79] Then, too, after Columbine, school shootings had become more frequent, with the victims of the Virginia Tech shooting on April 16, 2007, outnumbering the Columbine dead. The memorial, located at the southeastern edge of Clement Park (7306 W. Bowles Avenue at Pierce Street in Littleton), is a discrete structure focused on the victims of the shooting and the reactions of the immediate community. Family members felt that it provided "a quiet place for reflection mixed with a sense of triumph."[80] Surrounded by a park landscape, it is just over an acre in size. Although it is possible to climb the hill behind the memorial and see the high school, the memorial (like the commissioning process) is intentionally and emphatically self-contained.

The key elements are an inner Ring of Remembrance and an outer Ring of Healing (Figure 4.5). An image of the "Never Forgotten" ribbon designed by the parents of one of the victims, Kyle Velasquez, is inscribed on the ground; it had become an emblem of community solidarity. The inner ring is divided into three sections, each waist-high stone wall topped by panels engraved with the names of the dead and a personal reflection provided by their families. The overriding theme is overtly religious; eight statements invoke God. Cassie Bernall's inscription reaffirms that she "lost her life because of her belief in God." Rachel Joy Scott's tribute inserts her into the same narrative: "Her final words were testimony to her life. When asked if she believed in God, she replied, 'You know I do!'" John Tomlin's inscription recounts a recent religious conversion. Kelly Ann Fleming's consists of a poem she wrote that addresses the Lord directly. An excerpt from Lauren Townsend's diary recounts her vision of "A woman in the middle of a field of flowers kissing Jesus' wounds." The parents of Isaiah

Shoels, the only African-American victim, asserted: "The love of God was first in Isaiah's life." Matthew Kechter is called "a gift from God."

FIGURE 4.5 *DHM Design. Columbine Memorial inner Ring of Remembrance and outer Ring of Healing, Clement Park, Littleton, Colorado. Photograph by Jeffrey Beall.*

In a more secular vein, two inscriptions, one to Daniel Mauser, the other to Kyle Velasquez, honor their sons' struggles to deal with developmental difficulties. The only reference to larger societal issues was provided by Brian Rohrbough, Daniel's father: "My son, in a Nation that legalized the killing of innocent children in the womb; in a Country where authorities would lie and cover up what they knew and what they did; in a Godless school system your life was taken." Although the memorial committee tried to convince him to alter or tone down his comment, he refused. It was Rohrbough who destroyed the two crosses in the immediate memorial dedicated to Eric and Dylan. Later, in 2008, he ran for U.S. Vice President as an America's Independence Party candidate, together with presidential candidate Alan Keyes.

The outer Ring of Healing is built into the side of a hill, somewhat reminiscent of the way the *VVM* is set into the ground (Figure 4.6). Like the Oklahoma City memorial, it acknowledges the larger circle of those affected. The stepped perimeter red brick wall is punctuated by plaques at various heights, engraved with quotes by students, parents, first responders, and some of those who spoke at the groundbreaking. Included is Clinton's comment, by now a kind of official spin on such civic traumas: "Columbine was a momentous event in the history of the country. . . . Even in the midst of tragedy we've seen the best, the best there is to see about our nation and about human nature."

One student wrote: "I think this caused people to strengthen rather than shake their faith in God." Another stated: "Those of us who are people of faith in this community turned to God, found he was there and found he wasn't silent." From a different perspective, a parent observed: "The definition of normal changed that day," while a student commented: "I no longer take anything for granted," and another concluded: "I don't think our school was any different than any other high school in America."

FIGURE 4.6 *DHM Design. Columbine Memorial Ring of Healing, Clement Park, Littleton, Colorado. Photograph by Jeffrey Beall.*

In between the rings of the memorial are benches where visitors may sit and rest or reflect. Nothing suggests the violence of the shooting or the national reverberations it prompted. There is no reference to Eric Harris or Dylan Klebold. The focus is on the victims featured in the inner circle. There is no memorial museum, nor is one planned. The Littleton Historical Museum houses the objects left at the immediate memorial and mounts occasional exhibitions on significant anniversaries.

I visited the memorial on the tenth anniversary of the shootings, April 20, 2009. The early evening service in the Clement Park Amphitheater was titled "A Time to Remember, a Time to Hope." The National Anthem was sung, followed immediately by "Columbine Blue," the high school song. Steve Poos-Benson of the Columbine United Church presented the invocation, focusing on "healing, hope, transformation, thriving and life," the power of God to heal lives, and the need to go forward. In a projected video message, former President Clinton expressed his regrets at not being there as he had been ten years ago on the day that "changed us forever," asserting again that Columbine was a model for how to "rebuild the best of our common humanity."

Student body president Beau Lendorf insisted: "I never think about the shootings." Even though the current seniors were seven or eight years old

when they occurred and current freshmen were only four, this is hardly cred-
ible. After all, as school staff representative Lee Andres observed, Columbine
was now "the most famous high school in America," precisely because of the
rampage. Nevertheless, he hoped that students would simply see it as their
school and that it would serve as "a symbol of strength, courage and hope."
Ruth Feldman, a Columbine parent and community representative, spoke of
the mural of trees in the high school atrium where the library once stood as
inspiring students to look upwards. Rousing applause greeted Valerie
Schnurr (representing the injured) when she stated: "We are not victims. We
are all survivors," followed by a standing ovation when she affirmed that,
"there is life after tragedy." Dawn Anna, speaking for the families, framed
April 20 as "a national day of recommitment" to be kinder to one another
and honor the dead by being honorable. This too prompted a standing ova-
tion, as did the appearance of Frank DeAngelis, principal at the time of the
shootings, who served in that capacity until May 2014. He expressed pride in
all the classes and acknowledged the people of Virginia Tech who had en-
dured a similar tragedy. Referring to the dead as "guiding lights," he urged
the audience to "turn pain into healing, hatred into love." Doves were re-
leased and bagpipes played. There was a somber, respectful mood infused
with a subdued sense of triumph, quite different from the upbeat, celebratory
atmosphere at Oklahoma City. But then, since this crime did not occur on
federal property there had been no influx of government dollars and no eco-
nomic revival here.

On the day of the tenth anniversary, the cover of *The Denver Post* featured
not the official memorial but the one at Olinger Chapel Hill Mortuary and
Cemetery, funded mainly by the Olinger company and the victims' families,
an indication of the cemetery's continued importance as a site of commemo-
ration (Figure 4.7). The thirteen black granite crosses arranged in a semi-
circle each had flowers and a candle in a white paper bag at their base. Four
surrounding benches were marked "Columbine." Corey DePooter, Rachel
Scott, Dave Sanders, and one of the shooters (in an unmarked grave) were
buried here. The secular issues implicit in the Columbine story were ad-
dressed elsewhere. That morning on the west steps of the Colorado State Cap-
itol, "Columbine Remembrance and Rededication," a sparsely attended public
event, focused on tighter gun control. Organized by the group Protest Easy
Guns, and hosted by Colorado Ceasefire and the Million Mom March, it in-
cluded speakers John Manyon (a Vietnam veteran and Denver native) and
Arnie Grossman (author of *One Nation Under Guns*). Representatives from
the Virginia Tech shooting brought ribbons in honor of the Columbine vic-
tims.[81] Tom Mauser, whose son Daniel died at Columbine, lamented that the
killers' names were well known but those of the victims were not. Andy God-
dard, whose son Colin was a victim at Virginia Tech, railed: "Just drink the
NRA Kool-Aid: Guns don't kill people; People kill people. These are

not acceptable losses." A scant few weeks earlier, the status of national gun control legislation was lamented once again in the editorial pages of the *New York Times.*[82]

FIGURE 4.7 *Olinger Chapel Hill Cemetery Columbine Memorial, Centennial, Colorado. Photograph by Darryl B. Hamblett, Hebron, CT.*

Elsewhere, the Littleton Historical Museum, several miles from the memorial site, hosted an exhibition, *Difficult Times, Difficult Choices: Why Museums Collect After Tragedies* (April 21–September 20, 2009). Prompted by her participation on a panel at the meeting of the American Association of Museums (now the American Alliance of Museums) and Association of Public History, Lorena Donahue, deputy director and curator of collections, selected items from the museum's permanent collection, among them five books of messages and 860 artifacts left at the immediate memorial.[83] She included a small display case devoted to Eric and Dylan because teddy bears were left for them at the site too; in total it contained three toys, a flower, and two letters (the authors were not identified). Outside of media summaries, this exhibition and Tom Mauser's comment earlier that day were the only references to the two boys that I encountered.

At the memorial site a woman carrying a sign urging remembrance for "all 15 victims" was asked to leave.[84] An article in the *Denver Post* revisited the

firing of Rev. Don Marxhausen who, in response to a call from Tom Klebold at the time of the shootings, held a service for Dylan in his church, St. Philip Lutheran. The minister was asked not to speak at the first anniversary and was eventually ousted from his job after a decade of service. He noted the community's "impatience to heal and its hunger to blame someone long after the shooters turned their guns on themselves." He also observed: "If the members could have dragged the boys' bodies through town and thrown rocks at them, they would have felt better. But we live in a civilized society. . . . People want to be fixed and made whole fast. If a leader is associated with the source of their anxiety, then the leader must go." Columnist Susan Greene saw Marxhausen's perceived transgressions as an attempt to practice "free speech and mercy."[85]

Contextualizing Columbine

Even though the religious frame for the Columbine shootings prevailed locally and appeared widely in the media, the rampage raised a myriad of secular issues, most critically: gun control, bullying at school, identifying and treating teenage psychological and family problems, and the effects of violent expressions in popular culture. These topics, addressed in a multitude of news accounts, several books on the shooting, and at least two important films, focused on the victims but also included the shooters. They suggest a range of subjects that might appropriately be addressed in a memorial museum or education center.

Secular Narratives

School shootings could not happen without guns and, predictably, *gun control* emerged as a major issue of debate after Columbine. The underage killers got their weapons from an acquaintance who bought them at a local gun show where the usual time period for permit approval was waived. Two weeks before he was killed, Tom Mauser's son Daniel discussed the "gun show loophole" in the Brady Law with him. The 1994 Congressional act requiring background checks of handgun buyers was enacted after the attempted assassination of President Ronald Reagan that wounded and partially paralyzed press secretary James Brady. After Daniel's death, Mauser took a leave from his job at the Colorado Department of Transportation to become an activist for "new laws that would make it harder for children and criminals to get guns."[86] Two weeks after the Columbine shootings he protested at the National Rifle Association (NRA) convention held in nearby Denver.[87] Although the Colorado legislature subsequently passed a law that made it "a felony in Colorado to buy guns for someone who can't buy them legally and a

misdemeanor to give guns to juveniles without their parents' permission," the gun show loophole remained.[88] A study in 2000 disputed the success of the Brady Law, concluding that even required background checks were too limited.[89] As one writer predicted: "[T]he U.S. will continue to be armed to the teeth."[90] Indeed, no national gun control laws were enacted in response to the Columbine shootings. By the tenth anniversary even the legal limitations in Colorado were threatened. The following year, efforts to increase restrictions on gun ownership were defeated; this prompted gun control advocates to say "it's as if Columbine never happened."[91] There are, however, nuances in the gun control narrative. Katherine Newman reported that although the number of guns in the United States doubled from 1970 to 2003 to about 200 million, the number of families owning firearms did not. She saw the problem as one of widespread availability and easy access, a normalization of guns resulting in their presence in schools sometimes not being reported.[92] Brooks Brown felt that "No matter how strict the gun laws were, [Eric and Dylan] were determined to find a way around them. If people want to buy weapons illegally, it's only a matter of time before they succeed."[93]

Both Eric and Dylan apparently had endured physical and verbal *bullying*, as have nearly all school shooters.[94] Apparently, the degree to which this kind of abuse was tolerated at Columbine was extreme.[95] After earlier school shootings, students at Columbine commented that their school was ripe for a similar attack.[96] Typically, the bullies were athletes who ranked at the top of the high school hierarchy, reflecting accepted cultural codes of masculine appearance and behavior.[97] Columbine's principal had been a sports coach and quite a few teachers also functioned as coaches, thus cementing a system that valued athletic prowess above other qualities. Although many concluded that Eric and Dylan mainly shot students at random, they planted their bombs in the area of the cafeteria where the jocks typically sat.[98] At the time the media did not give much credence to the role of bullying; subsequently it was studied and taken more seriously.[99] Apparently there were no serious attempts at Columbine to revamp a high school culture that celebrated sports heroes at the expense of others, often condoning their ostracizing behavior and worse.[100] A year after the shootings the director of the Denver District Attorney's Juvenile Diversion Division concluded that bullying at the high school definitely existed and, although the school seemed to have acted appropriately in some instances, much was "unclear or altogether unknown."[101]

The majority of school shootings take place in small towns or suburbs where the importance of high school sports is typically far greater than in cities, with athletic reputations continuing to define individuals who continue to live in the vicinity. Furthermore, sports may provide a school or an entire community with a positive identity, thus reinforcing the valorization athletes routinely receive. Nearly all known school shooters were considered

outcasts by themselves and others, while many suffered from a range of psychological ills not diagnosed until afterwards. These boys had few mechanisms to deal with the daily abuse of bullying and despaired of ever escaping it. In many cases, school shootings are a form of suicide.[102]

Psychological problems, not well tolerated in the culture at large, are an anathema in high school where to admit to them (especially for boys) will likely prompt more bullying. Although one popular explanation for Columbine and other school shootings is that the perpetrators "just snapped," Newman and others argue persuasively that this is almost never the case. Rather, precipitating events may help explain when shootings occur, but not why.[103] Brooks Brown thought that escalating rage contributed to the sense of hopelessness that finally triggered the rampage at Columbine.[104] By that time Dylan had written at length about his depression and suicidal ideation as well as his practice of cutting himself. A month before the Columbine shootings, when NATO forces began bombing the former Yugoslavia, Eric (the son of a retired air force pilot) tried unsuccessfully to join the Marine Corps; he was rejected because he was taking a prescribed psychopharmacological medication for depression.[105] Another explanation placed the blame on their presumably troubled family lives. Brown, however, attests that Dylan "came from a good home, with two loving parents who were far better to him than many other parents. . . . It doesn't make any more sense to blame them than it does to blame [rock musician] Marilyn Manson."[106] Nearly two thirds of the school shooters studied by Newman lived in two-parent families, although this statistic conveys nothing of the quality of their family lives. Newman concluded that in general, family problems like psychological illness, "may contribute to school shootings, but their role is not straightforward."[107]

Secular narratives also typically targeted forms of *popular culture* characterized by varying degrees of violence: contemporary music, "the Internet, television, films, videos, video games, books, styles of dress and T-shirts."[108] Eric and Dylan liked the video game *Postal*, inspired by shootings in post offices (as in, "going postal"), in which the main character fires at everyone in his path. The only way to quit the game is to put the gun in the killer's mouth and pull the trigger. However, they preferred *Doom*, which featured a space marine who takes on demons in various guises. According to Jeff Kass: "*Postal* had details that prefigured Columbine, and *Doom's* philosophy of the lone Marine against the rest of [the denizens of] hell supported Eric and Dylan's us against them mentality."[109] Their favorite movie was Oliver Stone's *Natural Born Killers* (NBK, 1994), based on a screenplay by Quentin Tarantino. It features a couple (played by Woody Harrelson and Juliette Lewis) who go on a killing spree and focuses equally on their rampage and the media attention it prompts. In early February 1998 Eric and Dylan adopted NBK as a code name for their planned attack.[110]

The *"blame the media"* narrative was often accompanied by cries for censorship.[111] But if these widely popular cultural expressions actually prompted school shootings there would ostensibly be many more. It could also be argued that the media reflect cultural norms or preferences rather than motivate specific forms of behavior.[112] Most likely, as Katherine Newman suggested, they provide models, a cultural script.[113] This becomes critical if viewers are already searching for extreme solutions.[114] Sociologist Ralph W. Larkin identified a "revolt of the angry white male" in the early to mid-1990s that was evident in the standoffs at Ruby Ridge, Idaho and Waco, Texas, and culminated in the Oklahoma City bombing.[115] These incidents, related to the paramilitary movement that evolved in response to the failure of the Vietnam War, also provided a model for the rampage at Columbine High School. Eric noted in his journal that he intended to outdo McVeigh's body count; elsewhere he cited the 1992 Los Angeles Riots, World War II, Vietnam, as well as *Duke* and *Doom*, thus merging his real and virtual world inspirations.[116] According to Brooks Brown, the appeal of video games lies in their predictability and the player's control:

> In a video game you only get what you know; nothing changes. So video games are a sort of haven, an escape to a logical, exciting world where two things are certain: justice is done, and you get what is due you based on your actions. Everything happens through your own doing, your own mistakes, and your own achievements. . . . It's a type of drug—a fantasy—where happiness exists because things make sense.[117]

In this context the games provide a welcome escape from the perceived and actual misery of high school; according to nearly all interpretations, Eric and Dylan "didn't have the right good looks, money or athletic prowess. Their social skills were hopeless."[118]

Newman suggested convincingly that a specific cluster of factors must exist to create a climate where school shootings may occur: (1) the shooters must think of themselves as marginal in the social world that matters to them; (2) they must have psychosocial problems that magnify the impact of bullying or other such marginalization; (3) there must be available cultural scripts that provide positive models for violent behavior; (4) there is an absence of systems to identify and help troubled teens before their behavior escalates; and (5) there must be guns available to the shooter(s).[119] All these factors were present at Columbine. And yet, none were even remotely alluded to in the comments included in the built memorial. Although such a project was beyond the scope of the local historical society, it is useful to imagine an education center whose exhibits might have addressed the issues discussed above. This in turn might have prompted the implementation of measures that would continue to explore and address these critical issues.

Memorial Films

Two films, Michael Moore's *Bowling for Columbine* (2002), a kind of mock-
ing documentary of the United States, and Gus Van Sant's *Elephant* (2003),
a meditation on the high school experience, situated the rampage in a larger
context and reached a much wider audience. *Bowling for Columbine*, which
won an Academy Award for best documentary (2003), is a commentary on
national identity defined by the persistence of violence, a media-created cli-
mate of fear, a problematic health care system, the decline of the economy,
and the ready availability of guns. In his signature pseudo-challenging style
Moore queries: "Are we a country of gun nuts or are we just nuts?" Referring
to the ongoing American violence in Eastern Europe, he announces: "The
President bombed another country we couldn't pronounce." Marilyn
Manson, whose song lyrics were cited as a possible inspiration for the kill-
ings, emerges as one of the more balanced commentators in the film, ob-
serving that he doesn't have the kind of power that can prompt violent
outbreaks. When asked what he might say to the killers, he replied: "I would-
n't say anything. I would listen to what they have to say, and that's what no
one did."[120]

Although Gus Van Sant's *Elephant* is a fictionalized musing set in an un-
named American town, the intended reference to Columbine is clear.[121] The
camera tracks a range of students played by non-actors in an actual Portland,
Oregon, high school, filming them from behind as they wander through the
eerie corridors. Alarmingly, it seems as if any one of them might conceivably
turn out to be the killers. Eventually the shooters are revealed as homosexual
brothers showering together before leaving for school for the last time. Van
Sant thought of this rendezvous "as a pre-sexual experimentation, a gesture
they might make before they kill themselves," but was concerned that it might
wrongly be interpreted, "that the killers had to be gay."[122] In fact, there is no
indication that Eric was gay; Larkin speculated that Dylan might have had
homosexual feelings but did not act on them.[123] *Elephant* won the Palme d'Or
and Best Director Award at Cannes but opened at the New York Film Festival
to mixed reviews. Elvis Mitchell, writing for the *New York Times*, found it
"unusual and remarkable" while Peter Rainer in *New York* magazine de-
scribed it as "a lurid tease posing as an art film."[124] Van Sant's implicit mes-
sage that the killers might have been anyone suggested an even darker vision
than Moore's. For all his disgust with the status quo, Moore pointed to cul-
prits and suggested apparently simple solutions to widespread problems,
while Van Sant conveyed that there was no way to profile a school shooter
(something many professionals believe) and therefore nothing that might be
done to prevent future killings.

Moore's linkage of Columbine with expressions of cultural violence and
national policy was something most secular narratives failed to do. The day

after the Columbine massacre, the U.S.-led bombing attack continued in the Balkans and President Clinton asserted: "[P]arents must teach their children to resolve disputes through 'words, not weapons.'"[125] Initially more attention was paid to the video games Eric and Dylan played and the music they listened to than to the quality of their lives. Eric left a suicide note that has not been reproduced frequently:

> By now its over. . . . Your children who have ridiculed me, who have chosen not to accept me, who have treated me like I am not worth their time are dead. . . . Surely you will try to blame it on the clothes I wear, the music I listen to, or the way I choose to present myself, but no. Do not hide behind my choices. You need to face the fact that this comes as a result of YOUR CHOICES. . . . You taught these kids not to accept what is different.[126]

Eric was right about some things. The "blame the media" interpretation was favored by both candidates for U.S. President at the time—Texas Governor George W. Bush, a longtime opponent of gun control, and Vice President Al Gore who, together with his wife Tipper, had previously founded the Parents Music Resource Center, a moral clearing house for suitable music akin to movie ratings.[127] But blaming the media could also be seen as a way of censoring what have been called "some of the most meaningful critiques of U.S. violence."[128]

In another sense, the killings at Columbine and other schools can be seen as an attack on the American way of life. As Dave Cullen observed: "Eric attacked the symbol of his oppression: the robot factory and the hub of adolescent existence," while Jeff Kass stated: "School shooters commit their crimes not for drugs or money, but a generalized revenge against the social order," and Mark Ames wrote: "It isn't the office or schoolyard shooters who need to be profiled—they can't be. It is the workplaces and schools that need to be profiled."[129] In this context, Ames argues that there are no random victims since "the perpetrators are attacking the entire company, the workplace as an institution, the corporate culture, as much as the individual whom they shoot. . . . Everyone in the targeted company is guilty by association, or they're collateral."[130] Using military terminology referring to civilian casualties of war, this statement precisely echoes the way Timothy McVeigh described the victims of his bombing.

Eric and Dylan definitely saw themselves as leading a larger rebellion. In his video diary Eric stated: "We're going to kick-start a revolution, a revolution of the dispossessed."[131] Even more calmly and clearly, Luke Woodham, the Pearl, Mississippi, high school student who on October 1, 1997, killed two students and wounded seven others after killing his mother, wrote: "I am not insane, I am angry. I killed people because people like me are mistreated everyday. It was not a cry for attention, it was not a cry for help. It was a scream in sheer agony saying that if you can't pry your eyes open, if I can't do it

through pacifism, if I can't show you through the displaying of intelligence, then I will do it with a bullet."[132] If there were a place in memorial education centers or museums for the voices of the perpetrators (listening to them, as Marilyn Manson suggested), we might have a better understanding of these horrific, tragic crimes.

The Religious Frame

> [F]rom the beginning the reflex was to look not for reasons but for meaning.
>
> NANCY GIBBS, *TIME* MAGAZINE

Although it is not surprising that spiritual explanations of the shootings played a dominant role locally, where over half the funerals for the Columbine dead were held in evangelical churches, the extent and degree to which they were featured in the secular media seems remarkable. In the chaos of senseless violence, a mediated narrative emerged from bits and pieces of recollections by survivors and witnesses.[133] A hero and two martyrs were identified in storylines that survived even in the face of evidence to the contrary.[134] The hero was teacher and coach Dave Sanders who, after saving students, died in the high school from a loss of blood.[135] The martyrs were two teenage girls. Widely repeated anecdotes of Cassie Bernall and Rachel Scott, both seventeen years old when they were killed, included themes of sexual purity and an eroticized love of God as well as early premonitions of death. Cassie's story was more prominent.

Cassie Bernall allegedly was shot when she answered, "yes," to the question: "Do you believe in God?" This account persisted even after subsequent reports confirmed that the question was never put to Cassie.[136] Thus she was repeatedly characterized as a martyr. As a recent convert to evangelical Christianity, Cassie became a heroine of the growing Christian youth movement and in the Columbine community.[137] Her religious narrative was widely secularized.[138] Within days of the shooting, reports on Cassie appeared on NPR and CNN's *Larry King Live*. The *Boston Globe*'s April 24, 1999, headline read, "a martyr amid the madness,'" while the story noted that "accounts of the final moments of Cassie's life echo with the history of early Christendom, when a profession of faith could be a fatal act."[139] On April 26, 1999, she was described on ABC's mainstream *20/20* newsmagazine as a "modern-day martyr [who] refused to renounce her faith." At Cassie's televised funeral, pastor George Kirsten stated that she "went to a martyr's death, and we're going to celebrate that because she's in the martyr's hall of fame." Youth minister Dave McPherson, who had married Cassie's parents nineteen years earlier, called her funeral service a wedding with Christ as the groom who "on the

20th returned for Cassie."[140] McPherson's parting words to the audience were: "The ball is in your court now. What impact will her martyred life have on you?"[141]

Another version of the "Yes, I believe" story featured Rachel Joy Scott; like Cassie's story, it too was later discounted.[142] In the May 10, 1999, issue of *Time* magazine, Roger Rosenblatt ended his article with "Rachel, you were always in the light."[143] Pastor Bruce Porter recalled Rachel's story in *The Martyr's Torch: The Message of the Columbine Massacre*; his book included endorsements from the Governor of Colorado, the Mayor of Denver, and a member of the Missouri House of Representatives.[144]

Cassie's and Rachel's families have each written books and set up foundations. In October 1999 Cassie's mother Misty published *She Said Yes: The Unlikely Martyrdom of Cassie Bernall*.[145] She recalled Cassie's troubled teen years, during which she dabbled in witchcraft and self-mutilation and wrote of murdering her parents. In response, Misty Bernall quit her job, barred Cassie from seeing her friends, monitored her calls, and regularly searched her book bag. Misty and her husband introduced Cassie to a Christian youth organization and, after some agonizing times, their daughter seemed to find religion. In the wake of Cassie's death, members of the group showed up for Sunday meetings wearing T-shirts imprinted with "Yes" on the front and the dictionary definition of a martyr on the back. Bernall's book sold three hundred thousand copies in its first week of publication and was on the *New York Times* bestseller list for some time; there was also an audio version. Not all sales, I imagine, can be attributed to the Youth Ministry Offices that adopted it. Perhaps, as Dave Cullen suggested: "The transformation of Cassie Bernall represents . . . the best these churches have to offer teens. Two years ago, she was strung out on drugs, deeply involved in witchcraft, and writing hateful letters to her parents." Cullen quotes one pastor who suggested that Cassie was "going down the road of Dylan and Eric."[146]

Rachel's divorced parents, Darrell Scott and Beth Nimmo, published *Rachel's Tears: The Spiritual Journey of Columbine Martyr Rachel Scott* (2000), a collection of writings by and about Rachel and her faith in God.[147] The title refers to a drawing she is said to have made some twenty minutes before her death: a pair of crying eyes with thirteen drops falling onto a rose. The advertising blurb reads: "Was there a prophecy in Rachel's Tears. . . . Her life ended! Her legacy began!" Rachel's journals, discovered after her death, also contained passages such as: "This will be my last year, Lord. I have gotten what I can. Thank you (May 2, 1998)," and "God is going to use me to reach the young people. I don't know how. I don't know when."[148] Following the shooting Darrell Scott founded Columbine Redemption, a ministry that published *Rachel's Journal* and a website featuring Rachel's artwork and poems. His videotape, "Untold Stories of Columbine," included excerpts from Rachel's funeral service, broadcast worldwide on CNN. After his daughter's death, Scott,

a former pastor of a three-hundred-member church in Lakewood, Colorado, gave up his job as a sales manager for a food company to become a full-time missionary, speaking at churches, stadiums, and high school gyms, regularly drawing crowds of three thousand and more. He insisted: "God is using Rachel as a vehicle. If I believed for one second that God had forsaken my daughter or that he had gone to sleep or that he wasn't aware, I would be one of the angriest men in America."[149]

As some observed, the martyrs were a valuable marketing and recruiting tool for churches.[150] Teens and young adults were apparently mesmerized by the story. For at least two years it was a widespread topic on college admission essays, prompting one official to note that "Columbine is this generation's Kent State . . . a really defining moment."[151] Re-enactments became popular at Halloween Hell Houses in hundreds of Christian youth groups throughout the country. Seen as "an evangelical Christian alternative to the traditional haunted house," a Hell House contained a room where students sit in a library while two boys burst in with guns. They ask two girls named Cassie and Rachel if they believe in God and shoot them when they say yes. The demon-guide then gloats, "Once again I win!"[152]

Martyrdom may be defined as "a literary form, a genre . . . 'a collective story.'"[153] Surprisingly, or perhaps not considering the need for the church to bolster its influence in modern times, the twentieth century has seen more Christian martyrdoms than any other including the period of early church history.[154] The writings of martyrs are marked by recurrent themes of peace, rest, and quiet, all present in the Columbine memorial committee's vision statement.[155] By defining the slain as martyrs, emphasis was shifted from the crime to a religious context and to the agency of the victims, implying that they had chosen their fate by averring their faith. (Traditionally, martyrs dating back to the time of Jesus Christ have chosen their fate, often with a pointed, memorable remark.)[156] Franklin Graham, son of evangelist Billy Graham, speaking at the communal funeral service for the Columbine victims, stated that violence in the schools could only be ended with the reintroduction of prayer.[157] Vice President Gore, retired general Colin Powell, and Democratic U.S. Representative Dick Gephardt (MO) were all in attendance. In Billy Graham's millennial message, delivered November 1, 1999, he observed positive signs of a spiritual revival in the wake of the Columbine High School tragedy, especially among teenagers.[158]

Spiritual explanations defined Columbine variously as a manifestation of the contemporary culture of death and the result of the decline of morality following the liberal revolutions of 1968. After decades of a so-called godless, lawless society, it was thought that students no longer valued life. In this context the killings prompted a widespread call for the return of prayer and the posting of the Ten Commandments in the schools.[159] Considered in secular terms, it was a remarkably successful strategy of diversion.

Conclusion

Columbine remains a model for the disaffected, cited by (among others) Native American Jeff Weise, who killed nine at his school and two elsewhere on a Red Lake, Minnesota, reservation in 2005.[160] Four days before the eight-year anniversary of Columbine, Cho Seung-Hui committed suicide after he killed thirty-two on the campus of Virginia Tech; in his explanatory manifesto he referred to Eric and Dylan as inspirational.[161]

In almost every form of memorialization of the Columbine rampage, matters of church and state were intertwined. Nancy Gibbs observed in *Time* magazine:

> Columbine confounds the Constitution; everyone is coloring outside the lines, between what is sacred, what is secular. Ministers call on lawmakers to pass gun-control laws, lawmakers call for religious revival, and Al Gore appears on Larry King Live . . . to recall his days as a divinity student and cite parables and argue that Littleton is "a spiritual signal," a chance to ask questions that aren't for church or state, but both.[162]

In response to the Republican religious right, the Democratic Party chose orthodox Jew Joe Lieberman as their Vice Presidential candidate; he called for a prominent role for religion in public life.[163] Quoting the first and second presidents of the United States on the link between religion and morality, he observed: "We know that the Constitution wisely separates church from state, but remember: the Constitution guarantees freedom *of* religion, not freedom *from* religion."[164] Subsequently, during the two terms of George W. Bush's presidency (2001–2009), there was widespread conflation of church and state. Soon after his inauguration, the President proposed that government funds be available for churches that offer social service programs for the indigent. To implement this he used executive orders both to establish a White House Office of Faith-based and Community Initiatives and to inaugurate centers at five cabinet agencies to ensure cooperation between church-related service programs and the government. In many ways Columbine, with its strategies of diversion and denial, was both a microcosm and a harbinger of this phenomenon.

Even though the Columbine killings feature prominently in cultural memory, the built memorial is little more than a place marker, strategically located near but not visible from the high school. While significant memorials exist in local cemeteries and in the films and extensive studies that the Columbine shootings prompted, this chapter suggests critical issues that could have been constructively included in a memorial museum or education center. It offers alternative frames to the nearly exclusive spiritual interpretations that focused overwhelmingly on the martyrdom of the victims.

Coda: The shootings at Sandy Hook Elementary School in Newtown, Connecticut, on December 14, 2012, seemed of a different order. The primary victims shot and killed by twenty-year-old Adam Lanza were twenty very young children; six staff members also died. Immediate memorials piled up, an outpouring so massive that at one point local officials pleaded with people to stop leaving things and donate instead to their own charities.[165] Columbine and Virginia Tech were often invoked and some victims' family members met with those who had also lost loved ones in former school shootings.[166] Frank DeAngelis, high school principal during the Columbine shootings, appeared to have altered his perspective: "It's never over. I think people believe that you're going to wake up some morning and everything is going back to normal. But we found we had to redefine what normal is, just like Newtown and Sandy Hook will have to redefine what normal is."[167] Once again a few voices called for more attention to mental health issues, most notably the voice of Andrew Solomon, author of the widely praised *The Noonday Demon: An Atlas of Depression*, but scant attention was paid to the plight of the shooter. Solomon wisely cautioned that:

> To understand a murder-suicide, one has to start with the suicide, because that is the engine of such acts. Adam Lanza committed an act of hatred, but it seems that the person he hated the most was himself. If we want to stem violence, we need to begin by stemming despair. . . . Only by understanding why Adam Lanza wished to die can we understand why he killed. We would be well advised to look past the evil against others that most horrifies us and focus on the pathos that engendered it.[168]

A new round of pleas for gun control reached the federal level, but there were also far-reaching calls for more guns, especially armed guards posted in all schools. In Newtown many, including Lanza's mother, cherished their weapons; she had taught her son to use firearms. Although there appeared to be a widespread belief that, if anything, the Newtown tragedy would finally prompt gun control measures, at least for assault rifles, that was not the case. In March 2013 Francis X. Clines lamented:

> Platitudes bunch like flowers across the nation's history of trying to achieve effective gun controls. After the Columbine school massacre, a Mother's Day march in 2000 on the National Mall drew hundreds of thousands of citizens demanding action. It was an impressive sight that participants thought could surely not be ignored by Congress. Its agenda also included the same proposal for universal background checks for gun ownership that is being sought, nearly 13 years later, as the only responsible way to mark the Newtown tragedy.[169]

A year later a *New York Times* editorial reported that seventy laws had been passed to ease restrictions on carrying personal weapons.[170] The fight for

responsible gun control, however, had not been abandoned. In April 2014 former New York City Mayor Michael Bloomberg donated $50 million to an umbrella organization called Everytown for Gun Safety, intended to rival the NRA.[171] On the same day that Bloomberg announced this initiative a new play, *The Library*, opened at New York City's Public Theater. Clearly inspired by Columbine, it included as one of the victims of a fictitious school shooting "a heroic martyr" whose mother "was quick to land a deal for a book about her daughter's death." Focusing on the aftermath of such civic tragedies, it offered a critique of our "media-driven culture that searches for instant heroes, while turning tragedy into profit as fast as it can."[172] School shootings have not abated even after Sandy Hook.

{ 5 }

Commemorating 9/11: From the *Tribute in Light* to *Reflecting Absence*

We remember. We rebuild. We come back stronger!

PRESIDENT BARACK OBAMA (COMMENT INSCRIBED ON A STEEL
BEAM AT 1 WORLD TRADE CENTER)

The terrorist attack on the World Trade Center (WTC) in New York City on September 11, 2001 (9/11), challenged the foundations of American national identity as nothing had since the Vietnam War. Not only was the emblematic center of American capitalism suddenly gone, the United States Capitol in Washington, D.C., and The Pentagon in Arlington County, Virginia, had been threatened as well. There was widespread shock combined with barely repressed panic. As author William Langewiesche saw it, "The dread that Americans felt during the weeks following the September 11 attacks stemmed . . . from a collective sense of being dragged headlong into an apocalyptic future for which society seemed unprepared."[1]

When two U.S. planes flown by American-trained Al-Qaeda pilots deliberately crashed into the WTC's Twin Towers on September 11, 2001, it was televised worldwide almost instantaneously and featured the following day on the cover of newspapers, like a reverberating visual echo. Some years later Hans-Peter Feldmann created an installation, *9/12 Front Page*, consisting of one hundred front pages matted on white and arranged in grids that papered the walls of a room.[2] The ball of fire and the cloud of black smoke rising from the collapsing second tower appeared most often. Surrounded by these terrifying images, the international impact of the bombings was experienced viscerally with shocking intensity, suggesting what Susie Linfield described in *The Nation* as "a world united, if only for a day, in awe-struck fear."[3] By the time it was exhibited at the International Center of Photography in 2008, Feldmann's installation prompted a more layered experience, including heightened awareness of post-9/11 history (especially the intervening wars in Iraq and Afghanistan) and its conflation with personal memories.[4]

Everyone remembers where they were on the morning of September 11, 2001. I was flying back from Stockholm, where I had given a talk on the practice of immediate memorials.[5] When we were halfway across the Atlantic Ocean all U.S. airspace was closed and the plane re-routed back to Sweden. For the next four days, sheltered and fed courtesy of SAS Airlines, stranded passengers watched the repeated images of the planes crashing into the WTC towers. It didn't matter that the words were in Swedish, a language few of us understood. The endless visual loop imprinted and delivered the essential message: the Twin Towers and what they represented had been destroyed. The re-enactment of the unthinkable seemed burned onto our retinas and into our conscious and unconscious minds.

Infinitely more famous in their destruction than their existence, the Twin Towers were now perceived as icons of a mythical lost innocence, a time before it was conceivable that New York City could be bombed—when Wall Street prompted thoughts only of the fiscal condition of the U.S. economy. The 1993 bombing of the basement of the WTC appeared to have been all but forgotten; its discrete memorial by Elyn Zimmerman was among the many things destroyed on 9/11.[6] Designed by Minoru Yamasaki (1912–1986), the towers were for many, as Holland Cotter observed: "at best two cold, giant vertical bars of silver bullion, at worst obscene gestures of capitalist might."[7] Stylistically criticized as an attempt to humanize or romanticize classical modern design, they now assumed a venerated stature.[8] With their soaring height and decorative columns at ground level they were the tallest buildings in the world when they opened in 1972. Their unique elements were their doubling, their height, and their columns that hinted at Gothic and, ironically, Islamic design elements.[9] Arguably, the most interesting response they prompted was Philippe Petit's tightrope walk on August 7, 1974.[10] Over time, as postmodernism replaced modernism as the dominant architectural style and mode of thinking, the towers seemed less objectionable but they never achieved the visually iconic status of the Empire State or Chrysler buildings, perhaps because their silhouette was not easily distinguished from other modern skyscrapers.

Once the towers were gone, their previous function as place markers in the sky and on the ground was immediately apparent. For New Yorkers they were an orienting feature of personal geography.[11] In the aftermath of their destruction, few seemed able to imagine a world without them. From the start there was a push to rebuild the Twin Towers as they were, or even taller. Immediate memorials appeared at once around Ground Zero and discussions began about what kind of permanent memorial should be built. A scant two weeks after the attack an image of two shafts of light evoking the towers appeared on the front page of the *New York Times Magazine*. This image, then known as the *Phantom Towers*, would be realized as a temporary memorial on the six-month anniversary of the attacks: it provided a much-needed

symbol from the start, one interpreted in terms of hope. There were significant interim memorials as well. Various relics of the attack were exhibited and served for a time as a gathering point, a locus for mourning, reinforcing a narrative of survival. These ultimately found a place in the National September 11 Memorial Museum (NS11MM), which opened on May 21, 2014 after several postponements due to budget issues. The permanent memorial, *Reflecting Absence*, designed by Michael Arad and Peter Walker, opened to victims' families on the tenth anniversary of the attack, and to the public the following day.

Immediate Memorials

Although many remarked that all of New York City turned into an immediate memorial after 9/11, this was hyperbole. The transformation of public space was neither total nor uniform, but it marked a significant phase in the memorialization process. Or, as one writer put it, "City space was reorganized according to the needs of a grieving public."[12] In addition to the evolving memorial at Union Square, the perimeter fence of St. Paul's Chapel (adjacent to Ground Zero) was for a time transformed into a kind of Wailing Wall. Local shrines appeared at firehouses and neighborhood walls or fences. And in the aftermath of 9/11 the widespread presence of photography transformed public spaces into quasi-private sites and converted some museum and gallery venues into civic spaces of re-enactment and mourning.

Union Square

After the destruction of the Twin Towers the city was closed off below 14th Street, so crowds gathered at Union Square Park to create a huge immediate memorial (Figure 5.1).[13] At first, and in the days that followed, the number and identity of the casualties were unknown.[14] The missing initially were presumed to be just that—missing. Thus there were few items left at the immediate memorials associated with the deceased, whether gifts for specific individuals or objects of shared experience. Commentary, however, was everywhere, transforming Union Square into a communal forum, an echo of the role it once played in city history.[15] People left personal expressions in poetry and prose, written on the ground or on huge rolls of paper provided for that purpose.[16] One postcard featured the Twin Towers covered by a handwritten message: "They are missing. I am looking for these two great brothers of New York."[17] American flags, ubiquitous throughout the city, appeared draped in front of the statue of George Washington at the south end of the park.[18] Henry Kirke Brown's sculpture, dedicated on July 4, 1856, the second equestrian monument to be

FIGURE 5.1 *Immediate memorials at Union Square Park, New York, New York, September 2001. Photograph by Michele H. Bogart.*

cast in the United States and the city's first outdoor bronze sculpture, functioned as a symbolic locus of political expression in the Union Square immediate memorial (Figure 5.2).[19] Washington's boots were colored pink and a blue peace symbol was taped in his outstretched hand. His horse was covered with antiwar graffiti and a prominent peace symbol decorated his rear flank. The base of the statue was obscured by comments of love and peace.

Described as an "outdoor memorial to loss and grief," the immediate memorial at Union Square accommodated opposing views about the terrorist attacks.[20] *New York Times* art critic Michael Kimmelman saw it as "a true modern war memorial . . . a strange blend of patriotic flag-waving and Vietnam-era protest."[21] After two weeks the NYC Department of Parks and Recreation, in consultation with the city's Art Commission (now the Design Commission), decided to remove the graffiti from the statue of Washington and restore Union Square to its pre-9/11 state.[22] This process of desacralization, what Kenneth E. Foote called the rectification of a site, implies "no

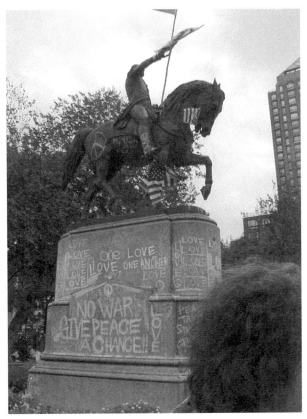

FIGURE 5.2 *Henry Kirke Brown equestrian portrait of George Washington covered in antiwar messages, Union Square Park, New York, New York, September 2001. Photograph by Michele H. Bogart.*

lasting positive or negative meaning" will be associated with it.[23] While there are no remaining visible signs, the transformation of Union Square in the wake of 9/11 became an indelible part of personal memory for those who experienced it. Widely photographed, it will undoubtedly figure in subsequent written and filmed histories of the event and the site.

St. Paul's Chapel

By early November 2001, Lower Manhattan was partially reopened and the main locus for public remembering became St. Paul's Chapel of the Episcopalian Parish of Trinity Church on Broadway, one block east of the WTC site. Immediately after the attack and for some eight months afterward, the church (completed in 1766, the oldest public building in continuous use in Manhattan) became a refuge for relief workers at Ground Zero.[24] When the public

began congregating at its doors, the church hung huge canvas drop cloths on its perimeter fence so visitors could sign their names and leave messages, creating what might be considered a contemporary version of a Wailing Wall. Describing the Western (or Wailing) Wall in Jerusalem after the city was reunited in 1967, Michal Ronnen Safdie remarked: "From a place of prayer and memory used by individuals, it became a place of mass assembly as well. What had once been a site of primarily religious significance became a focal point of national life."[25] Similarly, after 9/11, people gathered at St. Paul's to mark an event that immediately assumed national and international significance.

On the second anniversary of 9/11, a piece of debris from the WTC site was deposited in a crevice at the Wall in Jerusalem.[26] Like that Wailing Wall, the fence at St. Paul's attracted prayers of hope and wishes for peace. It was not, however, a revered relic of a lost edifice; rather, its constantly changing surface (evidence of so many visitors) became a barrier separating the rescue workers and volunteers inside from those outside who came to bear witness to the destruction and honor its victims. A year after its creation some neighborhood residents requested the removal of the mounds of material that could now "be mistaken for a camp for derelicts."[27] The interior of the church, however, continued as a memorial to 9/11. The exhibition *Out of the Dust: A Year of Ministry at Ground Zero*, which opened one year after the attacks, transformed this religious space into an ad hoc gallery with distinctly secular overtones (Figure 5.3).[28]

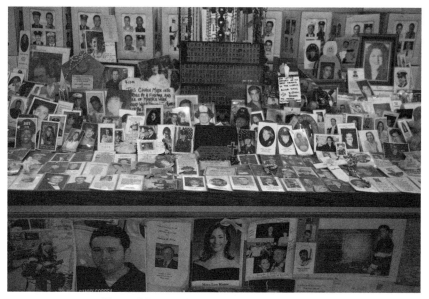

FIGURE 5.3 *View of "Out of the Dust," St. Paul's Chapel of the Episcopalian Parish of Trinity Church, New York, New York. Photograph by Vincent Desjardins, available under Creative Commons BY 2.0 license.*

Other communal walls could be found at major transportation hubs: Grand Central Terminal, Pennsylvania Station, and the Port Authority Bus Terminal (Figure 5.4). These, too, served as gathering places to post private messages recording the signer's presence at a historical moment, creating a record of togetherness. One veteran public art administrator confided that although she never participated in public rituals, she felt the need to sign the wall at the bus terminal that she passed daily on her way to work. As Yehuda Amichai observed, "Every wall can serve as a Western Wall."[29]

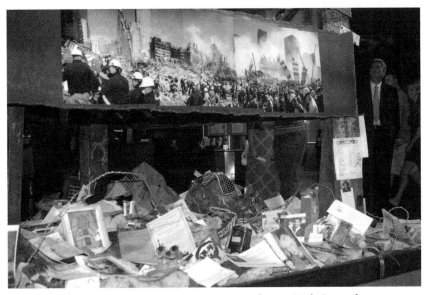

FIGURE 5.4 *Memorial wall in Penn Station, New York, New York, September 9, 2002. FEMA/Andrea Booher.*

Smaller immediate memorials marking local sites of loss appeared in front of firehouses throughout the city incorporating images of firemen and tributes to their rescue mission (Figure 5.5). Firemen were the newly anointed heroes for a culture more accustomed to venerating celebrities and victims. Just as after the sudden death of Princess Diana people gathered at sites she had frequented in life, so New York's immediate memorials marked the spaces associated with those who perished on 9/11. Neighborhood fences and walls served to display images and recollections of local victims. Through photographs the missing became spectral presences.

The Proliferation of Photographs

Photographs are a common feature of immediate memorials, effectively conflating private and public space in a dramatic and significant way.[30]

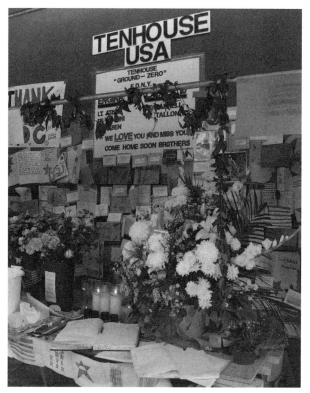

FIGURE 5.5 *Immediate memorial outside FDNY Engine 10, known as Ten House, located near Ground Zero, New York, New York, September 27, 2001. FEMA/Michael Rieger.*

Immediately after 9/11 those seeking loved ones copied photographs from the intimate frame of their family albums or mantles and created posters pairing these images with personal information. The sheer proliferation of these faces affixed to neighborhood fences, storefronts, subway stations, and lampposts transformed the anonymous character of many New York City public spaces. People gathered and paid attention as they rarely do in this city, suddenly participants in some kind of communal wake, often silent, sometimes asking strangers: "Did you know . . . ?" As the presumed missing were acknowledged dead, the photos became memorials to those who had somehow become more than just strangers.[31]

 After 9/11, photography also assumed another role, acknowledging public participation in documenting the actual event, details of the destruction, and aspects of the recovery. For many, the impulse to record was spontaneous: instead of running for cover they grabbed their cameras and rushed to rooftop vantage points. Making pictures (the term professional photographers prefer) provided both something to do and perhaps a symbolic shield,

a protection of sorts from the horror of reality. Many of the works of these amateur and professional photographers were displayed in an impromptu exhibition, *Here Is New York: A Democracy of Photographs* (September 25, 2001–September 29, 2002), organized by Alice Rose George, Gilles Peress, Michael Shulan, and Charles Traub (Figure 5.6). At the 116 Prince Street Gallery in Soho, images were scanned, printed on archival paper, pinned to the walls, and hung from strings at eye level. There were no frames and no names. Prints were priced at an affordable $25. In the first two months more than half a million dollars in net proceeds were donated to The Children's Aid Society for its WTC relief efforts. The exhibition evoked the chaos of memory—the visual, sensory, emotional overload of images—fragments that all together could never capture the whole. Subsequently, portions of the exhibition traveled to the Museum of Modern Art and the International Center of Photography in New York; venues in Chicago, Washington, D.C., and elsewhere in the United States; as well as London, Paris, Tokyo, and several cities in Germany.[32] At the New York and Berlin venues where I viewed the exhibition, public response was muted—both contemplative and apparently emotional. The photographs transformed these spaces into places of communal mourning, a phenomenon also observed at other 9/11-related exhibitions.

FIGURE 5.6 *View of "Here is New York," 116 Prince Street Gallery, New York, New York. Photograph by Taís Melillo, available under Creative Commons BY-NC-SA 2.0 license.*

Exhibitions

Around the start of 2002, a few New York galleries mounted significant exhibitions, one calling for personal responses, another taking a global view of the tragedy, and a third asking architects to reimagine Ground Zero. In November 2001, Exit Art issued a web-based open call for personal responses expressed on a single 8 1/2 by 11-inch piece of paper. *Reactions* (January 26–March 30, 2002) displayed over 2,500 such sheets on freestanding supports and in loose-leaf binders at the Soho gallery whose directors, Papo Colo and Jeanette Ingberman, had conceived the project. It included poetry, musical scores, texts, letters, drawings, paintings, collages, and photographs, an echo of the materials left at immediate memorials but homogenized here by the size restriction.[33] This practice was later expanded by the NS11MM by creating a non-curated electronic registry for people "to express their reactions to 9/11 through visual, tactile or auditory media."[34] Both acknowledged public response in a non-hierarchical way that conveyed the widespread impact of the attacks.

Renewing, Rebuilding, Remembering at the Van Alen Institute (February 13–April 26, 2002) attempted to contextualize 9/11 in a global perspective.[35] Curated by Raymond Gastil and Zoe Ryan, it considered "reconstruction success stories where vital urban places are integrated with specific monuments to tragedy, working together as a living memorial." Beirut and Sarajevo had been devastated by extended warfare; Manchester and Oklahoma City were hit by terrorist bombs; Kobe and San Francisco were sites of natural disasters; and divided Berlin was rebuilt as a single city after the fall of the Berlin Wall. More text than images, the exhibition was important and seemingly unique in offering alternatives to the prevalent narratives that treated 9/11 as a singularly devastating event.

The most influential 9/11-related exhibition was *A New World Trade Center: Design Proposals* (January 16 to February 17, 2002) at Max Protetch Gallery in Chelsea. Curated by Protetch, Aaron Betsky, the staffs of *Architectural Record* and *Architecture* magazines, and other architecture professionals, it featured sixty-one invited submissions that reimagined the WTC Towers in ways that never strayed far from the original.[36] Most memorably, it included Julian LaVerdiere and Paul Myoda's proposal for the then named *Towers of Light*, based on their September 2001 *Phantom Towers* illustration.[37] An extraordinary number of proposals imagined the towers as living beings with emotive skins; others depicted them merging or clustering, as if for comfort or warmth. Like LaVerdiere and Myoda's *Tribute in Light*, these proposals suggested ascension. Another prominent theme was the absence of the towers. Most proposals included trees, gardens, and water features. Protetch thought of the exhibition as "a cathartic experience not only for myself and for the

artists and architects who created the proposals, but also for the larger public."[38] It was crowded even on weekday mornings; total attendance was estimated at five hundred per week. People stared fixedly at visual evocations of the buildings that had come to stand for a world that no longer seemed to exist. Subsequently, the exhibition was chosen to represent the United States at the 2002 Venice Biennale of Architecture. At the time the U.S. Department of State, which sponsored the exhibition, presented Venice with a twisted charred beam from the South Tower. The U.S. pavilion contained a model of the WTC, photographs taken when the Twin Towers were new, and a selection of photographs of Ground Zero by Joel Meyerowitz.[39] Thus the exhibition framed and defined U.S. national identity in terms of 9/11 and the destroyed WTC buildings.

Artists' Proposals

Many artists responded to the terrorist attacks in moving and provocative ways. Muralists transformed neighborhood walls with images of the Statue of Liberty and American flags.[40] Some were by well-known graffiti artists like Tats Cru.[41] Others were dedicated to specific fire companies.[42] By 2004, so many of these memorial murals had been covered by ads that residents in the East Village protested.[43]

Mary Miss wanted to unify the decimated sixteen-acre site and provide people with a place to remember and grieve. She proposed a temporary project, *Moving Perimeter: A Wreath for Ground Zero*, to surround the site with "a continuous band of sky-blue fencing, seating, trees and flowers" that would include ramped overlooks as well as flexible partitions with places to leave flowers.[44] Although endorsed by Commissioner of Cultural Affairs Schuyler G. Chapin and Community Board 1, *Moving Perimeter* was not built.[45] Subsequently Miss began soliciting proposals for temporary memorials and posting them on her website as well as that of the New York Foundation for the Arts (NYFA).

Hans Haacke's *Poster Project* (Figure 5.7), sponsored by public art organization Creative Time for the six-month anniversary of 9/11, focused attention on the absence of the Twin Towers in a subtle and provocative way.[46] He created stark white sheets with cutouts of the silhouettes of the two buildings that were then pasted over billboards at various locations, where the negative spaces in the cutouts were filled with an array of advertising images. This evoked both the commercial identity of the WTC and the ways some people tried to fill the anxiety-provoking void left by the attack: by following instructions from elected officials to return to normalcy through shopping.

FIGURE 5.7 *Hans Haacke.* Untitled. *2002. Photographs by Charlie Samuels, courtesy Creative Time.*

Martha Cooper and Dario Oleaga, among other photographers, docu-
mented the numerous immediate memorials around the city. Already well
known for her images of subway graffiti and memorial murals, Cooper exhib-
ited one hundred of her photographs in late 2001 at the Urban Center in New
York (two of her photographs are shown in Figure 5.8).[47] Dario Oleaga's pic-
tures of altars erected in his Dominican neighborhood in Washington Heights
were on display at the Bourbon-Lally Gallery in Montreal.[48] His images of 9/11
were also displayed on a website and reproduced in a Christian journal.[49]

(a) (b)

FIGURES 5.8a AND 5.8b *Martha Cooper. Photographs of immediate memorials in New
York City. Copyright Martha Cooper, provided courtesy of the artist. All other rights
reserved.*

Although much of the art associated with 9/11 inspired feelings of sadness and loss, Eric Fischl's sculpture, *Tumbling Woman* (Figure 5.9), installed in Rockefeller Center's indoor underground concourse around the time of the first anniversary, prompted recollections of images of falling bodies that had been largely suppressed in the media.[50] As Tom Junod and Andrew Chaikivsky observed in *Esquire* magazine: "In the most photographed and videotaped day in the history of the world, the images of people jumping were the only images that became, by consensus, taboo—the only images from which Americans were proud to avert their eyes."[51] Negative responses to Fischl's sculpture were no doubt intensified by an inflammatory article in the *New York Post*, which objected to the sculpture's nudity and interpreted it as depicting "the exact moment her head smacks pavement following her leap from the flaming World Trade Center."[52] Jerry Speyer, an art collector and chairman of the Museum of Modern Art, as well as co–chief executive of the real estate company that owned Rockefeller Center, received several bomb threats.[53] The sculpture was removed after a week.

FIGURE 5.9 *Eric Fischl. Tumbling Woman. 2002. Bronze. 37 x 74 x 50 inches. Edition of 5 with 3 Artist Proofs. Installation in Rockefeller Center concourse. AP Photo/Rick Gentilo. Courtesy of Eric Fischl.*

Fischl's comments were inconsistent. He noted that he began working with this image a year earlier when he took photographs of a model tumbling around on a studio floor. At one time he stated that he created this work in response to the death of a friend who had worked on the 106th floor of one of the towers, "by making a monument to what he calls the 'extremity of choice' faced by the people who jumped."[54] Elsewhere he associated its pose with the

falling sensation that often occurs in dreams just before waking.[55] Adjacent
to the skating rink where it could hardly be ignored, the sculpture forced
viewers to consider the panic and desperation of some of the WTC victims in
their final moments, a very different experience than the reassuring one of-
fered by the dominant narrative of resilience or recovery of the survivors or
the city.[56]

Interim Memorials

Interim memorials, those with some consistent presence in public once im-
mediate memorials no longer mark significant sites, serve an important
purpose—both to give mourning a focus and to create an implicit narrative.
In the decade between the 9/11 attacks and the completion of the permanent
memorial at the WTC site, relics played a major role in New York. In a reli-
gious context such objects are treated as sacred remains of a departed saint or
other venerated figure.[57] The secular vestiges of 9/11, pertaining both to the
destroyed buildings and elements of the site itself, were consistently inter-
preted as suggesting themes of survival, communal spirit, sacrifice, and hope.
Subsequently they were installed in the memorial museum to convey a simi-
lar message.

Relics of the Twin Towers

The widespread impulse to envision the lost towers as the symbolic body of
the nation was nowhere more evident than at the official ceremony that sig-
naled the change in status of Ground Zero from hallowed ground back to
prime real estate, awaiting both commercial rebuilding and a permanent me-
morial.[58] On the evening of May 29, 2002, workers at the site (operating engi-
neers, ironworkers, teamsters, laborers, and dock builders) took turns using a
blow torch to cut away a piece of the *last standing beam* (also referred to as
"the last column") (Figure 5.10), a memento of their experience of working for
eight and a half months (thirty-seven weeks) clearing Ground Zero.[59] Column
No. 1, 001 B, had been covered with graffiti, personal farewells, and statistics
of losses by the Fire Department (343 dead), Port Authority Police Depart-
ment (37 dead) and the New York Police Department (23 dead).[60]

The American flag on top of the column was removed and given to Lou
Mendes of the New York City Department of Design and Construction. Then
the beam was wrapped, first in black muslin and then in an American flag, in
preparation for its removal from the site.[61] The departure ceremony on the
morning of May 30 was silent but for the tolling of bells and a drum roll. At
10:29 a.m., the time Tower Two collapsed on 9/11, the bells rang in four sets of
five, the traditional signal of a fallen mayor or firefighter that prompts

FIGURE 5.10 *Construction workers carefully maneuver the last piece of debris removed from Ground Zero. The event marked the final removal of the last remaining World Trade Center structure, Column Number 1,001 B of Two World Trade Center, May 28, 2002. U.S. Navy photo by Photographer's Mate 2nd Class Bob Houlihan.*

firefighters to lower the American flag to half-staff. Then a stretcher carrying symbolic remains of the still unidentified bodies was placed in a New York City Fire Department ambulance. The last column, described as "looking like a giant coffin," was positioned on a flatbed truck (Figure 5.11) and driven to Hangar 17 at John F. Kennedy International Airport (JFK) as bagpipers played *America the Beautiful*. Sustained applause from the crowd followed.[62] The symbolic missing bodies and actual building relic, both wrapped in American flags, were thus linked in the widely televised event.[63] Some seven years later

the beam was returned to Ground Zero, where it became part of the perma-
nent exhibition in the memorial museum. According to NS11MM president
Joseph C. (Joe) Daniels: "This major artifact, with its many markings and in-
scriptions, commemorates the sacrifice of so many. It will stand proud in the
museum as a symbol of the spirit of unity and dedication that brought people
together at Ground Zero."[64]

FIGURE 5.11 *Departure of "The Last Column" from Ground Zero, May 30, 2002. AP
Photo/Bebeto Matthews. Copyright 2015, The Associated Press.*

The *steel beam cross* was discovered four days after the bombing by Frank
Silecchia, a construction worker searching for survivors around Tower Six
where much of the debris from Tower One had fallen (Figure 5.12, one exam-
ple of a piece of the towers that resembled a cross). For the first few weeks
while it was still at Ground Zero, it functioned as a surface for messages and
a place for prayers. After it was removed to an adjacent site it was placed on a
pedestal and a Franciscan priest, Father Brian J. Jordan, celebrated Sunday
Mass there.[65] Jordan, joined by Silecchia and others, objected vehemently to
the announcement made the week before Easter 2006 that the cross would be
moved into storage at Hangar 17 at JFK together with other large artifacts. In
response, the Rev. Kevin V. Madigan offered a temporary site alongside St.
Peter's Roman Catholic Church on Barclay Street, one block away from
Ground Zero.[66] The cross was moved there on October 6, 2006, where Father
Jordan blessed it and the crowd sang *God Bless America* in an impromptu

ritual that conflated the religious significance of the cross and the national content of the event that created it. The WTC Memorial Foundation promised to find a permanent home for the cross in the NS11MM, at that point scheduled to open in 2009.[67]

FIGURE 5.12 *Piles of rubble and debris are all that remain of the 110-story twin towers of the World Trade Center and several of its neighboring buildings. In Building 6, firefighters have found pieces of the towers that resemble crosses. They have dubbed the building "God's House." September 26, 2001. Photo by Mike Rieger/FEMA News Photo.*

For a time the cross remained adjacent to the Church Street side of St. Peter's, the oldest Roman Catholic Parish in New York State (organized in 1785). Closer to the bus stop than the front of the church, the cross, although behind a fence, seemed to belong to the street. A welded sign identified it as "The Cross at Ground Zero," found September 13, 2001, blessed October 4, 2001, and temporarily relocated October 5, 2006. Here people

tossed money as well as a few objects, including a dog tag turned face down, at its base, but in this ad hoc site it was hard to imagine the previous power of the cross at Ground Zero, where workers had its image tattooed on their bodies and many attributed a miraculous power to it. Replicas were available in a range of items, mostly jewelry, sold in the gift shop of St. Paul's Chapel around the corner at 209 Broadway.[68] Some, however, objected to the inclusion of the cross in the NS11MM. In July 2011, the New York–based nonprofit group American Atheists filed a lawsuit to keep the cross from being displayed based on the fact that it was a specifically religious symbol and the museum was partly government funded.[69] The following year the museum filed to dismiss the federal suit, identifying the cross "as a relic of the 2001 attack and not a religious symbol."[70] Ultimately, in March 2013 a judge dismissed the suit on the grounds that the cross "could help tell the story of the terrorist attack."[71] Nevertheless, for some, the spiritual significance was germane. For Frank Silecchia, who found the cross at Ground Zero: "Faith won over atheism. I'm kind of proud because that was my initial goal: to help ease the burden of humanity. All I can do is thank God for answering my prayer."[72]

Although the *survivors' stairs* (Figure 5.13) did not have the same spiritual connotations as the steel beam cross, it too assumed a symbolic significance and was the focus of an intense preservation effort.[73] Located at Vesey Street, the stairway was the escape route for hundreds in Tower Four, the only way to exit the plaza after the second tower collapsed. It was also the last visible structure above ground level at the WTC site. In one of its newsletters, the WTC Survivors' Network described it as a place "from which survivors, and everyone whose life was profoundly changed that day, could gain a vantage point from which to contemplate the footprint voids, paying respect to their lost friends, colleagues and loved ones."[74] While they petitioned and argued for its retention on site, the stairway continued to deteriorate. In May 2006 the National Trust for Historic Preservation listed it as one of "America's 11 Most Endangered Places."[75] In 2007, Avi Schick, chief of downstate development for the Empire State Development Corporation, proposed a plan to incorporate the stairs into the descent to the NS11MM.[76] On March 9, 2008, the so-called survivors' stairs supported by a steel cradle, was moved to a temporary location nearby. The strangely disembodied structure topped by an American flag consisted of a twenty-two-foot-high steep ramp, its steps covered in plywood, with a candle on each rung. On July 19, the stairway was lowered into the ground to bedrock, where it eventually became part of the museum.[77] The stairway that once provided a way out of the destroyed building now defines the passage that descends into the museum, creating an eerie parallel.

FIGURE 5.13 *The "survivors staircase" remains at the World Trade Center on Wednesday, Oct. 3, 2007 in New York. The staircase, which will be preserved, is the last remaining piece of the World Trade Center remaining above street level. AP Photo/Mark Lennihan. Copyright 2015, The Associated Press.*

One of the most famous architectural relics of the WTC was the large *skeletal segment of the South Tower* (Figure 5.14). Just two weeks after the attack, Philippe de Montebello, then director of the Metropolitan Museum of Art, suggested in a *New York Times* op-ed piece that it would be an appropriate memorial to 9/11: "New York should make a commitment now to preserving the searing fragment of ruin already so frequently photographed and televised that it has become nearly as familiar to us as the buildings that once stood there. Already an icon, it should stand forever as a sculptural memorial, incorporated into whatever other structures or landscapes are chosen as fitting for this site." Citing examples of Coventry, Berlin, and Hiroshima, all cities that had converted ruins into monuments, he concluded: "A relic of destruction, it could become a testament to renewal."[78] A month later in a review of the various suggestions for 9/11 memorials, *New York Times* reporter Dinitia Smith asked: "Should a portion of the skeletal remains of the tower that still stands in the ruins serve as a memorial, just as the frame of a building destroyed by the atomic blast was left as part of the Peace Memorial in Hiroshima?"[79] The power of these relics was repeatedly contrasted with the sterility of the proposals for the built memorial. In 2003 when *New York Times* reporter Eric Lipton observed the objects stored in Hangar 17, he commented: "What is unmistakable is the enormous, immutable power that emanates

from these inanimate objects. . . . It is a force that . . . causes almost instanta-
neous discomfort and reflective pause." Lipton quoted the response of a heat-
ing contractor: "You can sense the people who were never found. It feels like
holy ground."[80]

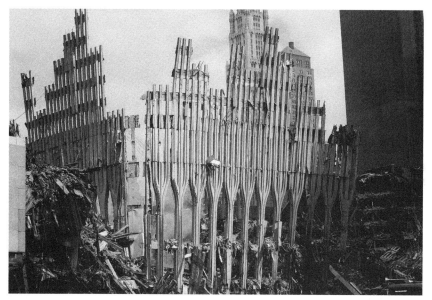

FIGURE 5.14 *The remaining section of the World Trade Center is surrounded by a
mountain of rubble following the September 11 terrorist attacks, September 27, 2001.
Photo by Bri Rodriguez/FEMA News Photo.*

Other building fragments were incorporated into memorials to victims of
9/11 in various locations. Shortly after the start of recovery efforts, the city
started giving these lesser relics away to anyone who agreed not to use them
for profit. By late November 2005 over 150 towns, fire departments, churches,
and museums housed vestiges of the site.[81] Mayor Leonard Curcio of Wash-
ingtonville, New York, intended to use one in a memorial for the five local
firefighters who had perished in the 9/11 rescue efforts. When a worker
wrapped a length of steel beam in a vinyl tarp like a shroud, the mayor ob-
served: "We're treating this beam like we're going to get a body. It's a symbol.
It's some sort of icon of what we lost."[82] As the eighth anniversary of 9/11 ap-
proached, the Port Authority of New York and New Jersey invited police and
fire departments as well as mayors and other city leaders around the country
to request a relic of the steel stored in Hangar 17 at JFK; approximately two
thousand pieces remained, about half described as very large. Only cities or
organizations with a plan of display were eligible; one came from a group of
fire departments in France. Occasionally, these fragments were wrapped in

an American flag before shipping.[83] The appeal of relics is intense, their significance understood at once. They serve both as tangible links to the destruction and evidence of survival, a powerful signal to remember but not give up hope.

Destroyed or Damaged Public Art

While significant building remnants went into storage for future use, damaged *public art* from the World Trade Center buildings was treated differently.[84] Masayuki Nagare's slightly marred *Cloud Fortress (World Trade Center Plaza Sculpture)* (1967–1972) (Figure 5.15), which remained in the area between what had been Towers 4 and 5, weighed so much that it was destroyed to assure a firm ground for bringing heavy machinery onto the plaza.[85] A sculpture on the plaza by James Rosati (*Ideogram*), a relief in the lobby of Tower One by Louise Nevelson (*Sky Gate New York*), and a tapestry by Joan Miró in Tower Two were buried in the rubble.[86] Alexander Calder's *Bent Propeller* was the focus of a search and rescue mission and then a restoration project undertaken by the Calder estate.[87]

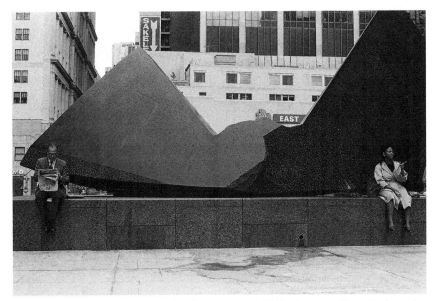

FIGURE 5.15 *Mayasuki Nagare.* Cloud Fortress (World Trade Center Plaza Sculpture). *1975. Granite. Photograph by Drew Witt.*

Fritz Koenig's more seriously damaged *The Sphere* (1968–1971), originally sited in the pool at the center of the plaza (Figure 5.16), served as an interim memorial. After the attack it was installed in Battery Park on Eisenhower

Mall near Bowling Green (Figure 5.17) and was officially unveiled on the six-month anniversary of the attack; that same evening the *Tribute in Light* first shone from dusk until 11:00 p.m.[88] Originally intended as "a monument to foster peace through world trade," *The Sphere* now served as both a relic of the disaster and a monument to survival.[89] On a sunny Sunday in July 2008, a steady stream of visitors stopped to photograph it and read the explanatory signage at its base. By May 2012 the Port Authority announced plans to remove the sculpture because it would impede planned park renovations. To date, *The Sphere* remains in Battery Park, but is planned for installation as a feature in the museum, where it would continue to serve, as Pat Foye, Port Authority executive director, observed, as an "important reminder of survival and resilience."[90]

FIGURE 5.16 *Fritz Koenig. The Sphere. 1968–1971. Bronze. World Trade Center Plaza, September 1984. Photograph by Robert J. Fisch.*

Elyn Zimmerman's rose-colored granite memorial to the victims of the 1993 attack on the WTC (Figure 5.18) was destroyed. The circular fountain, once sited on the plaza directly above the underground parking lot where a detonated bomb killed six and injured some one thousand more, featured a perimeter wall inscribed with names of the victims and the statement: "On February 26, 1993, a bomb set by terrorists exploded below this site. This horrible act of violence killed innocent people, injured thousands, and made victims of us all."[91] Working with an enormous site but a limited budget, Zimmerman thought the inscription would lure people closer. She wanted to

FIGURE 5.17 *Fritz Koenig. The Sphere. 1968–1971. Bronze.*
Installed in Battery Park, February 2012. Photograph by
Wikimedia Commons user "7mike5000."

use landscaping to help create a separate space but was unable to obtain fund-
ing for this aspect of the project.[92] Once installed, people unexpectedly began
throwing coins into the fountain, requiring a filter to be added. At the unveil-
ing in spring 1995, Edward Smith, husband of one of the victims, observed:
"We realize that the spirit of the loved ones will live on in this quiet, gentle
spot in the shadow of the towers."[93] William Macko, whose father was killed,
felt that the memorial was more his grave than the place where he was actu-
ally buried.[94] On anniversaries of the attack, mourners attended a mass at
nearby St. Peter's Roman Catholic Church and then visited the memorial,
observing a moment of silence and tossing roses onto the stone wall.[95] On
February 26, 2002, and on each subsequent anniversary, the surviving frag-
ment of the memorial was taken to the church for a mass of remembrance for
the victims.[96] The relic was placed in a velvet-lined box with dovetail joints
and brass fittings. In 2004, there were plans to include it in a temporary me-
morial until the 9/11 memorial was built and the names of the 1993 victims

could be included on its walls.[97] For a time the fragment of Zimmerman's memorial was enclosed in a steel column adjacent to the WTC site; it was eventually incorporated in the NS11MM's historical exhibition.

FIGURE 5.18 *Elyn Zimmerman.* World Trade Center Memorial. *1993. Red, black, and white granite. World Trade Center Plaza (destroyed). Courtesy of the artist.*

Ground Zero Remains

In addition to relics of the buildings, actual *architectural elements* of the site itself were treated with special reverence. These, too, were eventually incorporated into the museum and became part of a triumphal survivor narrative. The *slurry wall*, the first part of the original WTC complex to be built, was completely invisible before 9/11. The 3,300-foot-long foundation wall separated the site from Hudson River groundwater. Because the wall withstood the terrorist bombings, many more people inside the buildings were able to escape. Had it collapsed, other structures might have become destabilized and recovery efforts would have been severely hindered.[98] Although not visually striking, architect Daniel Libeskind found it as "eloquent as the Constitution itself" and envisioned it as having "a heroic place in the city." The architect made it a central element of his rebuilding master plan even though its deteriorating condition required fortification that would change its appearance over time.[99] Three original panels, an approximately sixty-two by sixty-four-foot segment of the slurry wall, now occupy the heart of the West Chamber of

the NS11MM, constituting its largest single exhibit. Its impact is powerful; Joe Daniels observed, "We think the slurry wall could take on the resonance of the Wailing Wall."[100]

Although the *footprints of the towers*, the outlines that mark where they once stood, were barely visible after the cleanup, they featured prominently in all rebuilding plans. The guidelines for the memorial had specified that the design "make visible the footprints of the original World Trade Center towers" but this stipulation was modified to require only that the permanent memorial provide access to the footprints.[101] Eventually their location was delineated by the trees surrounding the memorial pools. Each tree was planted where a structural column of the Twin Towers once stood. Michael Arad, the designer of the memorial, thought of the trees as a living tribute to the buildings.[102] Unfortunately, none of this is apparent.

In a sense, it was the site of Ground Zero itself, transformed almost daily, that was the interim memorial attracting the greatest attention. By December 2001 people could peer into the increasingly empty space and leave tributes to the victims along the unpainted plywood walls of the *Viewing Platform* designed by a team of architects: David Rockwell, Kevin Kennon, Elizabeth Diller, and Ricardo Scofidio. Located at the western end of Fulton Street alongside Saint Paul's Chapel and in use until the following summer when it was demolished to provide access for utility crews, it accommodated some seven thousand visitors daily.[103] According to Rockwell, who spearheaded the venture, the architects wanted to build something that would enable a more broadly based serious dialogue about the development of the site.[104] While the future of the hole in the ground that was Ground Zero continued to be debated, the sky above that had served as a backdrop to the mile-high towers became the site of the widely reproduced and revered memorial acknowledging their absence, the *Tribute in Light*.

The *Tribute in Light*

From the moment they appeared on the September 23, 2001, cover of the *New York Times Magazine*, the twin shafts of light reaching into the night sky seemed a perfect (dis)embodiment of the missing towers, marking at once their absence and former presence (Figure 5.19). An instant icon, this work was for many and may remain *the* quintessential 9/11 memorial.[105] Its graphic or digitized image, seen by millions around the world, prompted an overwhelmingly uplifting interpretation. This positive reading was reinforced as the work's title evolved from *Phantom Towers* to *Towers of Light* to *Tribute in Light*. Intended initially as a temporary gesture to mark the six-month anniversary of the destruction at Ground Zero, it became a 9/11 anniversary ritual.

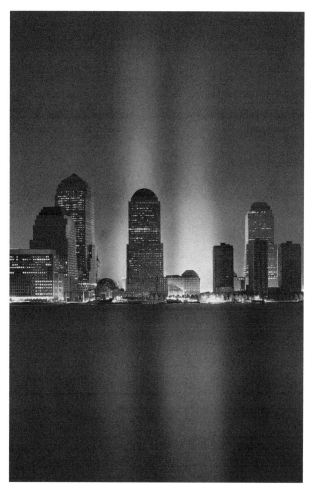

FIGURE 5.19 The New York Times, *Julian LaVerdiere, Paul Myoda. Cover, "Remains of the Day," from* The New York Times Magazine, *September 23, 2001. Copyright 2015,* The New York Times. *All rights reserved. Used by permission and protected by the Copyright Laws of the United States. The printing, copying, redistribution, or retransmission of this Content without express written permission is prohibited.*

Shortly after the attack, Anne Froelich, art director of the *New York Times Magazine*, called Anne Pasternak, director of Creative Time, to ask for suggestions of artists who might give "some visual response" to 9/11. Pasternak thought initially of Christo, Jenny Holzer, Rachel Whiteread, and James Turrell.[106] Then she remembered Julian LaVerdiere and Paul Myoda, who had proposed a light project for the top of Tower One as part of Creative Time's DNAid series "about the current mania surrounding genetic

engineering."[107] The two had conceived *Bioluminiscent Beacon* while they were artists in residence at the WTC from winter 2000 through spring 2001.[108] They thought of it as:

> [A] location-specific public sculpture affixed to a monopole atop a NYC skyscraper. At nightfall, *Beacon* intermittently emits a cool blue light by harnessing the bioluminescent character of a colony of dinoflagellates, a single-cell plankton. As an artistic interpretation of this organism's morphology, the sculptural form refocuses biomorphic abstraction through the lens of cyborg reality; the bioluminescent quality of these organisms is amplified with the aid of history's first wet-wired computer chip acting as a "slave" to trigger supplemental light.[109]

Elsewhere they observed: "The *Bioluminiscent Beacon* should be understood as a living memorial to a life form that has been transubstantiated both genetically-altered and wet-wired to offer a rich and continually expanding set of tools for the investigation of life itself. The artistic endeavor addresses the issues of scale, encrypted languages, and the mystical nature of the macrocosmic and microcosmic universe."[110] For 9/11 the artists transformed their concept of "a living memorial to a life form" into twin shafts of light that they called *Phantom Towers*. LaVerdiere observed: "Those towers are like ghost limbs, we can feel them even though they're not there anymore." He called their work "an emotional response more than anything . . . an artistic gesture that might offer consolation or a sense of security or hope."[111] Myoda defined the project as a response to the magazine's call for "a memorial image for the fallen WTC."[112] The artists wanted "to make what had been unmade, to re-extend what became on the 11th, a symbolic, architectural extension of our very bodies." They "imagined two great banks of lights occupying the footprints of the buildings."

Independently, two days after the attack, architects John Bennett and Gustavo Bonevardi, partners in PROUN Space Studio (a firm in the West Village specializing in architectural computer modeling and animation) began emailing a virtual image of the Twin Towers silhouetted against a night sky to friends and colleagues. Bonevardi recalled: "I wanted everything to be okay. I wanted to make things better. I wanted the Twin Towers back and I wanted it all now. The answer was simple, light."[113] They called their design the "Project for the Immediate Reconstruction of the Manhattan Skyline" and considered the possibility of versions in other cities: London, Paris, Buenos Aires. They, too, wanted to recreate the towers but their outlook was more emphatically optimistic: "We wanted it to be an expression of humanity's brighter side, forward looking and inspirational. We saw it as a celebration of creativity, ingenuity and technology—a declaration of existence." Myoda observed: "Our image pointed more to the loss; now we think it should be more solid with less of the spectral quality."[114]

The September 30 issue of the *New York Times Magazine* announced that a collaboration between the two artists and two architects would realize the project now called the *Towers of Light* under the auspices of Creative Time.[115] In October, the Municipal Art Society of New York (MAS), a powerful non-profit civic organization, added architect Richard Nash Gould and light fabricator Paul Marantz to the team; the venture was now described as "organized by the auspices of the Municipal Art Society" with "artistic support from Creative Time."[116] A few years later LaVerdiere and Myoda noted that after their initial decision to work with Bonevardi and Bennett together with Creative Time, the arts organization "was contacted by the MAS, and were told that an architect associated with them, Richard Nash Gould, also had a similar idea, and insisted that we all work together or desist."[117] According to *New York Times* reporter David W. Dunlap, Agnes Gund (then president of the Museum of Modern Art) suggested to Kent Barwick, president of the MAS that he get everyone together, while Susan K. Freedman (director of the Public Art Fund) obtained support from the new mayor, Michael Bloomberg.[118] There were many indications that this collaborative process was far from smooth. One individual described Paul Marantz's role as that of "ersatz referee between the dual, and occasionally dueling teams—two artists, two architects."[119] Afterwards LaVerdiere and Myoda maintained: "[W]ithout our sustained efforts in the development stage of this project, the *Tribute in Light* would never would have been realized."[120] Considering that they had already designed a light sculpture for the top of a skyscraper, this is likely the case. Some eight years later LaVerdiere viewed it as "an altruistic project that generated a lot of hatred." He and Myoda made no money from the project.[121]

The *Tribute* was a public success as soon as the initial image appeared on the *New York Times Magazine* cover. An overwhelming majority, 93% of the 8,327 comments received by Creative Time were positive. The few negative reactions referred to potential concerns about migratory birds, light pollution, and energy issues.[122] Creative Time worked with the Audubon Society to monitor the possibility that the celestial navigation of birds might be disturbed if the bright lights overpowered that of the stars.[123] An 11:00 p.m. shutoff time was established to address concerns about the disruptive effects of the nighttime lights on local residents.

As the project moved forward, the title changed—signaling both the desire for a positive interpretation and the power of the victims' families to influence the memorial process. By the end of September 2001, the *Phantom Towers* were routinely referred to as the *Towers of Light*. This title (and interpretation) continued to be used even after it was officially changed to the *Tribute in Light* at the start of 2002. Monika Iken, whose husband Michael was one of the 9/11 victims, thought the new name would ensure that "the memorial will stand as a tribute to honor and reflect the lost souls who died at the WTC."[124] Similarly, Christine Huhn-Graifman, another 9/11 widow,

explained that the change in title meant "it's less about the towers and more about the victims."[125] Most often the two interpretations merged. An editorial in the *Daily News* saw the ephemeral towers as signifying "not merely buildings but oh so many bright, shining lives."[126] An article in *USA Today* referred to the interim memorial as "symbolically recreating the WTC and memorializing those lost there."[127]

The *Tribute in Light* consists of two fifty-foot square beams created by two banks of forty-four-foot-high power lights (Figure 5.20). They first appeared on March 11, 2002, switched on by twelve-year-old Valerie Webb, whose mother had died a year earlier and whose father perished on 9/11. Soprano Jessye Norman sang *America the Beautiful* at the ceremony, affirming yet again the national significance of the interim memorial and the incorporation of 9/11 into concepts of national identity. The lights, aimed straight up at the sky, appeared to merge when viewed from the ground at Battery Park City. On that first night in Lower Manhattan, crowds were sparse and several individuals commented that they thought the light memorial would be larger. One observer speculated that the location (not in the footprints, as originally envisioned by LaVerdiere and Myoda) and the shape, neither of which really mimicked the towers, made the realization less impressive than anticipated.[128] From certain points in Brooklyn, only a single beam was evident.[129] By contrast, LaVerdiere was moved beyond expectation: he had no idea it would be "so mystical and ephemeral. It's like the aurora borealis; it's so sanctifying."[130] Many shared his reaction. A professional poll of 1,038 New Yorkers indicated that 39% wanted the lights to stay on until a permanent memorial was built and 36% felt they should be permanent.[131] It's not clear if their opinion was based on viewing the actual lights or their reproduction. For the next month the beams were projected "every night from dusk to 11 p.m., cloud cover, helicopter traffic and bird migration permitting."[132] On the last night, April 13, 2002, they were allowed to fade into the morning before being turned off at 6:09 a.m.[133] Subsequently they have continued to appear on every 9/11 anniversary to date.

Sudden loss or shock typically prompts the desire to go back in time to the reality that existed just before the event, the reassuring status quo. Thus, initial responses to the *Tribute in Light* interpreted the interim memorial in terms of bringing the towers back. Julie V. Iovine observed in the *New York Times* that it would "recreate the twin towers as ghostly apparitions."[134] David Abel, writing in the *Boston Globe*, saw it as a way to repair the skyline: "In a matter of weeks, the city's scarred skyline could be restored to the jabbed splendor of the time before September 11. At least, as an illusion."[135] Frank Sanchis, director of the MAS, saw the need to place something in the void left by the towers: "You look downtown and there's something that's not there that used to be there. And, at least when it's dark, these lights would put something there."[136] Kathy Ganci, whose fire chief husband Peter died on 9/11, observed: "These beams fill an emptiness," and Jeannie Pagan (who worked

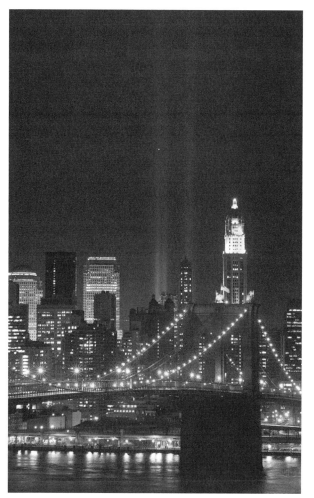

FIGURE 5.20 *Julian LaVerdiere and Paul Myoda.* Tribute in Light. *The* Tribute in Light, *a tribute to the victims of the World Trade Center terrorist attacks, light up the sky above lower Manhattan in this view from the Brooklyn borough of New York, Monday, March 11, 2002. The Brooklyn Bridge is seen in the foreground. AP Photo/Daniel P. Derella. Copyright 2015, The Associated Press.*

on the ninety-ninth floor of the south tower and whose cousin died in the north tower) stated: "This put my towers back there for me. That big empty void is finally filled."[137] Robert Knafo, writing in *Slate*, thought the interim memorial "would represent the Twin Towers in spectral form" and saw it as "'standing in' for the buildings themselves and the enormity of their absence." He also interpreted the lights as "variously evoking the hopeful beacon, the prayerful candle, the memorial flame."[138] For some, however, the invocation of the destroyed towers was overwhelming. A woman who worked at the

nearby World Financial Center wrote: "[T]he idea of looking at ghosts of what used to be is abhorrent." Another person commented: "When I look at these pictures, the illuminations bring to mind a ghost. . . . I don't think we need such a ghastly reminder of what happened." And someone else responded: "It is like seeing a flame right after you have burned."[139]

The late Herbert Muschamp, architecture critic for the *New York Times*, observed: "[L]ight can easily absorb a range of ideological connotations," ranging from the 20th Century Fox logo to Albert Speer's *Lichtdom* (*Cathedral of Light*), designed for the 1934 Nuremberg rally.[140] Speer's spectacle consisted of 130 anti-aircraft searchlights aimed skyward, which surrounded the audience to apparently stunning effect.[141] Light projections are not new to public art. Contemporary artists, most notably Krystof Wodiczko, have used them on existing buildings to revisit their meaning or highlight current problems, thus conflating past and present into a single image.[142] But instead of using a building as a screen to create a kind of counter-monument, the *Tribute in Light* used the sky, expanding the projection—actually and symbolically—to a larger universe. Many were prompted to think of God.[143] One person recalled Frank Lloyd Wright's project for a virtual church steeple made of light in Kansas City.[144] A Brooklyn firefighter saw the lights as a link to his perished colleagues: "This is the light that shines up on our brothers in heaven. Or better yet, this is the light that they are shining down on us."[145] In a more secular vein, the *Tribute* prompted memories of the Towers of Light at the Electric Power and Light Company's pavilion at the 1964 World's Fair.[146] Less flattering associations linked the lights to Las Vegas, Broadway, and Hollywood glitz.[147] But in the end the more positive, spiritual interpretation prevailed; the most frequent comparison was to a memorial candle.[148]

As early as October 2001, Knafo defined the twin shafts of light as "a kind of interim monument, and in a sense, a bridge between acts of informal commemoration and more permanent monuments to come."[149] An art history survey textbook historicized the *Tribute in Light* as "a symbolic gateway to Western democratic freedom, standing not far from another such symbol, the Statue of Liberty in New York City's Harbor." The twin beams are described as "giant votive candles for what became known as New York's 'phantom limbs'" and are interpreted as "both personally poignant . . . but also politically powerful and confrontational in its symbolism. New York, it proclaimed, would rebuild itself and its amputated skyline."[150] This interpretation was based on an image of the *Tribute in Light* that appeared on the cover of an art magazine (created when the project existed only in graphic form) rather than a photograph of its realization.

Seeing a reproduced image of the memorial was a radically different experience than viewing it directly. Most saw only the graphic image and the perceptions of those who saw the actual *Tribute in Light* were informed by having seen it reproduced so often. On the front page of the *New York Times* the two parallel

shafts of white light, tinged blue, arose behind a cluster of lit buildings in Lower Manhattan. Reporter Dan Barry described them as "two soaring towers of light, defiantly piercing the night sky from the wounded western stretch of Lower Manhattan."[151] While this and other transcendent interpretations emerged quickly, a more literal reading was suppressed, one that was apparent in the presence of the actual memorial. With the light revealing countless particles of dust, the *Tribute in Light* readily suggested the remains of the towers and many of its victims.[152] In the November 2001 issue of *Art in America* that featured the *Tribute in Light* on its cover, David Ebony predicted that the lights would "evoke the immaterial essence of those killed in the attack, many of whose remains may never be found."[153] Rarely expressed, this more literal interpretation of the light projection suggests a re-enactment of the bombings. What you see in the reproduced images rather than in the actual memorial, however, is the illusion of more solid shafts ascending into the night sky. Thus the evoked towers, understood variously to signify the bodies of the victims, the buildings themselves, and implicitly the body of the nation, suggest an apotheosis far from the actual experience of the 9/11 attacks.

The Permanent Memorial: *Absence vs. Presence*

The open competition to design a memorial for 9/11 was launched amid unclear and shifting parameters.[154] Nine guiding principles and five required physical elements defined a program that was all but impossible to fulfill.[155] The first was to: "Embody the goals and spirit of the mission statement," but the mission statement was so vague (except for the cited dates and numbers dead) that it might have applied to both the Oklahoma City bombing and the Columbine shootings. It read:

> Remember and honor the thousands of innocent men, women, and children murdered by terrorists in the horrific attacks of February 26, 1993 and September 11, 2001.
>
> Respect this place made sacred through tragic loss.
>
> Recognize the endurance of those who survived, the courage of those who risked their lives to save others, and the compassion of all who supported us in our darkest hours.
>
> May the lives remembered, the deeds recognized, and the spirit reawakened be eternal beacons, which reaffirm respect for life, strengthen our resolve to preserve freedom, and inspire an end to hatred, ignorance and intolerance.

This fundamental focus on casualties was underscored by the first program element, which insisted that designs "recognize each individual who was a victim of the attacks." No distinction was made between the victims of the 1993

and 2001 attacks; also no distinction was made between rescue workers (first responders) called to the site and those who simply went work that morning or just happened to be at the WTC. This would change as the design evolved.

While several of the competition guidelines simply reiterated the mission statement, more specific instructions were to: "encourage reflection and contemplation; evoke the historical significance and worldwide impact of September 11, 2001; and create an original and powerful statement of enduring and universal symbolism." The first was eroded as the museum evolved, while the last expressed the hope that a new paradigm as powerful as Maya Lin's *Vietnam Veterans Memorial* might emerge from the open competition. Lin was on the design committee and many have observed that she had a strong influence on the winning selection. The very last guideline, which posited that the memorial "is to evolve over time," was widely interpreted as a caveat positing that the final version would not be determined for a time. Indeed, circumstances involving politics, finances, and projected use eventually altered its appearance.

The program elements insisted on a distinct "area for quiet visitation and contemplation," and one "for families and loved ones of victims" as well as an approximately 2,500-square-foot "separate accessible space to serve as a final resting-place for the unidentified remains from the World Trade Center site," thereby creating a literal cemetery. The memorial was also required to "make visible the footprints of the original World Trade Center towers." Thus the evocation of the buildings and their symbolic voids became the essential focus of Michael Arad's winning design. Other requirements included that the memorial "convey historic authenticity," which might be accomplished by including "surviving original elements" and preserving "existing conditions of the World Trade Center site." These elements were eventually included in the adjacent museum.

Daniel Libeskind's winning design for the rebuilding of the entire World Trade Center site, ostensibly selected for its respect for the space and its relics, had embraced the memorial concept. His proposal, centered on a void framed by an array of buildings including a symbolic tower and a memorial museum, was being reworked even as the memorial committee met. Today what was originally called the Freedom Tower, an awkward soaring shape that is a symbolic 1,776 feet high, became One World Trade Center, and the museum was subsequently designed by the architecture firms Snøhetta and Davis Brody Bond instead of Libeskind. This "refining process" continued for quite some time.

A year after it had featured the *Tribute of Light* on its cover, the *New York Times Magazine* marked the second anniversary of 9/11 by publishing a number of proposals for the rebuilding of Ground Zero. Unofficially, Maya Lin had sketched an idea that would "transform the footprints of the former trade center into reflecting pools surrounded by a park" (Figure 5.21).[156] The chosen memorial design by New York City Housing Authority architect

Michael Arad is remarkably similar; Lin was a strong supporter.[157] Echoes of her much admired and imitated *Vietnam Veterans Memorial* were apparent in all eight finalists' designs. I overheard many who viewed the models at the World Financial Center observe that they had trouble telling them apart. Eric Fischl, whose sculpture *Tumbling Woman* was removed from Rockefeller Center after complaints that it was too distressing, observed that "these sanitized designs could be memorials to anything almost anywhere."[158]

FIGURE 5.21 *Maya Lin. Sketched proposal for World Trade Center Memorial, from* The New York Times Magazine, *September 8, 2002. Courtesy of the artist and* The New York Times.

The competition for the memorial to 9/11 prompted 5,201 entries—more than the number who died in the terrorist attacks. Of the eight finalists' designs all but Arad's were complex, multi-part installations whose layered symbolism was not immediately apparent.[159] Light figured prominently in five of the designs and was specified in most of their titles. The dominant use of this element may in part have been a response to the success of the *Tribute in Light* or the reference in the mission statement to "eternal beacons." Norman Lee and Michael Lewis's design, *Votives in Suspension*, consisted of a descending ramp to a space containing candles over a reflecting pool with lights (suspended at different levels) reflected upward. Families and friends were intended to light one for each lost life. The actual names of the dead would be listed in alphabetical order on exterior walls. The submission by bbc art + architecture (Gisela Baurmann, Sawad Brooks, Jonas Coersmeier),

Passages of Light: the Memorial Cloud, was a cathedral-like structure opening to bedrock with ten thousand vertical conduits for light. A circle of light for each victim was embedded at ground level. The tri-partite *Garden of Lights*, by Pierre David with architecture students Sean Coriel and Jessica Kmetovic, included an alabaster altar inscribed with the name of a victim, handwritten by a family member, at the bottom level. At street level there was a memorial garden, and on the in-between level there was a room under each footprint; the South room was filled with "lights of hope," while the North room contained a steel wall forged from salvaged metal of the towers and a light to represent each of the victims whose names had not been identified. Brian Strawn and Karla Sierralta in *Dual Memory* proposed that the south tower footprint contain sugar maple trees. The footprint of the north tower was to have a surface marked with portals of light, one for each victim. Light came from an underground gallery that also housed images of each victim accompanied by a biography. Each portal contained a waterfall, which washed over the image. Toshio Sasaki's *Inversion of Light* defined the north tower by a floor plan illuminated from below and depicted the south tower by a reflecting pool above a circle of lights. Each of the five light-dominated designs had so many components that their meaning was compromised both by confusing symbolism and a cluttered appearance. Two other submissions with similar problems focused on water as a primary feature. *Lower Waters*, by Bradley Campbell and Matthias Neuman, comprised a rectangular waterfall dropping into a pool beneath the north tower, along with a wall of names arranged alphabetically. This space would bring people to bedrock, where they could see the slurry wall. *Suspending Memory*, by Joseph Karadin with Hisn-Yi Wu, featured a weeping wall consisting of stones representing victims with water trickling from each stone into a "Pool of Tears."

Most critics had intensely negative responses to the finalists' designs. Michael Kimmelman summed up the dominant view: "Instead of invention they offer novelty: theatricality, gadgets, spectacle, the stuff of entertainment and shallow pleasure, tricked up by treacly titles, the antithesis of what a memorial should provide. . . . These eight designs are pastiches of different media and styles—the definition of postmodern, in keeping with so much contemporary mixed-media art."[160] As the submissions were mediocre and overdesigned, he urged that the competition start over and include invitations to known professionals. Nicolai Ourossoff, architecture critic for the *New York Times*, lamented: "What a memorial requires is an eloquent silence—a silence that would offer collective solace rather than a field of distractions."[161] Letters to the editor of the *New York Times* echoed complaints that the designs were all too similar and the conviction that something better must be possible.[162] So did the attendees at a public forum held at Pace College on November 22, 2003, many of whom lived near the World Trade Center site; some were artists and educators. Summing up their opinions, Alan Feuer wrote: "Over all, the eight proposals flunked—miserably . . . [people found them] busy, dreary,

stagnant, dehumanizing, overly funereal, depressingly similar, uninspiring, disconnected from the neighborhood and, frankly, boring."[163]

Without question Arad's proposal differed radically from the seven other finalists' in its simplicity. As Herbert Muschamp observed: "Seen as a group, these finalists make the strongest possible case for simplicity as the most suitable aesthetic for ground zero. . . .[If] *Reflecting Absence* enjoys an advantage over the others, that is because it has the greatest potential to be the least."[164] It consisted of two sunken reflecting pools covering most of the footprints of the Twin Towers, installed thirty feet below grade, with each surrounded by walls of water. Discussing his winning design, Arad explained: "Sculptors talk about how the sculpture is already in the stone and all they're doing is chipping away at it. This is the opposite. Our void is already there. It's there in the sky. And we're building *around* it."[165] Like Maya Lin's design for the *VVM*, his seemed more like a conceptual starting point than a realized vision. The selection committee brought in established landscape architect Peter Walker to design the empty spaces at ground level with greenery in order to create a unifying design.

Arad initially wanted to build the memorial underground with the base of the fountains below grade and the remains of unidentified victims buried there in a crypt. There was considerable public resistance to the idea of an underground memorial; in any event by 2008 budget constraints made it prohibitive.[166] The ramps were eliminated and the voids brought up to ground level, no longer filling the footprints of the World Trade Center Towers; they were 31% smaller. No indication of precisely where the towers stood informed visitors who, according to David W. Dunlap, were "seeing only 69% of the story."[167] Gone was the meditative space that some felt was the key feature of Arad's design.[168] Narrative elements and relics of the attacks were relegated to the museum, prompting Ouroussoff to conclude that the museum "will serve as the de facto memorial, since that is where most visitors will directly confront the tragedy of Sept.11. It will essentially be a storehouse for relics of the dead, including memorabilia salvaged from the wreckage of that day."[169] It now appeared to replicate the museum model developed at Oklahoma City. A *New York Times* editorial expressed the concern that "some will have the urge to add every memento or to use the spaces as more personal memorials to the individual victims rather than as a broader public expression of the event and its meaning."[170]

Initially, the names of the victims were to be listed randomly on bronze panels surrounding each void. Eventually this scheme was replaced with one that grouped the names according to nine set categories. WTC North lists those who worked in or were visiting 1 WTC on 9/11; the crew and passengers of American Airlines Flight 11 that crashed into Tower One; and those who were killed in the February 23, 1996, bombing. WTC South lists those who were visiting at the WTC or other areas of the complex on 9/11; first responders, all of whom received 9/11 Heroes Medals of Valor awarded by the White

House on September 9, 2005; the crew and passengers of United Airlines Flight 175 that crashed into Tower Two; those who worked in or were visiting the Pentagon on 9/11; the crew and passengers of American Airlines Flight 77; and those aboard United Airlines Flight 93 that was headed for the White House but forced by some passengers to crash in Shanksville, Pennsylvania.[171] Specific affiliations are noted only for first responders, firefighters, and police. Others are listed according to a system defined as "meaningful adjacencies," significant relationships identified by their families. Some 1,200 adjacencies were requested; all were accommodated.[172] Since these personal connections are significant only to those who knew the victims, they will become only more inscrutable over time (Figure 5.22). Unlike the arrangement of names on the *VVM* according to the date of death, this arrangement will seem arbitrary to most visitors. As Witold Rybczynski observed: "A national memorial should speak to more than the families or the victims."[173] Indeed, why not use publicly meaningful categories such as names of companies or agencies where people worked with names arranged alphabetically within each? This would both reflect the history of the commemorated event and make the names easy to find, while still providing gathering places for those who knew one another.[174] At night the names, like the Oklahoma City chairs, are illuminated from within emphasizing the sanctity of the victims.

FIGURE 5.22 *Michael Arad.* National September 11 Memorial *names arrangement (detail). 2011. New York, New York. Photograph by Burt Roberts.*

Unveiled on the tenth anniversary of the attack, the memorial garnered more negative than positive responses. From the start there was concern over the memorial's focus on the voids and the victims (Figure 5.23). Art historian Kirk Savage observed that: "[I]f the idea of the 'therapeutic or traumatic memorial' is taken to its extreme . . . there is a risk of losing the sense of a broader meaning. In the end, there has to be a collective meaning to this event that justifies [the victims'] memorialization."[175] Similarly, historian Martin B. Duberman wished that the memorial would go beyond "a simple memorializing of those who were lost," while Eric Fischl argued for a narrative that would make the memorial more than a cemetery.[176] Its funereal aspect, coupled with the dominance of the voids with their rushing water, set the stage for an experience of re-enactment. Philip Nobel, author of *Sixteen Acres: Architecture and the Outrageous Struggle for the Future of Ground Zero* (2005), thought the overemphasis on the footprints represented "the buildings mourned" and overpowered the names inscribed on their perimeters.[177] Blair Kamin, too, observed that: "[T]he pools evoke the towers' absence. . . . Rooting the memorial in the particular qualities of its site sends a clear message: This is where people were murdered, where the towers pancaked downward in an apocalyptic vision of smoke, fire and ash."[178] Similarly, Justin Davidson noted his reaction to viewing the South pool: "I thought, as I was meant to, of the immensities that once filled those foundations, of all the people swallowed there, and of the ricocheting cataclysms that followed," and at the North pool: "What hit me there was the awful anticlimax of repetition."[179] Rybczynski also noted the totally closed experience, finding "nothing comforting about gazing into the vast pit—or, rather, two pits—of the 9/11 memorial, the water endlessly falling and disappearing into a bottomless black hole. The strongest sense I came away with was of hopelessness." Consistently referring to the voids as pits, he described their lining as "black granite—black as death" and hoped that eventually the surrounding park would "counteract the nihilism of the pits."[180] Criticism targeting negativity also greeted the *VVM* but the experience of the two memorials is radically different. The *VVM* leads the visitor first into darkness and then into light, while the 9/11 memorial leaves the viewer staring down into an apparently bottomless chasm (Figure 5.24). David Simpson was the most emphatic about this fearful aspect:

> This is a monument to violence, and its effect is terrifying. . . . The water roars and deafens—like jet engines up close . . . the noise and speed of the moving water is mesmerizing but threatening; the pool is much too turbulent to reflect anything; and at the center of the pool there is another vertiginous drop into a black marble-clad shaft whose bottom is just out of sight. Standing beside the pool, I felt drawn in, tempted to destroy myself, as one does when standing on the edge of Niagara Falls. . . . All that stands between the beholder and the 30-foot drop are the bronze panels with the names of the dead, who thus provide a sort of safety barrier between us and absolute vertigo.[181]

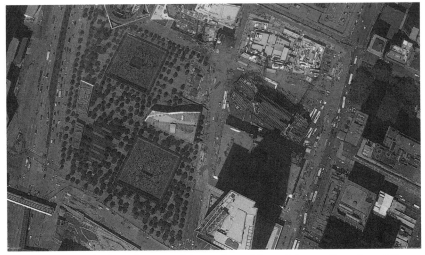

FIGURE 5.23 *Michael Arad.* National September 11 Memorial. *2011. Overview of site, with National September 11 Museum at right of memorial pools. New York, New York. Courtesy Google; map data: Google.*

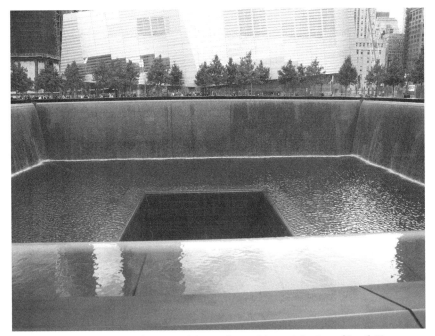

FIGURE 5.24 *Michael Arad.* National September 11 Memorial, *view of South Tower memorial plaza waterfall. Photograph by Burt Roberts.*

Before the opening, Arad speculated that people would be drawn immediately to the voids that would be open on all sides, forcing them to stare into the abyss.[182] He carefully engineered the flow of water so that the number of drops would reflect the number of victims of the attacks, but this is, of course, impossible to perceive. Adam Gopnik concluded that "emotively, [the pools] seem to suggest less the promise of eternal memory and more of a cycle of endless loss and waste."[183] To grasp the memorial's dark essence—not just look at it and register its elements (waterfalls, stone parapets, the names and objects left)—you have to stand close, look down, and listen. Then it becomes difficult to ignore its downward pull. The rush of pouring water and its accompanying roar powerfully suggests the falling of the towers, its constant disappearance a symbolic visual and aural re-enactment that is felt viscerally. This echo of the continually disappearing towers is reinforced by the descent into the museum as if into a tomb, where the experience of re-enactment is also dominant.

The National September 11 Museum

The mission of the 9/11 Memorial Museum, located at the World Trade Center site, is to bear solemn witness to the terrorist attacks of September 11, 2001 and February 26, 1993. The Museum honors the nearly 3,000 victims of these attacks and all those who risked their lives to save others. It further recognizes the thousands who survived and all who demonstrated extraordinary compassion in the aftermath. Demonstrating the consequences of terrorism on individual lives and its impact on communities at the local, national, and international levels, the Museum attests to the triumph of human dignity over humanity depravity and affirms an unwavering commitment to the fundamental value of human life.

9/11 MEMORIAL MISSION STATEMENT

It creates a museum of experience. It is devoted not to history but to something much more personal and immediate: memory. And in keeping with its devotion to experience, it tries to become an experience itself. . . . It is as if by enshrining memory and individual experience, it left little room for more elaborate and public considerations. It doesn't even try to offer a rough first draft of history. . . . Ideas and debates don't interfere with the determined accumulation of sensations and memories.

EDWARD ROTHSTEIN, "A MEMORIAL TO PERSONAL MEMORY,"
NEW YORK TIMES, MAY 22, 2014

The built memorial places absence at its center. From a different perspective, pointing up instead of looking down, the *Tribute in Light* conveys the disintegration of the towers and bodies alike. The museum attempts to restore both. One version of Daniel Libeskind's master plan for the site included an International Freedom Center, which would have focused on worldwide struggles against totalitarianism; this more global view was abandoned along the way. The creation of a memorial museum was not specifically included in the five Program Elements. The fifth element, however, called for the design to: "Create a unique and powerful setting that will . . . be distinct from other memorial structures like a museum or visitor center."[184] The realization that something was needed beyond the memorial itself emerged gradually.[185] Today the location is a confusing mixed-use site. It is a memorial space (a cemetery, actually) in a park-like setting that also serves as a crosswalk for those who work in the area and a forecourt for office buildings adjacent to the site. Intending to celebrate a return to normalcy for the American way of life, it is by necessity tightly policed.[186]

The museum is located on the northeast corner of the site. Visitors enter as if it were an airport terminal defined by the now-routine searches of bodies and bags prompted by 9/11. The pavilion, designed by Snøhetta, provides a gradual descent into the museum proper, punctuated by two tridents once a part of the Gothic base of Yamasaki's original towers. The museum proper, the work of Davis Brody Bond, occupies some 110,000 square feet at 70 feet below ground to bedrock, the foundation of the original World Trade Center. It is overwhelming in scale: the enormous space, the number of relics (personal and architectural), and the depiction of the devastation. The visit begins with a map marking the trajectory of the planes that crashed into the Twin Towers and a brief narrative of events, accompanied by a cacophony of sounds recorded that day, recreating the confusion prompted by the deadly assault.

When one finally reaches bedrock, one faces a commissioned wall-sized work of art by Spencer Finch, which fronts on the chamber containing the unidentified remains of the victims (Figure 5.25). At its center is the inexplicably inappropriate quote by Virgil. "No day shall erase you from the memory of time," taken from the *Aeneid* refers to a pair of Trojan warriors (gay lovers) who had just brutally slaughtered sleeping enemy soldiers before they in turn were violently killed. As Caroline Alexander commented, "The central sentiment that the young men were fortunate to die together could, perhaps, at one time have been defended as a suitable commemoration of military dead who fell with their companions. To apply the same sentiment to civilians killed indiscriminately in an act of terrorism, however, is grotesque."[187] In response to widespread criticism, the museum removed the reference to the *Aeneid* from the quote but chose to retain the words because, according the to the director Alice M. Greenwald, it was in keeping with the "museum's overall commemorative context."[188] A similar kind of false positive pervades Spencer

Finch's *Trying to Remember the Sky on that September Morning*, consisting of 2,983 squares of paper, one for each victim, each hand-painted a distinct shade of blue. Recalling both the brilliant color of the sky on the day of the attacks and more indirectly the bits of flimsy office paper that floated around afterwards, its very lightness seems as incongruous as the color of the sky on September 11. It creates an inexplicably bright faux façade for the most somber of spaces behind it, the crypt. According to Charles B. Strozier and Scott Gabriel Knowles: "As of today the Sept. 11 memorial museum is the only museum in the world in which unidentified human remains constitute a central, and yet tragically unacknowledged, feature."[189] It unquestionably makes the September 11 Memorial Museum a literal cemetery (or crematorium). The inclusion of this repository was problematic for many family members.

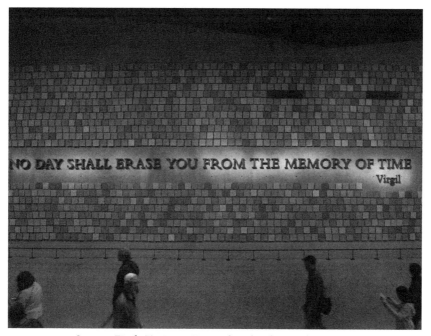

FIGURE 5.25 *Spencer Finch.* Trying to Remember the Sky on That September Morning. *2014. National September 11 Museum. Photograph by Edward Stojakovic, available under Creative Commons BY 2.0 license.*

An array of architectural and personal relics brings the visitor face to face with evidence of the destruction. The remains of the Survivors' Stairs parallel the initial descent. The portion of steel façade located at the point where hijacked Flight 11 crashed into the North Tower between the ninety-third and ninety-ninth floors momentarily projects visitors into the space of the victims who worked there. It is both unimaginable and completely overwhelming.

Wall text next to a remnant of glass from the South Tower informs us that only one window from the forty thousand in the Twin Towers appears to have survived intact. A display surrounding "The Last Column" notes that many first responders may in fact be buried nearby. An image of a leaf inscribed into the floor is used as a symbol to mark other places where people are believed to have died. Foundation Hall is bound on one side by the slurry wall (Figure 5.26). Despite the dire associations the relics prompt, they have been aestheticized and recontextualized in a museum environment. Altogether they create a cavernous space for re-enactment.

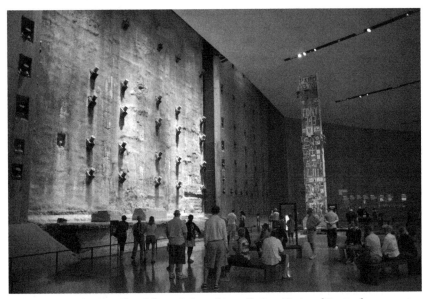

FIGURE 5.26 *Slurry wall and "Last Column" installation, National September 11 Museum. AP Photo/Chris Melzer. Copyright 2015, The Associated Press.*

Individual victims are evoked in many places. The so-called "Missing Posters" with the words "Have You Seen . . . ?" are displayed at several spots, echoing the way they were encountered around the city in the days after the attack. "In Memorium," the exhibition located in what had been the South Tower, consists of a square room whose walls are covered with 2,977 head-shots of those who died at Ground Zero, the Pentagon, and in Shanksville, Pennsylvania, each encased in a Plexiglas rectangle, arranged in alphabetical order (Figure 5.27). Here one feels the full force of former Mayor Michael Bloomberg's telling remark: "The museum is a place to understand 9/11 through the lives of those killed and those who rushed here to help."[190] Creating a gigantic high school yearbook effect that conveys uniformity more than individuality, the images are reminiscent to the "Portraits of Grief" published

in the *New York Times* at the time of the attack and analyzed by David Simpson in terms of their predictable format and content.[191] A dark room at the center of the gallery features projected images of specific individuals accompanied by recorded recollections spoken by their family members and friends. The gallery also contains a computerized touchscreen table, which may be scanned for more details about specific victims. You can hear the names of the dead being read as you enter and exit the exhibition, much as they are on the anniversary of 9/11. It is hard to imagine what kind of significance this extensively documented archive pertaining to these accidental victims will have for future generations. It may provide a comforting place to mourn and remember for anyone with a personal connection to the dead. The implicit message, it would seem, is that anyone might have been there and therefore everyone is at risk, that we are all potential victims of surprise attacks or other fatal disasters.

FIGURE 5.27 *"In Memorium" exhibition detail, National September 11 Museum. Photograph by Jennifer K. Favorite.*

Near the South Tower Gallery is an exhibition of images by Stephane Sednaoui entitled "Witness at Ground Zero: September 12–16, 2001," leading to a room with continuous screenings of *Rebirth at Ground Zero.* There is always a line waiting to see the ten-minute film, which surrounds viewers on three sides with fast-forwarded images of the rebuilding accompanied by anonymous voices: "Life coming up on the ashes of death and destruction"; "You just continue to heal"; "If it weren't for the joy you wouldn't have the pain of loss"; "That much living just can't stop"; and concluding with "It will turn

around. I promise you." Even though the tone is rueful, the message is consistently upbeat. This feel-good film is in marked contrast to the fifteen-minute *Facing Crisis: America under Attack* playing in the auditorium on the upper level of the museum that also houses the small café. President George W. Bush recalls being told: "America is under attack." He is visibly upset, observing: "I became a wartime president. . . . Life's just that way. You have to deal with things you don't want to deal with." New York City Mayor Rudolph Giuliani, tormented by seeing someone jump from a tower window and hearing that no one above the fire could be saved, observed: "We're going to have to make this up as we go along." New York State Governor George Pataki described the burning and smoldering Ground Zero as "the worst image you could have of hell." Unlike *Rebirth at Ground Zero*, it is neither over-produced nor imbued with a triumphal narrative.

Located in what had been the North Tower, the "September 11, 2001" exhibition is divided into three sections: "The Day—9/11," "Before 9/11," and "After 9/11." The initial section focuses on the actions of first responders and others who provided assistance and presents an experiential recreation of events at the various attack sites. A separate gallery, preceded by a warning that disturbing content is on display, highlights the experiences of those inside or nearby the World Trade Center. Another gallery includes images of people jumping from windows, looking as small as birds. The experience of this first section, packed with personal and architectural relics, is overwhelming.

"Before 9/11" includes a list of the organizations housed in the Twin Towers and considers the buildings' symbolic power as evidenced in movie posters. Relics of the 1993 bombing include a segment of the built memorial by Elyn Zimmerman. A section entitled "The Plot" presents the rise of the terrorist network of Al-Qaeda in a film on Osama bin Laden that has been much criticized for its sketchy presentation and lack of context. As one commentator observed: "If they are going to get into the history of the ideologies behind Al Qaeda they need to get into the full political context of the Middle East in the 20th century that created these organizations."[192] The film "The Rise of Al Qaeda," narrated by NBC news anchor Brian Williams, referred to "Islamic terrorists," sparking a controversy about the way it seemed to implicate and link Islam and Muslims in general to the attacks.[193] This section also chronicles the activities of John P. O'Neill (special agent of the National Security Division in charge of New York office), and the subsequent investigation and trials. The section ends with an installation entitled "Back in Business."

Part 3, "After 9/11," is much more brightly lit. It begins with images of destruction, an array of "Missing" posters, and the glass-enclosed window display case of a shop containing T-shirts covered with the gray dust of 9/11 ashes. There is documentation of demolition and excavation, information

detailing how victims were identified and showing the number of individuals lost by each organization housed at the World Trade Center. The final quote reads: "May the lives remembered, the deeds recognized, and the spirit re-awakened be eternal beacons, which affirm respect for life, strengthen our resolve to preserve freedom, and inspire an end to hatred, ignorance, and intolerance." The last thing a visitor sees is an image of the *Tribute in Light* as it appeared on September 11, 2012. The accompanying text asserts that it was "designed to evoke the memory of the Twin Towers and the brightness of too many lives taken far too soon."

From the start, the most powerful 9/11 memorials were the actual relics of the buildings and Ground Zero itself, defined by David Brooks and others as "a mass grave," as well as the ephemeral *Tribute in Light*.[194] The architectural fragments, emblems of the towers and what they stood for are now institutionalized in the National 9/11 Memorial Museum together with images of the victims, all embedded in an experience of re-enactment of the bombings and the mourning thereafter. The sites of death of the victims marked within the museum emphasize its status as a crematorium or cemetery. The sense of re-enactment that pervades the museum is obvious to many. In a perceptive, sharply critical review Phillip Kennicott observed: "Repetition is the essential thing: We suffer the trauma again and again in a way that inflates our sense of participation in it. This isn't history, it's spectacle, and it engulfs us, makes us a part of it, animating our emotions as if we were there, again, watching it all unfold."[195]

Re-enactment is the essential strategy of an experiential museum where emotion dominates, overwhelming any attempt at (re)consideration of the event—its historical context, present significance, future implications. Staying rooted in that day keeps reflection at a distance, augmented here by the cavernous space that evokes the spiritual, if not specifically religious overtones of a sacred institution. There is the explicit veneration of the dead, coupled with the conflation of heroes and victims, an aspect that was noticed even by those who lost close relatives in the attack. Steve Kendall objected to his sister being called a hero: "[T]he heroes ran *into* the buildings; she was just a person who happened to have gotten to work a little early on a Tuesday morning, and that was horrible and heartbreaking and difficult enough without the extra assignation."[196] Edward Rothstein observed that the dead were victims: "the vast number have no claim on public attention other than our sympathy. . . . Yet more attention is given to individuals here than at any other memorial I can recall. . . . We become preoccupied with the private, not the public."[197] The private is the personal context of the cemetery, the public the larger cultural memorial. In order to obviate the distinction, the museum experience is calculated to make the viewer identify both with the victims and their grieving families. Kennicott saw the museum as expressing "a *new religion*, fully articulated and perfectly adapted for our distracted, self-involved,

media-saturated world . . . this is the great, subterranean cathedral of Amer-
ica Militant, Suffering and Exceptional."[198]

Our misguided commemoration of the 9/11 attacks is glaringly evident in
what has been omitted both from the museum itself and the memorial com-
plex in general, what Rosalyn Deutsche termed the absence of "critical
memory."[199] Gone are the International Freedom Center (intended to serve as
a forum to consider broader issues pertaining to freedom and the curtailment
thereof), the Drawing Center (committed to creative expression in the most
personal of art forms), and any consideration of the Arabic neighborhood
known as Little Syria that once flourished in and around the site. The Arabs
who lived there were Christians who prayed in churches, indicative of a far
more complex reality than the simplistic stereotypes fostered by the
museum.[200] Also absent, as Kennicott noted, is the problematic aftermath of
the attacks, that is:

> [H]ow 9/11 actually changed America, how we are all under surveillance,
> our phones tapped, our e-mails collected, how security fears mean one can
> no longer enter the Supreme Court through its front door or step onto the
> west terrace of the Capitol. You've learned nothing about the overwhelm-
> ing cost of two wars, the loss of civil liberties, the secret renditions, the
> systematic use of torture and the prison camps just out of the reach of the
> once-vigorous U.S. constitution.[201]

The experience of the National September 11 Memorial Museum is emotion-
ally exhausting and overly stimulating but ultimately repetitive and self-
contained. That is the nature of re-enactment.

Conclusion

Now our official sympathy towards all kinds of victims frees us from
responsibility. Or remorse.

ARTURO PEREZ-REVERTE, *THE PAINTER OF BATTLES*

The Vietnam War continues to haunt political discourse. As historian Wolf-
gang Schivelbusch observed: "[T]he destruction of September 11 uncovered
the suppressed remains of Vietnam."[1] The *VVM* was built to separate the sol-
diers from the war in which they were killed; this was deemed necessary be-
cause irreconcilable, deeply held convictions still existed about United States
policy at the time and because, in a sense, the surviving veterans were treated
so ignobly. According to Kirk Savage the *VVM* "justifies the soldiers not as
heroic agents, but as honorable victims who deserve our recognition."[2] This
strategy of focusing on the dead exclusively, thereby diverting attention away
from the event that caused their death, continued in memorials dedicated to
Oklahoma City, Columbine, and 9/11. All valorized these victims as if they
were heroes, something the *VVM* did not do. The Oklahoma City bombing,
the Columbine High School shootings, and the attack on the World Trade
Center reflected a deep hatred for established institutions: a federal work
place, a high school, and, more broadly, the United States as a hegemonic
power—they were all symbolic targets. The perpetrators of these crimes were
motivated by an apocalyptic belief that their actions would somehow change
the world, and in some respects they were right.[3]

As talk of the *Oklahoma City National Memorial* began, a *Los Angeles
Times* reporter commented: "[T]he project's size and scale and spiritual mag-
nitude is most commonly compared to that of the Vietnam Veterans Memo-
rial or the U.S. Holocaust Memorial Museum."[4] From the start it was seen in
a national context, tied directly to the most visited memorials on the National
Mall and implicitly their subjects. Later it was also linked to the Columbine

shootings and the attacks of 9/11. The initial aesthetic strategy of avoiding fig-
ural images (so effective at the *VVM*) was specifically incorporated in the
Oklahoma City Memorial mission statement. While it was argued that the
VVM reflected a postmodern construct in terms of the diversity of the public
responses it evoked, the Oklahoma City memorial was postmodern in its
formal solution from the start, a complex with many distinct elements that
existed more as an aggregate of parts than an integrated whole.

Separated by a day and a few years, Oklahoma City (April 19, 1995) and Co-
lumbine (April 20, 1999) are forever linked by the closeness of their anniver-
saries and the media attention they prompted. By 2005 photos of mourners in
both cities were displayed side by side in the *New York Times*, grouped with
images of 9/11 under the frame of ongoing terrorism.[5] Almost immediately
after the school shootings at Columbine, local residents of Oklahoma City
offered solace and assistance to those in Littleton. They sent a gift of a "survi-
vor tree," which was then planted in Clement Park adjacent to the high school.
Counseling professionals volunteered information and guidance pertaining
to the potential long-term personal and communal effects of such civic
trauma. Just as the Oklahoma City memorial had prompted thoughts of the
VVM, the attacks of 9/11 prompted thoughts of the Oklahoma City bombing;
at that time Timothy McVeigh was discussed as an early incarnation of Osama
bin Laden.[6] Almost immediately after 9/11, a team from Oklahoma City came
to New York to provide advice and assistance. These events, however, differed
in essence and execution and in the number of victims and extent of damage.
There was also a vast discrepancy in the economic and political significance
of the cities where they occurred.

One month after 9/11, Hans Butzer (one of the architects of the Oklahoma
City Memorial), writing in an op-ed piece in the *New York Times*, emphasized
the importance of process in considering a memorial. He concluded that,
"working together to achieve a consensus will be just as much a memorial as
any construct that is built."[7] Besides this rather dubious conclusion, it was not
even remotely possible to implement a similar commissioning procedure in
New York. Bob Johnson, head of the Oklahoma City Memorial Foundation,
emphasized the two hallmarks of the Oklahoma City process as listening and
public participation, but only illusions of that process occurred in New York.[8]
The city is just too big and too varied, and there were too many stakeholders
from the start—among them local, state, and federal government agencies
and politicians; the Port Authority of New York and New Jersey; city uni-
formed police and firefighters; victims' families; and, of course, funders. Nev-
ertheless, by the end of 2001, Edward Linenthal, writing in the *New York
Times*, referred to Oklahoma City as "New York's new sister city . . . joined at
the hip through bereavement."[9] At the same time, he cautioned against a nar-
rative that ignores "the toxic impact of terrorism" and "the obscene language
of pop psychology with its false promise of 'closure.'" These remained the

prevailing themes of the Oklahoma City and 9/11 memorials and museums, while at Columbine a religious narrative was more dominant.

Failing to make distinctions between commemorated events eradicates their particular meaning and implications, factors upon which history is grounded. An exhibition at the Oklahoma City Memorial Museum on the seventh anniversary of the attack emphasized its similarities with 9/11: *A Shared Experience* (April 19, 2002—September 1, 2003) focused on terror, courage, response, experience, and lessons. Framing both tragedies under "a general thesis of redemption," the exhibition was intent on "finding moral and spiritual lessons in the resilience of the American people."[10] For Oklahoma City, this identification provided a kind of civic aggrandizement, a link to an event with international repercussions, something already implicit in the creation of its National Memorial Institute for the Prevention of Terrorism. This is not to say that similarities do not exist, but rather that it is critical to recognize essential differences between an international attack killing thousands and a homegrown assault killing fewer than two hundred. Inappropriate links are not unique to Oklahoma City. The USNHMM suggested a connection between the Holocaust and 9/11 on the first anniversary of the attacks by having the names of those who died in the 2001 attacks read aloud by Holocaust survivors and museum staff members. While it is possible to read the nearly three thousand names of the victims of 9/11 in several hours, it would take considerably more than a week to articulate the names of six million Holocaust victims.

Strategies of widespread denial and diversion are evident in the memorials that are the focus of this book. There is denial of what appears to be visually obvious, that the *VVM* is the symbolic burial place for Americans who died in that much disputed conflict. The thousands who left objects at the base of this mourning wall implicitly understood that. Each formal addition, however well intentioned, may be seen as an attempt to divert and mitigate that fact. Similarly, the *Tribute in Light* that literally evoked the myriad particles of dust that filled the air after the World Trade Center attack was rarely seen in this context. Strategies of diversion and denial are even more evident in the adjacent museums and education centers associated with these memorials. At the forthcoming *VVM* Education Center, the undeclared war will be contextualized in American history as part of a continuum that began with the Revolution. In the Oklahoma City memorial and museum, the bombing is reframed as a communal triumph over tragedy. At the 9/11 memorial and museum, the focus is on the victims and the reenactment of the attack, rather than on the causes of the plot. Areas of conflict and complexity are obscured.

The *VVM* initiated the paradigm of the therapeutic memorial, as noted by Kirk Savage, who also defined it as the first such example dedicated to victims: "In the end, there has to be a collective meaning to this event that

justifies their memorialization. . . . That's why I think the therapeutic monument has to be didactic in some way, has to have a rationale, a meaning that justifies the collective focus on this event."[11] The model of the therapeutic memorial has expanded to include the actual commissioning as an essential part of the healing process for families of those who have died. In a sense this was implicit in the *VVM* since the veterans, arguably a family group, instigated the memorial competition and raised the funds to build the winning design. The focus on honoring those who died in or because of the Vietnam War led to a conflation of national or civic memorials and private cemeteries. The recent emphasis on images of and stories about these individuals attempts to make them known to a larger public. But since most members of this larger audience do not know the war dead personally, and similar narratives are used to describe each of them, the overall effect is to make them less, rather than more, distinguishable from one another. When this strategy of commemoration is applied across the board, an image of homogeneous victims emerges that actually does little to honor them, as they blur in the aggregate.

The Memorial Process Reconsidered

It is useful to redefine the memorial process as tri-partite: immediate, interim, and permanent. From the moment the *VVM* appeared, and as soon as the subsequent attacks discussed here occurred, immediate memorials were established. These ephemeral clusters expressed the all-encompassing jolt of sudden grief, material evidence of the social benefit of this prevalent mourning ritual. A vital step in acknowledging tragic death and managing shock, immediate memorials visually reflect the confusion that people feel as they try to assimilate the unthinkable. Interim memorials provide ongoing foci of mourning, places to gather and grieve in public. Of necessity, permanent memorials take longer and require more reasoned thought, a longer view, and considerable fundraising. Such memorials are places for public recognition of lives lost in the context of national events understood in a larger scope. It is precisely this historical frame that may escape family members of victims at the time when they are coping with extreme personal loss. No doubt, the communal effort of working with others suffering in similar circumstances is helpful, but there are other venues in which energies and emotions could be put to better use. A grieving community needs many things, and those most affected may be the best qualified to define and implement them. Indeed, this group might be put in charge of creating an interim memorial for as long as it is deemed necessary, perhaps until the permanent memorial is built. This might take singular or multiple forms—a symbolic structure, a meeting place, or any combination of elements. Funds would have to be raised, committees

formed, and time limits periodically revisited. Eventually, decisions would have to be made about the ultimate fate of such projects. Interim memorials could accomplish the same goals for victims' families as commissioning the permanent memorials but would leave that long-range undertaking primarily to a group of professionals with experience and knowledge of the field, and without those emotional needs.

The input of family members should be an essential part of the permanent memorial process as well. These individuals might participate in the actual selection process, but could also form an advisory board, providing a clear picture of their needs. The commission of a permanent memorial requires a long view, and sudden mourners cannot reasonably be expected to provide that. Currently, family members constitute a privileged class of survivors, often considered heroes themselves, an extension of the honored status of the victims celebrated in these memorials. Thus we get memorials that try to comfort, which has traditionally been the role of religion. To get a sense of the potency of the spiritual frame of these events, we need only think of Presidents Clinton and Bush's comments about Oklahoma City or the local response to the Columbine shootings. Therapeutic comfort is typically accompanied by an emphasis on insight as a path to greater understanding. Solace of the sort offered here serves to estrange us further from historical understanding.

Whatever the disaster, individuals must recover and cities must rebuild. Hence, project directors promote narratives of resilience, defined by urban planners Lawrence J. Vale and Thomas J. Campanella as "a socially and economically productive form of denial . . . a suitable interpretive framework that enables psychological, emotional, and symbolic recoveries."[12] But there is something amiss when memorials to tragedies impose a celebratory frame. They can and should honor individual deaths and the fractured lives of their survivors. They may prompt grieving and cathartic healing, validated and made safe at a site of public mourning. Museums or education centers should fully document disasters and provide a forum for further discussion, a place to question and to debate. David Reiff concluded that after those "who lived through the attack or were old enough to know that it had occurred" have died: "What will remain then will not be memory but remembrance, which . . . may be many things, positive as well as negative, but is always a form of politics."[13]

A variety of political and highly emotional concerns influenced the creation of the memorials discussed here. Understandably, they avoided the toughest question of all: What did these people die for? In Vietnam they died fighting for a highly contested undeclared war that had little to do with the abstract ideas used to justify it: "freedom, democracy, honor, patriotism."[14] At Oklahoma City the cause of death was the revengeful act of a young

American veteran of the Gulf War, still angry about the Waco killings and disillusioned with his country. At Columbine the victims died because two teenage boys were enraged by the quality of their daily lives. Regardless of the medical conditions from which they may or may not have been suffering or what medications they were taking, their rampage was related to their experience at a highly regarded American high school. Finally, the attacks of 9/11 were planned and executed by fanatic terrorists with a long-standing hatred of the United States. If we lose sense of these dire acts, we have no chance of understanding or addressing the circumstances that caused them.

By 2012, Alice Greenwald, director of the National September 11 Memorial Museum, remarked: "It's not always an authoritative museum. It's about collective memory."[15] Actually, this museum, like the one at Oklahoma City and the planned education center at the *VVM*, is about *selective* memory, creating a triumphal narrative over a complex series of events that are still reverberating. It is an abdication of professional responsibility of the most egregious kind, obviating any possibility of approaching an accurate history or a usable past.

On more than one occasion President Clinton stated, "Oklahoma City made us all Americans again." This concept encapsulates the way disastrous events prompt a communal empathic response that often morphs into a victorious tale. This is the essence of a diversionary narrative. At the same time, the implicitly heroic status conferred on the victims is a denial of what actually happened. Seen as an aggregate, the *VVM* and its education center, the Oklahoma City National Memorial and Museum, the Columbine Memorial, and the National September 11 Memorial and Museum invoke the presence of absent bodies. In this way they not only camouflage history but also define the United States as a nation of victims, exactly the concept they and their accompanying triumphal narratives were apparently created to obscure.

The Latin word *monumentum* derives from the verb *moneo*, "to warn," and signifies "something that serves to warn or remind with regard to conduct of future events."[16] The purpose of memorials—especially national ones—is to remember those who died *and* the circumstances that led to their death. These structures must have an immediate resonance not only for those who lost family members and loved ones, but also for everyone affected by the tragedy. They must have a broader significance as well because they define the present to the future.

{ NOTES }

Introduction

1. See Kirk Savage, "The Self-Made Monument: George Washington and the Fight to Erect a National Memorial," in *Critical Issues in Public Art: Content, Context, and Controversy*, ed. Harriet F. Senie and Sally Webster (New York: Harper Collins, 1992), 5–32.

2. For a discussion of the use and significance of obelisks in United States commemoration see John Zukowsky, "Monumental American Obelisks: Centennial Vistas," *Art Bulletin* 58 (December 1976): 574–581.

3. For a history of the Bunker Hill monument, see Nathalia Wright, "The Monument That Jonathan Built," *American Quarterly* (Summer 1953): 66–74.

4. For a discussion of this project commissioned by the Institute of Contemporary Art in Boston, see Sarah J. Purcell, "Commemoration, Public Art, and the Changing Meaning of the Bunker Hill Monument," *The Public Historian* 25 (Spring 2003): 55–71.

5. See Scott Sandage, "A Marble House Divided: The Lincoln Memorial, the Civil Rights Movement, and the Politics of Memory, 1939–1963," *Journal of American History* 80 (June 1993): 135–167.

6. Drew Gilpin Faust, *The Republic of Suffering: Death and the American Civil War* (New York: Alfred A. Knopf, 2008).

7. Susan-Mary Grant, *A Concise History of the United States of America* (Cambridge: Cambridge University Press, 2012), 8. Grant, 12, refers to the U.S. as "the single most powerful nation on earth" at the time.

8. Marvin Kalb and Deborah Kalb, *Haunting Legacy: Vietnam and the American Presidency from Ford to Obama* (Washington, D.C.: Brookings Institution Press, 2011).

9. See chapter 1 for a discussion of this interpretation.

10. Kalb and Kalb, 1, begin their book with this observation: "The Vietnam War ended on April 30, 1975. For the first time in American history, the United States lost: not to another superpower, which would have been bad enough, but to a small country in Southeast Asia. . . . It was a humiliating experience for a nation proud of its history of freedom, economic opportunity, and military power. A certain mood of boundless self-confidence seemed to settle into a deepening self-doubt, as though the United States, having suffered its first defeat, had reached a tipping point in its distinguished history."

11. Patrick Hagopian, *The Vietnam War in American Memory: Veterans, Memorials, and the Politics of Healing* (Amherst: University of Massachusetts Press, 2009), 14, observed: "In the middle of the 1990s, 72 percent of a sample of the American public still agreed that the Vietnam War was 'one of the worst moments in American history.'"

12. See chapter 3 for a full discussion of the National Oklahoma City Memorial and Museum.

13. George W. Bush and Richard Cheney, Petitioners v. Albert Gore, Jr. and Joseph Lieberman, et al., docket nos. 00–949, argued Dec. 11, 2000; decided Dec. 12, 2000. See http://sss.supremecourt.gov/Search.aspx?FileName=/docketfiles/00–949.htm.

14. Jay Winter, *Sites of Memory, Sites of Mourning: The Great War in European Cultural History* (Cambridge: Cambridge University Press, 1995), 51. Winter notes that they were also "places where people grieve, both individually and collectively," 79.

15. Winter, 107, 93. See also Drew Gilpin Faust, *This Republic of Suffering: Death and the American Civil War.*

16. See Edward Linenthal, *Preserving Memory: The Struggle to Create America's Holocaust Museum* (New York: Oxford University Press, 1995). See also Michael Berenbaum, *After Tragedy and Triumph: Essays on Modern Jewish Thought and the American Experience* (Cambridge: Cambridge University Press, 1991); and James E. Young, *The Texture of Memory: Holocaust Memorials and Meaning* (New Haven, CT: Yale University Press, 1993).

17. The evolving goals of the Anne Frank Foundation are discussed by Hilene Flanzbaum, ed., *The Americanization of the Holocaust* (Baltimore: Johns Hopkins University Press, 1999), 1–5.

18. Carter's support for the USHMM is discussed by James E. Young, "America's Holocaust: Memory and the Politics of Identity," in Flanzbaum, 71–73.

19. The mission statement of the USHMM is posted on its website. See http://www.ushmm.org/museum/mission/; accessed July 27, 2012.

20. See the mission statement of the Oklahoma City Memorial Center on its home page, at http://www.oklahomacitynationalmemorial.org; accessed July 27, 2012.

21. The mission statement of the USHMM is posted on its website. See http://www.ushmm.org/museum/mission/; accessed July 27, 2012.

22. See Ken Johnson, "Art and Memory," *Art in America* 81 (November 1993): 97. One example shown in the USNHMM is the story of the S.S. St. Louis, which turned away 936 Jewish refugees, sending them back to Europe, where they were killed. For the larger context of this lamentable history, see David S. Wyman, *The Abandonment of the Jews: America and the Holocaust, 1941–1945* (New York: Pantheon Books, 1984). Lawrence L. Langer, "The Alarmed Vision: Social Suffering and Holocaust Atrocity," *Daedalus* 125 (Winter 1996): 47ff, presents an interesting perspective on the American resistance to understanding received information about the Holocaust.

23. Linenthal, *Preserving Memory* (1995); Edward Linenthal, *The Unfinished Bombing: Oklahoma City in American Memory* (New York: Oxford University Press, 2001).

24. Edward T. Linenthal, "The 'Predicament of Aftermath': Oklahoma City and September 11," in *The Resilient City: How Modern Cities Recover from Disaster*, ed. Lawrence J. Valed and Thomas J. Campanella (New York: Oxford University Press, 2005), 55.

25. Adam Gopnik, "Stones and Bones: Visiting the 9/11 Memorial Museum," *New Yorker*, July 7, 2014, 38–44. See also Christopher Hawthorne, "Architecture Review: At 9/11 Museum, A Relentless Literalism," *Los Angeles Times*, May 5, 2014.

26. Kirk Savage, "Trauma, Healing, and the Therapeutic Monument," in *Terror, Culture, Politics: Rethinking 9/11*, ed. Daniel J. Sherman and Terry Nardin (Bloomington and Indianapolis: Indiana University Press, 2006), 109.

27. Kenneth E. Foote, *Shadowed Ground: America's Landscapes of Violence and Tragedy* (Austin: University of Texas Press, 1997; 2003), 7.

28. Kirk Savage, *Monument Wars: Washington, D.C., the National Mall, and the Transformation of the Memorial Landscape* (Berkeley: University of California Press, 2009), 261, 266.

29. David Simpson, *9/11: The Culture of Commemoration* (Chicago: University of Chicago, 2006).

Chapter 1

1. John Hellmann, *American Myth and the Legacy of Vietnam* (New York: Columbia University Press, 1986), x.

2. Walter Capps, *The Unfinished War: Vietnam and the American Conscience* (Boston: Beacon Press, 1982, 1990).

3. Patrick Hagopian, *The Vietnam War in American Memory: Veterans, Memorials, and the Politics of Healing* (Amherst: University of Massachusetts Press, 2009), 14.

4. Marvin Kalb and Deborah Kalb, *Haunting Legacy: Vietnam and The American Presidency from Ford to Obama* (Washington, DC: Brookings Institution Press, 2011).

5. The most notable exception is the Civil War. For a discussion of its commemoration see James Mayo, *War Memorials as Political Landscape: The American Experience and Beyond* (New York: Praeger, 1988), 170–190. See also Cynthia Mills and Pamela H. Simpson, *Monuments to the Lost Cause: Women, Art, and the Landscapes of Southern Memory* (Knoxville: The University of Tennessee Press, 2003). The relationship between the *Vietnam Veterans Memorial* and Civil War commemoration is discussed below.

6. *The Vietnam Veterans Memorial Fund Design Competition: Design Program*, 1980, specifies that the memorial "honor the service and memory of the war's dead, its missing, and its veterans—and not the war itself."

7. The story of Jan C. Scruggs, who spearheaded the drive for the *VVM*, and Maya Ying Lin, the twenty-one-year-old architecture student at Yale University who won the competition, has been recounted many times. See especially Jan C. Scruggs and Joel Swerdlow, *To Heal a Nation: the Vietnam Veterans Memorial* (New York: Harper & Row, 1985), and Hagopian, *The Vietnam War in American Memory.* See also Nicolas J. Capasso, "Vietnam Veterans Memorial" in *The Critical Edge: Controversy in Recent American Architecture*, ed. Tod Marder (Cambridge, MA: MIT Press, 1988), 189–199; Elizabeth Hess, "A Tale of Two Memorials," *Art in America* 71 (April 1983): 121–124; Harriet F. Senie, *Contemporary Public Sculpture: Tradition, Transformation and Controversy* (New York: Oxford University Press, 1992), 29–39; and Robin Wagner-Pacifici and Barry Schwartz, "The Vietnam Veterans Memorial: Commemorating a Difficult Past," *American Journal of Sociology* 97 (September 1991): 376–420.

8. This was rectified in 1984 when a body from Vietnam was added to the site. The Tomb of the Unknown houses the body of an unidentified soldier from World War I. Three separate graves in front of the tomb contain bodies from World War II, the Korean War, and Vietnam. Together these comprise the Tomb of the Unknowns. See http://www.dcmilitary.com/army/standard/12_23/38142–1.html, accessed December 6, 2005.

9. Remarks by Scruggs, SUNY, Purchase, October 1988.

10. The characters Nick, John, and Michael went to Vietnam the morning after John's wedding. John returns a paraplegic; Nick becomes a drug addict and eventually commits suicide in an illegal gambling game evolved from a form of wartime torture. Michael returns to Vietnam to find him, only to bring his body home.

11. See Hagopian, 83, for a detailed discussion.

12. The other founding members of the VVMF were Robert Doubek, a friend of Scruggs and a Washington lawyer, and John Wheeler, also a lawyer and a West Point graduate. Both were Vietnam veterans. Their early activities and fundraising attempts are discussed in Scruggs and Swerdlow, 7–59.

13. During World War II the site was the home of temporary quarters built for the Navy. After these were torn down in the late 1960s, it became a frequent setting for anti-war protesters. For the Bicentennial in 1976 it was transformed into a landscaped park. The history of the site is recounted in J. Carter Brown, "The Mall and the Commission of Fine Arts," *Studies in the History of Art* 30 (1991): 248–261. According to Brown, "Legend has it that the idea originated with President Richard Nixon's remark to John Ehrlichman, while on the presidential helicopter, that the site's temporary buildings in which he had worked during World War II, ought to go" (251).

14. Public Law 96–297 was signed by President Jimmy Carter on July 1, 1980. The VVMF was given five years to build their privately funded memorial. Every aspect of the design would require the approval of the Department of the Interior (since the site, as federal land, is under the jurisdiction of the National Park Service), the Fine Arts Commission (their approval is necessary for all aesthetic additions or improvements on public property in the District of Columbia), and the National Capital Planning Commission (in charge of preserving the city's original plan).

15. The VVMF hired Paul Spreiregen to manage the competition. He had recently published a book on the subject: *Design Competitions* (New York: McGraw-Hill, 1979).

16. Members of the jury were recommended by Spreiregen and approved after being interviewed by Scruggs and the two other founding members of the VVMF. The jury consisted of architects Pietro Belluschi and Harry Weese; landscape architects Hideo Sasaki and Garrett Eckbo; critic Grady Clay (editor of *Landscape Architecture*); and sculptors Richard Hunt, Constantino Nivola, and James Rosati.

17. *The Vietnam Veterans Memorial Fund Design Competition: Design Program*, 1980.

18. Kirk Savage, *Monument Wars: Washington, D.C., the National Mall, and the Transformation of the Memorial Landscape* (Berkeley: University of California Press, 2009), 267.

19. The VVMF, apparently, was not united. James Webb, author of the novel *Fields of Fire*, objected but was overruled. Webb, together with Tom Carhart, who had resigned from the VVMF to submit his own design, became the most vocal critics of Lin's design. See Joan Pachner, "Whose Memorial Is It Anyway?" (unpublished paper, New York University, 1982), 5–9.

20. Lin's design stipulated two one-hundred-foot-long walls. The dimensions were changed to accommodate the listing of all the names.

21. Lin, as quoted in Hess, "A Tale of Two Memorials." Daniel Abramson discussed the narrative implications of the listing of the names in "Maya Lin and the 1960s: Monuments, Time Lines, and Minimalism," *Critical Inquiry* 22 (Summer 1996): 679–709. How to list the names became a critical issue in the evolution of the design for a 9/11 national memorial; Lin was a member of the jury. See chapter 5 for further discussion of this issue.

22. Savage, 270ff, discusses the nature of this experience.

23. Hagopian, 351ff.

24. Helene Lipstadt, "Learning from Lutyens," *Harvard Design Magazine* (Fall 1999): 65–70, argues that Lutyens has "reconceptualized precedent" into an "experiential

architecture of existential meaning," thereby creating an anti-monument. A similar interpretation of Maya Lin's design was one of the strongest objections to it.

25. Poppies were adopted as a symbol of remembrance for World War I because this brilliantly colored flower continued to grow in the muddied soil that was the western front, surviving when little else did.

26. Maya Lin, *Boundaries* (New York: Simon and Schuster, 2000), 4–11.

27. Lin is quoted in "America Remembers," *National Geographic* 167 (May 1985): 557.

28. Suzaan Boettger, *Earthworks: Art and the Landscape of the Sixties* (Berkeley: University of California Press, 2002), 1–8, 16–21. My discussion of the Oldenburg piece is largely based on Boettger's account and analysis. *Sculpture in Environment* was an exhibition sponsored by New York City's Department of Cultural Affairs under the aegis of Doris Freedman, then special assistant for the Department. The exhibition catalogue, *Sculpture in Environment* (New York: Department of Cultural Affairs, 1967) contains a forward by August Heckscher, then Commissioner of Cultural Affairs, and an essay by Irving Sandler. See also Senie, *Contemporary Public Sculpture*, 130–131.

29. Claes Oldenburg, *Proposals for Monuments and Buildings 1965–69* (Chicago: Big Table Publishing Company, 1969), 50–51.

30. Erika Doss, *Memorial Mania: Public Feeling in America* (Chicago: University of Chicago Press, 2010), 44.

31. See Senie, *Contemporary Public Sculpture*, 140ff.

32. Quoted in Boettger, 21. Oldenburg also referred to this piece as a wound. Maya Lin said of her design, "I had an impulse to cut open the earth . . . an initial violence that in time would heal. The grass would grow back, but the cut would remain." See "America Remembers," 557.

33. In 1969 Serra worked with Robert Smithson on his *Spiral Jetty* in the Great Salt Lake, arguably still the most emblematic earthwork. In the summer of the following year Serra and artist Joan Jonas, together with *Artforum* editor Philip Leider, traveled to a remote mesa in Nevada to see Michael Heizer's *Double Negative*, two deep monumental incisions in the land. See Philip Leider, "How I Spent My Summer Vacation, or, Art and Politics in Nevada, Berkeley, San Francisco, and Utah," *Artforum* 9 (September 1970): 40–41.

34. "Rigging," in Richard Serra and Clara Weyergraf, *Richard Serra: Interviews, Etc., 1970–1980* (Yonkers, NY: Hudson River Museum, 1980), 134–135. The interview with Gerard Hovagymyan took place in January 1980. I discuss Serra's work in relation to Lin's design in *The 'Tilted Arc' Controversy: Dangerous Precedent?* (Minneapolis: University of Minnesota Press, 2002), 9–10.

35. Maya Lin, interview with Michael Brenson, Sept. 23, 1998, at New York University in conjunction with the exhibition *Maya Lin: Topologies* at the Grey Art Gallery, Sept. 1–Oct. 31, 1998.

36. Perot is quoted in Hagopian, 106, 114.

37. For an excellent analysis of the political agendas behind the controversy, including the behind-the-scenes activities of the White House, see Hagopian, *The Vietnam War in American Memory*, Chapter 3: "The Discourse of Healing and the 'Black Gash of Shame,'" 79ff.

38. See Hagopian, *The Vietnam War in American Memory*, 349.

39. The inscriptions on the *VVM* are the same size as the names that surround them, and few visitors to the Memorial appear to read them. The inscriptions also appear on

every page of the directories at the site where people pause to look up specific names and find their location on the wall.

40. See "Stop that Monument," *National Review* 19 (September 1981): 1064. Norman B. Hannah, "The Open Book Memorial," *National Review* 33 (December 1981): 146, wrote, "The memorial is clearly an 'open book' in which Americans not only honor their dead, but see the Vietnam War in the stream of history. . . . This is the 'open book' memorial. That is what it looks like, and that is what it means." This interpretation is also discussed by Charles L. Griswold, "The Vietnam Veterans Memorial and the Washington Mall: Philosophical Thoughts on Political Iconography," *Critical Inquiry* 12 (Summer 1986): 708. Arthur C. Danto, "The Vietnam Veterans Memorial," in *The State of the Art* (New York: Prentice Hall Press, 1987), 113, observed: "Everything about it is part of a text. Even the determination to say nothing political is inscribed by the absence of a political statement."

41. Hess, 126. Lin complained that throughout the process she was treated like a little girl, no doubt a result of unstated negative prejudices about her gender, youth, and Chinese-American ethnicity. See also Scruggs and Swerdlow, 101–102, 106. Boettger, 17, discusses the placement of Oldenburg's *Placid Civic Monument* in a similar feminist context. Located near the Metropolitan Museum of Art, it provided a clear view of Cleopatra's Needle in Central Park, an Egyptian obelisk dating from about 1500 B.C.E., suggesting a relational connection that is startlingly similar to that of the *VVM* and the *Washington Monument*.

42. Lin, quoted in Hess, 123.

43. Quoted in Scruggs and Swerdlow, 100. According to the authors, "After that, no one mentioned making the wall white."

44. For a discussion of Carhart's comments and their effect in the media see Scruggs and Swerdlow, 100ff. Carhart had entered the design competition with a representational sculpture of an officer standing in a purple heart and lifting the dead body of a G.I. in a sacrificial gesture. See Scruggs and Swerdlow, 80–81.

45. This was reported in professional journals and the general press. See, for example, *Architectural Record*, February 1982, 28, and *New York Times,* January 13, 1982, and January 27, 1982, in the "Washington Talk" column.

46. This is the essential theme of Hagopian's invaluable study.

47. Scruggs, as quoted in Hagopian, 82, said that he saw the *VVM* project as a way "of getting even for the people killed in Vietnam. Just getting their names up on a wall in Washington, DC, was an act of revenge, a way of getting even for their deaths."

48. Perot's role is discussed by Scruggs and Swerdlow, 23, 45, 61, 67, 99ff, 105ff; Hess, 122–123; and Nicholas J. Capasso, "The National Vietnam Veterans in Context: Commemorative Public Art in America 1960–1997" (Ph.D. diss., Rutgers University, 1998), 193.

49. See Hagopian, 79ff, for a detailed analysis of the behind-the-scenes role played by the Reagan White House.

50. For an interesting discussion of this point and the depiction of the Vietnam War on film, see William Adams, "War Stories: Movies, Memory, and the Vietnam War," *Comparative Social Research* 11 (1989): 165–189.

51. Carole Blair, Marsha S. Jeppeson, and Enrico Pucci Jr., "Public Memorializing in Postmodernity: The Vietnam Veterans Memorial as Prototype," *Quarterly Journal of Speech* 77 (August 1991): 276, contrast Frederick Hart's *The Three Servicemen* with Lin's memorial: "This moment of life contrasts sharply with the wall's narrative of death."

52. Scruggs and Swerdlow, 83–85. Their concern that once they began representing one contingent of the war's participants there would be no end to the demands to represent others proved to be correct.

53. On January 27, 1982, Senator John Warner, a Republican from Virginia and a supporter of the VVMF, called a closed-door meeting. Maya Lin was not present, nor was any representative of the architectural firm Cooper-Leckey, who was in charge of realizing Lin's design. According to a press release from Senator Warner's office dated March 24, 1982, the compromise called specifically for a flagpole with an inscription to be placed atop the apex of the walls "to symbolize the American service men and women who follow and fight for the principles embodied in the American flag" and a statue of "a strong, commanding figure symbolizing those who served in Vietnam" to be placed in front of the walls. The meeting is described in Capasso, "The National Vietnam Veterans Memorial in Context," 94ff; Hess, 125–126; Scruggs and Swerdlow, 100ff. Scruggs observed, "Aesthetically, the design does not need a statue, but politically it does" (101).

54. See Hagopian, 166ff, for a detailed analysis of the politics and political issues behind the placement of both the flagpole and Hart's statue. Most significant was that Reagan needed these location issues to be resolved so he could "invoke the memorial as a symbol of national unity" (174). This was critical because he needed support for his policies in Central America.

55. Blair, Jeppeson, and Pucci, 277 present one exception, as the flagpole is mentioned in their work.

56. The panelists were Arthur (Art) Mosley (who worked in real estate), William (Bill) Jayne (Deputy Director of the Vietnam Veterans Leadership Program), James Webb (a writer), and Milt Copulas (a specialist in Energy). According to Scruggs and Swerdlow, 115, the first two liked Lin's design, the other two didn't.

57. Tom Wolfe, "The Artist the Art World Couldn't See," *New York Times Magazine*, January 2, 2000, 18. Wolfe includes a scathing discussion of the contemporary art world and Hart's non-relationship to it.

58. I first saw Landowski's statue of Norman Prince on a tour of Washington Cathedral on December 19, 2005. My thanks to the docent staff at the Cathedral for answering my questions and providing access to their files. Sources are conflicted as to whether Lt. Norman Prince was the founder of or one of the first six pilots in the Lafayette Escadrille, a famous flying squadron of Americans and Frenchmen who fought the air battle in France during World War I. After his death in 1916, he was buried in the American Pro-Cathedral in Paris. Subsequently it was announced that his body would be entombed in Washington Cathedral and a famous sculptor would create an image for the church. See "War Hero to Rest in Cathedral," *The Cathedral Age* (Midsummer 1919): 118–121.

59. Paul Landowski was born in Poland but worked primarily in France, studying with Auguste Rodin and settling in Boulogne in 1906. A museum dedicated to his work opened there in 1963. Landowski was one of the official sculptors of the Third Republic, a member of the French Academy (1926), and director of the French Academy in Rome (l'Académie de France à Rome, 1933–1937). He was responsible for many monuments in Paris and elsewhere. Perhaps most famously he sculpted the ninety-eight-foot-high statue of Christ the Redeemer that tops the mountain overlooking Rio de Janeiro. See http://perso.wanadoo.fr/artsculpture/Biographie/landowski.htm, accessed December 20, 2005. Landowski remains all but unknown in the United States.

60. Although the visual evidence is overwhelming that Landowski's statue served as a model for Hart's memorial, it is possible that Hart did not specifically remember this source. For a discussion of how it is possible to absorb and incorporate all kinds of information but not recall the source(s) see, for example, Daniel L. Schacter, *The Seven Sins of Memory* (Boston: Houghton Mifflin Company, 2001).

61. Remark made to the author during a tour of Washington Cathedral in December, 2005.

62. "Vietnam Memorial War," *Art News*, January 1983, 10–11.

63. Hart's statement is reproduced in Benjamin Forgey, "Hart's Vietnam Statue Unveiled," *Washington Post*, September 21, 1982, B1.

64. Hagopian, 193.

65. Diane Carlson Evans, "Moving a Vision: The Vietnam Women's Memorial," Vietnam Women's Memorial Foundation website; available at http://www. vietnamwomensmemorial.org/pdf/dcevans.pdf; accessed September 28, 2005. Additional information was provided by Evans in an e-mail to the author dated January 10, 2006. All quotes, unless otherwise noted, are from these sources.

66. Evans is quoted in Kim Heikkila, "Citizen Jane: *China Beach*, the Vietnam Women's Memorial, and U.S. Popular Memory" (paper presented at the annual Popular Culture Association Conference, University of Minnesota, April 14, 2001); revised for *In-Country Women* (May 14, 2001); available at http://www.illyria.com/vnheikkila.html; accessed October 12, 2005.

67. Evans met Brodin at a veterans' reunion in Minnesota. His bronze sculpture *The Squad* was included in an exhibition of art by veterans. Impressed by his realistic depiction of thirteen "grunts" on patrol, Evans was again reminded of her war years, and she asked Brodin to create an image suitable for her intended tribute to women of the war.

68. The day before the Commission approval meeting, Benjamin Forgey wrote "*The Nurse* in answer to Hart's statue has no psychological or physical relationship with the memorial as a whole." ("Women and the Wall Memorial Proposal: Honor without Integrity," *Washington Post*, October 22, 1987, E11.) Hart testified that his sculpture created a delicate balance with the Wall that would be upset by another addition, and Maya Lin wondered where it would all end. J. Carter Brown, head of the Commission, told the press that it didn't matter what the sculpture looked like, "it would still detract from the enormous power of the memorial" (Forgey, E11). Elsewhere Brown observed that Brodin's maquette resembled a nurse about to "upchuck into her helmet" ("Washington's Memorial Mania," *Newsweek,* May 27, 1991, 25.) Marling and Wetenhall, "The Sexual Politics of Memory: The Vietnam Women's Memorial Project and 'The Wall,'" 362, observed, "What Brown neglects to specify, however, is precisely how much *The Nurse* might dilute the power of the Wall as compared to how much the existing statue on the site—*Three Fighting Men*—already compromises the Wall's inclusive embrace by its omission of women."

69. The two first-place winners were Robert Desmon, then of Green River, Wyoming, and Eileen Barry of East Islip, New York. The VVMF board members who selected Goodacre were Diane Carlson Evans, Doris Troth Lippman, Judith Helein, Daniel Daly, Wilma Blackman, A.J. Carson, Shirley G. Crowe, and Evangeline Jamison. Information provided by Carlson Evans in an email to the author, January 10, 2006. See also Hagopian, 304.

70. For a description of the fractious competition and original choices see Hago-pian, 305. Like Hart, Goodacre was unknown in the official high-art world. In 1998 she designed the seven-and-a-half-foot-high portrait of Ronald Reagan for the Reagan Library in California. A year later she created the image of Sacagawea for the U.S. dollar coin.

71. Before presenting Goodacre's design to the Fine Arts Commission for approval, the VWMP solicited endorsements from the American Legion, Veterans of Foreign Wars, Vietnam Veterans of America, Paralyzed Veterans of America, and Disabled American Veterans.

72. Goodacre's interpretation is taken from "Vietnam Women's Memorial: Sculptor's Notes," http://www.vietnamwomensmemorial.org/pages/frames/memorial12.html; accessed September 27, 2005. All quotations, unless otherwise noted, are taken from this source.

73. See, for example, Michele H. Bogart, *Public Sculpture and the Civic Ideal in New York City: 1890–1930* (Chicago: University of Chicago Press, 1989); Cynthia Mills and Pamela H. Simpson, eds., *Monuments to the Lost Cause: Women, Art, and the Landscapes of Southern Memory*; and Marina Warner, *Monuments & Maidens: The Allegory of the Female Form* (New York: Atheneum, 1983).

74. Jill Johnson, "Three Women in Bronze—Three Sisters in Vietnam," *The Seattle Times*, April 28, 2002, J1.

75. Eric Schmitt, "A Belated Salute to the Women Who Served," *New York Times*, November 12, 1993, A1, 29. Schmitt explains that President Clinton was attending a wreath-laying at the Tomb of the Unknown Soldier and spoke at Arlington National Cemetery because he "had a strained relationship with the military partly because he avoided the draft during the Vietnam War."

76. John Bodnar, *Remaking America: Public Memory, Commemoration, and Patriotism in the Twentieth Century* (Princeton, NJ: Princeton University Press, 1992), 5.

77. For a discussion of Arlington National Cemetery see James Mayo 170–190. Arlington was initially considered a Union cemetery, although hundreds of Confederate soldiers were buried there. Not until 1900 was a section set aside for the Confederate side. See http://www.arlingtoncemetery.mil/VisitorInformation/MonumentMemorials/Confederate.aspx; accessed December 29, 2010.

78. Sonja K. Foss, "Ambiguity as Persuasion: The VVM," *Communication Quarterly* 34 (Summer 1986): 326–340, argues that the refusal to take a stand on the war is tantamount to a negative interpretation of it. Peter Ehrenhaus, "Silence and Symbolic Expression," *Communication Monographs* 55 (March 1988): 41–57, defines silence "as the absence of speech or as the refusal to speak," and considers silence as a specific type of "encounter," focusing on "what one can do in silence, what one can come to know through silence" (41). He concludes that, "In its deviation from convention, the VVM embodies an object-silence that is politically strategic" (49).

79. Kristin Ann Hass, *Carried to the Wall: American Memory and the Vietnam Veterans Memorial* (Berkeley: University of California Press, 1998), 34ff, discusses the primary role of Gettysburg in the focus on individual graves. For an analysis of the preoccupation with names in the memorial process, see Thomas W. Laqueur, "Names, Bodies, and the Anxiety of Erasure," in *The Social and Political Body*, ed. Theodore R. Schatzki and Wolfgang Natter (New York and London: The Guilford Press, 1996), 123.

80. Harry W. Haines, "What Kind of War? An Analysis of the Vietnam Veterans Memorial," *Critical Studies in Mass Communication* 3 (March 1986): 6, observed, "the Memorial's enshrinement is Thanatotic by virtue of its placement *in* the earth" and that Lin's "design mutes the debate [over the war], makes it inappropriate in the shadow of the dead."

81. Richard Morris, "The VVM and the Myth of Superiority," in *Cultural Legacies of Vietnam: Uses of the Past in the Present*, ed. Richard Morris and Peter Ehrenhaus (Norwood, NJ: Ablex Publishing Corporation, 1990), 199–222, identifies two American memorial traditions: romanticist and heroist. He associates the *VVM* with the former, which he links to the development of landscape cemeteries.

82. Morris, 202. The history of Mount Auburn Cemetery and American cemeteries in general will be discussed further in chapter 2.

83. This anecdote is related by Scruggs and Swerdlow, 124. It is repeated in Thomas B. Allen, *Offerings at the Wall: Artifacts from the Vietnam Veterans Memorial Collection* (Atlanta: Turner Publishing, Inc., 1995), 10. Many of the objects discussed here are illustrated in this book. A Purple Heart is a U.S. military medal awarded to those wounded in combat while in service.

84. See, for example, John Ketwig, ". . . and a hard rain fell," in *Unwinding The Vietnam War; From War into Peace*, ed. Reese Williams (Seattle: The Real Comet Press, 1987), 37.

85. My thanks to Janna Schoenberger for research on the Vietnam Veterans Memorial Collection at the Museum Resource Center, which she incorporated in a term paper for a seminar I taught at the CUNY Graduate Center, spring 2009. Much of the material in this section is based on her work, in particular her interview with Tyra Walker at the MRCE on April 6, 2009. In addition to the VVMC, Walker also oversaw another forty collections for the National Parks Service at MRCE.

86. Subsequently, similar collections have been saved at Oklahoma City and the September 11 National Memorial & Museum.

87. Hass, 102, relates the practice of leaving objects at the wall to funerary customs, observing that "the things left at the Wall are not exactly like the things left in . . . cemeteries" (84), and "Although the leap from the grave to a national memorial is new, it is impossible to imagine that the impulse to decorate the wall has not been shaped by . . . funerary traditions" (88).

88. Allen, 5.

89. President Clinton issued a plea to "make memory real" on April 30, 1995, at the Warsaw Ghetto Resistance Organization's commemoration services marking the fiftieth anniversary of the end of World War II and the liberation of the concentration camps. See Melvin Jules Bukiert, "When the Holocaust Isn't News: The Partisan Hymn will live," *New York Times*, May 3, 1995, A23. I previously discussed the leaving of objects at the VVM in "Objects Left, Individuals Remembered: 'Making Memory Real' at the Vietnam Veterans Memorial" in *Memory and Oblivion: Acts of the XXIXth International Congress of the History of Art, Amsterdam 1996*, ed. Wessel Reinink and Jeroen Stumpel (Amsterdam: Erasmus Boekandel, 1999), 1085–1090.

90. A. Cheree Carlson and John E. Hocking, "Strategies of Redemption at The Vietnam Veterans Memorial," *Western Journal of Speech Communication* 52 (1988): 203–215, discuss the objects and letters in terms of personal strategies of rhetoric.

91. Hagopian, 358ff, 365–366, discusses this aspect in some detail.

92. The master of ceremonies was Jan Scruggs. The primary speakers at the 2005 Veterans Day Observance at the Wall, co-hosted by the VVMF and the National Park Service, were Brigadier General Peter M. Dawkins, USA (Retired); and Vice Chairman, Citigroup Bank, and Brigadier General Evelyn "Pat" Foote, USA (Retired). The keynote address was given by General Peter Pace, USMC, the 16th Chairman of the Joint Chiefs of Staff.

93. Maya Ying Lin, "Design Competition: Winning Designer's Statement" (Washington, DC: VVMF, 1982).

94. Hass, 64–86, discusses relevant mainstream burial practices from George Washington's time to the present and describes, among others, African American, Mexican American, Italian American, and Native American funerary customs.

95. Alan Radley, "Artefacts, Memory and a Sense of the Past," in *Collective Remembering*, ed. David Middleton and Derek Edwards (London: Sage Publications, 1990), 46–59, observes "that remembering is something which occurs in a world of things, as well as words, and that artefacts play a central role in the memories of cultures and individuals."

96. Tim O'Brien, *The Things They Carried* (New York: Penguin Books, 1991), 4–25.

97. See Laura Palmer, *Shrapnel in the Heart: Letters and Remembrances from the Vietnam Veterans Memorial* (New York: Vintage Books, 1988) for a collection of poignant examples.

98. Kenneth T. Jackson and Camilo Jose Vergara, *Silent Cities: The Evolution of the American Cemetery* (New York: Princeton Architectural Press, 1989), 120.

99. I discuss this aspect of the VVM in "Aus der Mitte: Das Vietnam Veterans Memorial Ein Mahnmal mit zentripetaler und zentrifugaler Wirkung." In *Denkmale und kulturelles Gedachtnis nach dem Ende der Ost-West-Konfrontation*, ed. Gabi Kolff-Bonekamper and Edward van Voolen (Berlin: Akademie der Kunste, Jovis Verlag, 2000), 251–264. Another facet of the *VVM* exists on the Internet. The chief executive officer of America Online, a Vietnam veteran, created a searchable database of the men and women listed on the *VVM*. One can find the names, hometowns, dates, and causes of death, read personal stories left by others, view photographs, and post messages. Its existence was reported in "America Online," *U.S. News & World Report*, June 5, 1995, 71.

100. Capasso, "The National Vietnam Veterans Memorial in Context," 246.

101. Three were owned by Vietnam Combat Veterans, Ltd., started by John Devitt; one by Service Corporation (SCI), a cemetery developer in Texas; one by Lake County Vetz, a group helping homeless veterans in northern Illinois; and one owned and managed by the VVMF. See "The Facts about Replicas of the VVM," VVMF press release, no date. See also Hagopian, 386ff. SCI, the nation's largest funeral company, offered to build one or two moving walls in order to display them in their cemeteries. A member of the Vietnam Veterans of America responded "that it is hard enough to visit a wall inscribed w/ the names of one's dead friends w/o having to go to a cemetery to view it" (Hagopian, 391).

102. VVMF press release, March 23, 1998.

103. Conversation with Monica Worth, information officer and curator for the VVMF, October 1998.

104. Lisa Gough, Director of Communications, VVMF, email correspondence with the author, December 13, 2005.

105. Chief O'Loughlin offered "a blessing of the Wall and the spirits of those it memorializes," and wanted to "put the healing wall into the hearts of mankind." Rabbi

Goldstein, dressed in an army uniform heavily decorated with medals, led a prayer asking "Almighty God . . . by [whose] decree nations rise and fall . . . surrounded by chariots of fire by an army more powerful than any on earth . . . to recognize their [veterans'] sacrifice . . . [and] uphold standards of their services."

106. VVMF press release, August 15, 1997, states: "Measuring approximately 123 feet apiece, two 'wings' of the replica meet at an angle of 121 degrees and rise to five feet at their vertex. The traveling memorial was constructed by a team of fine craftsmen from Waukegan, IL under the supervision of Lake County Vetz, an organization assisting homeless veterans. Each of the 58,202 names on the Wall is laser-etched into panels of reflective black, powder-coated heavy aluminum supported by a structural aluminum frame."

107. For an excellent analysis of both Lin's and Hart's sculptures as memorial prototypes, see Capasso, "The National Vietnam Veterans Memorial in Context," 240–257.

108. For a discussion of this and various other design proposals for the *Korean War Memorial* see Jory Johnson, "Granite Platoon," *Landscape Architecture* 80 (January 1990): 69–71.

109. Marita Sturken, *Tangled Memories: The Vietnam War, the AIDS Epidemic, and the Politics of Remembering* (Berkeley: University of California Press, 1997) presents a provocative argument linking the history of the Vietnam War and AIDS to U.S. politics at the time.

110. Jones is quoted in Peter S. Hawkins, "Naming Names: The Art of Memory and the NAMES Project AIDS Quilt," *Critical Inquiry* 19 (Summer 1993): 756.

111. Hawkins, 756. Carole Blair, Marsha S. Jeppeson, and Enrico Pucci Jr., "Public Memorializing in Postmodernity: The Vietnam Veterans Memorial as Prototype," also argue that the *VVM* was a prototype for the AIDS quilt.

112. Hawkins, 760.

113. This aspect of mourning is discussed by Elinor Fuchs, "The Performance of Mourning," *American Theatre* 9 (January 1993): 14–17.

114. Robert Harbison, *The Built, The Unbuilt, and the Unbuildable: In Pursuit of Architectural Meaning* (New York: Thames and Hudson, 1991), 66.

115. Jennifer Favorite, "Memory's Challenge: The Vietnam Veterans Memorial Education Center at 'The Wall That Heals,'" unpublished research paper produced as an independent study paper for a course in memorials taught by the author at the CUNY Graduate Center in Fall 2009.

116. "Plans for Education Center to Be Revealed," VVMF press release, September 18, 2000.

117. Jan Scruggs, interview with Robert Siegel, *All Things Considered*, National Public Radio, May 26, 2003, available at http://www.npr.org/templates/story/story.php?storyId=1,275,639; accessed June 14, 2011.

118. "The Legacy of Heroes," http://buildthecenter.org/; accessed June 9, 2011.

119. Scruggs and Swerdlow, 94.

120. Hart's sculpture, in turn, prompted a significant rebirth of representational memorials. It revived the archetypal anonymous "everyman" soldier that had first appeared in commemorations of Union soldiers after the Civil War and amended it to include a narrative element and racially diverse figures. See Capasso, "The National Vietnam Veterans Memorial in Context," for an extensive discussion of this prototype. Adaptations of both Hart's and Lin's memorials now exist nationwide.

121. Rick Miller, "Silently We Commune," in *Writing on the Wall*, ed. Jan C. Scruggs (Washington, DC: Vietnam Veterans Memorial Fund, 1994), 46–49. Miller, a Vietnam veteran, writes movingly of his instinctive response to the Wall as a cemetery and its link to Arlington. He wants to scream at the tourists at the *VVM* who intrude on his mourning, "Leave, leave me alone in this graveyard—this is sacred ground." He directs them to the white graves at Arlington and tells them "this black Wall is a condensed version of that cemetery."

122. As Savage, 276, 279, observed, "soldiers who are not heroes become victims. . . . In the end the didactic push of the inscription justifies the soldiers not as heroic agents but as honorable victims who deserve our recognition."

Chapter 2

1. C. Allen Haney, Christina Leimer, and Julian Lowery, "Spontaneous Memorialization: Violent Death and Emerging Mourning Ritual," *Omega* 35 (1997): 161.

2. A portion of this chapter was previously published as "Mourning in Protest: Spontaneous Memorials and the Sacralization of Public Space," *Harvard Design Magazine* 9 (Fall 1999): 23–27. An expanded version appeared in Jack Santino, ed. *Spontaneous Shrines and the Public Memorialization of Death* (New York: Palgrave Macmillan, 2006), 41–56.

3. Cheryl R. Jorgensen-Earp and Lori A. Lanzilotti, "Public Memory and Private Grief: The Construction of Shrines at the Sites of Public Tragedy," *Quarterly Journal of Speech* 84 (1998): 158, describe this need as "a desire to do something for the dead and for ourselves." Rebecca M. Kennerly, "Getting Messy: In the Field and at the Crossroads with Roadside Shrines," *Text and Performance Quarterly* 22 (October 2002): 230, observes that "acts of making and visiting shrines do seem to have an impact on the individual and communal need to do *something* in response to seemingly senseless events." Sally F. Moore and Barbara G. Myerhoff, eds., *Secular Ritual* (Assen/Amsterdam, the Netherlands: Van Gorcum, 1997), 199, state that "Action is indicated because rituals persuade the bodies first: behaviors precede emotions in the participants."

4. Sylvia Grider, "Spontaneous Shrines and Public Memorialization," in *Death and Religion in a Changing World*, ed. Kathleen Garces-Foley (Armonk, NY, and London: M. E. Sharpe, 2006), 250–251, argues against the usage of "makeshift" to describe these assemblages because they are "specific and deliberate" and provide "a focus of order and purpose to the chaos and destruction."

5. Erika Doss, *Memorial Mania: Public Feeling in America* (Chicago: University of Chicago Press, 2010), 64ff, discusses these memorials as expressions of grief.

6. Kennerly, 239, observes that calling this practice spontaneous dismisses its "cognitive, volitional, and strategic" aspects. Moore and Myerhoff, 17ff, discuss predictability as a salient characteristic of rituals.

7. Moore and Myerhoff, 3, describe secular rituals as "an especially dramatic attempt to bring some part of life firmly and definitely into orderly control." Immediate memorials may indeed be prompted by this impulse, even if the control they exhibit appears disorderly. A number of authors define immediate memorials as rituals. See also, Haney, Leimer, and Lowery, 159–171.

8. Kennerly, 250, defines it as a "public performance of melancholic mourning." Haney et al., 162, observe, "No one is automatically included in or excluded from spontaneous memorialization. People who participate in this ritual are often not included in the culturally prescribed group of mourners. . . . Therefore, spontaneous memorialization extends the boundaries of who is allowed or expected to participate in the mourning process."

9. See, for example, Elizabeth Hallam and Jenny Hockey, eds., *Death, Memory and Material Culture* (Oxford: Berg, 2001).

10. See, for example, Jeannie Banks Thomas, "Communicative Commemoration and Graveside Shrines: Princess Diana, Jim Morrison, My 'Bro' Max, and Boogs the Cat," in *Spontaneous Shrines and The Public Memorialization of Death*, ed. Jack Santino (New York: Palgrave Macmillan, 2006), 17–40.

11. See, for example, Audrey Linkman, *The Victorians: Photographic Portraits* (London: I. B. Tauris Parke, 1993) and *Photography and Death* (London: Reaktion Books, 2011), as well as Karen Sanchez-Eppler, "Then We Clutch the Hardest," in *Sentimental Men: Masculinity and the Politics of Affect in American Culture*, ed. Mary Chapman and Glenn Handler (Berkeley: University of California Press, 1999), 64–88.

12. See Jack Santino, ed., *Halloween and Other Festivals: Death and Life* (Knoxville: University of Tennessee Press, 1994); Regina Marchi, "*El Dia de los Muertos* in the USA: Cultural Ritual as Political Communication," in *Spontaneous Shrines*, 261–283.

13. See, for example, Maida Owens, "Louisiana Roadside Memorials," and Jonathan Lohman, "A Memorial Wall in Philadelphia," in *Spontaneous Shrines*, 119–145 and 177–214.

14. David E. Stannard, ed., *Death in America* (Philadelphia: University of Pennsylvania Press, 1975), xv, remarked that the single theme uniting his anthology reveals "that the way a people look at death and dying is invariably and inevitably a direct concomitant of the way they look at life." Similarly, David Charles Sloane, *The Last Great Necessity: Cemeteries in American History* (Baltimore and London: The Johns Hopkins University Press, 1991), 7, observed that the cemetery is "an excellent primary source on how Americans of a certain time felt about death, art, nature, and society."

15. James J. Farrell, *Inventing the American Way of Death, 1830–1920* (Philadelphia: Temple University Press, 1980), provides a useful analysis of the cultural context of cemeteries. Richard E. Meyer, ed., *Cemeteries and Gravemarkers: Voices of American Culture* (Ann Arbor, MI: U.M.I. Research Press, 1989), 105, observes that cemeteries have "an element of dynamic evolution . . . they reflect changing cultural realities, and they take on distinctive flavors relating to regionalism, ethnicity, religious influence, and a whole host of other factors."

16. J. B. Jackson, "The Vanishing Epitaph: From Monument to Place," *Landscape Journal* 17 (1967): 23.

17. See Sloane, 11, and Kenneth T. Jackson and Camilo Jose Vergara, *Silent Cities: The Evolution of the American Cemetery* (Princeton, NJ: Princeton Architectural Press, 1989), 36. Additionally, segregation was practiced in national as well as local cemeteries, with Arlington National Cemetery segregated until 1948, when President Truman issued an executive order to desegregate the armed forces. See Jackson and Vergara, 26.

18. Sloane, 11, observes that the "dead were unprotected" and frequently moved around, reflecting not only the growth of towns but the belief that the dead threatened the living, with graveyards emitting noxious gases that spread disease.

19. See Farrell, 99.

20. Stanley French, "The Cemetery as Cultural Institution: The Establishment of Mount Auburn and the 'Rural Cemetery' Movement," *American Quarterly* 26 (March 1974): 56–57, suggests that the rural cemetery movement helped pave the way for Central Park in that Andrew Jackson Downing's 1841 treatise calling for public parks mentions the popular use of Mount Auburn Cemetery. Blanche Linden-Ward, *Silent City on a Hill* (Columbus: Ohio State University Press, 1989), 12–13, states, "Mount Auburn inspired the first proposals for public parks . . . [Andrew Jackson Downing] can be credited with achieving public funding for New York's Central Park."

21. French, 84, states that the intended civic role of the cemetery was to "provide a strong improving influence on all members of society."

22. Sloane, 12, 97.

23. Farrell, 130.

24. The first lawn cemetery plan was developed by landscape gardener Adolph Strauch at the Cemetery of Spring Grove, Cincinnati, in 1855. See Sloane, 97; Farrell, 113. According to Jackson and Vergara, 30, Forest Lawn is the "most visited private burial place in the U.S."

25. Geoffrey Gorer, "The Pornography of Death," *Encounter* 5 (October 1955): 49–52.

26. Jessica Mitford, *The American Way of Death* (New York: Simon and Schuster, 1963). Farrell, 213, argues with Mitford's centrality of the profit motive, emphasizing instead the "complexity of cultural change."

27. Richard Huntington and Peter Metcalf, *Celebrations of Death: The Anthropology of Mortuary Ritual* (Cambridge: Cambridge University Press, 1979), 187–195, discuss the depersonalization of death rituals, concluding that, "The endless shying away from confrontation with mortality is undeniably a marked feature of American culture."

28. Catherine Howett, "Living Landscapes for the Dead," *Landscape* 17 (1967): 9, observes that "the places where we bury our dead are no longer important parts of the landscape we inhabit. Our postmodern culture has lost touch with older conceptions of the cemetery as 'sacred space,' second only to the church as a physical manifestation of the community's attitude toward the ultimate questions of life and death." Jackson and Vergara, 97, sum up the decline: "In the last decade of the twentieth century, American cemeteries seem anachronistic and irrelevant. To many, they occupy valuable space, which could be put to better use. To others, they are almost invisible. They are unvisited, unloved and unimportant. A century ago, cemeteries stood, along with hospitals, churches and schools, as major institutions of urban life."

29. Jackson and Vergara, 72.

30. For a discussion of this aspect of immediate memorials, see Jorgensen-Earp and Lanzilotti, 151, and Haney et al., 161.

31. Kennerly, 249.

32. Jack Kerouac, "Introduction," in Robert Frank, *The Americans* (New York: Grove Press, 1959), 9.

33. Tom Lewis, *Divided Highways: Building the Interstate Highways, Transforming American Life* (New York: Viking, 1997), ix, observes that, "The Great Wall of China and the Interstate Highway system are among the only human creations that can be seen by astronauts from an orbiting spacecraft."

34. James M. Jasper, *Restless Nation: Starting Over in America* (Chicago: University of Chicago Press, 2000), x, argues that the essence of the United States is the belief "that

people can start over, at any time, and make the kind of life they desire." He sees this as the basis for the American dream "displaced onto the Frontier, the West, someplace farther along the trail," 30. Finally, he concludes, "For us the road itself is a place, in fact our favorite place," 246.

35. Jean Baudrillard, *America* (London, New York: Verso, 1989), 1, 9.

36. The National Highway Traffic Safety Administration provides statistics on fatalities nationally and state by state, available at www.nhtsa.gov; accessed September 23, 2014. See also http://www.madd.org/statistics; accessed September 23, 2014.

37. Owens, 138, suggests that perhaps the real reason that roadside memorials "make people uncomfortable . . . is that we don't want to admit that the most dangerous thing that most of us do is get in a car." She speculates that perhaps "we value our freedom and mobility too much to address it."

38. Holly Everett, "Roadside Crosses and Memorial Complexes in Texas," *Folklore* 111 (April 2000): 91, mentions that roadside crosses date from 1689. See also Alberto Barrera, "Mexican-American Roadside Crosses in Starr County," in *Hecho en Tejas: Texas-Mexican Folk Arts and Crafts*, ed. Joe Stanley Graham (Denton: University of North Texas Press, 1991), 278–292; Cynthia Henzel, "*Cruces* in the Roadside Landscape of Northeastern Mexico," *Journal of Cultural Geography* 11 (1991): 93–106; and David Kozak and Camillus Lopez, "The Tohono O'odham Shrine Complex: Memorializing the Locations of Violent Death," *New York Folklore* 17 (Winter–Spring 1991): 1–20.

39. Owens, 125; Holly Everett, *Roadside Crosses in Contemporary Memorial Culture* (Denton: University of North Texas Press, 2002), 78, 103.

40. Everett, "Roadside Crosses and Memorial Complexes," 92, notes "car parts collected from the wreckage of the inciting accident." Owens, note 14, 140, observes a similar custom in Arizona and Yugoslavia where the steering wheel and tires are "incorporated into the more elaborate sites."

41. Owens, 129, reports that, based on her two-year survey, the custom is widespread in twenty-nine states, five Canadian provinces, four Latin American countries, and seven other countries. She cites several distinctly non-Catholic examples, including native American reservations in Montana and Arizona.

42. Everett, "Roadside Crosses and Memorial Complexes," 92, cites 1984 as the date the first MADD cross appeared in Austin, Texas. These markers note the name and birthdate of the victim, the words "killed at this location" followed by the date, and then "by a drunk driver."

43. Michael J. McCarthy, "Roadside Memorials Bring Some States a New Kind of Grief," *Wall Street Journal*, March 10, 1997, A12, reports that Jewish groups and the American Civil Liberties Union protested the crosses in both Boulder County, Colorado, and the state of Florida. Ian Urbina, "As Roadside Memorials Multiply, a Second Look," *New York Times*, Feb 6, 2006, A19, notes that in 2001 a lawyer with the Freedom from Religion Foundation in Madison, Wisconsin, successfully defended a Denver man who was arrested for removing a religious roadside memorial.

44. Everett, *Roadside Crosses in Contemporary Memorial Culture*, 25–37, argues that crosses may be seen as an expression of civil religion, as first articulated by Jean Jacques Rousseau in *The Social Contract* (1762).

45. Owens, 131, notes that Judith Martin ("Miss Manners") devoted several columns to the practice between 1996 and 2003. She endorsed "the new 'etiquette of catastrophe'

where the site of the disaster . . . may serve as well as the tombstone to make one feel near to the dead person."

46. There is ample bibliography on the death of Princess Diana. Adrian Kear and Deborah Lynn Steinberg, eds., *Mourning Diana: Nation, Culture and the Performance of Grief* (London and New York: Routledge, 1999) provide a range of analyses and interpretations.

47. George Monger, "Modern Wayside Shrines," *Folklore* 108 (1997): 113, suggests that "the massive TV coverage of Modern Wayside Shrines 'the Anfield Pilgrimage' disseminated the idea across the country." Similarly, Owens, 130, observes "Local and national media, through television and newspapers, have influenced the spread of this tradition with both high-profile, out-of-state cases and local sites considered news-worthy." See also Suzanne Greenhalgh, "Our Lady of Flowers: The Ambiguous Politics of Diana's Floral Revolution," in *Mourning Diana*, 41, and Hege Westgaard, "'Like a Trace:' The Spontaneous Shrine as a Cultural Expression of Grief," in *Spontaneous Shrines*, 162.

48. Robert James Smith, "Roadside Memorials—Some Australian Examples," *Folklore* 110 (1991): 103–105, studied the practice in New South Wales in Australia. He noted this pilgrimage practice with bus accidents involving tourists on holiday.

49. In Roman Catholic belief, an individual who has died without the administration of last rites, such as the victim of sudden death, requires a special appeal to God. Everett, *Roadside Crosses in Contemporary Memorial Culture*, 18, discusses the belief that the "'victim's spirit is troubled' and therefore remains at the site rather than moving on to the next life." Barrera, 279, reports this comment by a Mexican-American family member: "It is the place where the victim's soul departed from the body."

50. Thomas, 3.

51. Barrera, 281, notes one example that still exhibited fresh flowers forty-four years after it was created.

52. Owens, 132.

53. Kennerly, 247–248.

54. See, for example, Everett, "Roadside Crosses and Memorial Complexes," 97–98; Kennerly, 244, 247; Monger, 114; Smith, 103,105; and Michael A. Fuoco, "The Crossroads of Tragedy and Tribute: Road Memorials Help Families Cope with the Anguish of Losing a Loved One," *Post-Gazette*, Jan 14, 2001, available at http://old.post-gazette.com/magazine/20010114memorials2.asp; accessed July 2, 2012.

55. See, for example, Hank Seaman, "Mother Warns of Drunken-driving Deaths," *Southcoast Today*, March 29, 2004, available at http://www.southcoasttoday.com/apps/pbcs.dll/article?AID=/20040329/NEWS/303299997; accessed July 2, 2012.

56. Smith, 104.

57. On fame, see for example, Leo Braudy, *The Frenzy of Renown: Fame and Its History* (New York: Oxford University Press, 1986), and Joshua Gamson, *Claims to Fame: Celebrity in Contemporary America* (Berkeley: University of California Press, 1994).

58. There can be no celebrity without publicity. Braudy, 3–4, notes, "From the beginning, fame has required publicity. . . . In the past that medium was usually literature, theater, or public monuments. With the Renaissance came painting and engraved portraits, and the modern age has added photography, radio, movies, and television." And subsequently, the Internet has expanded venues exponentially.

59. Zoe Sofoulis, "Icon, Referent, Trajectory, World," in *Planet Diana: Cultural Studies and Global Mourning*, ed. Ien Ang, Ruth Barcan, et al., (Kingswood, NSW, Australia: University of Western Sydney, Nepean, 1997), 13, concludes that "distinctions between mediated and actual emotions break down the closer one examines the psychology of emotions and identifications. The feelings about Diana's death, like feelings generally, were both mediated *and* real."

60. Diana Taylor, "Downloading Grief," in Kear and Steinberg, 187–210, argues that the outpouring of grief for Princess Diana was mediated, manipulated, and ultimately unreal. Maureen Dowd, "Death and the Maiden," *New York Times*, September 3, 1997, A23, disdains celebrity culture as "a mass psychosis. . . . All that the celebrity culture teaches is a counterfeit empathy, which mistakes prurience for interest and voyeurism for a genuine human identification. Living vicariously is not the same thing as living imaginatively."

61. Thomas de Zengotita, "Celebrity, Irony and You," *The Nation*, December 2, 1996: 15–18, argues that the lives of celebrities provide the subject of social discourse, thereby creating a common bond among spectators.

62. The response to Princess Diana's death was widely interpreted as a protest to the royal family and its refusal to recognize her. See, for example, various essays in Kear Steinberg, Ang, Barcan et al.

63. See, for example, Susan Sachs, "The Celebrity Who Was a 'Regular Guy,'" *New York Times*, July 23, 1999, A20.

64. Senator Kennedy's speech was widely reprinted. See, for example, "The Kennedy Memorial: In Eulogy, Senator Recalls Nephew Who Belonged to the American Family," *New York Times*, July 24, 1999, B4.

65. "Tragedy Revisits the Kennedys," *New York Times*, July 19, 1999, A16.

66. Michael Wolff, "Kennedy With Tears," *New York*, August 2, 1999, 26–29. William Safire, "Is Life Unfair?" *New York Times*, July 19, 1999, A17, observed "the Kennedy dream seemed to have died again. All the what-ifs returned."

67. Francis X. Clines, "Streams of Strangers Keep Vigils," *New York Times*, July 19, 1999, A1, A13.

68. See, for example, N. R. Kleinfield, "Doors Closed, Kennedys Offer Their Farewells," *New York Times*, July 24, 1999, A1, B4.

69. Wickham Boyle, "A TriBeCa Goodbye," *New York Times*, August 1, 1999, CY13.

70. Boyle, CY13.

71. Jane Gross, "Small Gestures of Grief for a Young Man Larger Than Life," *New York Times*, July 22, 1999, B1.

72. "A Week of Grieving," *New York Times*, July 25, 1999, WK14.

73. See, for example, Andrew C. Revkin, "Haze and Darkness Combined to Make Flight to Martha's Vineyard Risky, Pilots," *New York Times*, July 19, 1999, A12. A summary of opinions on the crash can be found at "JFK Jr. Pushed Safety Limits, Pilots Say," *St. Petersburg Times Online*, July 19, 1999, available at http://www.sptimes.com/News/71999/Worldandnation/JFK_Jr_pushed_safety_.shtml; accessed July 2, 2012. At the time of his death, JFK Jr. had his pilot's license for little over a year, had not yet qualified for flying using only cockpit instruments, and only recently recovered from a foot injury. The weather conditions were marginal, it was dark, and there was no flight instructor along.

74. For an excellent analysis of this event and its repercussions, see Deborah Parédez, "Remembering Selena, Re-membering *Latinidad*," *Theatre Journal* 54 (March 2002): 63–84. The following discussion is largely based on her article.

75. A chain link fence was also used as the support for an immediate memorial in Oklahoma City the following month and subsequently after 9/11 at St. Paul's Chapel adjacent to Ground Zero.

76. These included magazine articles, television specials, websites, films and videos, commemorative Coca-Cola bottles, murals in her hometown of Corpus Christi, Texas, and in New York City, a museum, and much more. See Parédez, 65.

77. Ilan Stevens, "Santa Selena," *Transition* 70 (1996): 42.

78. Parédez, 66.

79. Robert Hanley, "Gunfire From Car Kills Child and Man on East Orange, N.J., Sidewalk," *New York Times*, August 22, 2003, B5. This is but one example of a widespread phenomenon.

80. See Janice Mann, "'Malice Green Did Like Jesus': A Detroit Miracle Story," in *Reclaiming the Spiritual in Art: Contemporary Cross-Cultural Perspectives*, ed. Dawn Perlmutter and Debra Koppman (Albany: SUNY Press, 1999), 117–128.

81. For an analysis of African and African-American burial practices, see John Michael Vlach, *The African-American Tradition in Decorative Arts* (Athens and London: University of Georgia, 1990), 139–147.

82. For a discussion of memorial walls see Martha Cooper and Joseph Sciorra, *R.I.P.: Memorial Wall Art* (New York: Henry Holt & Company, 1994).

83. Vlach, 143.

84. See Todd S. Purdum, "A Police Shooting Death, A Study in Contrasts," *New York Times*, June 5, 1999, A9.

85. Dan Barry and Maria Newman, "Boys Tell of Man's Beating, but None Use the Word 'Murder,'" *New York Times*, June 29, 2001, B1.

86. Brian Land and Wilfred Gregg, *The Encyclopedia of Mass Murder* (New York: Carroll & Graf, 1994), 5, state, "In many respects the workplace represents a macrocosm of the family home, with managers and supervisors cast in a 'parental'—or sometimes 'spouse'—role, and workmates as 'siblings.'"

87. On the San Ysidro shooting and its aftermath see Jessica Gresko, "20 Years Later, San Ysidro McDonald's Massacre Remembered," *NC Times*, July 17, 2004, available at http://www.nctimes.com/news/local/article_2ba4343e-7009-54ce-98df-79a23ff8d0d7.html; accessed July 2, 2012.

88. See Joe Deegan, "Fear Tracer," *San Diego Reader*, July 7, 2005. The ethnicity of the preponderance of victims was reflected in one study of the consequences of the shooting. Researchers interviewed recent immigrant poor Mexican American women, 35–50 years of age. See also Richard Hough, William Vega et al., "Mental Health Consequences of the San Ysidro McDonald's Massacre: A Community," *Journal of Traumatic Stress* 3 (January 1990): 71–92.

89. Fast food restaurant shootings don't always result in the closing of those restaurants. On October 16, 1991, George Hennard drove his truck through the window of Luby's Cafeteria in Killeen, Texas, and then, using a Glock 17 and a Ruger P89, shot and killed twenty-three and wounded twenty before shooting himself after he was wounded by police. This supplanted San Ysidro as the worst mass shooting in U.S. history.

Nevertheless, Luby's stayed open for another nine years, finally closing for financial reasons. See Thomas C. Hayes, "Dozens of Others are Wounded in Worst Mass Shooting: Gunman Kills 22 at a Cafeteria in Texas," *New York Times*, October 17, 1991, A1.

90. See "McDonald's Memorial," *Find A Grave* (organization website), available at http://www.findagrave.com/cgi-bin/fg.cgi?page=gr&GRid=11,353; accessed July 2, 2012.

91. Kenneth E. Foote, *Shadowed Ground: America's Landscapes of Violence and Tragedy* (Austin: University of Texas Press, 1997), 7ff.

92. David B. Nance, "Descansos: Roadside Memorials on the American Highway," available at http://webpages.charter.net/dnance/descansos/descansos-main.htm; accessed July 2, 2012. Nance links the practice of roadside memorials to *descansos*, literally, resting places, created at rest stops by members of Hispanic funeral processions en route between church and cemetery. All quotes, unless otherwise noted, are from his website. The site also includes technical information on cameras, film, and lenses, and provides sources of the scanned images.

93. One particularly poignant narrative reads: *Amy. U.S. Hwy. 24, near Red Cliff, Colorado.* Just north of the high bridge at Red Cliff on US 24 between Leadville and Vail, the highway begins its winding climb over Battle Mountain. Until recently, some stretches of this road did not have guardrails between the road and the steep plunge to the bottom of the Eagle River canyon below. This cross was in a pullout along the highway, 700 feet above the bottom of the canyon, where there were no guardrails or other markers to show the edge. Amy, a young woman form Leadville, accidentally drove off of here in the middle of a summer's night in 1999. I took this photo a few weeks later. When I passed this spot in May, 2000, there were some plastic flowers tied to the new guard rail that now protects this pullout, but this cross was gone. Amy's car, however, is still there. The canyon is very narrow, with no access by road, and barely enough room even for the railroad track that winds through along the river. Cars that fall into this canyon—and Amy's was not the first—are much too difficult to remove. Instead, they are simply pushed off the tracks and left where they are.

94. Leslie Hoffman, "Fine Arts: Shrines Preserve the Memory of Loss," *Post-Gazette*, February 21, 2003, available at http://old.post-gazette.com/ae/20030221shrines0221fnp7.asp; accessed July 2, 2012. Hoffman observed, "while the concept is intriguing, the photographs fall a bit flat sometimes and seem to wallow in the giant space of the gallery."

95. Broches's comments were included in the exhibition she co-curated with Iris Falck Donnelly, "Sites of Memory and Honor," Hera Gallery, Wakefield, Rhode Island, March 13–April 17, 2004. In addition to her and Donnelly's work, the exhibition included contributions by Sylvia de Swaan and Dietrich Christian Lammerts. See http://www.heragallery.org/exhibitions/exhibitionarchive/sitesofmemory.htm; accessed July 2, 2012.

96. Tomas Ybarra-Frausto, "Cultural Context," *Ceremony of Memory: New Expressions in Spirituality Among Contemporary Hispanic Artists* (Santa Fe: Center for Contemporary Arts of Santa Fe, 1988), 9–13. The artists in the exhibition were Juan Boza, Maria Brito-Avellana, Rimer Cardillo, Enrique Chagoya, Eddie Dominguez, Cristina Emmanuel, Carmen Lomas Garza, Celia Alvarez Munoz, Maximiliano Pruneda, Patricia Rodriguez, Peter Rodriguez, and Angel Suarez Rosado. For a further discussion of these cultural practices see, for example, Pat Jasper and Kay Turner, *Art among us/Arte entre nosotros: Mexican American Folk Art of San Antonio* (San Antonio, TX: San Antonio Museum Association, 1986); Patricia Fernandez Kelly, "Death in Mexican Folk Culture,"

in Stannard, 92–111; Regina Marchi, "El Dia de los Muertos in the USA: Cultural Ritual as Political Communication," in Santino, 261–283; and Joseph Sciorra, "Yard Shrines and Sidewalk Altars of New York's Italian-Americans," *Perspectives in Vernacular Architecture* 3 (1989): 185–198.

97. Amalia Mesa-Bains is quoted in Linda Weintraub, *Art on the Edge and Over* (Art Insights: Litchfield, CT: 1996), 93.

98. Mesa-Baines, in Weintraub, 95.

99. David Rubin, *Contemporary Hispanic Shrines* (Reading, PA: Freedman Gallery, Albright College, 1989), np.

100. Mesa-Bains, in Weintraub, 95.

101. Amalia Mesa-Bains, "Artists Working in Social Space: A Theoretical Approach," available at http://www.thephotographyinstitute.org/journals/1998/mesa_bains.html; accessed July 2, 2012.

102. Mesa-Bains, "Artists Working in Social Space," makes specific reference to the immediate memorials to Princess Diana and to Polly Klaas, the twelve-year-old California girl who was abducted from her home during a slumber party. See Polly Klaas Foundation website, at www.pollyklaas.org; accessed July 2, 2012.

103. Thomas Hirschhorn, "Four Statements, February 2000," in *Public Art: A Reader*, ed. Florian Matzner (Ostfildern-Ruit, Germany: Hatje Cantz, 2004), 247.

104. Christopher Phillips, "Art for an Unfinished City," *Art in America* (January 1999): 62–69. Phillips, in this review of the Berlin Biennale, observed that Hirschhorn's "was one of the few works in the Biennale that dared to directly engage Berlin's past as well as its people." He noticed "passersby from all walks of life stop to mutter, 'Otto Freundlich?' and then stay to try to piece the artist's story from the tattered materials on hand."

105. The idea of placing an altar for the American writer Raymond Carver in Fribourg appealed to Hirschhorn: "A makeshift monument, in a place where he did not live, where he did not die, but where he could have lived and died. . . . The *Altar to Raymond Carver* could be everywhere, and, for that reason, it's here. . . . I selected the site to the proximity of water under a bridge, next to a road that leads the walker nowhere. In any case, the only walkers are dog owners, who take their animals outside to piss or shit. The site seemed appropriate for this writer, who wrote about the shattered American dream." Thomas Hirschhorn, "Text: Thomas Hirschhorn, June 27, 1998," available at http://web.archive. org/web/20010528040136/http://www.thegalleriesatmoore.org/publications/hirsch/ statement.shtml; accessed July 2, 2012.

106. Hirschhorn, in Matzner, 248. For a discussion of the U.S. installation of his Raymond Carver altar, see Douglas Fogle, "No Heroics Please," available at http://web. archive.org/web/20010528042838/http://www.thegalleriesatmoore.org/publications/ hirsch/fogle.shtml; accessed July 2, 2012. Fogle observed, "Carver is a fitting subject for an artist who is a champion of the precarious, the ad hoc, the provisional, and the anti-hierarchical. A creator of non-monumental monuments. An anti-heroic supporter of heroes. . . . Raymond Carver's hypothetical response to Hirschhorn can be found in his poem 'No Heroics, Please.'"

107. Hirschhorn, in Matzner, 247. According to critic Benjamin Buchloh, "The altars solicit a positive vandalism by allowing for a random addition of objects." They also "demonstrate that in the present the artist's desire to commemorate is inextricably bound up with forms of mass-culturally engineered adulation operating at the very center of

artistic production and reception." Benjamin H. D. Buchloh, "Cargo and Cult: The Displays of Thomas Hirschhorn," *Artforum* 40 (November 2001): 108–115, 172–173. See also, Buchloh, "Thomas Hirschhorn: Lay Out Sculpture and Display Diagrams," in *Thomas Hirschhorn*, ed. Benjamin H. D. Buchloh, Alison M. Gingeras, and Carlos Basualdo (London: Phaidon, 2004), 40–94.

108. For an analysis of Hirschhorn's *Bataille Monument*, see Claire Bishop, *Installation Art* (New York: Routledge, 2005), 124–127.

109. Hirschhorn, in Matzner, 250–251.

110. Hirschhorn, in Matzner, 251.

111. Hirschhorn, in Matzner, 250.

112. In an interview with Hirschhorn, curator Okwui Enwezor asked, "Don't you risk, in terms of the materials you use, the charge of being patronizing to so-called everyday people in terms of this idea of working very close to how 'people' identify, through their sense of recognition, what these materials are and what they mean," See Jamza Walker James, *Thomas Hirschhorn Jumbo Spoons and Big Cake* (Chicago: The Art Institute of Chicago, 2000), 2. My thanks to Annie Dell'Aria for this reference.

Chapter 3

1. A version of this chapter was previously published as "Commemorating the Oklahoma City Bombing: Reframing Tragedy as Triumph," *Public Art Dialogue* 3 (Spring 2013): 80–109. Edward T. Linenthal, *The Unfinished Bombing: Oklahoma City in American Memory* (New York: Oxford University Press, 1995, 2001), 2, wrote that the bombing "took place in what was envisioned as America's 'heartland,' shattering the assumption that Middle America was immune to acts of mass terrorism as well as the assumption that the nation still had 'zones of safety,' such as day care centers." Dennis Farney, "Oklahoma City Bombing: The Aftermath," *Wall Street Journal*, April 21, 1995, A4, began his article: "The Heartland isn't the Heartland any more. But then, maybe it never was . . . even here, evil and violence have always been part of human history. Just like anywhere else." Marita Sturken, *Tourists of History: Memory, Kitsch, and Consumerism from Oklahoma City to Ground Zero* (Durham, NC, and London: Duke University Press, 2007), 96, expanded this theme to include "a belief that ordinary people were outside the realm of politically motivated violence, a belief that rural areas and small Middle America cities existed somehow outside of the world of crime, violence, and ethnic hatred that affects other American cities."

2. Mark Ames, *Going Postal: Rage Murder, and Rebellion: From Reagan's Workplaces to Clinton's Columbine and Beyond* (Brooklyn: Soft Skull Press, 2005), 68, considered the Edmonton shooting the "first rebellious uprising against Reaganomics." He thought that "the perpetrators are attacking the entire company, the workplace as an institution, the corporate culture, as much as the individuals whom they shoot. That's why there are no 'random' victims—everyone in the targeted company is guilty by association, or they're collateral damage" (19). "Collateral damage" is how McVeigh referred to the victims of the Oklahoma City bombing.

3. Katherine S. Newman, *Rampage: The Social Roots of School Shootings* (New York: Basic Books, 2004), 115, cited the reaction of a local elementary school teacher who "was certain that the bombing was the work of an evil foreigner, because no American could

hate his country that much." Ames, *Going Postal,* 54, observed that "rebellion is always the fault of outsiders and evil. Postal workers rampage post offices not because something is wrong in post offices, but because Hollywood puts bad thoughts in their heads or because some postal workers are just lunatics with a penchant for snapping."

4. Richard Goldstein, *Village Voice,* May 19, 1995, 17.

5. Dale Russakoff and Serge F. Kovaleski, "Two Angry Men," *Washington Post National Weekly Edition,* July 24–30, 1995, 6, noted that in many respects what made McVeigh so frightening was that he seemed so typical. However, they observed, "Psychologists have warned for years that young people like McVeigh born in the late 1960s, whose families fractured in record numbers, whose economic frustrations far exceed those of their parents, are unusually alienated and vulnerable to fringe movements."

6. The initial warrant obtained by the ATF to search the compound was based on allegations of sexual abuse and stockpiling of illegal weapons. During an exchange of gunfire four federal agents and six of Koresh's followers were killed. The death of the agents prompted FBI involvement. For various perspectives on the siege at Waco and its significance see James R. Lewis, ed. *From the Ashes: Making Sense of Waco* (Lanham, MD: Rowman & Littlefield, 1994) and Stuart A. Wright, ed. *Armageddon in Waco: Critical Perspectives on the Branch Davidian Conflict* (Chicago: University of Chicago Press, 1995).

7. Linenthal, *The Unfinished Bombing,* 24. Around the time of the first anniversary of the bombing a sign on the back of a pickup truck presumed to be driven by a neo-Nazi in eastern Oklahoma read: "Remember Pearl Harbor! Remember Waco! Remember Oklahoma City." See Jo Thomas, "Unfinished Task: Memorial in Oklahoma City," *New York Times,* April 6, 1996, 1. The date of April 19 was so critical to McVeigh that he listed a birth date of April 19, 1972, on an application to obtain a driver's license under the name of Robert Kling; he was actually born April 23, 1968. See Frank J. Murray, "In Oklahoma Bells Toll for 168 Victims; Terrorist McVeigh Faces Execution on May 16," *Washington Times,* April 19, 2001, A1. McVeigh was also incensed by the 1992 confrontation at Ruby Ridge between ATF and FBI agents and the family of Randy Weaver that ended with the death of Weaver's wife and teenage son. For an analysis of this incident, see Jess Walter, *Ruby Ridge: The Truth and Tragedy of the Randy Weaver Family* (New York: Harper Collins, 2002; published in 1995 as *Every Knee Shall Bow*).

8. For an interesting account of McVeigh's experiences in the army see Charles B. Strozier, "Apocalyptic Violence and the Politics of Waco," in *The Year 2000: Essays on the End,* ed. Charles B. Strozier and Michael Flynn (New York: New York University Press, 1997), 107–108. The author, informed by his son's experience in Iraq, describes the battles in which McVeigh served as prime gunner as a massacre and murder. He speculates that McVeigh failed to make the Special Forces "for psychological reasons, probably because of his intense racism."

9. Catherine McNicol Stock, *Rural Radicals: Righteous Rage in the American Grain* (Ithaca, NY, and London: Cornell University Press, 1996).

10. McVeigh's assertion seems likely as the death of the children prompted the greatest wrath. Certainly these young victims diverted attention from the intended political message of the bombing.

11. Katha Pollitt, "Subject to Debate," *The Nation,* June 5, 1995, 784, states, "Timothy McVeigh is not some libertarian free spirit gone astray. He felt at home in the Army.... If we're seriously interested in understanding how a young man could blow up a building

full of hundreds of people, why not start by acknowledging that the state he now claims to oppose gave him his first lessons in killing?"

12. Linenthal, *The Unfinished Bombing*, 24.

13. Erika Doss, *Memorial Mania: Public Feeling in America* (Chicago: University of Chicago Press, 2010), 154, describes the rescue workers' hand-painted sign, "God bless the children and the innocent" affixed to a concrete slab, surrounded by flowers, pacifiers, poems, and teddy bears. Although she interprets this as an "inappropriate infantilization of the dead," given that there were many more adults killed, it might also be interpreted as an expression of the overriding grief prompted by so many young deaths. See also Linenthal, *The Unfinished Bombing*, 119ff. Kenneth T. Walsh, "The Soul and Character of America," *U.S. News & World Report*, April 30, 1995, available at http://www.usnews.com/usnews/culture/articles/950508/archive_010,742.htm; accessed July 5, 2012, described the memorials amidst the rubble as "expressions of gratitude to the heroes who had saved so many of the living."

14. Linenthal, *The Unfinished Bombing*, 165.

15. Jackie L. Jones, "Beginning to Rebuild: Designing Workshop Helps Oklahoma City Move Forward," *Blueprints (The Journal of the National Building Museum)* 13 (Fall 1995): 5.

16. Linenthal, *The Unfinished Bombing*, 147, observed, "More than any other image from the bombing the photograph of the fireman and the baby sparked a response from people around the world." In the following pages he recounts in detail the story of how police sergeant John Avera carried Baylee Almon (who had turned one the day before) out of the building and handed her to the fireman who in turn carried her to a member of an emergency services team. Linenthal also discusses the two men who captured the image on film: photographer Lester LaRue, who worked for Oklahoma Natural Gas, and amateur photographer Charles Porter IV. LaRue's photograph appeared on the cover of *Newsweek* on May 15 but he became embroiled in a controversy with his employer as to who had rights to the image. Porter went on to win the Pulitzer Prize (150).

17. For an analysis of the commercialization of the firefighter and the baby, see Linenthal, *The Unfinished Bombing*, 150ff and Sturken, *Tourists of History*, 99ff. Both authors discuss the various subsequent versions of the image, some showing Baylee clean and whole as opposed to dirty, bloody, and obviously injured. One painting of the subject transformed the firefighter into Jesus.

18. Sturken, 103.

19. Ruby C. Tapia, *American Pietas: Visions of Race, Death, and the Maternal* (Minneapolis, London: University of Minnesota Press, 2011), 5.

20. Kenneth E. Foote, *Shadowed Ground: America's Landscapes of Violence and Tragedy* (Austin: University of Texas Press, revised edition, 2003), 166.

21. Johnson is quoted in Karen Eisenberg, "Honoring the Victims of the Oklahoma City Bombing," *Blueprints (The Journal of the National Building Museum)* 13–14 (1995): 4.

22. Kirk Savage, *Monument Wars: Washington D.C., the National Mall, and the Transformation of the Memorial Landscape* (Berkeley: University of California Press, 2009), 266 ff.

23. Eisenberg, 4.

24. Kay Goebel is quoted in Eisenbeg, 4.

25. Brian McGrory, "Grief Tears a Community; Oklahoma City: A Year of Sorrow," *Boston Globe*, April 14, 1996, 1, itemizes some of the issues that characterized the

"quarreling and infighting among family members." See also Lois Romano, "Oklahoma City's Measure of Grief; Blast Survivors, Victims' Families Feud Over Planned Memorial," *Washington Post*, March 12, 1996, A1. She quotes Bud Welch, whose 23-year-old daughter died in the blast, and who served on several committees: "The whole process is a tinder box. Just one match would set it right off." Romano observed, "This is not a story of infighting in the traditional sense. Rather it is a story of grieving relatives forced to make decisions about honoring their loved ones without the benefit of time and distance from the tragedy." Phil Bacharach, "The Memorial," *The Oklahoma Gazette*, April 11, 1996, 25, quotes Bob Johnson's observation that the surveys "confirmed what we thought would be the case, and that is the sentiment among the families and survivors and the public at large was almost identical."

26. The mission statement is included on the memorial's website, at http://www. oklahomacitynationalmemorial.org/secondary.php?section=10&catid=195.

27. The designated Week of Remembrance began with a Day of Faith. Working with the Christian Leadership Foundation, religious congregations throughout the area were asked, "to recognize the hope and healing Oklahoma City has experienced in the last decade." See press release, dated April 8, 2005, included in the Tenth Anniversary press kit. The main anniversary ceremony took place in First United Methodist Church, one of several in the area.

28. See Rebecca Solnit, *A Paradise Built in Hell: The Extraordinary Communities That Arise in Disaster* (New York: Viking, 2009) on the formation of compassionate communities.

29. Jesse Katz, "Memorial: A Driving Need for Catharsis," *Los Angeles Times*, April 19, 1997, quoted a letter sent by the mother of one of the dead children to families of other victims: "If we delay too long, there are resources which may be taken from us. . . . Please know that we are losing the sympathy of the nation."

30. The exhibition is described in detail by Jesse Katz, "Inspiration Sought in Horror— Oklahoma City Wants Memorial Designers to Feel Bomb Victims' Pain," *Los Angeles Times*, January 7, 1997.

31. Paul Spreiregen, *Design Competitions* (New York: McGraw Hill, 1979).

32. Spreiregen is quoted in Romano, "Oklahoma City's Measure of Grief," A1.

33. Cleary is quoted in Jo Thomas, "Unfinished Task: Memorial in Oklahoma City," *New York Times*, April 6, 1996, 1.

34. See Romano, "Oklahoma City's Measure of Grief," A1. Paul Goldberger, "Requiem: Memorializing Terrorism's Victims in Oklahoma," *The New Yorker*, January 14, 2002, available at http://www.newyorker.com/archive/2002/01/14/020114crsk_skyline, accessed July 5, 2012, observed, "By almost every professional standard, Spreiregen was right," but concluded that in the end the stringency of the mission statement prevailed.

35. Stastny, a founder and CEO of StastnyBrun Architects, Inc., worked as an architect, urban designer, and competition facilitator. He subsequently served as competition advisor for the Flight 93 National Memorial International Design Competition.

36. "Oklahoma City Memorial: International Design Competition: Report of Design Evaluation Panel," p. 2. This document is reproduced in Amy Scarfone, "Monument and Memory: The Oklahoma City Memorial International Design Competition," MA thesis, Urban Planning, University of Washington, 1997, 47–48. A good summary of the design selection process is provided in Stanley Collyer, "The Search for an Appropriate Symbol:

the Oklahoma City Memorial Competition," *Competitions* 7(3) (1997): 4–15. The Stage I Evaluation Committee six professionals were: Robert Campbell, FAIA (architecture critic of the *Boston Globe*); Richard Haag, FASLA (a landscape architect from Seattle, Washington); Bill Moggridge (a British expert in industrial design and founder of IDEO); Michael Pride-Wells, AIA (then director of the University of Kentucky College of Architecture's Downtown Design Center); Adele Naude Santos, FAIA (founding Dean of the School of Architecture at the University of California, San Diego); and Jaune Quick-To-See Smith (a public artist based in New Mexico). The three members of the Families and Survivors Group were Polly Nichols (who had been severely injured in the blast and subsequently became executive director of the Oklahoma Foundation for Excellence, whose mission was "to recognize and encourage academic excellence in Oklahoma's public schools."); Toby Thompson (a local arts consultant); and Richard Williams (assistant building manager for the Murrah Building at the time of the bombing).

37. Linenthal, *The Unfinished Bombing*, 161–162, quotes Kari Watkins' concerns over the so-called "Baylee Almon clause" and the hope that it would also preclude images of Jesus. Watkins was the Memorial Foundation's executive director at the time.

38. A succinct description and analysis of the design process is given by Kim O'Connell, "The Gates of Memory," *Landscape Architecture* 90 (September 2000): 68–77; 92–93.

39. "Oklahoma City Memorial: International Design Competition: Report of Design Evaluation Panel," 2. Each finalist received $15,000 for this phase of the process.

40. The four professional members for the Stage II Jury were: Laurie Beckelman (then Vice President of the World Monuments Fund, New York City); Ignacio Bunster-Ossa, ASLA (landscape architect with Wallace, Roberts H. Todd in Philadelphia); Douglas Hollis (public artist based in San Francisco); and Lars Larup, (Dean, School of Architecture, Rice University, Houston). Collyer, 5, described the professional members of the Stage II panel as "high profile leaders in their fields" and speculated that they "undoubtedly played an important role in the decision-making process." The local members were: John Cole, Luke R. Corbett, Tom Hall, Dr. Paul Ileath, Jeannine Gist, David R. Lopez, Calvin Moser, Cheryl Scroggins, Phillip Thompson, Bud K. Welch, and Oklahoma City Mayor Ronald J. Norick.

41. After graduating from architecture school at the University of Texas in Austin, the Butzers moved to Berlin and founded Locus Bold Design in 1991 at a time when the city was enjoying a building boom. This was their first memorial design. See Jim Yardley, "5 Years After Terrorist Act, a Memorial to the 168 Victims," *New York Times*, April 20, 2000, A20. After winning the competition, they changed the firm name to Butzer Design Partnership and moved to Oklahoma City. The other finalists were Brian Branstetter and J. Kyle Casper (Dallas, Texas); Susan Herrington and Mark Stankard (Ames, Iowa); Richard Scherr and James Rossant (New York City); Hanno Weber & Associates (Chicago, Illinois). For descriptions and illustrations of their designs, as well as panel comments, see Scarfone, 50–56; 72–79.

42. Collyer, 8.

43. Yardley, "5 Years After Terrorist Act," A20; Doss, *Memorial Mania*, 137.

44. Kim O'Connell, "The Gates of Memory," 73–74.

45. One of the professional jurors, landscape architect Ignacio Bunster-Ossa, ASLA, remarked that the "vast Oklahoma sky . . . recalls heaven." See O'Connell, 92.

46. O'Connell, 77.

47. Doss, *Memorial Mania*, 137.

48. Fried's remarks were made at a panel discussion on Oklahoma City sponsored by the Municipal Art Society of New York, held in Manhattan on November 20, 2001, and attended by the author.

49. Leonard is quoted in Lois Romano, "Oklahoma City Mourns Anew as Memorial Opens," *Washington Post*, April 20, 2000, A08.

50. Paul Williams, *Memorial Museums: The Global Rush to Commemorate Atrocities* (Oxford: Berg, 2007), 95, suggested a wide range of sources for this symbol, "from the convention of leaving seats empty at social gatherings to honor those absent and from riderless horses at state funeral parades. More generally it expresses themes of unfulfilled lives, people denied their place in the world, and, given that victims included children at a daycare center in the building, childhood innocence." Doss, *Memorial Mania*, 170, discusses the Christian context of an empty chair as signifying both Christ's absence and the possibility of his return.

51. Stefanie Endlich and Thomas Lutz, *Gedenken und Lernen an historishen Orten: Ein Wegweiser zu Gedenkstatten fur die Ofper des Nationalsozialismus in Berlin* (Berlin: Landeszentrale fur politische Bildungsarbeit, 1995; rev. 1998), 136.

52. My thanks to Caroline Schonemann at the Akademie der Kunste in Berlin for this information.

53. Rebecca Krinke, Assistant Professor of Landscape Architecture, University of Minnesota, is quoted in O'Connell, 76, 94–96.

54. Vickie Lykins is quoted in Lois Romano, "Oklahoma City Mourns Anew as Memorial Opens," *Washington Post*, April 20, 2000, A8.

55. Sturken, *Tourists of History,* 113.

56. Goldberger, "Requiem."

57. "Oklahoma City Memorial: International Design Competition: Report of Design Evaluation Panel," 2.

58. O'Connell, 76.

59. O'Connell, 76.

60. Observations on Ullman were partially taken from an earlier article, Harriet F. Senie, "In Pursuit of Memory: Berlin, Bamberg, and the Specter of History," *Sculpture* 18 (April 1999): 46–51.

61. "Survivor Tree," *Oklahoma City National Memorial & Museum* (organization website), available at http://www.oklahomacitynationalmemorial.org/secondary.php?section=5& catid=120; accessed July 5, 2012. Unless otherwise noted, information about the Survivor Tree comes from this source.

62. "Survivor Definition for Purposes of Fulfilling the Memorial Mission Statement Only" (undated), Oklahoma City National Memorial and Museum archive.

63. Thomas is quoted in April Kinser, "They Never Forget: Fence Continues to Attract Remembrances of Bombing," *Dallas Morning News*, April 19, 2005, 1A, 10A. Kinser referred to the memorial fence as "a perpetual, living memorial." The front page featured a photograph of a detail of the fence covered with a variety of teddy bears interspersed with American flags and some personal keepsakes.

64. Sandy Bauers, "About 40,000 Items Have Been Left in Memory of the 168 Who Died; In Oklahoma City, A Fence Becomes Link to Blast Victims," *Philadelphia Inquirer,* April 16, 1999, A1. Archivist Sandy Thomas observed, "It's become a place where people come to release their own sorrow. And we're glad. It's OK."

65. John Kifner, "In Oklahoma, a Week of Remembrance," *New York Times*, April 18, 2005, A14.

66. Linenthal, *The Unfinished Bombing*, 283, n. 78.

67. Linenthal, *The Unfinished Bombing*, 283, n. 78.

68. Graver is quoted in Hilene Flanzbaum, ed., *The Americanization of the Holocaust* (Baltimore: Johns Hopkins University Press, 1999), 4.

69. Edward T. Linenthal, *Preserving Memory: The Struggle to Create America's Holocaust Museum* (New York: Columbia University Press, 1995; reissued 2001); Linenthal, *The Unfinished Bombing* (2001).

70. See, for example, Ian Buruma, "The Joys and Perils of Victimhood," *New York Review of Books* 46 (April 8, 1999): 4–9. He sees as alarming "the extent to which so many minorities have come to define themselves above all as historical victims" and in this context cites a reference to the Holocaust as "the Olympics of suffering."

71. Sean Scully, "Bush Dedicates Museum to Honor Bombing Victims; Oklahoma City Memorial Complete," *Washington Times*, February 20, 2001, A1.

72. Ron Hutcheson, "Bush Dedicates Bombing Museum," *Philadelphia Inquirer*, February 20, 2001, A1. Frank Bruni, "Bush Dedicates Museum at Site of Oklahoma City Bombing," *New York Times*, February 20, 2001, A1, made a similar observation. Subsequent quotes are from these two sources.

73. Bush is quoted in Yvonne Abraham, "Bush Hails 'Courage' of Oklahoma Survivors," *Boston Globe*, February 20, 2001, A1.

74. Keating is quoted in Bruni, "Bush Dedicates Museum," A1.

75. Watkins is quoted in Richard Willing, "Hope, Anxiety Surround Oklahoma Museum Opening," *USA Today*, February 19, 2001, 5A.

76. During 2014–2015, prior to the 20th anniversary, the names of some of the chapters were changed. Most notably, Chapter 1 was changed from "Background on Terrorism" to "A Day Like Any Other," which featured a brief orientation video intended to help visitors "understand the Mission of the Memorial and Museum." Chapter 10 was changed from "Hope" to "Responsibility and Hope." See the museum website for a complete list of the chapter titles as of the twentieth anniversary. https://oklahomacitynationalmemorial.org/about/the-memorial-museum/; accessed May 23, 2015. The theme of responsibility was featured in the new Responsibility Theater, where "visitors consider hypothetical scenarios and select how they would respond from a list of options. Each of the hypothetical scenarios is followed by a real story related to the bombing and its aftermath." In 2015 the theater won a MUSE Award for "outstanding achievement in museum media." Information about the Responsibility Theater is found in a museum press release, April 28, 2015. My thanks to Helen Stiefmiller for this and other information pertaining to recent museum additions.

77. Descriptions of the various chapters are based on the author's experience; quotes are from the Museum's web site. See http://www.oklahomacitynationalmemorial.org/secondary.php?section=12&catid=136; accessed July 5, 2012.

78. Vaughn is quoted in Bill Bell, "Museum Tells Somber Tale," *Daily News*, April 15, 2001, 33.

79. Southern Poverty Law Center, "Memories of 'Patriotism'" *Intelligence Report* 102 (Summer 2001): 6–8.

80. Watkins is quoted in Kyle Schwab, "Oklahoma City National Memorial & Museum now features Timothy McVeigh's car," September 15, 2014, available at http://newsok.com/oklahoma-city-national-memorial-museum-now-features-timothy-mcveighs-car/article/5342139; accessed February 20, 2015.

81. Schwab, "Oklahoma City National Memorial & Museum Now Features Timothy McVeigh's Car."

82. Oklahoma City National Memorial & Museum, "14 Years of Remembrance in the Memorial Museum," available at http://www.oklahomacitynationalmemorial.org/secondary.php?section=15&catid=191&id=1595; accessed February 20, 2015.

83. Linenthal, *Preserving Memory*, xv.

84. Mark Easterling et al., *The Oklahoma Gazette*, April 11, 1996, presents an extensive summary of the state of the city.

85. This new image was widely reiterated throughout the recovery. See, for example, Jim Yardley, "A City Changed Forever Pauses Today to Reflect," *New York Times*, April 19, 2000, A16, quotes Danney Goble, professor of letters at the University of Oklahoma: "If you asked most people now what they think of Oklahoma City, it's not 'The Grapes of Wrath,' anymore. They think of Oklahoma responding to the bombing.'"

86. Norick is quoted in Sam Walker, "Out of Its Darkest Moment, a Blueprint for Renewal," *Christian Science Monitor*, April 19, 1996, available at http://www.csmonitor.com/1996/0419/19014.html; accessed July 5, 2012.

87. Walker, "Out of Its Darkest Moment, a Blueprint for Renewal" includes a detailed discussion of the fate of Oklahoma City's downtown, typical of many cities after the post–World War II migration to the suburbs.

88. The issue began with articles on the victims, followed by coverage of the rescue workers, rebuilding downtown, leadership, the federal legacy, the memorial process, the militia movement, the media, and artistic expressions. A timeline noted the March 14 passing of a watered-down version of the anti-terrorism bill approved in the Senate on June 7. It tracked the almost immediate apprehension of Timothy McVeigh and Terry Nichols to their March 29 removal to the Federal Correctional Institute outside Denver.

89. Clinton is quoted in Sam Fulwood III, "Clinton Honors Victims of Oklahoma Bombing," *Los Angeles Times*, April 6, 1996, available at http://articles.latimes.com/1996–04-06/news/mn-55,503_1_bombing-victims; accessed July 5, 2012, as well as in Alison Mitchell, "New Sadness and Memories in Oklahoma," *New York Times*, April 6, 1996, 9.

90. The ceremony is described in detail in Jesse Katz, "168 Seconds of Silence," *Los Angeles Times*, April 20, 1996, available at http://articles.latimes.com/1996–04-20/news/mn-60,683_1_oklahoma-city; accessed July 5, 2012. According to Katz, more than one thousand members of the media were present.

91. Mark Potok, "Oklahoma City a Year Later: Anxiety," *USA Today*, April 17, 1996, 4A.

92. Jo Thomas, "In Oklahoma City, Silence for Each of the Victims," *New York Times*, April 20, 1996, 7.

93. Brian McGrory, "Grief Tears a Community; Oklahoma City: A Year of Sorrow," *Boston Globe*, April 14, 1996, 1, observed, "Oklahoma City is not doing well, not now, not according to those who live here. At federal agencies, workers often burst into tears at their desks. . . . And among victims who meet frequently to discuss a memorial to the

dead, infighting and name-calling have become commonplace. . . . The area itself remains . . . a ghost town at night and a macabre tourist attraction by day."

94. See, for example, Rick Bragg, "A Year of Sorrow," *New York Times*, April 19, 1996, A1. Nichols eventually received a life sentence.

95. Problems in Oklahoma City are described in many press reports. See especially Ian Katz, "Tomorrow Marks the First Anniversary of the Terror Bombing in Oklahoma that Killed 168 People," *The Guardian*, April 18, 1996, 2.

96. Sam Howe Verhovek, "A Look Back and Ahead at Oklahoma City Site," *New York Times*, April 20, 1997, 20.

97. Verhovek, 20.

98. Verhovek, 20.

99. "Oklahoma City Honors Blast Victims," *Los Angeles Times*, April 20, 1997, available at http://articles.latimes.com/1997–04-20/news/mn-50,713_1_oklahoma-city-bombing; accessed July 5, 2012.

100. Verhovek, 20.

101. "Oklahoma City Honors Blast Victims," *Los Angeles Times*.

102. Louis Sahagun, "Survivors Greet Verdict With Hugs, Tears," *Los Angeles Times*, June 3, 1997, available at http://articles.latimes.com/1997–06-03/news/mn-65,158_1_death-penalty; accessed July 5, 2012.

103. "Nation in Brief," *Washington Post*, April 11, 1998, A5.

104. Lois Romano, "Turning Point for Survivors in Oklahoma; Gore Breaks Ground at Bombing Shrine," *Washington Post*, October 26, 1998, A4.

105. Sandy Bauers, "About 40,000 Items Have Been Left in Memory of the 168 Who Died; In Oklahoma City, A Fence Becomes Link to Blast Victims," *Philadelphia Inquirer*, April 16, 1999, A1. The article includes a list of the various types of items left on the fence. Everything remained up for at least thirty days. Anything left by a loved one or one of the affected federal agencies could be removed only with their permission. American Indian objects intended to protect the site were left there unless they fell off. Other objects were collected periodically and archived. Every section of the fence was photographed once a week.

106. "A Ceremony 4 Years after Oklahoma City Bombing, A Message of Renewal," *New York Times*, April 20, 1999, A20.

107. The newly formed links between the two cities are discussed by Larry Fish, "Two Cities United by Their Tragedies; Oklahoma and Littleton Mark this Week's Anniversaries with Mutual Empathy," *Philadelphia Inquirer*, April 19, 2000, A3.

108. See http://www.roadsideamerica.com/story/11910; accessed July 5, 2012. The Branch Davidian Memorial consisted of a ring of eighty-three small stones around a large tree, one for each of the dead, and a large plaque listing their names. The inscription read: "On February 28, 1993 a church and its members known as the Branch Davidians came under attack by ATF and FBI agents. For 51 days the Davidians and their leader, David Koresh, stood proudly. On April 19, 1993 the Davidians and their church were burned to the ground. 82 people perished during the siege. 18 were children 10 years or younger." The Northeast Texas Regional Militia of Texarkana, Texas, donated the memorial. Some two hundred attended anniversary services in the church. A bell rang eighty-two times as survivor Clive Doyle read the names and ages of the dead.

109. The ceremony is described in detail in Romano, "Oklahoma City Mourns Anew," A8.

110. The official ceremony programs are archived and described in detail at http://www.oklahomacitynationalmemorial.org/secondary.php?section=5&catid=89&archived=list; accessed July 5, 2012.

111. Richard Benedetto, "Clinton Dedicates Oklahoma Memorial," *USA Today*, 20 April 2000, 3A.

112. This quote was cited in many articles. See, for example, Ann Scales, "'This Place Is Such Sacred Ground' Oklahoma City Site Dedicated," *Boston Globe*, April 20 2000, A3.

113. Linenthal, 234. The Sixteenth Street Baptist Church in Alabama was the site of the Ku Klux Klan bombing on September 15, 1963 that killed four girls. This horrifying murder together with President Kennedy's assassination two months later provided the momentum for the passage of the 1964 Civil Rights Act. The McDonald's referenced by Linenthal, actually in San Ysidro just north of the Mexican border, was the site of what was at that time (July 1984), "the largest single-day, single-gunman massacre in U.S. history." James Oliver Huberty killed twenty-one people, including five children and six teenagers, and wounded nineteen others before he was shot and killed by a police sniper. (See, for example, Jessica Gresko, "Twenty Years Later, San Ysidro McDonald's Massacre Remembered," *North County Times*, July 18, 2004, available at http://www.nctimes.com/news/local/article_2ba4343e-7009-54ce-98df-79a23ff8d0d7.html; accessed July 2, 2012.

114. See Jim Yardley, "A City Changed Forever Pauses Today to Reflect," *New York Times*, April 19, 2000, A16, for further discussion of this program.

115. Edwin Chen, "5 Years Later, a Poignant Rebirth for Oklahoma Bombing Site," *Los Angeles Times*, April 20, 2000, available at http://articles.latimes.com/2000/apr/20/news/mn-21,595; accessed July 5, 2012.

116. Watkins is quoted on "Oklahoma City Six Years Later," CBSNEWS.com, April 19, 2001, available at http://www.cbsnews.com/stories/2001/04/19/national/main286536.shtml; accessed July 5, 2012.

117. BBC News, "Oklahoma Marks Bomb Anniversary," April 19, 2001; http://news.bbc.co.uk/2/hi/americas/1285884.stm; accessed July 5, 2012.

118. See David Johnston, "Justice Dept. Sets Procedures for Viewing McVeigh's Death," *New York Times*, April 20, 2001, A17. The caption of a photograph on page one linked the image of a mourner at one of the memorial chairs with the upcoming execution.

119. See, for example, "McVeigh's Lawyer: He's Ready to Die," and David Johnston, "Set Back Again, McVeigh Abandons Bid for a Stay," *New York Times*, June 8, 2001, A1, A16.

120. See, for example, Robert Ingrassia and Helen Kennedy, "Long Wait Is Finally Over for Victims' Kin Hoping for Closure from McVeigh's Execution," *Daily News*, June 11, 2001, 7, and Valerie Richardson, "Imminent Execution Draws Mourners to Visit Memorial," *Washington Times*, June 11, 2001, A10. See also Jim Yardley, "Uneasily, Oklahoma City Welcomes Tourists," *New York Times*, June 11, 2001, A1, A14. A picture of the memorial was featured on the first page.

121. Goldberger, "Requiem."

122. Bender is quoted in Ray Steen, "Seven Year Anniversary Unites Oklahomans with New Yorkers," *RedCross.org*, April 22, 2002; available at http://web.archive.org/web/20081105172503/http://www.redcross.org/news/ds/terrorism/020421OKcity.html; accessed July 5, 2012.

123. Jayson Blair, "A Nation Challenged: Oklahoma City Bombing; Advice on the Task of Rebuilding, from a Mayor Who Knows Terror's Toll," *New York Times*, March 25, 2002, A1.

124. Humphreys is quoted Steen.

125. Lois Romano, "Most Survivors Skip Oklahoma Groundbreaking; New Building's Site, Design Opposed," *Washington Post*, December 5, 2001, A27.

126. For a discussion of the new building and the problems it posed for many, see Jim Yardley, "Survivors in Oklahoma City Fear New Office Building at Bomb Site," *New York Times*, April 11, 2002, A1; Charisse Jones, "Still Afraid to Go Back to Work," *USA Today*, April 19, 2005, 1A, 2A. Jones discusses the pressure placed on workers to return to work in the new building.

127. John Kifner, "In Oklahoma, a Week of Remembrance."

128. Nick Trougakos, "Oklahoma City Bombing: Ninth Anniversary; Tribute Paid with Tears, Memories," *The Oklahoman*, April 20, 2004, 1A.

129. Originally the Murrah Building displayed thirty-two works selected by a panel of art professionals under the auspices of the GSA's Art-in-Architecture program. Of these, twenty-three were recovered; the remaining nine were represented by photographs. At the opening of the exhibition, Joan Mondale remarked, "Today we rejoice in celebrating these surviving works of art, which, like the survivors in the audience remind us that beauty and courage will prevail." See Nick Trougas, "Building's Art Returns to Display," *The Oklahoman*, April 20, 2004, 14A. See also http://www.oklahomacitynationalmemorial. org/secondary.php?section=5&catid=55&id=46; accessed July 6, 2012.

130. Lutheran Disaster Response of New York, "We Remember Oklahoma City," *Lutheran Disaster Response of New York* (organization website), available at http://web. archive.org/web/20040905213419/http://www.ldrny.org/TOPNEWS/topnews04-15-04. html; accessed July 6, 2012.

131. The author attended most of the events associated with the tenth anniversary. Unless indicated otherwise, all observations and quotes are based on firsthand notes. The National Week of Hope Calendar was published in *The Mid-City Advocate*, April 14, 2005, 3. April 15 and 16: Oklahoma City Project created by the Oklahoma City Repertory Theatre played at Civic Center Music Hall. April 17: A Day of Faith featured a Holocaust Remembrance Ceremony at the Memorial in the afternoon and a candlelight ceremony in the evening. April 18: A Day of Understanding featured members of the national media who reported on the bombing discussing the impact of terrorism on the world in the last decade. April 19: A Day of Remembrance was marked by the traditional remembrance ceremony of 168 minutes of silence and a reading of the names of the dead. In the evening the first Reflections of Hope award was presented. April 20: A Day of Sharing included rescue workers, family members, and survivors visiting schools across the state to share their story. April 21: A Day of Tolerance had Oklahoma students participating in a simulation of the Model United Nations Security Council to learn about nonviolent resolution. April 22: A Day of Caring featured the Memorial Thank You Concert at the Ford Center with country singers Vince Gill and Toby Keith, as well as other Oklahoma artists. April 23: A Day of Inspiration was marked by families, survivors, and rescue workers greeting runners who came to Oklahoma City to participate in the Memorial Marathon. In the evening a worship service was held at First Church. April 24: A Run to Remember was the fifth annual Memorial Marathon.

132. Cornett is quoted in Ryan Chittum, "Oklahoma City's Revival; Ten Years After the Bombing, Downtown Sees a Renaissance; No More 'Inferiority Complex,'" *Wall Street Journal*, April 13, 2005, B1.

133. Watkins is quoted in John Kifner, "In Oklahoma, a Week of Remembrance."

134. Lois Romano, "10th Anniversary of Bombing Observed; Cheney, Clinton Speak at Oklahoma City Gathering," *Washington Post*, April 20, 2005, A3.

135. Kifner, "In Oklahoma, a Week of Remembrance."

136. According to the media packet titled "A Promise Kept/A Decade of Hope," "These trees symbolize the Memorial's growing educational programs and partnerships with schools across the country."

137. Carla Hinton, "Crowd Pays Tribute with Candles," *The Oklahoman*, April 18, 2005, 1A.

138. *The Mid-City Advocate*, April 14, 2005, 3.

139. Panelists included Linda Cavanaugh, Terri Watkins, Kelly Ogle, Sue Hale, David Page, and Jerry Bohnen.

140. The press was seated in the glass-enclosed "cry room"; some observed that it felt like watching an execution. One reporter mentioned that her kids emphasized their Okie accent, playing it up for attention. Several expressed negative feelings about "East Coast elitists."

141. John Kifner, "In Oklahoma City, a Day of Sorrow, Unity and Hope," *New York Times*, April 20, 2005, A14.

142. April Kinser, "They Never Forget: Fence Continues to Attract Remembrances of Bombing," *Dallas Morning News*, April 19, 2005, 1A, 10A.

143. Brian Burs, "Bombing Ceremony Marks Decade of Change," *The Journal Record*, April 18, 2005, 32, noted that the award also "exemplifies that hope not only survives but also thrives in the wake of political violence." The mission statement of the award reads: "The *Reflections of Hope Award* honors a living person or currently-active organization whose conduct exemplifies in an extraordinary fashion two core beliefs of the Oklahoma City National Memorial Foundation: that hope can survive and blossom amidst the tragedy and chaos of political violence and that, even in environments marred by such violence, peaceful, nonviolent approaches provide the best answers to human problems." See http://www.oklahomacitynationalmemorial.org/roh/mission.html; accessed July 6, 2012.

144. Subsequent winners were: Durga Ghimire (2006), co-founder of Tamakoshi Service Society, a community-based organization improving the lives of marginalized people in Ramechhap, Nepal; Seeds of Peace (2007), a program that brings together Israeli, Jordanian, Palestinian, Egyptian, Pakistani, Indian, and American teenagers in an effort to change their perceptions of each other and foster conflict resolution skills; Carolina for Kibera, an organization whose mission is to fight abject poverty and prevent violence through community-based development in the Kibera slum of Nairobi, Kenya; Dom Thomas Balduino (2008), who worked extensively in helping the poor of Brazil; Father Alex Reid, C.S.S. R., Liguori House in Dublin (2009), honored for his life's work in the peace process in Northern Ireland; President William Jefferson Clinton (2010); President George W. Bush and Family (2011); and journalist Anthony Shadid (2012, posthumous award). See http://www.oklahomacitynationalmemorial.org/roh/past.html; accessed July 6, 2012.

145. "Honorees Voice of Afghan Women Radio Reflections of Hope Award" pamphlet that included the menu for dinner, April 19, 2005. Dinner speakers included Robert Henry, Judge, U.S. Court of Appeals, Tenth Circuit; Polly Nichols, survivor as well as

member of the Board of the Museum; and Kim Henry, First Lady of Oklahoma and Honorary Chair of the Selection Committee. Committee members were Linda P. Lambert, Chair, Oklahoma City National Memorial Trust; Clark Bailey of the Memorial Foundation; Prudence Bushnell, former Ambassador to the Republic of Kenya; Don Ferrel, Adj. General of Oklahoma, Ret. and parent of Susan Ferrell, who died in the bombing; Dr. John Hope Franklin, James. B. Duke Professor Emeritus of History, Duke University; Erin Gruwell, Educator, and founder, Erin Gruwell Education Project; Judge Robert Henry; Dr. N. Scott Momaday, poet, author, artist; Justice Sandra Day O'Connor, Supreme Court of the United States; Jane Vessels, Assistant Editor, *National Geographic*; Kari Watkins, Executive Director, Oklahoma National Memorial & Museum. Momaday read a poem, *In the Spirit of Hope,* written for the occasion.

146. Judy Gibbs Robinson, "Memorial's Award Furthers Afghan Journalists' Efforts," *The Oklahoman*, April 19, 2005, 4A.

147. For a discussion of the Festival of the Arts see Brandy McDonnell, "Gusts of Enthusiasm Great Festival," *The Oklahoman*, April 20, 2005, 4A.

148. John Kifner, "In Oklahoma, A Week of Remembrance."

149. Chittum, "Oklahoma City's Revival; Ten Years After the Bombing, Downtown Sees a Renaissance; No More 'Inferiority Complex.'" While property values in some downtown areas increased around 500%, nearly one-third of the downtown office spaces remained vacant, double the national average. See also, Darren Currin, "Redevelopment of Bombing Region Exceeds Expectations," *The Journal Record*, April 19, 2005, 12ff.

150. "Securing The Future of the Oklahoma City National Memorial & Museum," brochure prepared for the five-million-dollar Second Decade campaign. Donors of $10,000 or more would become members of the Founders Society and be listed as such in the Museum lobby; those who gave $5,000 or more would have their names in bronze and granite panels in the Museum lobby. Others would be listed in the Museum lobby computers.

151. David Page, "Henry Approves $5 Million Injection to Memorial Foundation," *Journal Record*, April 19, 2005, 14. The article includes an itemization of the over $50 million in federal aid the city had received. Michael McNutt, "Law Boosts Memorial Funds," *The Oklahoman*, April 19, 2005, 1A, 2A, notes that the endowment was then $8 million. He quotes Frank Hill, chairman of the Oklahoma City National Memorial Foundation: "Today, remarkably on the eve of our 10th anniversary, we have secured the financial future of the Oklahoma City National Memorial."

152. Michael McNutt, "Law Boosts Memorial Funds," *The Oklahoman*, April 19, 2005, 2A.

153. Johnson is quoted in O'Connell, 70.

154. Christopher Knight, "Oklahoma's Lessons for New York," *Los Angeles Times*, January 26, 2003, available at http://articles.latimes.com/2003/jan/26/entertainment/ca-knight26; accessed July 6, 2012. Knight defined the memorial as "a six-acre lamentation in stone, metal, earth and water—a perpetual wail of enclosed grief, which never takes you beyond to an understanding of context."

155. Johnson is quoted in Maria Puente, "Bombing Memorial a Monument to Healing," *USA Today*, June 30, 1997, 8A.

156. Harriet F. Senie, "Memorial Complexes or Why Are Architects Getting the Big Commissions?" *Sculpture* 24 (December 2005): 10, discusses the implications of this practice.

Chapter 4

1. Some of the material in this chapter was previously presented in two academic papers: "From Collected to Collective Memory: Mourning and Denial in the Wake of the Columbine Killings," XXXth International Congress of the History of Art (CIHA) in London, September 2000, and "From Collected to Collective Memory: Cultural Denial in the Columbine Shootings," *Monuments, Memory, Modernism*, 12th Annual Front Range Symposium in Art History, University of Colorado, Boulder, September 2003.

2. The media located Columbine variously in Littleton, Boulder, and Denver. Technically the high school is in an unincorporated housing subdivision in Jefferson County and is part of the Jefferson County Public School District. See Sylvia Grider, "Public Grief and the Politics of Memorial: Contesting the Memory of 'the Shooters' at Columbine High School," *Anthropology Today* 23 (June 2007): 3. Littleton, is the most commonly referenced location.

3. According to Dave Cullen, *Columbine* (New York: Twelve, 2009), 13, "Columbine had one of the best academic reputations in the state; 80% of graduates headed on to degree programs." Ralph W. Larkin, *Comprehending Columbine* (Philadelphia: Temple University Press, 2007), 12, notes: "Columbine High School was not just a good school; it was one of the best schools in the state. Its students won academic honors. Its sports teams, especially its football and soccer teams, were perennial contenders for the state championships."

4. Jeff Kass, *Columbine: A True Crime Story* (Denver: Ghost Road Press, 2009), foreword.

5. Cullen, *Columbine*, 139.

6. Justin Watson, *The Martyrs of Columbine: Faith and the Politics of Tragedy* (New York: Palgrave Macmillan, 2002), 92.

7. Dave Cullen, "The Depressive and the Psychopath," *Slate*, April 20, 2004, available at http://www.slate.com/id/2099203/; accessed July 10, 2012.

8. Valerie Richardson, "Memorial to Honor Columbine Victims," *Washington Times*, June 17, 2006, A02, noted that the shootings had "inspired more than 20 books, two movies, hundreds of articles, a half-dozen songs and even its own lexicon." Katherine S. Newman, *Rampage: The Social Roots of School Shootings* (New York: Basic Books, 2004), 49, observed, "In the year after the Columbine shootings the nation's fifty largest newspapers printed nearly 10,000 stories related to the event and its aftermath, averaging about one story per newspaper every other day." Watson, 1, noted that 750 news organizations from around the world sent representatives to cover the story. He cites a Pew Research Center survey that reported the shooting "attracted by far the most public interest of any news story of 1999." A later Pew survey found a less than 10% difference between public interest in Columbine (68%) and the attacks of September 11, 2001 (74%).

9. It is important to note that not all school shootings have been reported or recorded. See "A Time Line of Recent Worldwide School Shootings," http://www.infoplease.com/ipa/A0777958.html; accessed July 11, 2007. On February 2, 1996, Barry Loukaitis, fourteen, killed two students and one teacher in his algebra class in Moses Lake, Washington. On October 1, 1997, Luke Woodham, sixteen, killed two students and wounded seven after allegedly first killing his mother. On December 1, 1997, Michael Carneal, fourteen, killed three students and wounded five as they participated in a prayer circle at Heath High School in West Paducah, Kentucky. Two weeks later, on December 15, 1997, Colt Todd,

fourteen, wounded two students in the parking lot of his school in Stamps, Arkansas. On March 24, 1998, Andrew Golden, eleven, and Mitchell Johnson, thirteen, set off a fire alarm at Westside Middle School and then shot and killed four students and one teacher and wounded ten others as they fled the building. The following month on April 24, 1998, Andrew Wurst, fourteen, killed one teacher and wounded two students at a dance at James W. Parker Middle School. The month of May 1998 saw two shootings: on May 19, Jacob Davis, eighteen, killed one student in the parking lot of Lincoln County High School; two days later Kip Kinkel, fifteen, killed two students and wounded twenty-two others in the cafeteria at Thurston High School after he killed his parents at home. On June 15, 1998, in Richmond, Virginia, a fourteen-year-old boy wounded one teacher and one guidance counselor in the school hallway. A year later Columbine set a record with fifteen dead (including the killers) and twenty-three wounded. This record held until April 16, 2007, when Cho-Seung-Hui, twenty-three, killed thirty-three students, including himself, at Virginia Tech in Blacksburg, Virginia.

10. Andrew Golden, aged eleven, and Mitchell Johnson, aged thirteen, were placed in a juvenile prison until they were each eighteen years old, and then in a federal penitentiary; they were released on their twenty-first birthdays. For an account of the shooting, see, for example, Nadya Labi, "The Hunter and the Choirboy," *Time*, April 6, 1998, 28ff. On their release, see Kenneth Heard, "1998 Schoolyard Killer Now 21, Due for Release," *Arkansas Democrat-Gazette*, May 25, 2007, front section.

11. Watson, 3, defines it as such an axial event, citing the reference to the "post–Columbine era" or "post–Columbine hysteria."

12. Newman, 50.

13. Although Eric made frequent references to Hitler in his notebooks and website, no connection between his birthday and the date of the attacks was mentioned. Cullen, *Columbine*, 35, speculates that since Eric mentioned "topping Oklahoma City . . . they may have been planning to echo that anniversary, as Tim McVeigh had done with Waco."

14. Cullen, *Columbine*, 323.

15. Brooks Brown and Rob Merritt, *The Truth Behind Death at Columbine* (New York: Lantern Books, 2002; 2006), 72ff. Eric writes of his desire to bomb and blow up "some downtown," ending his rant with "all I want to do is kill and injure as many of you pricks as I can, especially a few people. Like Brooks Brown" (84).

16. See Brown and Merritt. This series of events is discussed in cited monographs by Cullen and Kass, as well in various reports. See, for example, Nancy Gibbs and Timothy Roche, "The Columbine Tapes," *Time*, December 20, 1999, 40–51, and Steve Liss, "The Road to Healing: The Columbine Community Seven Months Later," *Time*, December 20, 1999, available at http://www.time.com/time/photogallery/0,29307,2042302,00.html; accessed July 10, 2012.

17. Cullen, *Columbine*, 84.

18. Kass, 112–113. Cullen, *Columbine*, 256ff, comes to the same conclusion.

19. Eric's paper is quoted in Kass, 85.

20. Dylan's story is included in Kass, 151–153. See also Peter Wilkinson, "Humiliation and Revenge: the Story of Reb and VoDka," *Rolling Stone*, June 10, 1999, 49–51ff. Reb and VoDka were Eric and Dylan's online nicknames.

21. The Basement Tapes are widely discussed in the books on Columbine. See, for example, Kass, 133ff.

22. Kass, 139.

23. Eric and Dylan planted one set of bombs a few miles away, timed to lure the police to a different location. Another set was planted in the cafeteria to force students into the parking lot, where they planned to shoot them. A third set was in their cars, timed to go off when ambulances and rescue workers arrived. See Gibbs and Roche, "The Columbine Tapes," 47.

24. Eric Harris's journal quoted in Brown and Merritt, 161.

25. Quoted in Larkin, 176.

26. Gibbs and Roche, 40–51.

27. Gibbs and Roche, 40–51. See also Cullen, *Columbine*, 329.

28. Michael Moore's *Bowling for Columbine* won the Academy Award for Best Documentary in 2003. Gus Van Sant's fictional *Elephant* earned the award of Best Director at Cannes the same year. Both are discussed in this chapter.

29. Many articles documented the memorial activities at Columbine High. See, for example, Gustav Niebuhr and Jodi Wilgoren, "From the Shock of Violent Deaths, New and More Public Rites of Mourning," *New York Times*, April 28, 1999, A24; and James Brooke, "A Neighborhood Park Draws Littleton Pilgrims," *New York Times*, May 6, 1999, A26.

30. Erika Doss, *Memorial Mania: Public Feeling in America* (Chicago: University of Chicago Press, 2010), 106.

31. Charley Able, "Symbols of Sadness: Fate of Clement Park Offerings Undetermined," *Rocky Mountain News*, April 19, 2000, available at http://m.rockymountainnews.com/news/2000/apr/19/symbols-sadness/; accessed July 10, 2012).

32. Letter to the author from Lorena Donohue, Deputy Director/Curator of Collections of the Littleton Historical Museum, August 8, 2000. All quotes, unless otherwise noted, are from this letter. Donohue felt that objects of shared experience such as, "star wars characters, trucks, volleyballs, etc.," overlapped with relics of the dead, often making them difficult to distinguish. I make the distinction that if the items belonged to the living, they are primarily intended as gifts; if they imply a shared experience (like playing a game), I would consider them objects of shared experience. Clearly, there is overlap. For a discussion of the objects left at the base of the Vietnam Veterans Memorial, see chapter 1.

33. Lorena Donohue, in conversation with the author, July 25, 2000.

34. After the murder of his father-in-law in 1996, Zanis started a personal ministry, Crosses for Losses, building and installing crosses to honor victims of violence at the site of their death. See Lorraine Adams, "Columbine Crosses Can't Bear Weight of Discord: Memorials Embrace Gunmen, Divide Mourners," *Washington Post*, May 3, 1999, A03; Dina Bunn, "Cross Maker Traversed Nation to Honor 15 With Gifts of Wood," *Chattanooga Times Free Press*, May 2, 1999, A8.

35. Larkin, 50.

36. Quoted in J. William Spencer and Glenn W. Muschert, "The Contested Meaning of the Crosses at Columbine," *American Behavioral Scientist* 52 (June 2009): 1379.

37. Sylvia Grider, "Public Grief and the Politics of Memorials: Contesting the Memory of 'the Shooters' at Columbine High School," 6.

38. Rohrbough is quoted in Grider, 6, and Larkin, 51. See also Lynn Bartels and Dina Bunn, "Dad Cuts Down Killers' Crosses," *Denver Rocky Mountain News*, May 1, 1999.

39. The fate of the crosses is recounted in Grider, 6ff.

40. John C. Ensslin and Kevin Vaughan, "Columbine Library Goal Reached," *Rocky Mountain News*, May 3, 2000, available at http://m.rockymountainnews.com/news/2000/may/03/columbine-library-goal-reached/; accessed July 10, 2012. The amount was raised by a two-day radio-thon, with two large donations: $250,000 from Donald Sturm and $100,000 from Sharon Magness.

41. Kenneth E. Foote, *Shadowed Ground: America's Landscapes of Violence and Tragedy* (Austin: University of Texas Press, revised edition, 2003), 24.

42. Trent Seibert, "Parent: 'A Weight Was Lifted': Columbine Families Tour New Atrium," *Denver Post*, July 19, 2000, B-02.

43. Ann Carnahan, "Hopeful Eyes Turn Upward," *Rocky Mountain News*, August 20, 2000, available at http://m.rockymountainnews.com/news/2000/aug/20/hopeful-eyes-turn-upward/; accessed July 10, 2012; "Artist Shows Mural for Columbine Atrium," *Rocky Mountain News*, April 9, 2000; Holly Kurtz, "Atrium Mural Heads for Columbine," *Rocky Mountain News*, July 25, 2000, available at http://m.rockymountainnews.com/news/2000/jul/25/atrium-mural-heads-columbine/; accessed July 10, 2012.

44. E-mail to the author from Virginia Wright-Frierson, August 23, 2000. There are 23 panels in all: 4 in the center (total 20 x 24 feet); 15 surrounding panels emphasizing an upward perspective with images of Colorado evergreens; and "4 additional panels painted in solid colors to help balance and integrate the whole."

45. Phyllis Velasquez (Kyle's mother) quoted in Carnahan, "Hopeful Eyes Turn Upward."

46. Charley Able, "Columbine Memorial Delayed," *Denver Rocky Mountain News*, April 1, 2004, available at http://m.rockymountainnews.com/news/2004/Apr/01/columbine-memorial-delayed/; accessed July 10, 2012. The committee's mission was "to develop a consensus recommendation to create a physical, permanent memorial for our community and others to honor and respect those touched by the Columbine High School tragedy." Revised Mission Statement, Columbine High School Memorial Committee, 7/13/99. My thanks to Bob Easton for this and other documents pertaining to committee deliberations. Committee members were Kathy Anderson (Jefferson Foundation); Lee Andres (faculty); Mandy Bowen (student); Alan Cram (former faculty); Pat Cronenberger (Mayor Pro Tem, Littleton); Bob Curnow (parent); Pete Doherty (parent); Robert Easton (Executive Director, Foothills Park and Recreation District); Larry Gloss (Gloss & Co. Philanthropic Consultants); Michael Greunke (Foothills Foundation, parent); Doug Ireland (Littleton Fire Dept.); Donn Kraemer (Lakewood SWAT); Kirsten Kreiling (Maverick Press); Sul Morgan-Smith (MRI/Batelle/Bechtel @ N.R.E.L); Dean J. R. Pearson, ASLA (The Architerra Group); Lora Raber-Knowlton (Foothills Foundation); Thea Rock (Citizen Outreach, Jefferson County Open Space); Paul Rufien (alumni); Ralph Schell (Director, Jefferson County Open Space); Tamara Shuck (DHM Design Corp); Darrell Schulte (parent); Courtney Shakowski (student); M.L. Tucker (LAFARGE Corporation).

47. Columbine Memorial (organization website), "Overview," available at http://www.columbinememorial.org/Overview.asp; accessed July 10, 2012.

48. Columbine Memorial (organization website), "Foundation Board," available at http://www.columbinememorial.org/Committee.asp; accessed July 10, 2012.

49. Columbine Memorial (organization website), "Overview."

50. See Cullen, 281–289, for a summary of events.

51. Holly Kurtz, "News Media Tour Columbine," *Rocky Mountain News*, April 10, 2000, available at http://m.rockymountainnews.com/news/2000/Apr/10/news-media-tour-columbine/; accessed July 10, 2012.

52. The full schedule was printed in Kevin Vaughan, "Columbine Events Include Ceremony at Clement Park," *Rocky Mountain News*, April 16, 2000, available at http://m.rockymountainnews.com/news/2000/apr/16/columbine-events-include-ceremony-clement-park/; accessed July 10, 2012.

53. Owens is quoted in Robert Weller, "Columbine: A Year Later, a Town Remembers Its Victims, *Athens Banner-Herald*, April 21, 2000, available at http://onlineathens.com/stories/042100/new_0421000032.shtml; accessed July 10, 2012.

54. Bill Scanlon, "Threats Shut Schools; Tens of Thousands in Metro Area Skip Classes," *Rocky Mountain News*, April 21, 2000, available at http://m.rockymountainnews.com/news/2000/apr/21/threats-shut-schools-tens-thousands-metro-area-ski/; accessed July 10, 2012.

55. Peggy Lowe, "Poll Shows Attitudes Largely Unchanged," *Rocky Mountain News*, April 19, 2000, available at http://m.rockymountainnews.com/news/2000/apr/19/poll-shows-attitudes-largely-unchanged/; accessed July 10, 2012.

56. Tina Griego, Holly Kurtz and Kren Abbott, "'We Have Made It through the First Year,'" *Rocky Mountain News*, April 21, 2000, available at http://m.rockymountainnews.com/news/2000/apr/21/we-have-made-it-through-first-year/; accessed July 10, 2012.

57. Michael Janofsky, "Year Later, Columbine Is Learning to Cope While Searching for Answers," *New York Times*, April 17, 2000, A12. Janofsky reported that, although little had changed in suburban Denver, at the high school everything had changed. "Columbine is now more than a school; it is part of the lexicon, shorthand for the terror of children killing children."

58. Clinton's statement is quoted in Griego, Kurtz and Abbot, "'We Have Made It through the First Year,'" *Rocky Mountain News*.

59. Joe Garner, "'I hope This Didn't Happen in Vain,'" *Rocky Mountain News*, April 21, 2000, available at http://m.rockymountainnews.com/news/2000/apr/21/i-hope-didnt-happen-vain/; accessed July 10, 2012.

60. See, for example, M.E. Sprengelmeyer, "Diary of a Day of Remembrance," *Rocky Mountain News*, April 21, 2000, available at http://m.rockymountainnews.com/news/2000/apr/21/diary-day-remembrance/; accessed July 10, 2012.

61. Holly Kurtz, "A Year's Memories: Columbine 2000 Yearbook Is Dedicated to the Victims, But Committed to Moving on," *Rocky Mountain News*, April 17, 2000, available at http://m.rockymountainnews.com/news/2000/Apr/17/years-memories/; accessed July 10, 2012.

62. Ireland is quoted in Cullen, *Columbine*, 302.

63. Charley Able, "Site Selected for Columbine Memorial," *Rocky Mountain News*, May 12, 2000, available at http://m.rockymountainnews.com/news/2000/may/12/site-selected-columbine-memorial/; accessed July 10, 2012.

64. Gary Massaro, "Parents Describe Columbine Memorial Plans as Generalities," *Rocky Mountain News*, July 29, 2000, available at http://m.rockymountainnews.com/news/2000/jul/29/parents-describe-columbine-memorial-plans-generali/; accessed July 10, 2012.

65. Able, "Columbine Memorial Delayed," *Rocky Mountain News*.

66. Ann Schrader, "Columbine Still Lacks Memorial," *Denver Post*, April 19, 2004, B-01. They hired Ann Roecker of Roecker Consulting.

67. See Cullen, *Columbine*, 338–340, for a summary of fundraising efforts at the time of the fifth anniversary.

68. George Merritt, Kieran Nicholson, John Ingold, "'Beacons of Hope': On the Fifth Anniversary of the Columbine Tragedy, Kin, Classmates and the Community Celebrate the Victims' Lives and Take Stock of Their Own," *Denver Post*, April 21, 2004, A-01.

69. In a diametrically opposed vein, Rapper Eminem included two tracks inspired by Columbine on his second album: *Remember Me* and "the joyfully homicidal anthem, *Kill You*." See N'Grai Croal, "Slim Shady Sounds Off," *Newsweek*, May 29, 2000, 62–64.

70. Robert Weller, "Columbine Remembered with Tears, Memories, Hope," *The Associated Press*, April 21, 2004.

71. Hochhalter is quoted in Merritt, Nicholson, and Ingold, A-01.

72. Michael Tamburello, who had helped to create a nonprofit group to support the victims, is quoted in Merritt, Nicholson, and Ingold, A-01.

73. Clinton is quoted in Cullen, *Columbine*, 334–335.

74. "Terror's Long Shadow April 17–23," *New York Times*, April 24, 2005, C2.

75. Kirk Johnson and Katie Kelley, "A Memorial at Last for Columbine Killings," *New York Times*, June 17, 2006, A10.

76. Johnson and Kelley, A10.

77. The protest flier is quoted in Nicholas Riccardi, "War Hero's Statue Gets Flak for Gun," *Los Angeles Times*, April 15, 2007, A20. Other accounts of the controversy are found in Valerie Richardson, "Community at Odds Over Fallen Hero's Statue," *Washington Times*, April 4, 2007, A01.

78. The dedication is described in Valerie Richardson, "Critics Foresee Scared Children," *Washington Times*, July 5, 2007, A03.

79. Ann Schrader, "A Tribute Etched in Stone: Columbine Memorial Opens Today," *Denver Post*, September 21, 2007, A-01.

80. Kevin Vaughan, "This Is a Good Day," *Rocky Mountain News*, September 22, 2007, available at http://www.rockymountainnews.com/news/2007/sep/22/this-is-a-good-day/; accessed July 11, 2012.

81. The description of this event is based on personal observation. It was reported by John Ingold, "At Capitol, Resolution and Rally Reflect on Tragic Day," *Denver Post*, April 21, 2009, 7A.

82. "Columbine Plus 10," *New York Times*, April 9, 2009, A26.

83. Littleton Museum Board meeting minutes, March 3, 2009, available at http://www.littletongov.org/meetings/default.asp?bordID=18; accessed July 10, 2012.

84. Joey Bunch, "Blooming Anew," *Denver Post*, April 21, 2009, 1A.

85. Susan Greene, "Merciful Is Shown None," *Denver Post*, April 21, 2009, 1B, 3B.

86. Michael Janofsky, "A Son's Echoing Question, A Father's Burning Mission," *New York Times*, February 5, 2000, A9.

87. Mauser told the protest rally, "It is time we own up to the fact that we have a violence problem in this society. Something is wrong in this country when a child can grab a gun so easily and shoot a bullet in the middle of a child's face, as my son experienced." Mauser is quoted in Erika Doss, "Spontaneous Memorials and Contemporary Modes of Mourning in America," *Material Religion* 2 (November 2006): 313.

88. Lynn Bartels, "Two Gun Laws Will Go into Effect Today," *Rocky Mountain News*, July 1, 2000, available at http://m.rockymountainnews.com/news/2000/Jul/01/2-gun-laws-will-go-effect-today/; accessed July 10, 2012. In February 2000 the Colorado Legislature defeated a measure that would have "required private firearms dealers at gun shows to conduct the same kind of background checks that licensed dealers perform." See Michael Janofsky, "Colorado Panel Defeats Move to Close a Gun-Show Loophole," *New York Times*, February 12, 2000, A9.

89. Fox Butterfield, "Study Disputes Success of the Brady Law," *New York Times*, August 2, 2000, A12.

90. See Jim D'Entremont, "Preachers of Doom," *Index on Censorship* 28 (July/August 1999): 193. D'Entremont, the head of the Boston Coalition for Freedom of Expression, predicted a year earlier: "In post-Littleton America, the legislation that becomes law may actually make it more difficult for the young, the unstable, or the criminally inclined to obtain firearms—but the US will continue to be armed to the teeth." Kathy Coffey, "One Year after Columbine: Reflections on the Million Mom March," *America*, June 17, 2000, 22–23, noted that the NRA announced it will spend $30 million to influence fall elections in order to continue maintaining their "stranglehold on national and state legislatures."

91. Vince Gonzales, "Colorado Kills Gun Laws," *CBS News*, available at http://www.cbsnews.com/2100-270_162-161459.html; accessed July 10, 2012. After the NRA contributed thousands of dollars to Colorado state legislators, only those measures supported by the NRA passed. "[L]aws requiring background checks at gun shows, safe storage of guns at home and an increase in the age for buying a handgun from 18 to 21" were voted down.

92. Newman, 69–70.

93. Brown and Merritt, 19.

94. Brown and Merritt, 27, notes that the problem for Dylan went back to the second grade. Ames, 185, reports that Eric and Dylan "were so marked for abuse that even talking to them was dangerous." Both Larkin, xx, and Kass, 56–58, report that both boys were bullied but they also bullied those beneath them in the high school social hierarchy. Larkin provides the most extensive analysis of bullying at Columbine.

95. Brown and Merritt, 50–69.

96. In Brown and Merritt, 7, Brooks Brown recalls "I suddenly remembered all the articles I'd read about Jonesboro and Pearl and Paducah, and Kip Kinkel and Michael Carneal and Luke Woodham. I remembered those times when we'd laughed in speech class that Columbine was next. We'd said that if any school was ripe to get shot up, it was ours."

97. Newman, 126ff, identifies criteria of high school popularity as looks, money, and codes of masculinity as significant factors. Brown, 47, notes, "Columbine's culture worshiped the athlete—and that unconditional adulation had a pretty bad effect on many of the jocks at our school."

98. See Larkin, 63. Newman, 139, and many accounts reported that Eric and Dylan began their rampage by shouting for the jocks to stand up. After asking individuals if they were jocks, they would shoot them if they were wearing a sports cap. This account does not appear to have been substantiated.

99. Ames, 195, notes that by 2004 "17 states had enacted anti-bullying legislation, nearly all passed in the aftermath of Columbine and Santee, while 16 more have legislation pending." A few years later, bullying was a commonplace subject. See, for example,

"Bullied to Death in America's Schools," ABC 2020, October 15, 2010, available at http://abcnews.go.com/2020/theLaw/school-bullying-epidemic-turning-deadly/story?if=11880481#.UARcRY7 N-Ql; accessed July 16, 2012.

100. Larkin, 62–121, provides the best analysis of the peer group structure at Columbine.

101. Regina Huerter's comments are quoted in Kass,188.

102. Newman, 56, 257. Ames, 119, observes "it is no wonder that workplace rage rebellions should take place in the form of one-man suicide missions." Elsewhere, he links office killings to school shootings.

103. Newman, 60, 243ff.

104. Brown and Merritt, 251, analyzed the process this way: "They saw no real future for themselves, and no acceptance from those around them. They became self-hating. Then they started to hate those around them. Then they became angry, and then they became violent. Finally, in one insane, twisted moment, they believed they had power over a world that had kept them down." Brown saw Eric as much more troubled than Dylan: "He had clear bipolar tendencies and was being treated with medication. He had a fascination with death, with firearms, and with rising above his tormenters, and his mental instability fueled that." By contrast, Dylan is perceived as "angry with society, with the hand he had been dealt, and with a world where he couldn't go a day without being spat at, mocked, or told he wasn't good enough." His description is very close to Newman's analysis cited above.

105. Kass, 69ff and 87ff.

106. Brown and Merritt, 19.

107. Newman, 61, 244.

108. D'Entremont, 190.

109. Kass, 55.

110. Kass, 89. Kass, 74, also notes that they could quote every line of the movie and that Eric listed David Lynch's enigmatic *Lost Highway* (1997) as his favorite movie on his AOL profile.

111. See for example, Joan Morgan, "White Noise," *Ms*, Aug/Sept. 1999, 96; Michael Lynch, "Kid's Beat: Free Speech Issues and Video Games," *Reason*, February 2000, 20.

112. Brown, 18, observed, "our society is violent in and of itself, and our music is a reflection of that. . . . Music . . . [is] is a symptom, not a cause. . . . So the bigger questions is this: What is happening to make society want this kind of entertainment? What do kids see happening in real life that makes violent video games so appealing?"

113. Newman, 69, 153ff, 249.

114. Ames, 179, argues that the media may provide a model but only for "people who feel oppressed and desperate. It offers them an answer, a solution, to some awful condition."

115. Larkin, 166 ff.

116. Cullen, *Columbine*, 32, 236.

117. Brown and Merritt, 39.

118. Kass, *Columbine*, 57. Cullen insists that the two boys were doing fine socially but were psychopathic sadists. Jonathan Kellerman, *Savage Spawn: Reflections on Violent Children* (New York: The Ballantine Publishing Group, 1999), argues for Eric's essential evilness.

119. Newman, 229. She observes, "If all five factors are necessary for a rampage to occur, eliminating any one of the factors will reduce the chances of another rampage."

120. Manson is quoted in Cullen, *Columbine*, 317.

121. See Elvis Mitchell, "Daring to Take Fictional Columbine to Cannes," *New York Times*, May 20, 2003, E1.

122. Van Sant is quoted in Mitchell.

123. Larkin, 146–147.

124. Elvis Mitchell, "'Normal' High School on the Verge," *New York Times*, October 10, 2003, E1; Peter Rainer, "Cheap Shots," *New York Magazine*, October 27, 2003, 81.

125. D'Entremont, 194, also noted, "On the day after NATO bombs killed 87 innocent refugees in Kosovo, Clinton was attempting to shame Hollywood producers into making less violent films." Cullen, *Columbine*, 15, summarized the situation this way: "In March 1999, as Eric and Dylan finalized their plans, NATO drew the line on Serbian aggression in a place called Kosovo. The United States began its largest air campaign since Vietnam. Swarms of F-15 squadrons pounded Belgrade. Central Europe was in chaos; America was at war."

126. See Ehrlich, 13.

127. D'Entremont, 192.

128. Henry Jenkins, co-author of *From Barbie to Mortal Kombat: Gender and Computer Games* (Cambridge: MIT Press, 1998), is quoted in D'Entremont, 193.

129. Cullen, *Columbine*, 277; Kass, 184; Ames, 152.

130. Ames, 19.

131. Ames, 149.

132. Ames, 149.

133. Howard J. Ehrlich, "The Columbine High School Shootings: The Lessons Learned," *Social Anarchism* 27 (1999): 5–13 describes the process in detail and applies it to Columbine.

134. William Glaberson, "When Grief Wanted a Hero, Truth Didn't Get in the Way," *New York Times*, July 25, 2000, A1, A22, concludes that "long after the reporters depart, a different story of the events often emerges. Usually, the first accounts present inaccurate information about the killer, the crime, the victims or the roles of the bystanders." Columbine is cited as a case in point.

135. Dave Sanders taught typing, keyboarding, business, and economics, and coached seven different sports. See Cullen, 21. According to most accounts, Sanders was wounded in the shootings but "bled out" due to the length of time it took law enforcement personnel to enter the high school.

136. According to a local year-end summary report, Emily Wyant, who had ducked under a table next to Bernall, said the event never happened. Later, Craig Scott, Rachel Scott's brother, realized the voice he thought was Cassie's was probably Valeen Schnurr, who had been shot. Schnurr reported that she had been criticized and ostracized when she contradicted the Cassie story. See Dan Luzzadder and Kevin Vaughan, "Biggest Question of All," *Rocky Mountain News*, December 14, 1999, available at http://denver.rockymountainnews.com/shooting/1214col1.shtml; accessed July 11, 2012. See also Cullen, 229. Larkin, 48ff, notes that the *Rocky Mountain News,* prompted by a fear of backlash from evangelicals, published the Cassie story as fact until it was proven otherwise on Salon.com. According to Larkin (49), "Among the evangelicals, the martyrdom of Rachel Scott and Cassie Bernall had become an article of faith."

137. See, for example, David Van Biema, "A Surge of Teen Spirit: A Christian girl, martyred at Columbine High, sparks a revival among many evangelical teens," *Time*, May 31, 1999, 58–59; Sara Rimer, "Columbine Students Seek Answers in Their Faith," *New York Times*, June 6, 1999, A26.

138. The following examples, unless otherwise noted, are taken from Art Toalston, "Cassie Bernall's Faith at gunpoint Reverberates Nationally, Globally," *Religion Today* 27 (April 1999), available at http://www.bpnews.net/bpnews.asp?id=1288; accessed July 11, 2012.

139. Eileen McNamara, "A Martyr amid the Madness," *Boston Globe*, April 24, 1999, A10.

140. McPherson is quoted in Watson, 46.

141. Carla Crowder, "Your Courage and Commitment to Christ Have Gained You a Special Place in Heaven," *Rocky Mountain News*, April 27, 1999, available at http://denver.rockymountainnews.com/shooting/0427bern5.shtml; accessed July 11, 2012.

142. S.C. Gwynne, "An Act of God? The Family of Rachel Scott Believes She Died at Columbine to Spark a Spiritual Revival among Youth," *Time*, Dec 20, 1999, 112.

143. Roger Rosenblatt, "A Note for Rachel Scott," *Time*, May 10, 1999, 102.

144. Bruce Porter, *The Martyrs' Torch: The Message of the Columbine Massacre* (Shippensburg, PA: Destiny Image, 1999).

145. Misty Bernall, *She Said Yes: The Unlikely Martyrdom of Cassie Bernall* (Farmington, PA: Plough Publishing House, 1999). A mass-market paperback was issued by Simon & Schuster that year.

146. Dave Cullen, "From Solace to 'Satan': Do Columbine–Area Evangelists Soothe or Fuel Kids' Alienation," *Denver Post*, May 30, 1999, G01.

147. Darrell Scott and Beth Nimmo, *Rachel's Tears: The Spiritual Journey of Columbine Martyr Rachel Scott* (Nashville: Thomas Nelson Publishers, 2000). In February 2009 they published a tenth anniversary edition.

148. Rachel's journals were later published by Beth Nimmo and Debra K. Klingsporn, *The Journals of Rachel Scott: A Journey of Faith at Columbine High* (Nashville: Tommy Nelson, 2001).

149. Darrell Scott is quoted in S.C. Gwynne, "An Act of God?" *Time*, December 20, 1999, 58.

150. David Cullen, "From Solace to 'Satan,'" G01, observed that many in the clergy "saw the killings as a God-given marketing opportunity, a chance to save souls."

151. Watson, 42.

152. Watson, x.

153. For interesting discussions of martyrdom, see for example, Daniel Boyarin, *Dying for God: Martyrdom and the Making of Christianity and Judaism* (Stanford, CA: Stanford University Press, 1999); Rona M. Fields, *Martyrdom: The Psychology, Theology, and Politics of Self-Sacrifice* (Westport, CT: Praeger Publishers, 2004).

154. Andrew Chandler, ed., *The Terrible Alternative: Christian Martyrdom in the Twentieth Century* (New York: Cassell, 1998), xi.

155. Bergman, 10.

156. Watson, 15–18, analyzes the traditional martyr narrative, emphasizing the need for publicity.

157. Hazen and Hines, 7.

158. See Holly G. Miller, "Billy Graham's Millennial Message of Hope," *Saturday Evening Post*, Nov/Dec 1999, 62–63.

159. Doss, "Spontaneous Memorials and Contemporary Modes of Mourning in America," 309, notes that a week after the shootings, "the pastor of Littleton's Celebration Christian Fellowship announced: 'Prayer in schools was officially reestablished on April 20, 1999 because it was accompanied by bombs and shootings. It is always the blood of martyrs that acts as rocket fuel for the church.'" See also Watson, 92–93. Porter, 62–63, includes arguments for school prayer and the prohibition of abortion, as well as attacks on popular culture.

160. Kass, 189.

161. There was ample press coverage of the Virginia Tech shootings but this was a college rather than a high school campus, and the older shooter, Seung-Hui Cho, was not obviously American. By then Columbine had already been lodged in cultural memory, so even though the death toll was greater at Virginia Tech, it did not replace Columbine as a widespread point of reference. For a detailed documentation of Virginia Tech, see Roland Lazernby, ed., *April 16th: Virginia Tech Remembers* (New York: Full Court Press, 2007). See also Cullen, *Columbine*, 348.

162. Nancy Gibbs, "Noon in the Garden of Good and Evil: The Tragedy at Columbine Began as a Crime Story but Is Becoming a Parable," *Time*, May 17, 1999, 54.

163. Martin E. Marty, "Bound by Belief: Jerry Falwell's Theological Tie to Joe Lieberman," *New York Times*, August 15, 2000, A23.

164. Richard Perez-Pena, "Lieberman Seeks Greater Role for Religion in Public Life," *New York Times*, August 28, 2000, A14.

165. Ray Rivera, "Asking What to Do with Symbols of Grief as Memorials Pile Up," *New York Times*, January 6, 2013, A1, A20. See also Peter Applebome, "With Care, Newtown Tries to Move on amid Tokens of Grief," *New York Times*, February 2, 2013, A19.

166. See, for example, Ray Rivera, "Families of Newtown Victims Organize Violence Prevention Effort," *New York Times*, January 6, 2013, A18. Even in the wake of the tragedy, one Newtown resident whose children had previously attended Sandy Hook, observed, "We hunt, we target shoot. We protect our homes. We're collectors. We teach our sons and daughters how to use guns safely. We're not afraid of a national conversation in our community and in Congress about responsibility and accountability. We know there are millions of people in this nation who agree with us."

167. Peter Applebome, "Tragedies of Past Offer a Guide as Aid Goes Unspent," *New York Times*, January 25, 2013, A18.

168. Andrew Solomon, "Anatomy of a Murder-Suicide," *New York Times*, December 23, 2012, SR 1, 6.

169. Francis X. Clines, "Platitudes Loom After the Newtown School Carnage," *New York Times*, March 30, 2013, A13.

170. "In Georgia, Carry a Gun, Just Not in the Capitol," *New York Times*, March 26, 2014, A22.

171. Jeremy W. Peters, "For Next Sep, Bloomberg Sets His Sights on the N.R.A.," *New York Times*, April 16, 2014, A12.

172. See Ben Brantley, "Cruel Truths Always Survive a Shooting," *New York Times*, April 16, 2014, C1, C5.

Chapter 5

1. William Langewiesche, *American Ground: Unbuilding the World Trade Center* (New York: North Point Press, 2002), 75.

2. Feldmann's work was included in the exhibition *Archive Fever—Uses of the Document in Contemporary Art* curated by Okwui Enwezor at ICP from January 18 to May 4, 2008.

3. Susie Linfield, "Every Photo an Archive," *The Nation*, May 5, 2008, 33; *Archive Fever* notebook; ICP archives; accessed July 22, 2010. Jerry Saltz, "Fever Dreams," *New York*, March 3, 2008, 70, was "reminded of how the entire world witnessed not just destruction but something akin to annihilation."

4. In her review of the exhibition Vered Maimon observed that the work made one "aware of the horrifying events that followed: the war in Iraq, Abu Ghraib, Guantanamo Bay, etc. In this regard the headlines in some of the newspapers—'A War on the World' as opposed to 'A War on America,' for example—read now as a missed opportunity since the sense of shared communality in the face of the events no longer prevails." See http://www.caareviews.org/reviews/1111; accessed July 18, 2012.

5. "Spontaneous Memorials, the Sacralization of Public Space, and the Formation of Collective Memory: From the Vietnam Veterans Memorial to the Columbine Killings," *Art and Influence*, Stockholm, September 9, 2011.

6. Elyn Zimmerman's memorial is discussed below.

7. Holland Cotter, "The 9/11 Story Told at Bedrock, Powerful as a Punch to the Gut," *New York Times*, May 14, 2014, A1.

8. Elliot Willensky and Norval White, *AIA Guide to New York City* (New York: Harcourt Brace Jovanich, 1988, third edition), 48, described the towers as "stolid, banal monoliths" and criticized their interruption of the city skyline. For a summary of architectural opinion of the WTC Towers, see, for example, Paul Goldberger, *Up From Zero: Politics, Architecture, and the Rebuilding of New York* (New York: Random House, 2004) and Philip Nobel, *Sixteen Acres: Architecture and the Outrageous Struggle for the Future of Ground Zero* (New York: Henry Holt and Company, 1995).

9. Laurie Kerr, "The Mosque to Commerce," *Slate*, December 23, 2001, available at http://www.slate.com/articles/arts/culturebox/2001/12/the_mosque_to_commerce.html; accessed July 18, 2012, quoted in Nobel, 38, claimed that the Trade Center towers became particularly hateful to Osama bin Laden because "He must have seen how Yamasaki had clothed the World Trade Center, a monument of Western capitalism, in the raiment of Islamic spirituality."

10. See Philippe Petit, *To Reach the Clouds: My High Wire Walk between the Twin Towers* (New York: North Point Press, 2002). A film on his exploits, *Man on Wire*, directed by James Marsh, was released in 2008.

11. See, for example, Kirk Johnson, "New Yorkers Lose Their Inner Rand McNally," *New York Times*, November 11, 2001, A1.

12. Leshu Torchin, "Spontaneous Memorials and Individual Narratives: Community Building Strategies," available at http://web.archive.org/web/20100916103244/http://www.nyu.edu/fas/projects/vcb/case_911/rebuilding/torchin.html; accessed July 18, 2012.

13. Union Square Park is bordered by 14th Street to the south. Portions of this section are adapted from the author's "A Difference in Kind: Spontaneous Memorials after 9/11,"

Sculpture, web special, available at http://www.sculpture.org/documents/scmag03/jul_aug03/webspecial/senie.shtml; accessed July 18, 2012; reprinted in the Swedish journal Area (Spring 2003): 56–59.

14. Initially people rushed to hospitals carrying images of those they were seeking and checking admission lists. See, for example, Jane Gross and Janny Scott, "Hospital Treks, Fliers and the Cry: Have you Seen . . . ?" New York Times, September 13, 2001, A3.

15. From the Civil War until well into the twentieth century Union Square was a site of civic demonstrations closely associated with workers' rights. By the 1960s and 70s it had deteriorated. Controlled by drug pushers, it was renovated in 1986 and eventually transformed into a public space used primarily for relaxation, with a popular farmers' market. See Willensky and White, 184ff, for a description and succinct history.

16. Examples of found poetry were circulated via email. I received one that began with: "do not stand by my grave and weep / for i'm not there, i do not sleep" and ended with "do not stand by my grave and cry / i am not there and did not die." At a time when there were no bodies this poignant sentiment seemed to offer some consolation.

17. John Kifner and Susan Saulny, "Posting Handbills as Votive Offerings," New York Times, September 14, 2001, A9.

18. Images appeared in the New York Times, September 14, 2001, A1, A14–15, with the following captions: "Flying the Colors: Americans responded to the attacks by displaying the flag"; "A symbol offers comfort on New York's streets"; "Americans at home and overseas confronted this week's terror attacks with one simple gesture, flying the flag. The displays seem as much acts of defiance as of patriotism." Flags sold out in many stores and were difficult to obtain in some areas. Afterwards the flags were translated into fashion statements and patterns, even appearing on bed sheets.

19. For a general discussion of the sculpture see Margot Gayle and Michele Cohen, Manhattan's Outdoor Sculpture (New York: Prentice Hall Press, 1988), 91–92. See also Karen Lemmey, "Henry Kirke Brown and the Development of American Public Sculpture in New York City," especially "Chapter 3: A Democratic Monument for the Empire City, George Washington," 135–185, Ph.D. dissertation, City University of New York, 2005. Washington's gesture derives from Michelangelo's statue of Marcus Aurelius at the Capitoline Hill in Rome, although the implicit comparison to a Roman emperor would have been an anathema to the country's first president and unknown to most contemporary viewers.

20. Andrew Jacobs, "Peace amid Calls for War," New York Times, September 20, 2001, A20.

21. Michael Kimmelman, "Offering Beauty, and Then Proof That Life Goes on," New York Times, December 30, 2001, AR35.

22. For a discussion of the restoration in the context of the city's use of public space see Marshall Berman, "When Bad Things Happen to Good People," in After the World Trade Center: Rethinking New York City, ed. Michael Sorkin and Sharon Zukin (New York: Routledge, 2002), 11.

23. Kenneth E. Foote, Shadowed Ground: America's Landscapes of Violence and Tragedy (Austin: University of Texas Press, 2003), 8, designates four categories for the treatment of such sites: sanctification, designation, rectification, and obliteration.

24. "St. Paul's Chapel, Parish of Trinity Church," pamphlet available at the church, nd. For a description of the early activities inside the church see David W. Dunlap, "Polished Marble and Sacramental Scuffs," New York Times, August 25, 2002, Sect 11, pp.1, 6; Daniel

J. Wakin, "Chapel and Refuge Struggles to Define Role," *New York Times*, November 28, 2002, B1, 7. The church produced three videos for sale on its role in the relief process.

25. Michal Ronnen Safdie, *The Western Wall* (Westport, CT: Hugh Lauter Levin, Associates, Inc., 1997), 31.

26. My thanks to Lars Kokonnen for this information. See Joel Greenberg, "Israel: In Sympathy, a Sense of Common Struggle," *New York Times*, September 12, 2002, B19.

27. See Michael Wilson, "How to Say 'Enough' Gracefully," *New York Times*, September 19, 2001, E1.

28. Lynn Brewster, Edward Stannard, and Diane Reiners, "Out of the Dust: A Year of Ministry at Ground Zero," pamphlet produced for Trinity Church, nd. See also, David W. Dunlap, "Historic Chapel Embraces Role as Monument to Sept. 11," *New York Times*, April 28, 2004, B1.

29. Yehuda Amichai, "Introduction," in Safdie, *The Western Wall*, 28.

30. Susan Sontag in *On Photography* (1977) observed, "A photograph is both a pseudo-presence and a token absence." Sontag is quoted in John Updike, "Visual Trophies: The Art of Snapshots," *New Yorker*, December 24, 2007, 144. For a provocative discussion of the role of photographs as relics as well as the significance of their material forms, see Elizabeth Edwards, "Photographs as Objects of Memory," in *Material Memories: Design and Evocation*, ed. Marius Kwint, Christopher Breward, and Jeremy Aynsley (Oxford and New York: Berg, 1999), 226. See also Barbara Kirshenblatt-Gimblett, "Kodak Moments, Flashbulb Memories: Reflections on 9/11," *The Drama Review* 47 (Spring 2003): 11–48.

31. For a discussion of this transformation, see Geoffrey Batchen, "Requiem," *Afterimage* 29 (January/February 2002): 5.

32. For a review of the exhibition at the Museum of Modern Art see Sarah Boxer, "Prayerfully and Powerfully, New York City before and after," *New York Times*, March 6, 2002, E1. For reception in Germany, see Otto Pohl, "Sept. 11 Photo Exhibition Touches a Nerve in Berlin," *New York Times*, July 7, 2002, 8. In addition to Berlin, the exhibition was seen in Dresden, Dusseldorf, and Stuttgart. Other venues continued to be added.

33. Information on *Reactions* is based on the Exit Art press kit and personal observation.

34. "About the National September 11 Memorial & Museum Artists Registry," *National September 11 Memorial and Museum* (organization website), available at http://registry.national911memorial.org/about.php; accessed July 18, 2012.

35. Raymond Gastil and Zoe Ryan, *Renewing, Rebuilding, Remembering* (New York: Van Alen Institute, 2002). All quotes are from this source unless otherwise noted. For a review of the exhibition, see Harriet F. Senie, "Renewing, Rebuilding, Remembering (Van Alen Institute)," *Sculpture* 21 (October 2002): 81–82. For other global approaches to 9/11, see the following anthologies: Joan Ockman, ed., *Out of Ground Zero: Case Studies in Urban Reinvention* (Munich: Prestel Verlag, 2002); and Lawrence J. Vale and Thomas J. Campanella, eds., *The Resilient City: How Modern Cities Recover from Disaster* (New York: Oxford University Press, 2005).

36. The following is adapted from the author's review of this exhibition, "National Icon: The Transfiguration of the World Trade Center Towers," *Sculpture* 21 (October 2002): 81–82. For a full description of the exhibition and the various projects see Max Protetch, *A New World Trade Center: Design Proposals from Leading Architects Worldwide* (New York: HarperCollins, 2002).

37. The realized project was subsequently credited to John Bennett, Gustavo Bone-vardi, Paul Marantz, and Richard Nash-Gold, and renamed *Tribute in Light*. It is dis-cussed in detail below.

38. Protetch, vii.

39. Paula Deitz, "Visionary Towers Crowd the Lagoon," *New York Times*, December 24, 2002, D8.

40. For illustrations, see, for example, "Portraits of Grief," *New York Times*, December 13, 2001, B9; Jane E. Brody, "For Those Awaiting Verification of a Loved One's Fate, a Spe-cial Kind of Grief," *New York Times*, January 20, 2001, B1; Holland Cotter, "Amid the Ashes, Creativity," *New York Times*, February 1, 2002, E33, E35. Cotter reviews both murals and exhibitions.

41. Alan Feuer, "Graffiti's Life After Death," *New York Times*, October 8, 2002, B1, B4.

42. See, for example, Patrick Gallahue, "Mural Honors Ladder 118," *The Brooklyn Paper*, August 26, 2002, 1, 9.

43. Letters to the Editor, "Vanishing Sept. 11 Murals," *New York Times*, August 8, 2004, CY11; Letters to the Editor, "A Sept. 11 Mural Painted Over," *New York Times*, October 24, 2004, CY13.

44. All information on this project, unless otherwise noted, is from a press kit provided by the artist. Her collaborators on this project were Victoria Marshall and Elliott Maltby.

45. Shaila K. Dewan, "Blue Halo Suggested For Wound Downtown," *New York Times*, January 2, 2002, B3.

46. "Untitled" (commemorative public project by Hans Haacke, March 11–25, 2002), *Creative Time* (organization website), available at http://creativetime.org/programs/archive/2002/HansHaacke/haacke/; accessed July 18, 2012.

47. See "Missing: A Photography Exhibit of Spontaneous Shrines," October 19–November 30, 2001, press release, Laura Hansen, co-director of Place Matters. See also Martha Cooper, *Remembering 9/11* (Brooklyn, NY: Mark Batty Publisher, 2011).

48. Seth Kugel, *New York Times*, October 21, 2001, 14 discusses the exhibition "Urban Still Life" as well as Oleaga's desire to preserve these temporary expressions with his work.

49. An archived version of the website is available at http://web.archive.org/web/20030202001824/http://www.yungo.com/galeria.htm; accessed July 18, 2012. See also Dario Oleaga, "Remembering 9/11," *Spiritus: A Journal of Christian Spirituality*, 2 (Spring 2002): 64–73. Leshu Torchin, "Spontaneous Memorials and Individual Narratives: Com-munity Building," mentions the presence of Oleaga's work on the Yungo website (which was no longer operative as of July 2008).

50. A notable exception was Richard Drew's digital color images that were widely re-produced on September 12, 2001. For an interesting interpretation of falling bodies see Andrea D. Fitzpatrick, "The Movement of Vulnerability: Images of Falling and September 11," *Art Journal* 66 (Winter 2007): 84–102.

51. Tom Junod and Andrew Chaikivsky, "The Falling Man," *Esquire*, September 2003, available at http://www.esquire.com/features/ESQ0903-SEP_FALLINGMAN, accessed July 18, 2012, discuss the censorship of this image in detail.

52. Andrea Peyser, "Shameful Art Attack," *New York Post*, September 18, 2002. For the story of the sculpture's removal see, "Sept. 11 Sculpture Covered Up," *CBS News*,

September 19, 2002, available at http://www.cbsnews.com/2100–201_162–522,528.html; accessed July 18, 2012.

53. Junod and Chaikivsky.

54. Junod and Chaikivsky.

55. Eric Fischl, "A Memorial That's True to 9/11," *New York Times*, December 19, 2003; A39; see also David Rakoff, "Questions for Eric Fischl," *New York Times Magazine*, October 27 2002, 15.

56. Alison Gillmor, "The Story of Eric Fischl's *Tumbling Woman*," September 8, 2006, available at http://web.archive.org/web/20080924154331/http://www.cbc.ca/arts/artdesign/tumbling.html, accessed July 18, 2012, remarks on the widespread desire for comfort, not confrontation.

57. The Catholic Encyclopedia defines a relic as "some object, notably part of the body or clothes, remaining as a memorial of a departed saint" and notes that the veneration of relics is "associated with many other religious systems besides Christianity." "Relics," *New Advent Catholic Encyclopedia* (website), available at http://www.newadvent.org/cathen/12734a.htm; accessed July 18, 2012.

58. The "End of Recovery" ceremony was announced at the start of the year by Mayor Michael Bloomberg. See Jennifer Steinhauer, "Tribute Will Signal the End of the Search," *New York Times*, January 17, 2002, B1. As it turned out, the symbolic "end of the search for remains at Ground Zero," was not the actual end of finding remains. The following month, on June 25, firefighters officially completed the task at Deutsche Bank. See "Their Job Complete, Last Recovery Crew of Firefighters Leaves the Trade Center Site," *New York Times*, June 25, 2002, A1, B6.

59. The clean-up process is described in excellent detail by Langewiesche.

60. Dan Barry, "Where Twin Towers Stood, a Silent Goodbye; An End to Awful Task," *New York Times*, May 31, 2002, A1, B6.

61. Charlie LeDuff, "Last Column From the Ground Zero Rubble Is Cut Down," *New York Times*, May 29, 2002, B3.

62. Andrew Jacobs, "Survivors Come Together, Taking Time to Share Their Memories and Grief," *New York Times*, May 31, 2002, B7.

63. Barry, "Where Twin Towers Stood," reported that one spectator was reminded of his mother's photographs of John F. Kennedy's funeral.

64. Daniels is quoted in Simon Akam, "A Makeshift Steel Shrine Returns to Ground Zero," *New York Times*, August 25, 2009, A19.

65. Edward Wyatt, "Steel-Beam Cross Considered for Memorial," *New York Times*, October 5, 2002, B3. Reverend Jordan's parish, Saint Francis of Assisi Roman Catholic Church, was located further uptown on West 32nd Street.

66. David W. Dunlap, "Plan to Move Ground Zero 'Cross' Upsets Priest," *New York Times*, April 12, 2006, B6.

67. Eric Konigsberg, "Brief Journey For an Icon of the Attack on New York," *New York Times*, October 6, 2006, B1, B4.

68. Michael G. Williams, "The 'Chapel that Stood': St. Paul's Picks Up Pieces After 9/11," *The Erickson Tribune*, September 2, 2007, 1. The assorted bracelets, necklaces, and pins, as well as key rings and replicas, refer to the image as both the Ground Zero Cross and the Miracle Cross.

69. Elissa Gootman, "Atheists Sue to Block Display of Cross-Shaped Trade Center Beam in 9/11 Museum," *New York Times*, July 28, 2011, A20.

70. Patricia Cohen, "Sept. 11 Museum Seeks Dismissal of Suit," *New York Times*, August 15, 2012, C2.

71. Associated Press, "Judge Dismisses Suit Over Steel Cross at 9/11 Museum," *New York Times*, March 29, 2013, available at http://www.nytimes.com/2013/03/30/nyregion/judge-dismisses-suit-over-steel-cross-at-9–11-museum.html; accessed January 5, 2015.

72. Silecchia is quoted in Bill Hutchinson, "Ground Zero Cross Can Remain at 9/11 Museum," *Daily News*, July 28, 2014, available at http://www.nydailynews.com/new-york/ground-zero-cross-remain-9–11-museum-court-article-1.1883174; accessed January 5, 2015.

73. See, for example, David W. Dunlap, "Survivors Pursue Effort to Save Stairway That Was 9/11 'Path to Freedom,'" *New York Times*, November 25, 2005, B3. Patty Clark, a senior aviation adviser at the Port Authority of New York and New Jersey who used the stairway as an escape route observed, "It's religious. It's literary. 'Ladder of success.' 'Jacob's ladder.' It's all of those things. 'Step program.' It's all very much woven into how we explain things. 'Stairway to heaven.'"

74. See David W. Dunlap, "Rebuilding, Yes, but Taking Pains to Preserve, Too," *New York Times*, December 30, 2004, B4.

75. David W. Dunlap, "Ground Zero Staircase Is Put on List of Most Endangered Sites," *New York Times*, May 11, 2006, B2.

76. David W. Dunlap reports on the survivors' staircase in the following articles: "Stairs to Remain Intact in Ground Zero Plan," *New York Times*, August 6, 2007, B3; "Extracting Survivors' Stairway for a Home at the 9/11 Museum," *New York Times*, January 17, 2008, B3; "A Last Glimpse of the 9/11 Stairway, before It Moves," *New York Times*, March 4, 2008, available at http://cityroom.blogs.nytimes.com/2008/03/04/a-last-glimpse-of-the-911-stairway-before-it-moves/; accessed July 18, 2012; "Glimpses of the 9/11 Stairway, and of 'Freedom,'" *New York Times*, March 7, 2008, B2.

77. "9/11 Survivors' Staircase to Move Again," *Staten Island Today*, July 19, 2008, available at http://www.silive.com/news/index.ssf/2008/07/911_survivors_staircase_to_mov.html; accessed July 18, 2012. According Alice Greenwald, director of the memorial museum, "The ceremony of descent will be alongside the survivors' stairway." Greenwald is quoted in Dunlap, "Extracting Survivors' Stairway."

78. Philippe de Montebello, "The Iconic Power of an Artifact," *New York Times*, September 25, 2001, A29. John Tierney, "Beauty From Evil: Preserving Felled Tower Facade as Sculpture," *New York Times*, September 25, 2001, A20, in decidedly more prosaic language, referred to the fragment as "that twisted aluminum remnant of the South Tower," and "the strange form looming above the rubble," although he acknowledged that "it had become the most revered shape in the city." Unlike de Montebello, he argued that "New York is too young and vibrant for the ruins and grand monuments to the past that are the trademarks of European capitals."

79. Dinitia Smith, "Hallowed Ground Zero," *New York Times*, October 25, 2001, E1.

80. Eric Lipton, "Surplus History from Ground Zero," *New York Times*, December 19, 2003, B1, B5.

81. "Twin Towers, USA," *New York Magazine*, November 28, 2005, 32. I-beam sections ended up in Portugal, Ireland, and Israel, as well as cities and towns across the United States. Apparently (records are incomplete) most became part of memorials or museum collections.

82. Matthew Purdy, "Just Steel, Tempered by Memory," *New York Times*, May 22, 2002, B1.

83. Michael Wilson, "9/11 Steel Forms Heart of Far-Flung Memorials," *New York Times*, July 7, 2001, A1, A3.

84. Decisions about what to do with surviving public art were made by a committee appointed by the Port Authority: Bartholomew Voorsanger, whose architecture firm co-ordinated the collection effort; Marilyn J. Taylor, chairwoman of Skidmore, Owings & Merrill; and Saul Wenegrat, an art consultant and former head of the Port Authority art program. See Eric Lipton and James Glanz, "From the Rubble, Artifacts of Anguish," *New York Times*, January 27, 2002, 1, 16.

85. The sculpture weighed as much as a crane. See James Glanz and Eric Lipton, *City in the Sky: The Rise and Fall of the World Trade Center* (New York: Henry Holt, 2003), 290–291.

86. The art in various corporate collections was more difficult to document than the public art, especially since many of the records were lost. The Port Authority had over one hundred works at the World Trade Center. Cantor Fitzgerald had an important collection of Rodin drawings and sculptures. A symposium organized by the International Foundation for Art Research (IFAR) on the lost artworks was held on February 28, 2002. For the proceedings of *September 11th: Art Loss, Damage, and Repercussions*, see http://www.ifar. org/nineeleven/911intro.htm; accessed July 19, 2012.

87. Karen Kaplan, "Sculpture Crushed on Sept. 11 Takes on New Symbolism," *Houston Chronicle*, December 24, 2001, available at http://www.chron.com/CDA/archives/archive. mpl/2001_3364793/sculpture-crushed-on-sept-11-takes-on-new-symbolis.html; accessed July 19, 2012.

88. An editorial, "Temporary Memorials at Ground Zero," *New York Times*, February 26, 2002, A24, advocated using the sculpture along with the *Towers of Light* to serve as temporary memorials.

89. Elissa Goodman, "A Day of Somber Reminders Revolves Around a Broken Sculpture and Lights," *New York Times*, March 11, 2002, A13.

90. Foye is quoted in Matt Chaban, "Where is Fritz Koenig's Ground Zero *Sphere* Going?" *New York Observer*, May 25, 2012, available at http://observer.com/2012/05/ wheres-the-koenig-sphere-going-the-port-authoritys-still-working-on-it/; accessed July 19, 2012. See also David Dunlap, "Spherical Symbol of Resilience Is Going Away, but It's Unclear Where," *New York Times*, May 3, 2102, available at http://cityroom.blogs.nytimes. com/2012/05/03/spherical-symbol-of-resilience-is-going-away-but-its-unclear-where/; accessed July 19, 2012.

91. Elyn Zimmerman, "The World Trade Center Memorial, 1993," *September 11th: Art Loss, Damage, and Repercussions*, available at http://www.ifar.org/nineeleven/911_ memorial1.htm; accessed July 19, 2012.

92. Robin Finn, "Making Stones Speak, So That People Remember," *New York Times*, August 7, 2002, B2.

93. Jim Dwyer, "The Memorial That Vanished," *New York Times Magazine*, September 23, 2001, 81.

94. David W. Dunlap, "Interim Shrine Is Proposed for Victims of 1993 Bombing," *New York Times*, February 26, 2004, B3.

95. This ritual is described in Dunlap, "Interim Shrine Is Proposed for Victims of 1993 Bombing."

96. Jim Dwyer, "Their Monument Now Destroyed, 1993 Victims Are Remembered," *New York Times*, February 26, 2002, B2. See also, Barbara Steward, "To Them, 2/26 Was Just as Bad as 9/11," *New York Times*, February 27, 2002, A10.

97. Dunlap, "Interim Shrine Is Proposed for Victims of 1993 Bombing." See also, Ian Urbina, "Manhattan: Memorial for '93 Trade Center Victims," *New York Times*, March 16, 2004, B4.

98. Glenn Collins, "A Wall Once Unseen, Now Revered," *New York Times*, June 23, 2003, B1, B8.

99. Libeskind is quoted in James Glanz, "Ahead of Any 9/11 Memorial, a Wall Bears Witness," *New York Times*, November 23, 2003, WK1.

100. Daniels is quoted in David W. Dunlap, "For 9/11 Wall, a Little Support and a Permanent Place," *New York Times*, April 28, 2008, B5. Dunlap identified Daniel Libeskind's 2002 proposal to display the wall as the source of this plan.

101. Glenn Collins and David W. Dunlap, "Fighting for the Footprints of Sept. 11," *New York Times*, December 30, 2003, B9.

102. Email from Jan Ramirez, dated July 25, 2012.

103. "Fulton Street Viewing Platform," *New York State Museum* (organization website), available at http://www.nysm.nysed.gov/wtc/response/fulton.html; accessed July 19, 2012.

104. Interview of David Rockwell by Kurt Andersen, February 20, 2002, available at http://www.ted.com/talks/david_rockwell_builds_at_ground_zero.html; accessed July 19, 2012.

105. John Perreault echoed the sentiments of many when he commented in 2005 that the *Tribute in Light* "was now the only memorial we really need." See John Perreault, "9/11: Art As It Is Written," *Artopia* (personal website), available at http://www.artsjournal.com/artopia/2005/09/911_art_as_it_is_written.html; accessed July 19, 2012.

106. This account of the origin of the project is largely taken from Yael Reinharz, "This Is Not a Memorial," Creative Time internal file memo, October 23, 2001.

107. Reinharz, "This Is Not a Memorial."

108. Sponsored by the Lower Manhattan Cultural Council, this artist-in-residence program provided free studio space in unoccupied areas of the 91st and 92nd floors of Tower One. When Tower One was destroyed on 9/11, the program was canceled. Erin Donnelly, Mouktar Kocache, et al., *Site Matters: The Lower Manhattan Cultural Council's World Trade Center Artists Residency, 1997–2001* (New York: D.A.P., 2004) provides a complete description and illustration of the various projects created during the program. The book is dedicated to "the memory of all those who lost their lives and to those who have suffered as a result of September 11, 2001" with the "hope that this publication of the World Views residency program will serve not only as a memento mori of a site that no longer exists, but also as an important historical record of the art that was created within it, and in response to it, on the cusp of a new century, a new millennium" (7).

109. Donnelly et al., 255.

110. Julian LaVerdiere and Paul Myoda, "Bioluminiscent Beacon," *tema celeste*, September–October 2001, accessed in the Creative Time archives.

111. "Filling the Void: A Memorial by Paul Myoda and Julian LaVerdiere," *New York Times Magazine*, September 23, 2001, 80.

112. Paul Myoda, untitled and undated talk, Creative Time archives. The following references to Myoda's initial interpretation, unless otherwise noted, are taken from this source.

113. Notes of a lecture given by Gustavo Bonevardi, Creative Time archives. The references to Bonevardi's inspiration, unless otherwise noted, are taken from this source.

114. Myoda is quoted in Calvin Tomkins, "Towers of Light," *New Yorker*, October 1, 2001, 39.

115. "Update," *New York Times Magazine*, October 7, 2001, 12.

116. "Tribute in Light," Municipal Art Society release, nd, Creative Time archives. The release describes the project as "A tribute to the memory of those who have been lost and a symbol of the spirit of the great city of New York." The main sponsors are listed as General Electric Company, Deutsche Bank, and AOL/Time Warner. Contributing sponsors: Con Edison, Agnes Gund, Alliance for Downtown New York, Covington & Burling, Mark Fletcher and Tobias Meyer, Robert Wood Johnson IV, Met Life, David Rockefeller, The Rudin Family Foundation, Sullivan & Cromwell, Forbes Magazine, the New York Times, The Wall Street Journal. Also listed are Thomas Healy and Fred Hochberg, LEF Foundation, Third Millennium Foundation, Phil Aarons and Shelley Fox Aarons, Albert D. Unger Foundation, Amanda Burden, Andy Warhol Foundation for the Arts, Andrew Heiskell, Lynford Family Foundation, Mark Willard and Association, Merrill Lynch, Millennium Partners, New York Times Company Foundation, Roy and Niuta Titus Foundation. Special thanks is given to the Public Art Fund, Lippincott and Margulies, and Urban Data Solutions.

117. Email from Julian LaVeridiere and Paul Myoda to Anne Pasternak, September 20, 2004, Creative Time archives.

118. David W. Dunlap, "From 88 Searchlights, an Ethereal Tribute," *New York Times*, March 4, 2002, B3.

119. Robin Finn, "Paul Marantz; From Disco Floors to Skylines, Illuminating Lives," *New York Times*, March 29, 2002, B2.

120. Email from Julian LaVerdiere and Paul Myoda to Anne Pasternak, September 20, 2004, Creative Time archives.

121. Julian LaVerdiere, comments made to a City College of New York Macaulay Honors College seminar class visiting Creative Time, September 11, 2009.

122. Creative Time archives, chart of email responses to *Towers of Light* project, November 5, 2001; 7,734 supported the project; 223 felt it was inappropriate; 139 were concerned about migratory birds; 139 were concerned about light pollution; and 85 were concerned about energy issues.

123. Email by Rebekah Creshkoff, forwarded by Noah Van Gelder to Creative Time, September 27, 2001, Creative Time archives. The similar wording of the emails suggests an organized response.

124. Iken is quoted in Maria Alvarez, David Seifman, William Newman, "Battery Woe for Towers of Light," *New York Post*, February 28, 2002, available at http://nypost.com/2002/02/28/battery-woe-for-towers-of-light/; accessed January 10, 2015.

125. Hunh-Graifman is quoted in Lynne Duke, "Six Months after, A Memorial Built on Beams of Light," *Washington Post*, March 5, 2002, C01.

126. Editorial, "Tonight, Remember the Morning," *Daily News*, March 11, 2002, available at http://www.nydailynews.com/archives/opinions/tonight-remember-morning-article-1.489459; accessed January 10, 2015.

127. Rick Hampon and Charisse Jones, "Eyes, Hearts Turn to Heavens over NYC," *USA Today*, March 12, 2002, 1.

128. Professor Lise Kjaer, City College, undated email to the author.

129. See photograph by Michelle V. Agins, *New York Times*, March 12, 2003, A1.

130. LaVerdiere is quoted in William Neuman, Maggie Haberman, Ed Robinson, and Ikimulisa Sockwell-Mason, "Fantastic: Glowing Tribute 'Shows World We Aren't Giving Up,'" *New York Post*, March 12, 2002, 9.

131. The poll was taken by Quinnipiac University Polling Institute. See David W. Dunlap, "A Survey Reveals Sentiment For Keeping Shafts of Light," *New York Times*, March 29, 2002, B2.

132. David W. Dunlap, "From 88 Searchlights, an Ethereal Tribute," *New York Times*, March 4, 2002, B3.

133. See Dunlap, "From 88 Searchlights, an Ethereal Tribute," for reactions to the end of the project.

134. Julie V. Iovine, "Designers Look Beyond Debris," *New York Times*, September 27, 2001, F1.

135. David Abel, "A Wish to Re-Create Towers—in Light," *Boston Globe*, September 29, 2001, A12.

136. Sanchis is quoted in "Twin Towers Could Reappear in Light Form," *Lighting Equipment News*, November 2001, 1. Accessed Creative Time archives.

137. Ganci and Pagan are quoted in Rick Hampon and Charisse Jones, "Eyes, Hearts Turn to Heavens over NYC," *USA Today*, March 12, 2002, 3A.

138. Robert Knafo, "Grave Yard: Lessons in Memorial-building," *Slate*, October 9, 2001, available at http://www.slate.com/articles/arts/culturebox/2001/10/grave_yard.html; accessed July 18, 2012.

139. Lynne Cavanaugh, email to Creative Time dated October 11, 2001; Robin Uribe, Leo McManus, undated emails to Creative Time.

140. Herbert Muschamp, "In Lights at Ground Zero, Steps Toward Illumination," *New York Times*, March 12, 2002, A15.

141. Howard Halle, "Fuhrer over Ground Zero," *Time Out New York*, September 11–18, 2003, also compared the *Tribute in Light* to Speer's light project. He admitted that the connection "creates a sort of uneasy symmetry for someone like me, who lost family in the Holocaust. Whatever else motivated the September 11 hijackers, clearly they were impelled by a virulent strain of anti-Semitism, one more extreme, you could argue, than Nazism itself." More recently, on May 14, 2007, the city of Rotterdam commemorated the 15-minute-long German bombing of the city in 1940 with a light project entitled *Brandgrens* (Bombardment Periphery). One-hundred light beams designated the limits of fire destruction in the city center. Intended by the art collective Mothership as a temporary memorial until a permanent one could be built, the project naturally prompted comparisons to the 9/11 light project in New York, but more strikingly with Albert Speer's light spectacle. See Greg Allen, "Bombardment Periphery, Rotterdam," *Greg.org* (personal website), available at http://greg.org/archive/2007/05/19/bombardment_periphery_rotterdam.html; accessed July 19, 2012. My thanks to Sheila Gerami for this reference.

142. See Lisa Saltzman, *Making Memory Matter: Strategies of Remembrance in Contemporary Art* (Chicago: University of Chicago Press, 2006), 30–47, for a discussion of Wodiczko's *Bunker Hill Monument Projection* (1989).

143. An email from Pepeeta Ameerali to Creative Time, no date, reads: "Light symbolizes to me and my family souls, spirit, hope, and most of all God." One from Dorota Mieroslawska, Warsaw, no date, reads: "Light. Remembrance. Beyond debris—the power and invincibility of Spirit."

144. Phaedra Svec, email to Creative Time, no date. "It is an elegant memorial. We have a virtual church steeple made of light in Kansas City. It was envisioned by Frank Lloyd and completed by Dale Eldred and Roberta Lord. It has become a powerful and well-loved icon, beaming into the night sky as a beacon to the great beyond."

145. Van Johnson is quoted in Gret Gittrich, David Saltonstall, and Corky Siemanszko, "Two Towers of Light Rise in Tribute to WTC Lost," *Daily News*, March 12, 2002, 4–5.

146. Creative Time archive.

147. Kevin K. from Staten Island in an email to Creative Time, October 3, 2001, identified himself as a firefighter. He felt that the project "makes the site of death of thousands of people look like the Strip in Las Vegas and 42nd Street," and worried that it would "turn this now sacred place into a sideshow." He went on to define the site as a cemetery and pointed out that there are no lights at Arlington or Gettysburg. Kim Thompson in an email to Creative Time, September 26, 2001, also objected: "Light cannons are associated in my mind with glitzy Hollywood premiers, and openings of Planet Hollywood or the like, not a serious memorial to massive loss of life"

148. Saskia Levy of the Municipal Art Society noted, "It's like a votive candle. It will have its time and its place. And then it will go out." See Dunlap, "From 88 Searchlights, an Ethereal Tribute."

149. Robert Knafo, "Grave Yard: Lessons in Memorial-Building."

150. Marilyn Stokstad, *Art: A Brief History* (Upper Saddle River, NJ: Pearson Prentice Hall, 2004, second edition), 526–527. My thanks to Ellen Handy for this reference. This discussion follows immediately after the *Vietnam Veterans Memorial*. Charlton Price of Kansas City, Missouri, letter to the *New York Times*, March 13, 2002, also connects the *Tribute in Light* to the Statue of Liberty, insisting "the towers of light must keep shining, along with Liberty lighting the world in New York Harbor." Paul Marantz, the lighting designer who helped realize the project, compared it to the *Vietnam Veterans Memorial*, saying that both were "sufficiently reductivist yet enormously evocative. People find in it what they need to find." See Robin Finn, "Paul Marantz; From Disco Floors to Skylines, Illuminating Lives," *New York Times*, March 29, 2002, B2.

151. Dan Barry, "Minutes of Silence and Shafts of Light Recall New York's Dark Day," *New York Times*, March 12, 2003, A1. The photograph was by Vincent Laforet.

152. Langewiesche, 3, described the collapse of the towers as follows: "For an instant, each tower left its imprint in the air, a phantom of pulverized concrete making a place that then became a memory."

153. David Ebony, "Towers of Light for New York City," *Art in America* 89 (November 2001): 63–64.

154. Parts of the following section are adapted from Harriet F. Senie, "Absence vs. Presence: The 9/11 Memorial Design," *Sculpture* 23 (May 2004): 10–11.

155. All quotations are taken from "World Trade Center Site Memorial Competition Guidelines," LMDC (Lower Manhattan Development Corporation). The cover page included the exhortation to: "Remember and honor the thousands of innocent men, women, and children murdered by terrorists in the horrific attacks of February 26, 1993 and September 11, 2001." The deadline for registration was May 29, 2003; the deadline for submission June 30, 2003.

156. Herbert Muschamp, "Don't Rebuild. Reimagine," *New York Times Magazine*, September 8, 2002, 56. Lin also proposed that on every anniversary "the towers of light would reappear, projecting from the pools."

157. See Nobel, *Sixteen Acres*, 253; David Simpson, *9/11: The Culture of Commemoration* (Chicago: University of Chicago, 2006), 79. On the similarity of proposals, see Paul Goldberger, "Slings and Arrows," *New Yorker*, February 9, 2004, 85–87. In addition to Lin, selection panel members were Paula Grant Berry, Susan K. Freedman, Vartan Gregorian, Patricia Harris, Michael McKeon, Julie Menin, Enrique Norten, Martin Puryear, Nancy Rosen, Lowery Stokes Sims, Michael Van Vlakenburgh, and James E. Young. For a summary of their positions see "13 Who Will Do the Choosing: Jurors for the Memorial Competition," *New York Times*, November 19, 2003, B4.

158. Eric Fischl, "A Memorial That's True to 9/11," *New York Times*, December 19, 2003, A19. Fishchl lamented the absence of narrative content or "true artistic expression." See also David Rakoff, "Questions for Eric Fischl: Post-9/11 Modernism," *New York Times*, October 27, 2002, 15.

159. The finalists' designs are illustrated on the Lower Manhattan Development Corporation's World Trade Center Memorial Competition website. See http://www.wtcsitememorial.org/finalists.html; accessed January 11, 2015.

160. Michael Kimmelman, "Ground Zero's Only Hope: Elitism," *New York Times*, December 7, 2003, AR1, 47. He complained: "Instead of beginning with a firm idea about the meaning of the memorial, we started with a time table."

161. Nicolai Ouroussoff, "For the Ground Zero Memorial, Death by Committee," *New York Times*, June 19, 2005, AR 31.

162. Letters to the editor, *New York Times*, November 21, 2003, A30. Lynn Jericho of Jersey City and author of a book about ground zero, wrote: "9/11 calls out for a memorial that symbolizes far more than the tragic loss of life. . . . Lacking any creative differences, the designs minimize the historical and spiritual significance of the event and place. . . . Among the 5,201 submissions, surely there were creative possibilities that went beyond the focus on memory of the dead." Similarly, Lisa Chamberlain of New York wondered, "With 5,201 entries, how can the chosen eight look so much the same?"

163. Alan Feuer, "On Memorial, Criticism Outstrips Praise," *New York Times*, November 23, 2003, 34.

164. Herbert Muschamp, "Amid Embellishment, a Voice of Simplicity Cries to Be Heard," *New York Times*, November 20, 2003, B3.

165. Arad is quoted in David. W. Dunlap, "Where Two Towers Once Stood, A Memorial Begins to Materialize," *New York Times*, November 17, 2008, A25.

166. "The 9/11 Memorial from All Sides," *New York 1*, July 8, 2011, available at http://www.ny1.com/content/top_stories/142578/9–11–a–decade–later–special–report–the–9–11–memorial–from–all–sides–full–program; accessed July 19, 2012.

167. David W. Dunlap, "Memorial Pools Will Not Quite Fill Twin Footprints," *New York Times*, December 15, 2005, B3.

168. See, for example, Rick Bell, "World Trade Center Memorial Redux," *The Architects' Newspaper*, July 12, 2006, 21, 23. D. Graham Shane, "Pataki's Messy Legacy," *The Architects' Newspaper*, July 12, 2006, 21, 23, felt that "The most shocking revelation of the new design drawings is that the site is again being rendered as flat."

169. Nicolai Ouroussoff, "The Ground Zero Memorial, Revised but not Improved," *New York Times*, June 22, 2006, E6. He also observed that the 9/11 museum was "not expected to address the complex roots of the murderous events," unlike the museum at the Berlin Holocaust Memorial, which is one-sixth its size.

170. "9/11 Memorial, Version 2.0," *New York Times*, June 22, 2006, A24.

171. "Names Arrangement," *National September 11 Memorial and Museum* (organization website), available at http://www.911memorial.org/names-arrangement; accessed July 19, 2012.

172. "The 9/11 Memorial From All Sides," *New York 1*, July 8, 2011.

173. Witold Rybczynski, "The 9/11 Memorial, Reviewed," *Slate*, September 7, 2011, available at http://www.slate.com/articles/arts/architecture/2011/09/black_holes.html; accessed May 8, 2014.

174. See Senie, "Absence vs. Presence: The 9/11 Memorial Design," for an expansion of the author's initial response.

175. This and subsequent quotes are cited in Janny Scott, "9/11 Memorial's Multiple Goals Leave New Yorkers Divided," *New York Times*, November 21, 2003, B1, B4.

176. Eric Fischl, "A Memorial That's True to 9/11," *New York Times*, Dec 19, 2003, A39. For Fischl, "[A] memorial should be more than a marker at a grave site. It should be a narrative. . . . Not only is the coffin being put in the ground, the tombstone is being buried along with it."

177. Philip Nobel, "Memory Holes," *Metropolis Magazine*, September 2011, available at http://www.metropolismag.com/September-2011/Memory-Holes/; accessed January 10, 2015.

178. Blair Kamin, "A First Look at the National September 11 Memorial: A Tough Work of Abstract Minimalism, Softened by Waterfalls and Oak Trees, Seeks to Meld Remembrance and Regeneration," *Chicago Tribune*, August 14, 2011, available at http://featuresblogs.chicagotribune.com/theskyline/2011/08/a-first-look-at-the-soon-to-open-national-september-11-memorial-a-tough-work-of-abstract-minimalism-.html; accessed January 10, 2015.

179. Justin Davidson, "Memorial: Affecting Remembrance or Adornment for Real Estate?" *New York*, August 12, 2011, available at http://nymag.com/news/9-11/10th-anniversary/9-11-memorial/; accessed May 8, 2014.

180. Rybczynski, *Slate*.

181. David Simpson, "Short Cuts," *London Review of Books* 33 (November 17, 2011): 22.

182. This and the following observations, unless otherwise indicated, were made by Arad in "The 9/11 Memorial from All Sides," *NY1*, July 8, 2011.

183. Adam Gopnik, "Stones and Bones," *New Yorker*, July 7, 2014, available at http://www.newyorker.com/magazine/2014/07/07/stones-and-bones; accessed January 10, 2015.

184. *The World Trade Center Site Memorial Competition Guidelines*, 2003, 19.

185. My thanks to John Hatfield for this observation. Conversation, April 21, 2014.

186. Contradictions of the site are discussed by Adam Gopnik, "Stones and Bones"; Michael Kimmelman, "Finding Space for the Living at a Memorial," *New York Times*, May 28, 2014, C1; Mark Lamster, "9/11 Museum Reconciles Conflicting Demands with Dignity," *Dallas Morning News*, September 2, 2014, available at http://www.dallasnews.com/entertainment/columnists/mark-lamster/20140906-911-memorial-reconciles-conflicting-demands.ece; accessed January 10, 2015.

187. For a detailed discussion of the misquote see, for example, Caroline Alexander, "Out of Context," *New York Times*, April 6, 2011, A27.

188. Greenwald is quoted in David W. Dunlap, "A Memorial Inscription's Grim Origins," *New York Times*, April 2, 2014, A20.

189. Charles B. Strozier and Scott Gabriel Knowles, "How to Honor the Dead We Cannot Name: The Problems with the September 11 Memorial Museum," *Slate*, May 12, 2014, available at http://www.slate.com/articles/health_and_science/science/2014/05/september_11_memorial_museum_controversy_unidentified_remains_and_lessons.html; accessed June 10, 2014. The authors comment on the difficulty of defining this problematic inclusion: "Is the new repository a part of the museum, a cemetery, a forensics lab, or a tomb for the unknown who will never be identified?"

190. Bloomberg is quoted in Stephen Nessen, "Photos: First Look at the 9/11 Memorial Museum," WNYC News, May 5, 2014, available at http://www.wnyc.org/story/photos-first-look-911-memorial-museum/; accessed January 10, 2015.

191. David Simpson, *9/11: The Culture of Commemoration*.

192. Amateur historian Todd Fine is quoted in Stephen Farrell and Peter Baker, "9/11 Museum Opens to a Somber Crowd," *New York Times*, May 21, 2014, A1.

193. For a summary of the objections see Sharon Otterman, "Film at 9/11 Museum Sets Off Clash Over Reference to Islam," *New York Times*, April 23, 2014.

194. David Brooks, "The Thing Itself," *New York Times*, October 14, 2011, available at http://www.nytimes.com/2011/10/14/opinion/the-thing-itself.html; accessed May 8, 2014.

195. Phillip Kennicott, "The 9/11 Memorial Museum Doesn't Just Display Artifacts, It Ritualizes Grief on a Loop," *Washington Post*, June 7, 2014.

196. Steve Kendall, "The Worst Day of My Life Is Now New York's Hottest Tourist Attraction," *Buzzfeed*, May 19, 2014, available at http://www.buzzfeed.com/stevekandell/the-worst-day-of-my-life-is-now-new-yorks-hottest-tourist-at; accessed January 10, 2015.

197. Edward Rothstein, "A Memorial to Personal Memory: Recalling September 11 by Inverting a Museum's Usual Role," *New York Times*, May 22, 2014, AR18.

198. Phillip Kennicott, "The 9/11 Memorial Museum Doesn't Just Display Artifacts, It Ritualizes Grief on a Loop," *Washington Post*, June 7, 2014, available at http://www.washingtonpost.com/lifestyle/style/review-911-memorial-in-new-york/2011/08/04/gIQARXETgJ_story.html; accessed January 10, 2015.

199. Rosalyn Deutsche, "The Whole Truth," *Artforum* 53 (September 2014), available at https://artforum.com/inprint/issue=201,407&id=47,864; accessed January 10, 2015. She concludes: "Hiding 9/11's traumatic disturbance of the nation's self-image, the museum concerns itself only with the violence we have suffered and supposedly triumphed over and, turning away from the rest of the world, resists trying to understand (which is not the same as forgiving or justifying) the psychic, political, economic, and cultural conditions of religious terrorism that contributed to the barbaric attack."

200. Alexander Nazaryna, "The 9/11 Museum's Biggest Oversight: The World Trade Center's Neighborhood," *Newsweek*, June 9, 2014, available at http://www.newsweek.com/911-museums-biggest-oversight-world-trade-centers-neighborhood-253,584, accessed January 10, 2015, suggests: "Maybe not all Arabs are the Arabs you think you know" and that maybe "mentioning Arabs in any context outside of *We have some planes* might discomfit patriots with no patience for nuance."

201. Phillip Kennicott, "The 9/11 Memorial Museum Doesn't Just Display Artifacts, It Ritualizes Grief on a Loop," *Washington Post*, June 7, 2014, available at http://www.washingtonpost.com/entertainment/museums/the-911-memorial-museum-doesnt-just-display-artifacts-it-ritualizes-grief-on-a-loop/2014/06/05/66bd88e8-ea8b-11e3-9f5c-9075d5508f0a_story.html; accessed January 10, 2015.

Conclusion

1. Wolfgang Schivelbusch, *The Culture of Defeat: On National Trauma, Mourning, and Recovery* (New York: Metropolitan Press, 2003), 293. Schivelbusch elaborated: "The Vietnam debate was never settled; rather, it was buried under the Reagan-era defense buildup, the double victories of the Cold War and the Gulf War, and the reestablishment of America's universally acknowledged military, commercial, and cultural hegemony over the rest of the world. But earthquakes and aerial bombardments often reveal what lies beneath—for instance, the ruins of earlier fallen cities."

2. Kirk Savage, *Monument Wars: Washington, D.C., the National Mall, and the Transformation of the Memorial Landscape* (Berkeley: University of California Press, 2009), 279.

3. For a discussion of the implications of this belief see Robert Jay Lifton, *Super Power Syndrome: America's Apocalyptic Confrontation with the World* (New York: Thunder's Mouth Press, 2003).

4. Jesse Katz, "Memorial: A Driving Need for Catharsis," *Los Angeles Times*, April 19, 1997, available at http://articles.latimes.com/1997–04-19/news/mn-50,375_1_memorial-committee; accessed July 30, 2012.

5. "Terror's Long Shadow," *New York Times*, April 24, 2005, WK2. The comment under the photograph of Oklahoma City read, in part, "terror's long shadow cast Americans back 10 years, 6 years, 4 years: There was the Oklahoma City bombing. There was the Colorado school shooting. There was, as ever, Sept. 11, 2001."

6. Robin Wright, "Terror in the Past and Future Tense," *New York Times*, April 26, 2005, A19.

7. Hans Butzer, "Deciding What Our Loss Means," *New York Times*, October 10, 2001, A19.

8. Johnson's remarks were made on November 20, 2001, at a panel on Oklahoma City at the Municipal Art Society in New York. The other speakers were Helene Fried, who ran the design competition; Tony Tung, described as an artist dealing with devastation; and Laurie Beckelman, chair of the New York City Landmarks Commission, who had served on the Oklahoma City Memorial jury. All comments and quotes from this event are based on the author's notes.

9. Edward T. Linenthal, "A Sisterhood of Grief," *New York Times*, December 21, 2001, CY3.

10. Jeffrey D. Feldman, "One Tragedy in Reference to Another: September 11 and the Obligations of Museum Commemoration," *Museum Anthropology* 105 (December 2003): 841.

11. Savage is quoted in Janny Scott, "9/11 Memorial's Multiple Goals Leave New Yorkers Divided," *New York Times*, November 21, 2003, B4. Similarly, addressing the larger problem of which victims merit a memorial, Kirk Savage asked: "If the extra-local significance makes the event monumental, then should not the monument focus on that wider significance?" See Kirk Savage, "Trauma, Healing, and the Therapeutic Monument," in *Terror, Culture, Politics: Rethinking 9/11*, ed. Daniel J. Sherman and Terry Nardin (Bloomington and Indianapolis: Indiana University Press, 2006), 111.

12. Lawrence J. Vale and Thomas J. Campanella, "Conclusion: Axioms of Resilience," in *The Resilient City: How Modern Cities Recover from Disaster*, ed. Vale and Campanella (New York: Oxford University Press, 2005), 340.

13. David Reiff, "After 9/11: The Limits of Remembrance," *Harper's Magazine*, August 2011, 49.

14. Robert Pogue Harrison, *The Dominion of the Dead* (Chicago and London: University of Chicago Press, 1992), 140.

15. Greenwald is quoted in Patricia Cohen, "At 9/11 Museum, Talking through an Identity Crisis," *New York Times*, June 3, 2012, A1.

16. Julian Bonder refers to the Latin definition of monument in his artist philosophy statement, "Memory Works," in *Companion to Public Art*, ed. Cher Krause Knight and Harriet F. Senie (Malden, MA: Wiley-Blackwell, forthcoming 2016).

{ BIBLIOGRAPHY }

Abramson, Daniel. "Maya Lin and the 1960s: Monuments, Time Lines, and Minimalism." *Critical Inquiry* 22 (Summer 1996): 679–709.

Adams, William. "War Stories: Movies, Memory, and the Vietnam War." *Comparative Social Research* 11 (1989): 165–189.

Allen, Thomas B. *Offerings at the Wall: Artifacts from the Vietnam Veterans Memorial Collection.* Atlanta: Turner Publishing, Inc., 1995.

Ames, Mark. *Going Postal: Rage Murder, and Rebellion: From Reagan's Workplaces to Clinton's Columbine and Beyond.* Brooklyn, NY: Soft Skull Press, 2005.

Ang, Ien, Ruth Barcan, et al. *Planet Diana: Cultural Studies and Global Mourning.* Kingswood, NSW, Australia: University of Western Sydney, Nepean, 1997.

Batchen, Geoffrey. "Requiem." *Afterimage* 29 (January/February 2002): 5.

Baudrillard, Jean. *America.* London, New York: Verso, 1989.

Berenbaum, Michael. *After Tragedy and Triumph: Essays on Modern Jewish Thought and the American Experience.* Cambridge: Cambridge University Press, 1991.

Bernall, Misty. *She Said Yes: The Unlikely Martyrdom of Cassie Bernall.* Farmington, PA: Plough Publishing House, 1999.

Bishop, Claire. *Installation Art.* New York: Routledge, 2005.

Blair, Carole, Marsha S. Jeppeson, and Enrico Pucci Jr. "Public Memorializing in Postmodernity: The Vietnam Veterans Memorial as Prototype." *Quarterly Journal of Speech* 77 (August 1991): 263–288.

Bodnar, John. *Remaking America: Public Memory, Commemoration, and Patriotism in the Twentieth Century.* Princeton, NJ: Princeton University Press, 1992.

Boettger, Suzaan. *Earthworks: Art and the Landscape of the Sixties.* Berkeley: University of California Press, 2002.

Bogart, Michele H. *Public Sculpture and the Civic Ideal in New York City: 1890–1930.* Chicago: University of Chicago Press, 1989.

Boyarin, Daniel. *Dying for God: Martyrdom and the Making of Christianity and Judaism.* Stanford, CA: Stanford University Press, 1999.

Braudy, Leo. *The Frenzy of Renown: Fame and Its History.* New York: Oxford University Press, 1986.

Brown, Brooks, and Rob Merritt. *The Truth Behind Death at Columbine.* New York: Lantern Books, 2002; 2006.

Brown, J. Carter. "The Mall and the Commission of Fine Arts." *Studies in the History of Art* 30 (1991): 248–261.

Buchloh, Benjamin H. D. "Cargo and Cult: The Displays of Thomas Hirschhorn." *Artforum* 40 (November 2001): 108–115, 172–173.

Buchloh, Benjamin H. D., Alison M. Gingeras, and Carlos Basualdo. *Thomas Hirschhorn.* London: Phaidon, 2004.

Buruma, Ian. "The Joys and Perils of Victimhood." *New York Review of Books* 46 (April 8, 1999): 4–9.

Capasso, Nicholas J. "The National Vietnam Veterans in Context: Commemorative Public Art in America 1960–1997." Ph.D. diss., Rutgers University, 1998.

Capps, Walter. *The Unfinished War: Vietnam and the American Conscience.* Boston: Beacon Press, 1982, 1990.

Carlson, A. Cheree, and John E. Hocking. "Strategies of Redemption at The Vietnam Veterans Memorial." *Western Journal of Speech Communication* 52 (1988): 203–215.

Cassel, Justine, and Henry Jenkins. *From Barbie to Mortal Kombat: Gender and Computer Games.* Cambridge: MIT Press, 1998.

Chandler, Andrew, ed. *The Terrible Alternative: Christian Martyrdom in the Twentieth Century.* New York: Cassell, 1998.

Chapman, Mary, and Glenn Handler, eds. *Sentimental Men: Masculinity and the Politics of Affect in American Culture.* Berkeley: University of California Press, 1999.

Collyer, Stanley. "The Search for an Appropriate Symbol: The Oklahoma City Memorial Competition." *Competitions* 7, no. 3 (1997): 4–15.

Cooper, Martha. *Remembering 9/11.* Brooklyn, NY: Mark Batty Publisher, 2011.

· Cooper, Martha, and Joseph Sciorra. *R.I.P.: Memorial Wall Art.* New York: Henry Holt & Company, 1994.

Cullen, Dave. *Columbine.* New York: Twelve, 2009.

Danto, Arthur C. *The State of the Art.* New York: Prentice Hall Press, 1987.

Deutsche, Rosalyn. "The Whole Truth." *Artforum* 53 (September 2014).

Donnelly, Erin, and Mouktar Kocache, et al. *Site Matters: The Lower Manhattan Cultural Council's World Trade Center Artists Residency, 1997–2001.* New York: D.A.P., 2004.

Doss, Erika. *Memorial Mania: Public Feeling in America.* Chicago: University of Chicago Press, 2010.

Ebony, David. "Towers of Light for New York City." *Art in America* 89 (November 2001): 63–64.

Ehrenhaus, Peter. "Silence and Symbolic Expression." *Communication Monographs* 55 (March 1988): 41–57.

Ehrlich, Howard J. "The Columbine High School Shootings: The Lessons Learned." *Social Anarchism* 27 (1999): 5–13.

Eisenberg, Karen. "Honoring the Victims of the Oklahoma City Bombing." *Blueprints (The Journal of the National Building Museum)* 13–14 (1995): 4.

Endlich, Stefanie, and Thomas Lutz. *Gedenken und Lernen an historishen Orten: Ein Wegweiser zu Gedenkstatten fur die Ofper des Nationalsozialismus in Berlin.* Berlin: Landeszentrale fur politische Bildungsarbeit, 1995; rev. 1998.

Everett, Holly. "Roadside Crosses and Memorial Complexes in Texas." *Folklore* 111 (April 2000): 91–103.

Everett, Holly. *Roadside Crosses in Contemporary Memorial Culture.* Denton, Texas: University of North Texas Press, 2002.

Farrell, James J. *Inventing the American Way of Death, 1830–1920.* Philadelphia: Temple University Press, 1980.

Faust, Drew Gilpin. *The Republic of Suffering: Death and the American Civil War.* New York: Alfred A. Knopf, 2008.

Feldman, Jeffrey D. "One Tragedy in Reference to Another: September 11 and the Obliga-
tions of Museum Commemoration." *Museum Anthropology* 105 (December 2003):
838–843.

Fields, Rona M. *Martyrdom: The Psychology, Theology, and Politics of Self-Sacrifice.* West-
port, CT: Praeger Publishers, 2004.

Fitzpatrick, Andrea D. "The Movement of Vulnerability: Images of Falling and September
11." *Art Journal* 66 (Winter 2007): 84–102.

Foote, Kenneth E. *Shadowed Ground: America's Landscapes of Violence and Tragedy.*
Austin, TX: University of Texas Press, 1997; 2003.

Foss, Sonja K. "Ambiguity as Persuasion: The Vietnam Veterans Memorial" *Communica-
tion Quarterly* 34 (Summer 1986): 326–340.

Flanzbaum, Hilene, ed. *The Americanization of the Holocaust.* Baltimore: Johns Hopkins
University Press, 1999.

Frank, Robert. *The Americans.* New York: Grove Press, 1959.

French, Stanley. "The Cemetery as Cultural Institution: The Establishment of Mount
Auburn and the 'Rural Cemetery' Movement." *American Quarterly* 26 (March 1974):
37–59.

Fuchs, Elinor. "The Performance of Mourning." *American Theatre* 9 (January 1993):
14–17.

Gamson, Joshua. *Claims to Fame: Celebrity in Contemporary America.* Berkeley: Univer-
sity of California Press, 1994.

Garces-Foley, Kathleen, ed. *Death and Religion in a Changing World.* Armonk, NY, and
London: M. E. Sharpe, 2006.

Gastil, Raymond, and Zoe Ryan. *Renewing, Rebuilding, Remembering.* New York: Van
Alen Institute, 2002.

Gayle, Margot, and Michele Cohen. *Manhattan's Outdoor Sculpture.* New York: Prentice
Hall Press, 1988.

Glanz, James, and Eric Lipton. *City in the Sky: The Rise and Fall of the World Trade Center.*
New York: Henry Holt, 2003.

Goldberger, Paul. "Slings and Arrows," *New Yorker,* February 9, 2004, 85–87.

Goldberger, Paul. *Up From Zero: Politics, Architecture, and the Rebuilding of New York.*
New York: Random House, 2004.

Gopnik, Adam. "Stones and Bones: Visiting the 9/11 Memorial Museum," *New Yorker,*
July 7, 2014, 38–44.

Gorer, Geoffrey. "The Pornography of Death." *Encounter* 5 (October 1955): 49–52.

Grant, Susan-Mary. *A Concise History of the United States of America.* Cambridge: Cam-
bridge University Press, 2012.

Grider, Sylvia. "Public Grief and the Politics of Memorial: Contesting the Memory of 'the
Shooters' at Columbine High School." *Anthropology Today* 23 (June 2007): 3–7.

Griswold, Charles L. "The Vietnam Veterans Memorial and the Washington Mall: Philo-
sophical Thoughts on Political Iconography." *Critical Inquiry* 12 (Summer 1986):
688–719.

Hagopian, Patrick. *The Vietnam War in American Memory: Veterans, Memorials, and the
Politics of Healing.* Amherst: University of Massachusetts Press, 2009.

Haines, Harry W. "What Kind of War? An Analysis of the Vietnam Veterans Memorial."
Critical Studies in Mass Communication 3 (March 1986): 1–20.

Hallam, Elizabeth, and Jenny Hockey, eds. *Death, Memory and Material Culture*. Oxford: Berg, 2001.

Haney, C. Allen, Christina Leimer, and Julian Lowery. "Spontaneous Memorialization: Violent Death and Emerging Mourning Ritual." *Omega* 35 (1997): 159–171.

Harbison, Robert. *The Built, The Unbuilt, and the Unbuildable: In Pursuit of Architectural Meaning*. New York: Thames and Hudson, 1991.

Harrison, Robert Pogue. *The Dominion of the Dead*. Chicago and London: University of Chicago Press, 1992, 140.

Hass, Kristin Ann. *Carried to the Wall: American Memory and the Vietnam Veterans Memorial*. Berkeley: University of California Press, 1998.

Hawkins, Peter S. "Naming Names: The Art of Memory and the NAMES Project AIDS Quilt." *Critical Inquiry* 19 (Summer 1993): 752–799.

Hellmann, John. *American Myth and the Legacy of Vietnam*. New York: Columbia University Press, 1986.

Hess, Elizabeth. "A Tale of Two Memorials." *Art in America* 71 (April 1983): 121–124.

Hough, Richard, William Vega, et al. "Mental Health Consequences of the San Ysidro McDonald's Massacre: A Community." *Journal of Traumatic Stress* 3 (January 1990): 71–92.

Howett, Catherine. "Living Landscapes for the Dead," *Landscape* 17 (1967): 9–17.

Huntington, Richard, and Peter Metcalf. *Celebrations of Death: The Anthropology of Mortuary Ritual*. Cambridge: Cambridge University Press, 1979.

Jackson, J. B. "The Vanishing Epitaph: From Monument to Place." *Landscape Journal* 17 (1967): 22–26.

Jackson, Kenneth T., and Camilo Jose Vergara. *Silent Cities: The Evolution of the American Cemetery*. New York: Princeton Architectural Press, 1989.

James, Jamza Walker. *Thomas Hirschhorn Jumbo Spoons and Big Cake*. Chicago: The Art Institute of Chicago, 2000.

Jasper, James M. *Restless Nation: Starting Over in America*. Chicago: University of Chicago Press, 2000.

Jasper, Pat, and Kay Turner. *Art among Us/Arte entre nosotros: Mexican American Folk Art of San Antonio*. San Antonio: San Antonio Museum Association, 1986.

Jones, Jackie L. "Beginning to Rebuild: Designing Workshop Helps Oklahoma City Move Forward." *Blueprints (The Journal of the National Building Museum)* 13 (Fall 1995): 5.

Johnson, Jory. "Granite Platoon." *Landscape Architecture* 80 (January 1990): 69–71.

Jorgensen-Earp, Cheryl R., and Lori A. Lanzilotti. "Public Memory and Private Grief: The Construction of Shrines at the Sites of Public Tragedy." *Quarterly Journal of Speech* 84 (1998): 150–170.

Junod, Tom, and Andrew Chaikivsky, "The Falling Man," *Esquire*, September 2003.

Kalb, Marvin, and Deborah Kalb. *Haunting Legacy: Vietnam and The American Presidency from Ford to Obama*. Washington, DC: Brookings Institution Press, 2011.

Kass, Jeff. *Columbine: A True Crime Story*. Denver: Ghost Road Press, 2009.

Kear, Adrian, and Deborah Lynn Steinberg, eds. *Mourning Diana: Nation, Culture and the Performance of Grief*. London and New York: Routledge, 1999.

Kellerman, Jonathan. *Savage Spawn: Reflections on Violent Children*. New York: The Ballantine Publishing Group, 1999.

Kennerly, Rebecca M. "Getting Messy: In the Field and at the Crossroads with Roadside Shrines." *Text and Performance Quarterly* 22 (October 2002): 229–260.

Kirshenblatt-Gimblett, Barbara. "Kodak Moments, Flashbulb Memories: Reflections on 9/11." *The Drama Review* 47 (Spring 2003): 11–48.

Kwint, Marius, Christopher Breward, and Jeremy Aynsley, eds. *Material Memories: Design and Evocation.* Oxford and New York: Berg, 1999.

Land, Brian, and Wilfred Gregg. *The Encyclopedia of Mass Murder.* New York: Carroll & Graf, 1994.

Langer, Lawrence L. "The Alarmed Vision: Social Suffering and Holocaust Atrocity," *Daedalus* 125 (Winter 1996): 47–55.

Langewiesche, William. *American Ground: Unbuilding the World Trade Center.* New York: North Point Press, 2002.

Larkin, Ralph W. *Comprehending Columbine.* Philadelphia: Temple University Press, 2007.

Lazernby, Roland, ed. *April 16th: Virginia Tech Remembers.* New York: Full Court Press, 2007.

Leider, Philip. "How I Spent My Summer Vacation, or, Art and Politics in Nevada, Berkeley, San Francisco, and Utah." *Artforum* 9 (Sept. 1970): 40–41.

Lemmey, Karen. "Henry Kirke Brown and the Development of American Public Sculpture in New York City." Ph.D. dissertation, City University of New York, 2005.

Lewis, James R., ed. *From the Ashes: Making Sense of Waco.* Lanham, MD: Rowman & Littlefield, 1994.

Lewis, Tom. *Divided Highways: Building the Interstate Highways, Transforming American Life.* New York: Viking, 1997.

Lifton, Robert Jay. *Super Power Syndrome: America's Apocalyptic Confrontation with the World.* New York: Thunder's Mouth Press, 2003.

Lin, Maya. *Boundaries.* New York: Simon and Schuster, 2000.

Linden-Ward, Blanche. *Silent City on a Hill.* Columbus: Ohio State University Press, 1989.

Linenthal, Edward. *Preserving Memory: The Struggle to Create America's Holocaust Museum.* New York: Oxford University Press, 1995.

Linenthal, Edward. *The Unfinished Bombing: Oklahoma City in American Memory.* New York: Oxford University Press, 2001.

Linkman, Audrey. *Photography and Death.* London: Reaktion Books, 2011.

Linkman, Audrey. *The Victorians: Photographic Portraits.* London: I. B. Tauris Parke, 1993.

Lipstadt, Helene. "Learning from Lutyens." *Harvard Design Magazine,* Fall 1999, 65–70.

Mayo, James. *War Memorials as Political Landscape: The American Experience and Beyond.* New York: Praeger, 1988.

Marder, Tod, ed. *The Critical Edge: Controversy in Recent American Architecture.* Cambridge MA: MIT Press, 1988.

Matzner, Florian, ed. *Public Art: A Reader.* Ostfildern-Ruit, Germany: Hatje Cantz, 2004.

Meyer, Richard E., ed., *Cemeteries and Gravemarkers: Voices of American Culture.* Ann Arbor: U.M.I. Research Press, 1989.

Middleton, David, and Derek Edwards, eds. *Collective Remembering.* London: Sage Publications, 1990.

Mills, Cynthia, and Pamela H. Simpson. *Monuments to the Lost Cause: Women, Art, and the Landscapes of Southern Memory.* Knoxville: The University of Tennessee Press, 2003.

Mitford, Jessica. *The American Way of Death.* New York: Simon and Schuster, 1963.

Monger, George. "Modern Wayside Shrines." *Folklore* 108 (1997): 113–114.

Moore, Sally F., and Barbara G. Myerhoff, eds. *Secular Ritual.* Amsterdam: Van Gorcum, 1997.

Morris, Richard, and Peter Ehrenhaus, eds. *Cultural Legacies of Vietnam: Uses of the Past in the Present.* Norwood, NJ: Ablex Publishing Corporation, 1990.

Newman, Katherine S. *Rampage: The Social Roots of School Shootings.* New York: Basic Books, 2004.

Nimmo, Beth, and Debra K. Klingsporn. *The Journals of Rachel Scott: A Journey of Faith at Columbine High.* Nashville, TN: Tommy Nelson, 2001.

Nobel, Philip. "Memory Holes," *Metropolis Magazine,* September 2011.

Nobel, Philip. *Sixteen Acres: Architecture and the Outrageous Struggle for the Future of Ground Zero.* New York: Henry Holt and Company, 1995.

O'Brien, Tim. *The Things They Carried.* New York: Penguin Books, 1991.

O'Connell, Kim. "The Gates of Memory." *Landscape Architecture* 90 (September 2000): 68–77; 92–93.

Ockman, Joan, ed. *Out of Ground Zero: Case Studies in Urban Reinvention.* Munich: Prestel Verlag, 2002.

Oldenburg, Claes. *Proposals for Monuments and Buildings 1965–69.* Chicago: Big Table Publishing Company, 1969.

Oleaga, Dario. "Remembering 9/11." *Spiritus: A Journal of Christian Spirituality* 2 (Spring 2002): 64–73.

Palmer, Laura. *Shrapnel in the Heart: Letters and Remembrances from the Vietnam Veterans Memorial.* New York: Vintage Books, 1988.

Parédez, Deborah. "Remembering Selena, Re-membering *Latinidad.*" *Theatre Journal* 54 (March 2002): 63–84.

Perlmutter, Dawn, and Debra Koppman, eds. *Reclaiming the Spiritual in Art: Contemporary Cross-Cultural Perspectives.* Albany, NY: SUNY Press, 1999.

Petit, Philippe. *To Reach the Clouds: My High Wire Walk Between the Twin Towers.* New York: North Point Press, 2002.

Porter, Bruce. *The Martyrs' Torch: The Message of the Columbine Massacre.* Shippensburg, PA: Destiny Image, 1999.

Protetch, Max. *A New World Trade Center: Design Proposals from Leading Architects Worldwide.* New York: HarperCollins, 2002.

Purcell, Sarah J. "Commemoration, Public Art, and the Changing Meaning of the Bunker Hill Monument." *The Public Historian* 25 (Spring 2003): 55–71.

Reinink, Wessel, and Jeroen Stumpel, eds. *Memory and Oblivion: Acts of the XXIXth International Congress of the History of Art, Amsterdam 1996.* Amsterdam: Erasmus Boekandel, 1999.

Rubin, David. *Contemporary Hispanic Shrines.* Reading, PA: Freedman Gallery, Albright College, 1989.

Safdie, Michal Ronnen. *The Western Wall.* Westport, CT: Hugh Lauter Levin, Associates, Inc., 1997.

Saltzman, Lisa. *Making Memory Matter: Strategies of Remembrance in Contemporary Art.* Chicago: University of Chicago Press, 2006.

Sandage, Scott. "A Marble House Divided: The Lincoln Memorial, the Civil Rights Movement, and the Politics of Memory, 1939–1963." *Journal of American History* 80 (June 1993): 135–167.

Santino, Jack, ed. *Spontaneous Shrines and the Public Memorialization of Death.* New York: Palgrave Macmillan, 2006.

Savage, Kirk. *Monument Wars: Washington, D.C., the National Mall, and the Transformation of the Memorial Landscape.* Berkeley: University of California Press, 2009.

Scarfone, Amy. "Monument and Memory: The Oklahoma City Memorial International Design Competition." MA thesis, Urban Planning, University of Washington, 1997.

Schacter, Daniel L. *The Seven Sins of Memory.* Boston: Houghton Mifflin Company, 2001.

Schatzki, Theodore R. and Wolfgang Natter. *The Social and Political Body.* New York and London: The Guilford Press, 1996.

Schivelbusch, Wolfgang. *The Culture of Defeat: On National Trauma, Mourning, and Recovery.* New York: Metropolitan Press, 2003.

Sciorra, Joseph. "Yard Shrines and Sidewalk Altars of New York's Italian-Americans." *Perspectives in Vernacular Architecture* 3 (1989): 185–198.

Scott, Darrell, and Beth Nimmo. *Rachel's Tears: The Spiritual Journey of Columbine Martyr Rachel Scott.* Nashville, TN: Thomas Nelson Publishers, 2000.

Scruggs, Jan C., and Joel Swerdlow. *To Heal a Nation: the Vietnam Veterans Memorial.* New York: Harper & Row, 1985.

Scruggs, Jan C., ed. *Writing on the Wall.* Washington, DC: Vietnam Veterans Memorial Fund, 1994.

Senie, Harriet F. "Absence vs. Presence: The 9/11 Memorial Design." *Sculpture* 23 (May 2004): 10–11.

Senie, Harriet F. "Aus der Mitte: Das Vietnam Veterans Memorial Ein Mahnmal mit zentripetaler und zentrifugaler Wirkung." In *Denkmale und kulturelles Gedachtnis nach dem Ende der Ost-West-Konfrontation*, edited by Gabi Dolff-Bonekamper and Edward van Voolen, 251–264. Berlin: Akademie der Kunste, Jovis Verlag, 2000.

Senie, Harriet F. "Commemorating the Oklahoma City Bombing: Reframing Tragedy as Triumph." *Public Art Dialogue* 3 (Spring 2013): 80–109.

Senie, Harriet F. *Contemporary Public Sculpture: Tradition, Transformation and Controversy.* New York: Oxford University Press, 1992.

Senie, Harriet F. "A Difference in Kind: Spontaneous Memorials after 9/11." *Area* (Spring 2003): 56–59.

Senie, Harriet F. "In Pursuit of Memory: Berlin, Bamberg, and the Specter of History." *Sculpture* 18 (April 1999): 46–51.

Senie, Harriet F. "Memorial Complexes or Why Are Architects Getting the Big Commissions?" *Sculpture* 24 (December 2005): 10.

Senie, Harriet F. "Mourning in Protest: Spontaneous Memorials and the Sacralization of Public Space." *Harvard Design Magazine* 9 (Fall 1999): 23–27.

Senie, Harriet F. "National Icon: The Transfiguration of the World Trade Center Towers." *Sculpture* 21 (October 2002): 81–82.

Senie, Harriet F. "Renewing, Rebuilding, Remembering (Van Alen Institute)." *Sculpture* 21 (October 2002): 81–82.

Senie, Harriet F. *The 'Tilted Arc' Controversy: Dangerous Precedent?* Minneapolis: University of Minnesota Press, 2002.

Senie, Harriet F., and Sally Webster, eds. *Critical Issues in Public Art: Content, Context, and Controversy.* New York: Harper Collins, 1992.

Serra, Richard, and Clara Weyergraf. *Richard Serra: Interviews, Etc., 1970–1980.* Yonkers, NY: Hudson River Museum, 1980.

Sherman, Daniel J., and Terry Nardin, eds. *Terror, Culture, Politics: Rethinking 9/11.* Bloomington and Indianapolis, Indiana University Press: 2006.

Simpson, David. *9/11: The Culture of Commemoration.* Chicago: University of Chicago, 2006.

Simpson, David. "Short Cuts." *London Review of Books* 33 (November 17, 2011): 22.

Sloane, David Charles. *The Last Great Necessity: Cemeteries in American History.* Baltimore and London: The Johns Hopkins University Press, 1991.

Smith, Robert James. "Roadside Memorials—Some Australian Examples." *Folklore* 110 (1991): 103–105.

Solnit, Rebecca. *A Paradise Built in Hell: The Extraordinary Communities That Arise in Disaster.* New York: Viking, 2009.

Sorkin, Michael, and Sharon Zukin, eds. *After the World Trade Center: Rethinking New York City.* New York: Routledge, 2002.

Southern Poverty Law Center. "Memories of 'Patriotism.'" *Intelligence Report* 102 (Summer 2001).

Spencer, J. William, and Glenn W. Muschert. "The Contested Meaning of the Crosses at Columbine." *American Behavioral Scientist* 52 (June 2009): 1371–1386.

Spreiregen, Paul. *Design Competitions.* New York: McGraw-Hill, 1979.

Stannard, David E., ed., *Death in America.* Philadelphia: University of Pennsylvania Press, 1975.

Stevens, Ilan. "Santa Selena." *Transition* 70 (1996): 36–43.

Stock, Catherine McNicol. *Rural Radicals: Righteous Rage in the American Grain.* Ithaca, NY, and London: Cornell University Press, 1996.

Stokstad, Marilyn. *Art: A Brief History.* Upper Saddle River, NJ: Pearson Prentice Hall, 2004, second edition.

Strozier, Charles B., and Michael Flynn, eds. *The Year 2000: Essays on the End.* New York: New York University Press, 1997.

Sturken, Marita. *Tangled Memories: The Vietnam War, the AIDS Epidemic, and the Politics of Remembering.* Berkeley: University of California Press, 1997.

Sturken, Marita. *Tourists of History: Memory, Kitsch, and Consumerism from Oklahoma City to Ground Zero.* Durham, NC, and London: Duke University Press, 2007.

Tapia, Ruby C. *American Pietas: Visions of Race, Death, and the Maternal.* Minneapolis, London: University of Minnesota Press, 2011.

Vale, Lawrence J., and Thomas J. Campanella, eds. *The Resilient City: How Modern Cities Recover from Disaster.* New York: Oxford University Press, 2005.

Vlach, John Michael. *The African-American Tradition in Decorative Arts.* Athens and London: University of Georgia, 1990.

Wagner-Pacifici, Robin, and Barry Schwartz. "The Vietnam Veterans Memorial: Commemorating a Difficult Past." *American Journal of Sociology* 97 (September 1991): 376–420.

Walter, Jess. *Ruby Ridge: The Truth and Tragedy of the Randy Weaver Family*. New York: Harper Collins, 2002.

Warner, Marina. *Monuments & Maidens: The Allegory of the Female Form*. New York: Atheneum, 1983.

Watson, Justin. *The Martyrs of Columbine: Faith and the Politics of Tragedy*. Palgrave Macmillan, New York: 2002.

Weintraub, Linda. *Art on the Edge and Over*. Litchfield, CT: Art Insights, 1996.

Willensky, Elliot, and Norval White. *AIA Guide to New York City*. New York: Harcourt Brace Jovanich, 1988, third edition.

Williams, Paul. *Memorial Museums: The Global Rush to Commemorate Atrocities*. Oxford: Berg, 2007.

Williams, Reese, ed. *Unwinding The Vietnam War*. Seattle: The Real Comet Press, 1987.

Winter, Jay. *Sites of Memory, Sites of Mourning: The Great War in European Cultural History*. Cambridge: Cambridge University Press, 1995.

Wyman, David S. *The Abandonment of the Jews: America and the Holocaust, 1941–1945*. New York: Pantheon Books, 1984.

Ybarra-Frausto, Tomas. *Ceremony of Memory: New Expressions in Spirituality Among Contemporary Hispanic Artists*. Santa Fe, NM: Center for Contemporary Arts of Santa Fe, 1988.

Young, James E. *The Texture of Memory: Holocaust Memorials and Meaning*. New Haven, CT: Yale University Press, 1993.

Zukowsky, John. "Monumental American Obelisks: Centennial Vistas." *Art Bulletin* 58 (December 1976): 574–581.

{ INDEX }

Note: Locators followed by the letter 'n' refer to notes

9/11 memorials. *See also National September 11 Memorial & Museum*
 immediate memorials and, 9, 55, 75, 123–30
 interim memorials and, 135–46
 murals and, 131–32
 near World Trade Center site, 75, 123–27
 at New York City firehouses, 124, 128–29
 photography in, 127–30
 photos of, 125–29
 Saint Paul's Chapel (New York City) and, 124, 126–28
 tributes left at, 75, 138–39
 Union Square (New York City) and, 124–26
 World Trade Center relics and, 135–42
9/11 terrorist attacks (2001)
 Al Qaeda terrorist organization as perpetrator of, 122, 166, 174
 artists' responses to, 130–35
 author's memories of, 123
 commercial airliners as targets of, 157–58
 media coverage of, 122–23
 national identity narratives and, 122, 132
 Oklahoma City bombing (1995) compared to, 87, 91, 170–71
 Oklahoma City's response to, 87–88, 170
 Pentagon as target of, 3, 122, 158, 164
 photography immediately following, 129–30, 134
 policy changes in United States following, 168
 World Trade Center as target of, 3–4, 7, 122–23, 153–54, 157–58, 161, 164, 166
9/12 Front Page (Feldman), 122, 220n4
115 Prince Street Gallery (New York City), 130

The Abandoned Room (*Der Verlassene Raum*, Biederman), 70–71
Abel, David, 150
Aeneid (Virgil), 162
Afghanistan, 91, 93, 122
AIDS Memorial Quilt, 36–37
Alexander, Caroline, 162
Alfred P. Murrah Federal Building (Oklahoma City). *See also* Oklahoma City bombing (1995)
 America's Kids Day Care Center at, 60–61, 63

architectural remains from, 75
artwork in, 88, 206n129
bombing (1995) of, 8, 59–60, 85
federal agencies housed in, 60
immediate memorials near ruins of, 61, 65, 75, 84
new Oklahoma City Federal Building across from ruins of, 88, 92
as site for *Oklahoma City National Memorial*, 62, 65
Allen, Thomas B., 30
Almon, Baylee, 63, 67, 84, 198n16
Al Qaeda, 122, 166, 174
altars at immediate memorials, 8, 56–57
American Airlines Flight 11 (9/11 terrorist attacks target), 157
American Airlines Flight 77 (9/11 terrorist attacks target), 158
American Atheists (nonprofit organization), 139
American Civil War, cemeteries built after, 1–3, 28
American Revolutionary War, 1, 60, 86
The Americans (Frank), 44–45
The American Way of Death (Mitford), 43
America's Kids Day Care Center (Murrah Federal Building, Oklahoma City), 60–61, 63
Ames, Mark, 115, 196n2, 197n3
Amichai, Yehuda, 128
Anderson, Marian, 2
Andres, Lee, 108
Anna, Dawn, 108
Arad, Michael
 design for *National September 11 Memorial & Museum* described by, 146, 157, 161
 National September 11 Memorial designed by, 4, 9, 124, 154–55
Arlington National Cemetery (Arlington, VA)
 Civil War dead buried at, 3, 28–29, 39, 183n77
 Kennedy graves at, 48
 Oklahoma City National Memorial and, 71
 segregation at, 188n17
 silence and respect emphasis at, 28–29
 Tomb of the Unknown Soldier at, 12, 28
 Vietnam War and, 12, 28, 177n8

Art Commission (New York City), 125
As We See It: The Murrah Memorial Fence (1999
 photography exhibit), 75
Audubon Society, 149

Backmann, Ingeborg, 56
Bacon, Henry, 2
Baker, Russell, 47
Barry, Dan, 153
Barwick, Kent, 149
Bataille, Georges, 58
Battery Park (New York City), 142–44
Baudrillard, Jean, 44
Baurman, Gisela, 155–56
bbc art + architecture, 155–56
Bell Atlantic Arts and Humanities
 Foundation, 35
Bender, Bob, 87
Bennett, John, 148–49
Bent Propeller (Calder), 142
Berg, Sven, 68
Berlin (Germany)
 Biennale (1998) in, 57
 Holocaust Memorial in, 8, 70–71
 wartime architectural remains preserved in,
 75, 140
Bernall, Cassie, 105, 116–17, 217n136
Bernall, Misty, 117
Berry Park (Littleton, CO), monument
 controversy at, 104
Bessette-Kennedy, Carolyn, 48
Betsky, Aaron, 131
Biederman, Karl, 70–71
Bin Laden, Osama, 166, 170, 220n9
Bioluminiscent Beacon (LaVerdiere and
 Myoda), 148
Bleier, Rocky, 34
Bloomberg, Michael, 121, 149
Bodnar, John, 28
Boettger, Suzanne, 17
Bonder, Julian, vi
Bonevardi, Gustavo, 148–49
Boston National Historical Park, 2
Bowling for Columbine (Moore), 9, 114
Brady, James, 110
Brady Law, 110–11
Branch Davidian compound shootout (1993,
 Waco, TX), 8, 60, 85, 113, 174, 197n6
Branch Davidian Memorial (Waco, TX),
 204n108
Brandgrens (Bombardment Periphery; 2007
 exhibit in Rotterdam), 229n141
Broches, Alexandra, 54
Brodin, Rodger M., 24–25, 182n67
Brooks, Sawad, 155–56

Brown, Brooks, 96, 111–13, 215n96
Brown, Henry Kirke, 124–26
Brown, J. Carter, 24
Bryant Park (New York City), 35
bullying at American high schools, 111–12,
 115–16, 215n99
Bunker Hill Monument (Charlestown, MA), 1–2
Bureau of Alcohol, Tobacco, and Firearms
 (ATF), 60
Burton, Scott, 70
Bush, George H.W., 25–26
Bush, George W.
 Columbine High School shooting and, 115
 conflation of church and state in presidency
 of, 119
 Oklahoma City National Memorial and,
 77–78, 87, 93, 173
 presidential election of 2000 and, 4
 September 11, 2001 terrorist attacks and, 166
 Vietnam Veterans Memorial Education
 Center and, 38
Bush, Laura, 77–78
Butzer, Hans and Torrey
 Berlin Holocaust Memorial's influence on, 8,
 70–71
 on field of empty chairs design element,
 71–72
 on Gates of Time design element, 69
 Locus Bold Design and, 67–68, 200n41
 on memorial planning processes, 170
 Oklahoma City National Memorial designed
 by, 67–72, 93

Cain, Bernest, 92
cajas (boxes in Mexican altar art), 55
Calder, Alexander, 142
Campanella, Thomas J., 173
Campbell, Bradley, 156
capillas (small chapels for Mexican altar art), 55
Capps, Walter, 11
Carhart, Tom, 20
Carter, Jimmy, 6
Carver, Raymond, 56–57, 195n105–n106
Casey, Thomas, 1
celebrity memorials
 celebrities in American culture and, 47–48,
 192n60
 mourning at, 8, 47–49, 56
 photos of, 45, 50
 tributes left at, 40–41, 48
cemeteries. See also specific cemeteries
 in Africa, 51
 American Civil War and, 1–3
 City Beautiful movement and, 42
 economic class distinctions at, 41

evolution in American customs and styles at, 41–44, 189n28

private and personal emphasis at, 10

regulations at, 41

tributes left at, 41, 51

Central Park (New York City), 17, 42

Ceremony of Memory (Ybarra-Frausto), 55

Chaikivsky, Andrew, 134

Chapin, Schuyler G., 132

Cheney, Dick, 90

Cho, Seung-Hui, 119, 210n9, 219n161

Cimino, Michael, 12

City Beautiful movement, 42

Civil War, cemeteries built after, 1–3, 28

Clark, Ramsey, 85

Cleary, William, 66–67

Clement Park (Littleton, CO)

Columbine fifth anniversary event (2004) at, 103

immediate memorial for Columbine school shooting in, 97–99, 102, 109

as site of permanent Columbine Memorial, 103, 105

"survivor tree" from Oklahoma City planted in, 170

Clines, Francis X., 120

Clinton, Bill

Columbine High School shooting commemorations and, 4, 94, 102–4, 106–7

Kosovo War and, 115, 217n125

Oklahoma City bombing commemorations and, 59, 83–86, 93, 173–74

Clinton, Hillary, 83

Cloud Fortress (World Trade Center Plaza Sculpture) (Nagare), 142

Coersmeier, Jonas, 155–56

Cohen, Steve and John, 103

Cold War, 3

Collyer, Stanley, 68

Colo, Papo, 131

Colossal Block of Concrete Inscribed with Names of War Heroes (Oldenburg), 17

"Columbine Friend of Mine" (Cohen and Cohen), 103

Columbine High School shooting (Littleton, CO, 1999)

as archetypal American school shooting, 95

"blame the media" narrative regarding, 113, 115

bullying culture at school preceding, 111, 174, 215n94

call for return of school prayer following, 118, 219n159

Christian youth group "Hell House" re-enactments of, 118

evangelical Christian reactions to, 98, 103–5, 116–18, 217n136

fifth anniversary commemoration (2004) of, 103

first anniversary commemoration (2000) of, 102

graduation (2000) following, 102–3

gun control politics affected by, 108–11, 119, 215n90

immediate memorials after, 97–99, 102

interim memorials after, 104

Kent State shootings (1970) compared to, 118

library and mural built at site of, 99–100, 104, 108

media coverage of, 116, 209n8

memorial films chronicling, 114–16

myths of adolescence shattered by, 3–4, 7, 95, 103, 107, 111–12, 115

Oklahoma City bombing (1995) compared to, 86, 102, 104, 170

Oklahoma City's response to, 170

perpetrators of, 94–97, 109–15, 174, 210n13, 211n23, 215n94, 216n104

planning of, 6, 95–96, 211n23

razing of areas at site of, 99–100

school sports culture preceding, 111, 215n97–n98

secular issues raised by, 110–13

September 11, 2001 terrorist attacks compared to, 104

victims depicted as martyrs in, 116–19

violent video games and, 112–13

Virginia Tech shooting (2007) and, 119

Columbine Memorial (Littleton, CO)

anniversary events at, 84, 107

benches in, 107

Christian-themed elements of, 94, 105–7, 171

Clement Park as site of, 103, 105

commissioning and planning of, 101–4, 212n46

conflation of civilian victims and military casualties in remarks at, 104

dedication (2007) of, 104–5

design elements of, 8–9, 94, 104–10, 212n44

diversion and denial strategies at, 101, 107, 113, 119, 174

funding of, 103, 105

groundbreaking (2006) at, 104

local cemeteries compared to, 9, 108–9, 119

mission statement for, 101

"Never Forgotten" ribbon and, 105

photographs of, 105–7

revisions to original designs of, 104

Ring of Healing at, 105–6

Ring of Remembrance at, 105–6

as symbolic cemetery, 4

Columbine Memorial (*continued*)
 tenth anniversary event (2009) at, 107,
 206n131
 theme of mourning at, 94
 tributes left at, 40
 triumph of hope narrative at, 94, 103, 106–8
 victims as focus of, 101, 105, 119, 169
Columbine Redemption ministry, 117
"Columbine Remembrance and Rededication"
 event (Denver, 2009), 108
Concord, Battle of (1775), 60
Contemporary Hispanic Shrines exhibit
 (1988), 56
Cooper, Martha, 54, 133
Coriel, Sean, 156
Cornett, Mick, 89
Cotter, Holland, 123
Coventry (United Kingdom), 140
Creative Time (public art organization), 132,
 147, 149
Cullen, Dave, 95, 115, 117
Curcio, Leonard, 141

Daniels, Joseph C. (Joe), 137
David, Pierre, 156
Davidson, Justin, 159
Davis Brody Bond, 154, 162
Davison, Mike, 21
"A Day of Faith" (Oklahoma City
 commemorations, 2005), 89, 206n131
Day of Remembrance (April 4, Holocaust
 commemoration date), 6
Day of the Dead (*Dia de Los Muertos*)
 celebrations, 41, 55
"A Day of Understanding" (Oklahoma City
 commemorations, 2005), 90, 206n131
DeAngelis, Frank, 108, 120
The Deer Hunter (Cimino), 12
Deleuze, Gilles, 58
del Rio, Dolores, 55
Department of Parks and Recreation (New
 York City), 125
DePooter, Corey, 108
descansos (rest stops on Hispanic funeral
 processions), 194n92
Detroit (Michigan), 51
Deutsche, Rosalyn, 168
DHM Design, 8, 103
Dia de Los Muertos (Day of the Dead)
 celebrations, 41, 55
Diana (Princess of Wales)
 fantasies associated with, 49
 immediate memorial at the Place de l'Alma
 to, 46, 57
 immediate memorials to, 45–46, 54, 57
 mourning of, 128

popularity after death of, 49
 tributes left to, 75
Diary of Anne Frank, 5
Diets, Jr., Danny, 104
*Difficult Times, Difficult Choices: Why
 Museums Collect After Tragedies* (Littleton
 Historical Society, 2009), 109
Diller, Elizabeth, 146
"direct sculptures" (*sculptures directes*), 57–58
DNAid series (Creative Time project), 147–48
Documenta 11 (Kassel, Germany), 58
The Dominion of the Dead (Harrison), 29
Donahue, Lorena, 109
Doom (video game), 112–13
Doss, Erika, 7, 17, 69–70, 98
Dowd, Maureen, 192n60
Drug Enforcement Agency (DEA), 60
Dual Memory (Strawn and Sierralta), 156
Duberman, Martin B., 159
Dunlap, David W., 157
Dunn, Paul, 86

earthworks, 17–18
East German Holocaust memorial project, 71
Easton, Bob, 101
East Orange (New Jersey), 51
Ebony, David, 153
Echoes From The Wall (Vietnam Veterans
 Memorial Foundation high school
 curriculum material), 37–38
Edmond (Oklahoma) Post Office shooting
 (1986), 59
Elephant (Van Sant), 9, 114
Ennead Architects, 37
Evans, Diane Carlson, 24–25, 182n67
Everytown for Gun Safety organization, 121
Exit Art (New York City), 131

Faust, Drew Gilpin, 2
FDNY Engine 10 ("Ten House," New York
 City), 129
Federal Bureau of Investigation (FBI), 59–61, 87
Feldman, Ruth, 108
Feldmann, Hans-Peter, 122, 220n4
Felton, Jr., Duery, 30
Ferrill, Don, 86–87
Feuer, Alan, 156–57
Fields, Chris, 63
Finch, Spencer, 162–63
Fine Arts Commission, 24–25, 178n14
"First Person—Stories of Hope" (*Oklahoma
 City National Memorial*), 88–89
First United Methodist Church (Oklahoma
 City), 88
Fischl, Eric, 134–35, 159
Flame of Liberty (Paris), 58

Fleming, Kelly Ann, 105
Foote, Kenneth E.
 on approaches to dealing with tragedy, 7,
 52, 100
 on desacralization of sites, 125–26
 on *Oklahoma City National Memorial*, 64
Forest Lawn Memorial Park (Glendale, CA),
 42–43
Foye, Pat, 143
Frank, Robert, 44–45
Freedman, Susan K., 149
Freedom Tower. *See One World Trade Center*
French, Daniel Chester, 2
Freundlich, Otto, 56–57
Fried, Helene, 67, 70
Froelich, Anne, 147
funeral and cemetery industry in the United
 States, 42–43

Ganci, Kathy, 150
Garden of Lights (David, Coriel, and
 Kmetovic), 156
Gastil, Raymond, 131
Gaylord, Frank, 36
George, Alice Rose, 130
George Washington sculpture (Union Square,
 New York City), 124–26
Gephardt, Dick, 118
Gettysburg cemetery (Gettysburg, PA), 2–3
Gibbs, Nancy, 116, 119
Giuliani, Rudolph, 166
Goddard, Andy and Colin, 108–9
Goldberger, Paul, 71, 87
Golden, Andrew, 210n9–n10
Golden, Jay, 53
Goldstein, Jacob Z., 35, 185–86n105
Goldstein, Richard, 59
Goodacre, Glenna, 26–27
Gopnik, Adam, 6, 161
Gore, Al
 Columbine High School shooting and, 115,
 118–19
 Oklahoma City bombing commemoration
 events and, 84–86
 presidential election of 2000 and, 4
 Vietnam Women's Memorial and, 27
Gore, Tipper, 115
Gorer, Geoffrey, 43
Gould, Richard Nash, 149
Graham, Billy, 78, 90, 118
Graham, Franklin, 118
Gramsci, Antonio, 58
Grand Central Terminal (New York City),
 immediate 9/11 memorial at, 128
Grant, Susan-Mary, 3
Grapes of Wrath (Steinbeck), 83

Graver, Lawrence, 77
Green, Malice, 51
Greene, Susan, 110
Greenough, Horatio, 2
Greenwald, Alice M., 6, 162, 174
Grider, Sylvia, 98
Grossman, Arnie, 108
Grounds for Remembering (Lin), 11
Ground Zero. *See* World Trade Center
gun control politics
 Bowling for Columbine and, 114
 Brady Law and, 110–11
 in Colorado, 110–11, 215n88, 215n91
 Columbine High School shooting (1999) and,
 108–11, 119, 215n90
 Everytown for Gun Safety organization and,
 121
 "gun show loophole" and, 110–11, 215n91
 Million Moms March (2000) and, 120
 National Rifle Association (NRA) and, 82,
 110, 121, 215n91
 Sandy Hook Elementary School shooting
 (2012) and, 120
Gund, Agnes, 149

Haacke, Hans, 132–33
Hagel, Chuck, 34, 38
Hagopian, Patrick, 11, 15, 20, 24
Hale, Sue, 90
Haney, C. Allen, 40, 188n8
Hangar 17 (John F. Kennedy Airport, New York
 City), 9/11 relics at, 136–37, 140–42
Harbison, Robert, 37
Harris, Eric
 bullying of, 111, 115, 174, 215n94
 celebrity aspirations of, 96–97
 guns obtained by, 111
 items left at immediate memorial for
 Columbine school shooting for, 109
 on McVeigh and Oklahoma City, 113
 planning of Columbine shooting and, 95–96,
 210n13, 211n23
 previous legal and disciplinary problems
 of, 96
 psychological problems suffered by, 96,
 216n104
 removal of immediate memorial cross for,
 98–99, 106
 revolutionary proclamation of, 115
 sexuality of, 114
 suicide note of, 115
 violent video games played by, 112–13, 115
Harrison, Robert Pogue, 29
Hart, Frederick, 22–24, 27, 182n60, 182n68
Hass, Kristin, 30
Haunting Legacy (Kalk and Kalb), 11

Hawkins, Peter S., 36
Hayes, Ellin, 100
Healing of People Everywhere (HOPE), 99–100
Hellmann, John, 11
Hemingway, Ernest, 104
Henderson, Robert, 104
Henry, Brad, 92
Here Is New York: A Democracy of Photographs
 (2002 exhibit), 130
Hess, Elisabeth, 20
Hill, Frank, 89–90
Hiroshima (Japan), 140
Hirschhorn, Thomas, 56–58, 195n104–n107
Hitler, Adolf, anniversary of the birthday of, 6, 95
Hochhalter, Anne Marie, 103
The Holocaust
 days of remembrance for, 6, 89
 memorials and museums for, 5–6, 8, 70–73,
 77, 169, 171 (*See also specific sites*)
 Oklahoma City bombing compared to, 77
House Un-American Activities Committee, 3
Howett, Catherine, 189n28
Huberty, James, 52, 205n113
Huhn-Graifman, Christine, 149–50
Humphreys, Kirk, 86–88

Ideogram (Rosati), 142
"I Have a Dream" (King), 2
Iken, Monika, 149
immediate memorials
 9/11 memorials and, 9, 54, 75, 123–30
 altars at, 8, 55–56
 artistic appropriation and, 56–58
 celebrity deaths and, 8, 40–41, 47–50, 56
 cemetery customs and, 41, 43, 47, 58
 Christian symbols at, 44–45, 47, 51, 55, 65,
 98–99
 Columbine High School shooting and,
 97–99, 102, 211n32
 as expressions of protest, 43
 flags and, 125, 221n18
 maintenance of, 62
 mourning at, 8, 39–41, 43, 47, 49–50, 53, 56,
 58, 99, 124, 172
 murals and, 132–33
 Oklahoma City bombing site and, 61, 65, 75, 84
 photography in, 53–54, 124, 127–30
 photos of, 45, 48, 50, 54, 125–29
 populist impulse behind, 58
 as public performances, 41
 roadside memorials and, 8, 40, 44–46, 53
 as sacralized space, 40, 43, 56, 61
 Sandy Hook school shooting (2012) and, 120
 Spanish and Latino influences on, 44, 55–56,
 194n92
 sudden death in streets, workplaces, and
 schools and, 50–52, 97–99

tributes left at, 8, 39–41, 43, 48, 58, 61–62, 98,
 120, 124, 211n32
victims as focus of, 39, 41, 46
Ingberman, Jeanette, 131
interim memorials. *See also* immediate
 memorials
 for 9/11 terrorist attacks, 135–46
 Columbine school shooting and, 104
 most affected members of grieving
 communities and, 172–73
 mourning at, 135, 172
 tributes left at, 138–39
 World Trade Center relics and, 135–42
International Center of Photography (New
 York City), 130
International Freedom Center proposal (New
 York City), 162, 168
Inversion of Light (Sasaki), 156
Iovine, Julie V., 150
Iraq War (2003–2012), 31, 122
Ireland, Patrick, 102–3
Istook, Jr., Ernest James, 90

Jackson, J. B., 41
Jackson, Kenneth T., 189n28
Jewish Federation of Greater Oklahoma, 89
John F. Kennedy Airport (New York City)
 Hangar 17, 9/11 relics at, 136–37, 140–42
Johnson, Jill, 27
Johnson, Mitchell, 210n9–210n10
Johnson, Robert (Bob), 64, 66–67, 76, 92–93,
 170
Jones, Cleve, 36
Jonesboro (Arkansas) school shooting (1998),
 95, 210n9–210n10
Jordan, Brian J., 137
Journey to Remembrance (Golden), 53
Junod, Tom, 134

Kabul (Afghanistan), 91
Kahlo, Frida, 55
Kaiser Wilhelm Memorial Church
 (Berlin), 75
Kalb, Marvin and Deborah, 11, 175n10
Kamin, Blair, 159
Karadin, Joseph, 156
Kass, Jeff, 95–96, 112, 115
Keating, Frank, 62, 78, 84–86
Kechter, Matthew, 104, 106
Kendall, Steve, 167
Kennedy, Edward M., 47
Kennedy, John F., 28, 47–48
Kennedy, Jr., John F.
 biographical background of, 47
 death of, 47, 96, 192n73
 funeral of, 47
 immediate memorial to, 47–49, 56

Kennedy, Robert F., 48, 60
Kennicott, Phillip, 167–68
Kennon, Kevin, 146
Kent State shootings (1970), 118
Kernan, Joseph D., 104
Kerouac, Jack, 44
Kerrey, Bob, 34
Kerry, John, 34
Keyes, Alan, 106
Kifner, John, 90
Killeen (Texas) shooting (1991), 193– 94n89
Kimmelman, Michael, 125, 156
Kimsey, Jim, 34
King, Jr., Martin Luther, 2, 20, 60
Kirsten, George, 116
Klebold, Dylan
 bullying of, 111, 174, 215n94
 celebrity aspirations of, 96–97
 family life of, 112
 guns obtained by, 111
 items left at immediate memorial for
 Columbine school shooting for, 109
 memorial church service for, 109–10
 planning of Columbine shooting and, 95–96,
 211n23
 previous legal and disciplinary problems
 of, 96
 psychological problems suffered by, 96, 112,
 216n104
 removal of immediate memorial cross for,
 98–99, 106
 sexuality of, 114
 violent video games played by, 112–13, 115
Klebold, Tom, 109–10
Kmetovic, Jessica, 156
Knafo, Robert, 151–52
Knowles, Scott Gabriel, 163
Koenig, Fritz, 142–44
Korean War Veterans Memorial, 35–36
Koresh, David, 60
Kosovo War (1999), 115, 217n125
Kristallnacht (Germany, 1938), 71

Lafayette, Marquis de, 2
Landowski, Paul, 22–23, 181n58–n59,
 182n60
Langewiesche, William, 122
Lanza, Adam, 120
Larkin, Ralph W., 113–14
Latinos in the United States, 49
LaVerdiere, Julian, 131, 147–51
Lee, Norman, 155
Leimer, Christina, 40
Lendorf, Beau, 107
Leonard, Diane, 70
Levine, Sherrie, 56
Lewis, Michael, 155

Lexington, Battle of (1775), 60
Libeskind, Daniel, 145, 154, 162
Library (Ullman), 72–73
The Library (play), 121
Lichtdom (*Cathedral of Light;* Speer), 152,
 229n141
Lieberman, Joe, 119
Lin, Maya Ying
 influences on, 5, 15–18
 National September 11 Memorial & Museum
 and, 154–55
 on people's feelings regarding the Vietnam
 War, 21
 on the personal and private nature of death,
 11, 31
 Vietnam Veterans Memorial and, 3, 8, 11–15,
 17–21, 28, 31, 38, 67, 93, 155, 157, 180n41,
 181n53, 182n68
Lincoln, Abraham, 2
Lincoln Memorial (Washington, DC)
 diversion strategy at, 2
 Hirschhorn's critique of, 58
 reflecting pool at, 69
 significant historical moments at, 2
 Vietnam Veterans Memorial's location near,
 7, 12, 24, 38
Linenthal, Edward
 on "embittered anti-government
 groups," 61
 on Oklahoma City bombing, 6, 59, 61, 77, 86,
 196n1
 on redemptive and consolatory narratives at
 memorials for mass deaths, 82–83
 on "toxic impact of terrorism" and "false
 promise of 'closure,'" 170
 on United States National Holocaust
 Memorial Museum, 6, 77, 82–83
Linfield, Susie, 122
Lipton, Eric, 140–41
"Little Syria" neighborhood (New York City),
 168
Littleton (Colorado). *See also* Columbine High
 School shooting (1999)
 cemeteries in, 9, 103–4, 108–9
 evangelical Christianity in, 9, 98, 105, 116
 immediate memorials in, 97–99, 102, 109
 police in, 96
 post-trauma stress and deaths in, 101–2
 as upper-middle-class suburb, 94–95
Littleton Historical Society and Museum, 98,
 107, 109
Locus Bold Design, 67–68
London Cenotaph, 4–5
Los Angeles (California), 51–52
Lower Waters (Campbell and Neuman), 156
Lowery, Julian, 40
Lutyens, Edwin, 5, 15–16

Macko, William, 144
Madigan, Kevin V., 137
Manson, Marilyn, 112, 114, 116
Manyon, John, 108
Maram, Najiba, 91
Marantz, Paul, 149
*The Martyr's Torch: The Message of the
 Columbine Massacre* (Porter), 117
Marxhausen, Don, 109–10
Mauser, Tom and Daniel, 108–10, 214n87
Max Protetch Gallery (New York City), 131
McCain, John, 34
McCarthy, Joseph, 3
McDonald's Corporation, 52
McPherson, Dave, 116–17
McVeigh, Timothy
 Bin Laden compared to, 170
 biographical background of, 59–60, 197n5
 military career of, 3, 60, 81, 174, 197n8, 197n11
 motivations for Oklahoma City bombing
 and, 8, 60–61, 173–74, 197n7
 on the Oklahoma City bombing victims, 115,
 197n10
 Oklahoma City National Memorial's
 discussion of, 81–82, 93
 trial and execution of, 82, 84–85, 87
Memorial Mania (Doss), 7
memorial walls, 51
Mendes, Lou, 135
Mesa-Bains, Amalia, 55–56
Meyerowitz, Joel, 132
Midler, Bette, 66
militia groups in the United States, 60, 81–82, 113
Milk, Harvey, 36
Million Moms March (2000), 120
Miró, Joan, 142
Miss, Mary, 132
Mitchell, Margaret L., 51–52
Mitford, Jessica, 43
Mondale, Joan, 88, 206n129
Mondrian, Piet, 56
Mondrian Altar (Hirschhorn), 57
Montebello, Philippe de, 140
monumentum, definition of, vi, 174
Monument Wars (Savage), 7
Moore, Michael, 9, 97, 114
Morris, Robert, 29
Moses Lake (Washington) school shooting
 (1996), 95, 209n9
Mothers Against Drunk Driving (MADD),
 44, 46
Mount Auburn Cemetery (Cambridge, MA),
 29, 42
mourning
 at celebrity memorials, 47–49, 56

 at immediate memorials, 8, 39–41, 43, 46,
 48–49, 53, 56, 58, 99, 124, 172
 at interim memorials, 135, 172
 at *Oklahoma City National Memorial*, 85,
 90–91
 at roadside memorials, 46, 53
 unifying power of, 39
 at *Vietnam Veterans Memorial*, 3, 5, 8, 12, 20,
 30–31, 35, 171, 187n121
Moving Perimeter: A Wreath for Ground Zero
 (proposal by Mary Miss), 132
Mujahid, Jamila, 91
Municipal Art Society of New York (MAS), 149
murals, 131–32
Murrah Federal Building (Oklahoma City). *See*
 Alfred P. Murrah Federal Building
 (Oklahoma City)
Murtha, John P., 38
Muschamp, Herbert, 152, 157
Museum and Archaeological Regional Storage
 Facility (MARS; Lanham, MD), 30–31
Museum of Modern Art (New York City), 130
My Lai Massacre (1968), 38
Myoda, Paul, 131, 147–49, 151
myths
 of American adolescence, 3–4, 7, 95, 103, 107,
 111–12, 115
 of American heartland as safe haven, 7,
 59–60, 64, 196n1
 of American national identity, 3–4, 39,
 58, 122
 of American patriotism, 61
 celebrity and, 48
 of children's innocence, 64
 Columbine High School shooting's
 shattering of, 3–4, 7, 95, 103, 107,
 111–12, 115
 Kennedy assassination's shattering of, 47
 of lost innocence, 123
 Oklahoma City bombing's shattering of, 3, 7,
 59–61, 64, 196n1
 September 11, 2001 terrorist attacks
 shattering of, 122–23
 Vietnam War's shattering of, 11, 39

Nagare, Masayuki, 142
NAMES Project, 36
Nance, David B., 53–54, 194n92–n93
National Endowment for the Arts, 62
National Memorial Institute for the Prevention
 of Terrorism (NMIPT; Oklahoma City), 87,
 93, 171
National Park Service (NPS), 30, 38, 178n14
National Park Service Museum Resource
 Center (Landover, MD), 30

National Rifle Association (NRA), 82, 110, 121, 215n91

National September 11 Memorial & Museum (New York City)

"After 9/11" exhibit at, 166–67

American Atheists' lawsuit against, 139

artwork at, 162–63

"Before 9/11" exhibit at, 166

cemetery for unidentified remains from World Trade Center and, 154, 157, 163, 167, 230n147

changes to original design of, 157

commemoration at, 9

"The Day—9/11" exhibit at, 166

design competition for, 153–57, 170, 231n162

diversion and denial strategies at, 168, 171, 174, 233n199

Facing Crisis: America under Attack film at, 166

memory as focus at, 161, 174

"Missing Posters" at, 164

mission statement for, 153, 161

names of victims listed at, 157–58

national identity narratives at, 137

National September 11 Memorial Museum (NS11MM) at, 5–6, 9, 124, 131, 137–39, 143, 146, 157, 161–68, 174

opening (2011) of, 124, 159

photos of, 158, 160, 163–64

Rebirth at Ground Zero film at, 165–66

re-enactment elements at, 162, 167

rescue workers as a focus of, 154, 161, 164, 166

responses to, 159, 161–63, 167–68

"The Rise of Al Qaeda" film at, 166

selective memory and, 174

symbolic cemetery in, 4, 9

"The Plot" exhibit at, 166

as a "therapeutic memorial," 159

Tribute in Light and, 162, 167

triumph of hope narratives at, 137, 153, 161, 164–65, 167, 170–71, 233n199

United States National Holocaust Memorial Museum and, 6

victims as a focus of, 153–54, 157–59, 161, 164–69, 171

Vietnam Veterans Memorial and, 155, 159

"wall of faces" installation at, 38, 81, 164–65

waterfalls in World Trade Center's footprints at, 4, 9, 146, 154, 157, 159–61

"Witness at Ground Zero: September 12–16, 2001" exhibit at, 165

World Trade Center relics at, 137–39, 143, 157, 162–64, 166–67

National Week of Hope (2005), 89

Native Americans, 91

Natural Born Killers (Stone), 112

Nelson, Louis, 36

Neuman, Matthias, 156

Newman, Katherine S., 95, 111–13

Newton (Connecticut) school shooting (2012), 120, 219n166

A New World Trade Center: Design Proposals (2002 exhibit), 131–32

New York Fire Department

immediate memorials to members of, 124, 128–29

World Trade Center rescue efforts and, 135, 152, 170

New York Police Department, 135, 170

Nichols, Polly, 90, 200n36

Nichols, Terry, 61, 81, 84

nichos (niches in altar art), 55–56

Nickles, Don, 86

Nimmo, Beth, 117

Nobel, Philip, 159

The Noonday Demon: An Atlas of Depression (Solomon), 120

Norick, Ronald, 64, 83, 200n40

Norman, Jessye, 150

Norman Prince tomb and sculpture (Washington National Cathedral), 22–23

The Nurse (Brodin), 24–25

Obama, Barack, 2, 122

O'Brien, Tim, 31

Offerings at the Wall (Allen), 30

ofrendas (offerings at "Day of the Dead" altars), 55–56

Oklahoma City bombing (1995)

9/11 terrorist attacks compared to, 87, 91, 170–71

burial of remains from, 85

Columbine High School shooting (1999) compared to, 86, 102, 104, 170

The Holocaust compared to, 77

immediate memorials near site of, 61, 65, 75, 84

myths shattered by, 3, 7, 59–61, 64, 196n1

perpetrators of, 3, 8, 59–61, 81–82, 84–85, 87, 115, 173–74, 197n7, 197n10–n11

photos from, 63, 198n16

tensions among victims' families and survivors of, 84

toll of the damage of, 84

victims of, 7, 60–61, 63–64, 198n13

Oklahoma City Federal Building (replacement for Murrah Federal Building), 88, 92

Oklahoma City National Memorial
 "9/11: A Shared Experience" exhibit (2002)
 at, 171
 anniversary events at, 8, 59, 61, 83–92
 anti-violence emphasized at, 66, 78, 82, 84
 Arlington National Cemetery and, 71
 Berlin Holocaust Memorial and, 8, 70–71
 black granite surfaces at, 69
 Changed Forever—Forever Changing exhibit
 (2005), 91
 "cherished children" theme at, 65
 civic renewal of Oklahoma City and, 83, 87,
 91–93, 208n149
 comfort theme at, 65, 67, 69
 commissioning and planning of, 62, 64–65,
 92–93, 170, 198–99n25
 conflation of civilian victims and military
 casualties in remarks at, 85–86, 93
 crime investigation discussed at, 79, 82
 critiques of, 92–93
 design competition for, 66–68, 199–200n36,
 200n40–n41
 diversion and denial strategies at, 61, 66, 78,
 81–82, 93, 171, 174
 emergency responders as a focus of, 65, 74,
 80–81
 exclusion of figurative representations
 in, 64, 67
 experiential narrative at educational center
 in, 77
 Festival for the Arts (2005) and, 91
 field of empty chairs at, 69–72, 82, 90–91, 93,
 158, 201n50
 fifth anniversary event (2000) at, 86–87
 first anniversary event (1996) at, 83–84
 fourth anniversary event (1999) at, 85–86
 funding of, 66, 208n150–n151
 garden cemetery model and, 65
 Gates of Time at, 68–69
 gift shop souvenirs at, 73–74
 glass overlook at, 82
 learning theme at, 65–66
 Library (Ullman) and, 72–73
 McVeigh discussed at, 81–82, 93
 memorial marathon event and, 87, 91
 Memory Fence at, 61–62, 75–76, 85–86, 91,
 201n63–n64, 204n105
 mission statement for, 64–67, 69, 76, 93
 mourning at, 85, 90–91
 Murrah Building architectural remains
 at, 75
 museum dedication (2001) at, 77–78, 87
 national identity narratives at, 59, 76
 National Memorial Center (NMC) at, 5–6,
 62, 66, 76–83

 National Memorial Institute for the
 Prevention of Terrorism (NMIPT) and,
 87, 93, 171
 ninth anniversary event (2004) at, 88–89
 official dedication (2000) of, 86
 peace theme at, 65, 67, 69
 photographs of, 62, 69–70, 72, 76, 79–81
 postmodern composite aesthetic at, 76, 170
 recognition theme at, 65
 re-enactment elements at, 78, 93, 202n76
 reflecting pool at, 69
 religious remarks by national politicians at,
 78, 83, 93, 173
 remembrance theme at, 65, 67
 Rescuers' Orchard at, 74
 Responsibility Theater at, 202n76
 schematic overview of, 68
 second anniversary event (1997) at, 85
 selective memory and, 174
 seventh anniversary event (2002) at,
 87–88
 sixth anniversary event (2001) at, 87–88
 spirituality and hope theme at, 65, 78, 83,
 89, 93
 Spreading Our Branches program and, 89
 Survivors' Wall at, 75
 Survivor Tree at, 65, 73, 85, 89
 as symbolic cemetery, 4, 8, 65, 69–73, 82, 93
 tenth anniversary event (2005) at, 59, 89–92
 therapeutic and healing emphasis at, 61, 64,
 81, 84, 92
 third anniversary event (1998) at, 85
 tourism and, 62, 92
 tributes left at, 8, 40, 62, 72, 75, 84–86, 90–91,
 201n63–n64, 204n105
 triumph of hope narrative at, 8, 61, 65, 67, 69,
 73, 75–78, 81–83, 88–89, 93, 170–71, 174
 United States National Holocaust Memorial
 Museum and, 6, 77, 169
 victims as focus of, 61, 64–67, 70, 75–78,
 81–86, 169
 Vietnam Veterans Memorial and, 169–70
 "wall of faces" installation at, 38, 81, 83
Oldenburg, Claes, 17
Oleaga, Dario, 54, 133
Olinger Chapel Hill Memorial Church
 (Littleton, CO), 102
Olinger Chapel Hill Mortuary and Cemetery
 (Littleton, CO), memorial at, 103–4, 108–9
O'Loughlin, James, 35, 185n105
O'Neill, John P., 166
One World Trade Center (2014), 154
Our Father Lutheran Church (Littleton, CO),
 102
Ourossoff, Nicolai, 156–57

Out of the Dust: A Year of Ministry at Ground Zero (exhibit at Saint Paul's Chapel in New York City), 127
Owens, Bill, 102

Pagan, Jeannie, 150–51
Palme, Olaf, 56
Parédez, Deborah, 49
Parents Music Resource Center, 115
Passages of Light: The Memorial Cloud (bbc art + architecture), 155–56
Pataki, George, 166
Paterson (New Jersey), 52
patriot movement in the United States, 81–82
Pearl (Mississippi) school shooting (1997), 95, 115, 209n9
Pennsylvania Station (New York City), immediate 9/11 memorial at, 128
Pentagon (Arlington, VA), terrorist attack (2001) on, 3, 122, 158, 164
Peress, Gilles, 130
Perez, Selena Quintanilla, 49–50
Perez-Reverte, Arturo, 169
Perot, H. Ross, 19–21
Petit, Philippe, 123
Phantom Towers (*New York Times Magazine* illustration by LaVerdiere and Myoda), 123–24, 131, 146–48
Pietà images, 26–28, 64
Place de l'Alma (Paris), 45, 57–58
Placid Civic Monument (New York City), 17
Pollitt, Katha, 197–98n11
Poos-Benson, Steve, 107
Port Authority Bus Station Terminal (New York City), immediate 9/11 memorial at, 128
Port Authority of New York and New Jersey, 135, 141, 143, 170
Porter, Bruce, 117
"Portraits of Grief" (*New York Times* series after 9/11 terrorist attacks), 9, 164–65
Portraits of Survival—The Original Art of the Murrah Building, 88
Postal (video game), 112
Poster Project (Haacke), 132–33
Powell, Colin, 118
Preserving Memory (Linenthal), 77, 82–83
Price, George, 20
Prince, Norman, 23, 181n58
Prince, Richard, 56
Princess Diana. *See* Diana (Princess of Wales)
"Project for the Immediate Reconstruction of the Manhattan Skyline" (Bennett and Bonevardi), 148
Project Heartland counseling service (Oklahoma City), 84

Protetch, Max, 131–32
PROUN Space Studio, 148
Psalm 46:5, 90
psychological problems among American high school students, 112–13, 120
public memorials. *See also specific memorials*
architectural professionals' roles in, 172–73
commissioning processes for, 92–93
conflation of heroism and victimhood in, 39
diversion and denial strategies at, 1–2, 5, 7, 10, 20, 38, 61, 66, 78, 81–82, 93, 101, 107, 113, 119, 168, 171, 173–74, 233n199
family members of civil tragedy victims and, 9–10, 172–73
feminist critiques of, 27
Hirschhorn's critique of, 58
homogenization of victims at, 172
mass death narratives and, 5
narratives of healing and, 27–28, 35
rites of passage and, 16
selective memory and, 174
"therapeutic memorials" and, 7, 13, 61, 64, 81, 84, 92, 159, 171–73
tri-partite conception (immediate, interim, and permanent) and, 172–73
triumph of hope narratives and, 5–10, 8, 61, 65, 67, 69, 73, 75–78, 81–83, 88–89, 93–94, 103, 106–8, 137, 153, 161, 164–65, 167, 170–71, 174, 233n199
ultimate purpose of, 174
victim categories and victim emphasis at, 7, 10, 39, 101, 105, 119, 153–54, 157–59, 161, 164–69, 171–73
Pulitzer Piece: Stepped Elevation (Serra), 18

Rachel's Tears: The Spiritual Journey of Columbine Martyr Rachel Scott (Scott and Nimmo), 117
Ralph Appelbaum Associates, 37
Randy Nolan, Randy Archuleta, U.S. 285, South of Fairplay, in South Park, Park County, Colorado (Nance), 54
Reactions (2002 exhibit), 131
Reagan, Ronald, 25, 110, 181n54
Red Lake (Minnesota) shooting (2005), 119
Reflecting Absence (Arad). *See National September 11 Memorial & Museum*
Reflections of Hope Award (Oklahoma City), 91, 207n143–n145
Reiff, David, 173
Renewing, Rebuilding, Remembering (2002 exhibit), 131
Reno, Janet, 86
retablo boxes, 56
"revolt of the angry white male" (Larkin), 113

roadside memorials
 cemeteries compared to, 46
 Christian symbols and, 43–44, 46
 lack of commercial and media influences on, 53
 media coverage of, 44–45
 mourning at, 8, 46, 53
 Native American influences on, 45
 pervasiveness of, 45
 photographs of, 53–54
 purposes of, 46
 the road in American culture and, 44
 tributes left at, 40, 44
*Roadside Memorials, Shrines and Other
 Markers* (Taylor), 53
Robb, Charles, 34
Robles, Hector, 52
Rockefeller Center (New York City), sculpture
 controversy (2002) in, 134–35
Rockwell, David, 146
Rohrbough, Brian and Daniel, 98–99, 106
Roman death masks, 41
Romano, Lois, 89
Rosati, James, 142
Rosenblatt, Roger, 117
Ross Barney + Jankowsky Architects, 88
Rothstein, Edward, 161, 167
Rubin, David, 56
Ruby Ridge (Idaho) shootout (1992), 113, 197n7
Ryan, Zoe, 131
Rybczynski, Witold, 158–59

Safdie, Michal Ronnen, 127
Safer, Morley, 25
Saint John's Chapel (at Washington National
 Cathedral), 22–23
Saint Paul's Chapel (New York City),
 immediate 9/11 memorial at, 124, 126–28
Saint Peter's Roman Catholic Church (New
 York City), 137–39, 144
Saint Philip Lutheran Church (Littleton, CO),
 109–10
Saldivar, Yolanda, 50
Sanchis, Frank, 150
Sanders, Dave, 98, 104, 108, 116, 217n135
Sandy Hook Elementary School shooting (2012;
 Newton, CT), 120, 219n166
San Ysidro (California), mass shooting at
 McDonald's (1984) in, 52, 86, 193n88,
 205n113
Sasaki, Toshio, 156
Savage, Kirk
 on political nature of monuments to
 victims, 7
 on "therapeutic memorials," 13, 64, 159, 171–72
 on the *Vietnam Veterans' Memorial*, 169,
 171–72

Savinar, Tad, 103
Schick, Avi, 139
Schivelbusch, Wolfgang, 169, 234n1
Schnurr, Valerie, 108, 217n136
school shootings in the United States, history
 of, 95, 111–12, 209n9, 210n10. *See also specific
 shootings*
Scofidio, Ricardo, 146
Scott, Darrell, 117–18
Scott, Rachel Joy
 burial of, 108
 evangelical Christian interpretations of the
 killing of, 105, 116–18
 family of, 102, 117–18
 immediate memorial for, 98
Scruggs, Jan C.
 on attempts to whitewash Vietnam
 War, 38
 Congressional testimony (1976)
 of, 12
 on symbolic cemetery quality of the Vietnam
 Veterans' Memorial, 28
 on traveling walls exhibits, 34
 Vietnam Veterans Memorial and, 7, 12–13, 20,
 24, 28
 Vietnam Veterans Memorial Education
 Center and, 37–38
Sculpture in Environment exhibition (New York
 City, 1967), 17
Sednaoui, Stephane, 165
selective memory, 174
Selena (Selena Quintanilla Perez), 47–50
Selena immediate memorial (Corpus Christi,
 TX), 49
September 11, 2001 terrorist attacks. *See* 9/11
 terrorist attacks
Serra, Richard, 18, 179n33
Shadid, Anthony, 90
Shadowed Ground (Foote), 7
Shanksville (Pennsylvania), September 11, 2001
 terrorist attacks and, 158, 164
*She Said Yes: The Unlikely Martyrdom of Cassie
 Bernall* (Misty Bernall), 117
Shoels, Isaiah, 105–6
Shulan, Michael, 130
Sierralta, Karla, 156
Silecchia, Frank, 137, 139
Simpson, David, 1, 159, 165
Sites of Memory and Honor (Broches), 54
*Sixteen Acres: Architecture and the Outrageous
 Struggle for the Future of Ground Zero*
 (Nobel), 159
Sixteenth Street Baptist Church Bombing
 (Birmingham, AL, 1963), 86, 205n113
Smith, Dinitia, 140
Smith, Edward, 144

Smith, Fred, 34
Snøhetta (architectural firm), 154, 162
Solomon, Andrew, 120
South Kingstown, Rhode Island (Broches), 54
Southwestern College Education Center (San
 Ysidro, CA), memorial at, 52
Speer, Albert, 152, 229n141
Speyer, Jerry, 134
The Sphere (Koenig), 142–44
Spinoza, Benedict de, 58
Spinoza Monument (Hirschhorn), 58
Spreiregen, Paul, 66
Stastny, Donald J., 67, 199n35
Stock, Catherine McNicol, 60
Strawn, Brian, 156
Strozier, Charles B., 163
Sturken, Marita, 64, 71, 196n1
Suspending Memory (Karadin and Wu), 156

Taft, William Howard, 28
Tancredo, Tom, 104
Tapia, Ruby C., 64
Tats Cru (graffiti artists collective), 132
Taylor, Chris, 53
"Terrorism and Beyond: The 21st Century"
 (RAND Conference, 2000), 86–87
Thiepval Memorial to the Missing of the Somme
 (Thiepval, France), 5, 15–17
"The Things They Carried" (O'Brien), 31
This Republic of Suffering (Faust), 2
Thomas, Jane, 75, 91
The Three Servicemen sculpture (*Vietnam
 Veterans Memorial*, Washington DC),
 21–24, 26–28
"A Time to Remember, a Time to Hope"
 (Columbine tenth anniversary event,
 2009), 107
Tohono O'odham Reservation, Arizona
 (Broches), 54
Tomb of the Unknown Soldier (Arlington
 National Cemetery), 12, 28
Tomlin, John, 105
Towers of Light. See Tribute in Light (LaVerdiere
 and Myoda)
Towers of Light (1964 World's Fair), 152
Townsend, Lauren, 105
Traub, Charles, 130
Tribute in Light (LaVerdiere and Myoda)
 creative team behind, 149
 dust from destroyed World Trade Center
 and, 153, 171
 first appearance (2002) of, 9, 150
 media depictions of, 152–53
 national identity narratives and, 150
 National September 11 Memorial & Museum
 (New York City) and, 162, 167

Phantom Towers (*New York Times
 Magazine* illustration) as inspiration
 for, 146–48
photo of, 151
proposal for, 131
reactions to, 149–53, 155, 230n147
September 11 anniversary events and, 150
sponsors of, 228n116
*Trying to Remember the Sky on that September
 Morning* (Finch), 163
Tumbling Woman (Fischl), 134–35
Turner Network Television (TNT), 35

Ullman, Micha, 72–73
*The Unfinished Bombing: Oklahoma City in
 American Memory* (Linenthal), 77
The Unfinished War (Capps), 11
Union Square (New York City)
 history of, 221n15
 immediate 9/11 memorial at, 124–26
United Airlines Flight 93 (9/11 terrorist attacks
 target), 158
United Airlines Flight 175 (9/11 terrorist attacks
 target), 158
United Methodist Church (Oklahoma City), 90
United States Capitol (Washington DC), 122
United States National Holocaust Memorial
 Museum (USNHMM; Washington, DC),
 5–6, 77, 169, 171

Vale, Lawrence J., 173
Van Alen Institute, 131
Van Sant, Gus, 9, 97, 114
Vaughn, Heidi, 81
Velasquez, Kyle, 105–6
Venice Biennale of Architecture (2002), 132
Vergara, Camilo Jose, 189n28
Versace, Gianni, 56
Veterans of Foreign Wars (VFW), 35
video games, 112–13
Vietnam Veterans Memorial (*VVM*,
 Washington DC)
 additions to original design of, 12, 15, 21–28
 black granite surface of, 20, 29, 69
 commissioning and planning of, 3, 6, 11–13,
 19, 29, 93, 172
 conflation of heroism and victimhood
 in, 39, 169
 diversion and denial strategies at, 171, 174
 documentation and commentary left at,
 32–33
 earthworks and, 17–18
 Education Center plan for, 5–6, 8, 34, 37–38,
 81, 171
 financing of, 19
 flagpole at, 21, 28, 181n53

Vietnam Veterans Memorial (continued)
 formal dedication (1982) of, 30
 gifts for the dead left at, 32
 Lin and, 3, 8, 11–15, 17–21, 28, 31, 38, 67, 93, 155,
 157, 180n41, 181n53, 182n68
 mourning at, 3, 5, 8, 12, 20, 30–31, 35, 171,
 187n121
 names and name sequencing at, 14, 19, 29,
 68, 158
 narrative of healing and, 35
 national identity and unity narratives at, 7,
 21, 38–39, 181n54
 National Park Service and, 30
 objections to design of, 19–21, 58
 objects of shared experience left at, 32
 photographs of, 13–14, 23, 26
 plaque at *The Three Servicemen* statue and, 27
 prologue and epilogue at, 19
 as a prototype, 35–37, 154
 Pulitzer Piece: Stepped Elevation and, 18
 relics left at, 31
 reverential behavior at, 29
 rubbings of engravings at, 12
 selective memory and, 174
 site of, 7, 12–13, 18, 20, 25–26, 178n13
 as symbolic cemetery, 12, 17, 19–20, 27–33,
 39, 171
 as "therapeutic memorial," 7, 13, 171–72
 *Thiepval Memorial to the Missing of the
 Somme* and, 15–17
 The Three Servicemen sculpture at, 21–24,
 26–28
 traveling walls exhibits and, 33–36, 99,
 185n101, 186n106
 tributes left at, 8, 12, 29–35, 39–40, 171
 United States National Holocaust Memorial
 Museum and, 6
 Veterans Day events at, 27, 30–31, 35
 Vietnam Women's Memorial and,
 24–28
 "wall of faces" installation plan for, 38, 81
 war dead rather than war emphasized at,
 10–13, 20, 31, 39, 169
Vietnam Veterans Memorial Collection
 (VVMC), 30
Vietnam Veterans Memorial Fund (VVMF)
 additions to original memorial design and,
 22, 24
 founding of, 12
 memorial design and, 19, 21
 memorial planning and, 12–13
 political allies of, 21
 traveling walls exhibits and, 33–35
 Vietnam Veterans Memorial Education
 Center and, 37–38

Vietnam War
 African American soldiers in, 20
 Agent Orange and, 27, 33
 Arlington National Cemetery and, 12, 28,
 177n8
 domestic political conflict regarding, 3, 7,
 10–11, 20, 38, 60, 113, 169, 173, 175n10,
 234n1
 gay soldiers in, 32–33
 jungle landscape and, 17–18
 media coverage of, 11, 17
 My Lai Massacre (1968) and, 38
 myths shattered by, 11, 39
 public opinion data regarding, 11
 relics from, 31
 veterans' struggles after, 12, 27, 33
 women's service in, 24
Vietnam Women's Memorial (VWM), 24–28
Vietnam Women's Memorial Project
 (VWMP), 26
Virgil, 162
Virginia Tech shootings (2007), 105, 108, 119,
 210n9, 219n161
Votives in Suspension (Lee and Lewis), 155

Waco (Texas)
 Branch Davidian compound shootout (1993)
 in, 8, 60, 85–86, 113, 174, 197n6
 Branch Davidian Memorial in, 204n108
 new Branch Davidian church in, 86
Walker, Peter, 9, 124, 157
Walker, Tyra, 30
Warner, John, 181n53
Washington Monument (Washington, DC)
 diversion strategy at, 2
 obelisk design of, 1, 20
 reflecting pool and, 69
 Vietnam Veterans Memorial's location near,
 7, 12, 20
Washington National Cathedral, 22–23, 28,
 181n58
Watkins, Kari, 78, 82, 87, 89
Watson, Justin, 94–95
Watt, James G., 20
Webb, Toby, 35
Webb, Valerie, 150
Webb, Wellington, 102
Webster, Daniel, 2
Weise, Jeff, 119
Western (Wailing) Wall (Jerusalem), 127
West Paducah (Kentucky) school shooting
 (1997), 95, 209n9
White House Office of Faith-based and
 Community Initiatives (George W. Bush
 administration), 119

Williams, Brian, 89–90, 166
Winchester, Susan, 92
"Wind Beneath My Wings" (Midler), 66
Winter, Donald C., 104
Winter, Jay, 4–5
Wodiczko, Krzysztof, 2, 152
Wolff, Michael, 47
Woodham, Luke, 115–16, 209n9
World's Fair (New York City, 1964), 152
World Trade Center (New York City)
 architectural design of, 123, 220n9
 damaged public art from, 142–45, 226n84,
 226n86
 design for rebuilding, 154 (See also *National
 September 11 Memorial & Museum*)
 distribution of relics from, 141–42, 225n81
 immediate memorials near Ground Zero
 and, 75, 123–27
 last standing beam (Column No. 1, 001 B) at,
 135–37, 164
 memorial to victims of 1993 terrorist
 bombing at, 123, 143–45, 166
 one remaining window from, 164
 photographs of relics from, 136–38,
 140–41
 relics from, 9, 124, 127, 132, 135–46, 157,
 162–64, 166–67
 rescue workers at, 124, 128–29, 135, 137, 139,
 152, 157–58, 167
 Saint Paul's Chapel and, 126–27

 skeletal segment of the South Tower relic
 from, 140–41, 225n78
 slurry wall from, 145–46, 156, 164
 steel beam cross relic from, 137–39
 survivors' stairs at, 139–40, 163, 225n73
 terrorist attack (2001) on, 3–4, 7, 122–23,
 153–54, 157–58, 161, 164, 166
 terrorist bombing (1993) of, 123, 143,
 153–54, 161
 viewing platform for Ground Zero at, 146
World War I, monuments
 London Cenotaph memorial and, 4–5
 Norman Prince tomb and sculpture and,
 22–23
 *Thiepval Memorial to the Missing of the
 Somme* and, 5, 15–17
World War II, 3, 21
Wright, Frank Lloyd, 152
Wright-Frierson, Virginia, 100
Writings on the Wall (Scruggs), 28
WTC (World Trade Center) Survivors'
 Network, 139
Wu, Hisn-Yi, 156

Yamasaki, Minoru, 123, 220n9
Yardley, Jim, 69
Ybarra-Frausto, Tomas, 55

Zanis, Greg, 98–99, 102, 211n34
Zimmerman, Elyn, 123, 143–45, 166

2/25/16